BASIC PHOTOGRAPHY

A Primer for Professionals

Michael J. Langford, F.I.I.P., F.R.P.S.
Senior Tutor in Photography
Royal College of Art, London

Fourth Edition

© 1977 FOCAL PRESS LIMITED

ISBN 0 240 50955 2 (Paperback) ISBN 0 240 50954 4 (Casebound)

All rights Reserved. No part of this publication may be reproduced, stored in a retrieval system, or transmitted, in any form or by any means, electronic, mechanical, photocopying, recording or otherwise, without the prior permission of the Copyright owner.

First published 1965
Second Impression 1967
Third Impression 1968
Fourth Impression 1970
Second Edition 1971
Sixth Impression 1971
Seventh Impression 1972
Third Edition 1973
Ninth Impression 1974
Tenth Impression 1975
Eleventh Impression 1976
Twelfth Impression 1977
Fourth Edition 1977

In Italian:
Trattato Di Fotografia Moderna.
Il Castello, Milano

In Spanish: Fotografia Basica. Ediciones Omega S.A.

Text set in 11/12 pt Photon Times, printed by photolithography, and bound in Great Britain at The Pitman Press, Bath

CONTENTS

FOREWORD

INTRODUCTION: THE PROCESS OF PHOTOGRAPHY

SECTION I

FORMING THE IMAGE

1. SOME BASIC PRINCIPLES OF LIGHT	19
Electromagnetic energy; wavelength	19
The visible spectrum. Inverse square law.	21
Changes when light meets a surface - Absorption, Reflection, Transmission,	
Refraction, Dispersion.	24
Refractive Index.	27
Summary.	30
Questions.	31
2. LENSES AND IMAGES	33
Pinhole images.	33
Evolution of the simple positive lens.	34
Focusing screens.	36
Focal length.	38
Image size.	39
Geometric object/image zones, and magnification - for distant subjects, same	
size photography, enlarging and projection.	41
Conjugate distance calculation.	44
Lens shapes.	47
Negative lens properties and applications.	47
Summary.	49
Questions.	49
3. LENSES AND ILLUMINATION	51
Compound lenses – purpose; 'principal planes'; determining focal length.	51
Image brightness - influence of effective aperture and focal length.	55

Relative aperture.	58
f-number scales.	58
Mechanical control of aperture.	60
f-number and exposure.	60
Effect of close-up work on image brightness, exposure modifications.	61
Summary.	63
Questions.	64
4. ANGLE OF VIEW	65
Lens covering power.	65
Angle of view – focal length and format.	67
Perspective.	69
Use of lens and viewpoint to control image size and perspective.	70
Wide-angle lenses, wide-angle distortion.	71
Normal angle lenses.	73
Long focus lenses.	73
Care of lenses; abrasions, condensation.	74
Summary.	75
Questions.	76
5. DEPTH OF FIELD – DEPTH OF FOCUS	79
Standards of sharpness – circles of confusion.	79
Depth of focus; controlling factors; practical significance.	80
Depth of field; factors; purpose and methods of achieving minimum and	
maximum depths.	83
Relationship between depth of field and focus.	88
Depth of field calculators.	89
Hyperfocal distance and its calculation.	90
Summary.	91
Questions.	92
6. CAMERA MOVEMENTS	95
The physical movements.	95
Rising front; drop front; cross front	97
Swing front	100
Swing back.	103
Combined use of movements.	106
Selection of suitable movements.	106
Summary.	108
Questions.	108

7. CAMERA SHUTTERS	111
Shutter construction:	111
Shutters within or near lens.	113
Focal plane shutters.	115
F.P. shutter image distortions.	117
Shutter speeds.	118
'Exposure Values'.	119
Selection of speed; control and visual significance of blur.	119
Summary.	121
Questions.	122
8. THE CAMERA AS A WHOLE	123
The human camera.	123
Basic camera types.	124
Direct vision cameras; suspended frame finders, rangefinders.	125
Twin lens reflexes: parallax, Fresnel screens.	131
Single lens reflexes: pentaprism viewfinders and rangefinders, iris pre-selector.	135
Technical (baseboard) cameras: drop baseboard, frame-finder, revolving back.	141
Technical (monorail) cameras: unit system, bag bellows	146
Unusual designs and special cameras.	150
The camera for the job.	152
Summary.	153
Questions.	155
Revision questions covering Section I.	157
SECTION II	
RECORDING THE IMAGE	
9. THE SENSITIVE MATERIAL – MANUFACTURE	161
Silver halides.	161
Binder and support – the functions of gelatin.	162
Manufacture - emulsion mixing; ripening; washing; after-ripening; dye sen-	
sitising. Coating on film, glass, paper.	165
Cutting, popular sizes.	171
Packing - sheet film, roll film, 35 mm cassettes, easy-load packs, paper.	173
Storage condition and expiry date.	175
Summary.	177
Questions.	177

10. THE SENSITIVE MATERIAL – CHOICE OF EMULSION	179
Emulsion contrast – use of low, medium and high contrast materials.	179
Emulsion resolving power – irradiation, halation.	180
Emulsion speed – arithmetical and logarithmic rating systems; change of	
exposure with change of emulsion.	182
Colour sensitivity - eye response to colour; blue sensitivity, ortho and pan	
emulsion response; wedge spectrograms; choice of colour sensitivity.	184
Overall choice of emulsion for various assignments.	189
Summary.	191
Questions.	191
11. THE EFFECT OF COLOUR FILTERS	193
Purpose and colour performance, filter absorption curves.	193
Filters as safelights; sodium safelights; safelight testing.	194
Filters on the camera – correction filters; contrast filters.	197
Assignments using contrast filters.	201
Special filters - viewing filters; graduated sky filters; haze filters; colour	
separation filters.	202
Filter factors in practice.	203
Filter qualities - gelatin; optical flats; optical and non-optical glasses; dyed	
glass; lighting gels.	203
Summary.	205
Questions.	205
12. SUBJECT LIGHTING – EQUIPMENT AND HANDLING	209
Hard light sources.	209
Spotlight.	212
Flashbulbs and tubes.	214
Soft light sources.	216
Floodlight.	217
Practical lighting principles.	219
Photo-electrics.	222
Summary.	225
Questions.	226
13. SENSITOMERTY	228
Plotting the emulsion performance graph-controlled light dosage; develop-	
ment; measuring resulting 'Density'.	228
The 'Characteristic Curve' – geographical features.	233

Gamma and emulsion contrast; gamma and wavelength. 'Correct' exposure;	224
average gradient; contrast index. Other information from the characteristic curve – fog level, speed, maximum	234
density.	240
The effect of development; effect of permutating developer and exposure	240
alterations.	242
Exposure latitude.	245
Practical information conveyed through sensitometry – limitations of data.	247
Summary.	249
Questions.	250
14. EXPOSURE MEASUREMENT	253
Factors determining camera exposure.	253
Estimating devices: test strip; tables; extinction meters.	254
Photo-electric meters, selenium and CdS; automated types; photometers.	256
Using an exposure meter: the problem; general readings; brightness range	
readings; keytone reading; incident light attachments.	259
Modifying readings; special conditions.	265
Practical lighting and exposure problems.	266
Summary.	267
Questions.	268
Revision questions covering Section II.	270
SECTION III	
PROCESSING THE RECORD	
15. PROCESSING FACILITIES AND PREPARATION	275
Darkroom layout – basic needs, size, walls and ceiling, floor, entrance, ventilation,	
interior layout, lighting and power.	275
Tanks and dishes – materials.	280
Chemicals and solutions: general preparation; mixing from bulk, weights and	
measures.	281
Dilution from stock – by 'part', by 'percentage'.	285
Diluting percentage solutions.	286
Summary.	286
Questions.	287
16. DEVELOPERS AND DEVELOPMENT	289
Function of development.	289
Developing agents.	289

Other developing ingredients: alkali, preservative, restrainer.	290
Developer types.	291
General purpose developer.	292
High contrast developer.	293
Degree of development: formula and solution condition, dilution, temperature,	
time, agitation, emulsion type.	294
Development technique.	301
Reading technical data.	303
Summary.	305
Questions.	306
17. FIXING WASHING AND DRYING	309
The object of fixation.	309
Dichroic fog.	309
Stop baths.	310
Fixing baths – plain, acid fixing, acid hardening fixing.	311
Fixing time - effects of formula; exhaustion (including regeneration); tempera-	
ture; agitation; emulsion content.	313
Fixing technique.	315
Washing – purpose and technique.	316
Tests for permanence.	317
Drying – drying marks.	318
Dish cleaning; negative fault evaluation; negative filing.	319
Special processes – Monobaths; Instant picture process.	322
Summary.	323
Questions.	324
18. PRINTING AND FINISHING	325
Factors controlling print quality.	325
Negative preparation – spotting, blocking out, masking.	325
Printing materials, chloride, bromide, chlorobromide, lith emulsions.	327
Emulsion contrast.	329
Surface and base – maximum black and white.	331
Printing equipment – basic enlarger; negative illumination; diffuse and condenser; 'Callier' effect.	334
Enlarging technique – shading, printing in, blur; printing b & w transparencies;	334
photograms.	340
Processing printing materials – development, fixation, washing.	343
Stabilisation print materials.	346
Glazing – hot and cold methods; glazing faults.	348
Mounting – dry, rubber gum.	348

Print finishing. Transparency binding.	350
Print faults.	351
Final image presentation – tone range, effect of illumination, mounts.	351
Summary.	353
Questions.	354
Revision questions covering Section III.	355
SECTION IV	
19. SUBJECT AND STATEMENT	359
The purpose of photographs - objective/subjective, based on science and	
philosophy.	359
Subject evaluation, visual analysis.	362
Interpretation of subject, relative to purpose, through photography: viewpoint,	
tone values, sharpness, timing.	363
Conclusions.	366
Practical projects.	366
APPENDICES A. Recommended reading - First year bibliography	371
B. Quick conversions	375
C. Recapping logarithms	377
D. Answers to calculation questions in the text	379
E. Chemical revision list	383
F. Schools offering full-time photographic courses	385
INDEX	389

To P. The first for the first . . .

ACKNOWLEDGEMENTS

For help and suggestions in preparing this book my thanks go to Alan Horder, John Still, Edward Martin and Frank Owen – fellow members of The Society for Photographic Education. Various manufacturers and Heads of schools kindly allowed me to reproduce photographs and questions from papers set for school and college courses. I hope that this up-dated edition will continue to be useful to all teachers and students.

FOREWORD

Basic Photography is the first of a series of books written mainly for professional photographers. It is intended for first-year students of photography at schools and colleges, and studio or photographic department staff at day release or evening classes. Designers will also find here a technical foundation to practical work. The book begins at ground level and presupposes no knowledge of the photographic process – nor does it assume that the reader has a scientific background.

Just how valid is photographic theory? Learning to photograph is rather like learning to write – first we have to shape the letters forming words, then learn to spell, and organise our grammar. But the individual who can do only this is no writer until he or she has ideas to express through words. Similarly, theory to the photographer is a means to a visual end – valid in so far as it offers him better control, improved self-confidence in achieving what he wishes to say through pictures.

Theory, then, exists to support practice. This means that even the most imaginative individual needs to understand his tools and his craft. The creative photographer handicapped by technical incompetence is unfair to himself and to the client – someone who is entitled to expect reliability.

'Photography' or 'light drawing' is essentially a combination of technique and visual observation. This first-year book is inevitably much concerned with principles and basic technique — an understanding of 'what happens'. Towards the end of the book a final section suggests ways in which our knowledge of the photograph process, combined with what we individually observe, may lead to satisfying visual images.

Since it is hoped that the text will encourage practical experiments, access to a large format (say 5 in \times 4 in) camera and lenses will be helpful, as well as a small format camera. At every opportunity 'case histories' of assignments are quoted to show how theoretical principles or techniques apply under practical conditions.

The book is arranged under three broad sections – Forming an image; Recording the image; and Processing the record. A fourth section introduces some aspects of picture subject and statement. Chapters are structured to be read chronologically, new terms are defined as they are introduced and each chapter builds on its predecessor. Every chapter closes with a comprehensive summary and questions from examination papers. Answers to calculation questions appear in Appendix D.

As a whole the book is designed to help students prepare for the technical aspects of photography examinations. It also covers the first year of study for students in City & Guilds (subject 744) part-time courses. Following the current practice of these syllabuses *Basic Photography* does not include colour photography, which is covered in the second-year textbook, *Advanced Photography*.

Finally, no book can offer the same personal tuition as a photographic course that it complements rather than replaces. A book allows the reader to go at his own pace – to

turn back without losing track. A course allows immediate discussion. A list of schools offering full-time courses in photography appears as Appendix F at the end of the book.

MICHAEL LANGFORD

Note. Throughout the text the terms 'Objective' and Subjective' photography are frequently used. Objective photography implies those fields – notably scientific – where the process is used as a visual notebook. In other words, the aim is to make an objective, factual record of the subject, a requirement which often calls for much technical ingenuity. In subjective photography (magazine illustrations, etc.), the subject is *interpreted*. The final result is therefore flavoured

by the attitude of the photographer or client as well as subject facts.

All applications of photography call for both objectivity and subjectivity in varying proportions.

INTRODUCTION

The Process of Photography

From the very first moment we use a camera to take pictures and process the results we are plunged into using a range of optical and chemical phenomena. Yet if theoretical knowledge is to be systematically acquired, it would be logical to commence coverage with optics and image forming, and work through to printing and finishing. To begin with however we ought to take a broad look at how photography works. This will help to put our day-to-day procedure into perspective; later in the appropriate section each aspect can be looked at in more detail. This introduction therefore maps out all the ground we shall be covering in the text.

The technique of photography can be broadly divided into optics, physics and simple chemistry:

Forming an Image

Some of the light rays reflected from or emitted by each part of the subject enter our camera lens. Here they are bent or 'refracted' to re-form as a detailed image of the subject. The image is formed upside-down at a set distance from the lens relative to subject distance and the bending power ('focal length') of the lens in use.

This image can be checked on a ground glass screen, moving the lens position until correct distance for clear or 'sharp' focus is found; later a light-sensitive material will replace the screen to record the image chemically.

By changing lenses image size is altered, allowing wider or small areas of subject to fill our pictures. By movement of the lens or focusing screen in directions other than backwards and forwards the image is shifted, altered in shape, and changed in distribution of sharp focus. These 'camera movements' therefore offer us important image controls.

Having formed the required optical image we need some way of strictly controlling its effect on light-sensitive material. This is achieved by the two exposure controls: (a) an adjustable diaphragm within the lens, scaled in 'f-numbers'. This enables us to dim or brighten the image. (b) a movable opaque shutter scaled in fractions of a second. This allows accurate timing of the period light is allowed to act on the film. Quite apart from exposure control, both have important influences on recorded image clarity, (a) expanding or contracting the distance between nearest and farthest subjects which are simultaneously sharply recorded, (b) altering the visual rendering of movement.

Lens and sensitive material, although basic, form only part of our image-making equipment. They are common denominators in a vast range of camera designs. Some

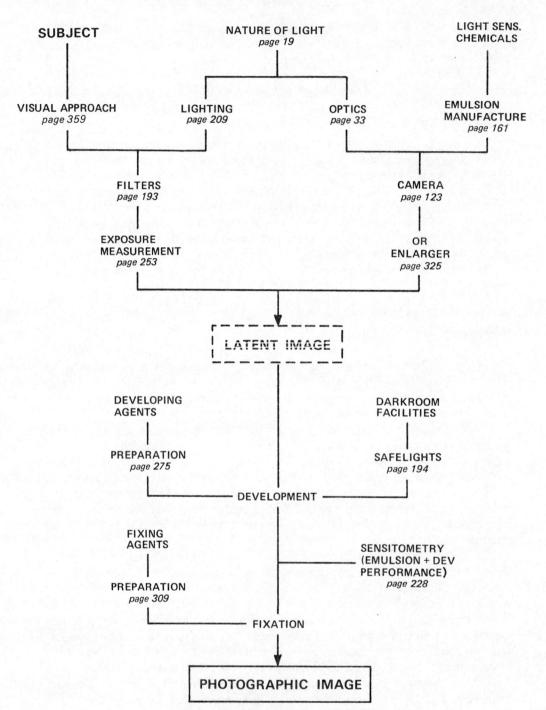

Fig. 1. The basic technical aspects of black and white photography.

produce pictures on small-width film, others have formats 10 in \times 8 in or larger. (N.B. Cameras of 6 cm picture width or smaller will be referred to as 'small-format' cameras, the remainder as 'large-format' equipment.)

Most small-format cameras are intended for hand-held use and include many ingenious features to aid focusing. Some larger cameras can be operated only on a stand. All offer some simple method of introducing light-sensitive material into the camera and removing it after exposure without 'fogging' to light.

Recording the Image

Most silver salts slowly decompose under the action of light to form finely divided black metallic silver. The most efficient are silver bromide, silver iodide, silver chloride (i.e., compounds with 'Halogen' elements). These light-sensitive, insoluble, creamy 'silver halides' are conveniently suspended as crystals ('grains') in gelatin, and coated on film or paper bases to form our photographic material.

During exposure to the optical image in the camera just a few atoms of silver are allowed to form – exposure times would otherwise run into hours. These few silver atoms form a 'latent' (or invisible) image. Later it will be amplified or 'developed' by appropriate chemicals to give about one hundred million times the quantity of silver, and so result in a visible image.

Obviously, different photographic materials have different characteristics. Some respond to all visible colours, others only to blue. Some materials respond more rapidly to light - i.e., are 'faster' - than others. By suitable choice of material, appropriate subject lighting, level of exposure and perhaps the use of colour filters, we can exert extremely wide control over the way our optical image affects the film. The exact 'performance' of a film therefore deserves close study - a study we call 'sensitometry'.

Processing the Record

After exposure, our sensitive material carrying its latent image is removed from the camera and, still screened from light, removed to a suitably equipped darkroom for processing. The chemicals which will develop light struck silver halides are most evenly and easily introduced to the crystals in the form of a solution, which will be absorbed into the gelatin. Strict control is necessary over time, temperature and agitation of solution for controllable development results.

During development, silver halide grains are converted into black silver grains, broadly in proportion to light received. At the same time the equivalent quantity of the original 'halogen' content is discharged as a by-product into the developer, limiting solution life.

We cannot yet look at the image in white light. The remaining creamy coloured silver halide grains which did not receive image light remain largely unaffected by development, and would eventually decompose. It is, therefore, necessary to change these now unwanted crystals into soluble compounds which may be washed away in water. This

chemical change is achieved in a 'fixing' solution (commonly containing 'hypo').

After washing and careful drying we find ourselves with a 'negative' image — in which bright subject highlights are reproduced in black silver, dark subject shadows by clear gelatin. The negative now requires printing by light on to further silver halide coated material to form a 'positive' result.

Printing takes place either by passing light through the negative, in contact with sensitised paper, or by projecting a suitably sized optical image of the negative on to the paper via an 'enlarger'. In both cases the paper receives greater light exposure through clear areas of the negative than dense areas, so that when a similar developing-fixing-washing processing cycle is completed the original subject highlights are reproduced light, shadows dark. We have a 'positive' image. If film-based photographis material is used instead of photographic paper the resulting positive is known as a black-and-white 'transparency'.

The main advantages of the negative positive system of black-and-white photography are:

- (a) Many prints may be made from a single camera-exposed negative.
- (b) Prints may be of a variety of sizes, on a variety of bases.
- (c) Other image controls can be exercised in printing, altering overall and local density, image shape and sharpness.

And so the wheel comes full circle – our original multi-coloured subject is represented in monochrome (single coloured) tones between black and white. It is ready for mounting and any art work or retouching prior to press reproduction or presentation to the client.

So much for the condensed process of photography. Having looked at the wood as a whole we can now move in to examine the trees . . .

Section I

FORMING THE IMAGE

From his shoulder Hiawatha
Took the camera of rosewood
Made of sliding folding rosewood;
Neatly put it all together ...
This he perched upon a tripod,
And the family, in order
Sat before him for their picture —
Mystic, awful was the process ...

I. SOME BASIC PRINCIPLES OF LIGHT

This first chapter looks at photographically important properties of light. Fundamentals such as these – which are more physics than photography – are important to grasp if we are later to build on them to show how lenses, filters, and various forms of lighting equipment operate in practice.

As photographers, light is our basic 'raw material' of communication. It conveys information to us about objects which are out of range of other senses – touch, smell, and sound. It channels information from objects via the camera lens to the sensitive photographic material. After processing, our photographic record would be useless without light to communicate its contents to the eye.

At this very moment light reflected from this page carries the shape of words to your eyes – just as sound would form the link if we were talking. But having lived with light from the moment of birth we have all long since taken this silent, untouchable form of energy for granted. What exactly is light?

Electro-Magnetic Energy

Physicists know that light is only one form of 'electro-magnetic energy'. Rather like a member of an enormous family of 'energy conveyors', light is related to wireless, radar, X-rays and cosmic rays. All these forms of electro-magnetic energy have the following properties in common:

- (1) They are 'radiated' from a source (lamp filament, transmitting aerial, the sun, etc.). Hence they are often collectively termed Radiant Energy.
- (2) They are able to span a vacuum such as space or pass through any substance 'transparent' to their energy. (Unlike sound which must be conveyed by vibration within a *carrier* substance such as air, water, etc.)
- (3) They all travel at a colossal speed. In a vacuum this is 186,000 miles per second (equal to a trip around the earth in 1/7 th second!). In other transparent materials water, glass, etc. speed is slowed as density of the material increases. Glass for example reduces light speed by one third.
- (4) They are radiated in virtually straight lines or 'rays'. In the case of light we can check this visually from the direction of the shadows, observations of 'sunbeams', etc.
- (5) They appear to travel in 'wave form'. This might be visualised as the cross-section of water surface through which ripples are spreading or radiating outwards from a stone dropped into a pool, (see Fig. 1.1).
- (6) They convey energy to a surface as a stream of particles. In the case of light these tiny particles are called 'photons'.

Recap. Electro-magnetic energy is particle energy travelling rapidly away from a source as straight-line rays. Within this straight-line path the energy appears to 'cycle' in regular waves pulsating at right angles to the direction of travel.

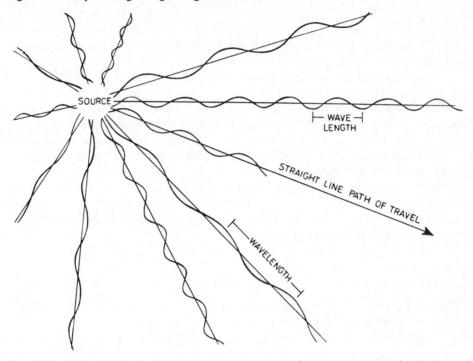

Fig. 1.1. A simple concept of electro-magnetic energy. Most light sources (e.g. the sun, photolamps) emit a mixture of wavelengths.

Whereas the idea of light as a stream of particles has relevance to exposure meters and photographic film itself, we are for the moment more concerned with properties (3), (4) and (5).

Wavelength

The important point about wave motion is that although the whole 'family' of electromagnetic radiations all appear to travel in this way, each type of radiation has its own length of wave. These differences in *wavelength* are vast and give each form of electromagnetic radiation its own very different properties. For example, some waves may measure over a mile from crest to crest and are familiar as long-wave radio waves. Others may be less than a ten-thousand millionth of one millimetre (Gamma rays).

We can relate the position of light rays within the family of electro-magnetic radiations by drawing a simple wavelength scale or *Electro-magnetic Spectrum*. One of the problems in doing this is choosing an appropriate unit of measurement. If centimetres were chosen, for instance, our radio waves would be quoted in millions

and gamma rays in hundred-millionths. Therefore the measurement scales change throughout the spectrum to keep numbers within manageable proportions (see Fig. 1.2).

Electro-magnetic radiations with wavelengths between 1 and 100 X-units (tenthousand millionths of a mm) have properties which include ability to penetrate dense metals or destroy human tissue. As wavelengths increase into thousands of X-units the radiations change from gamma rays through 'hard' X-rays to 'soft' X-radiation – rays with less penetrative powers and reduced lethal effects, as used in medicine. Longer wavelengths are usually calibrated in nanometres or Angström units.

- 1 Nanometre (nm) = 1 millionth of a mm = 10^{-7} cms
- 1 Angström Unit (1 Å) = 1/10 millionth of a mm = 10^{-8} cms

(This book will quote most wavelengths appropriate to photography in nanometres.)

Radiation with wavelengths between about 5 nm and 400 nm has little penetrative ability, having instead powers which include bleaching of dye-stuffs, and causing 'fluorescence' of some substances. This electro-magnetic radiation is known as *Ultra Violet*.

The human body is unable to sense gamma, X, or ultra-violet rays, although all can be harmful to body tissue. Fortunately, the majority of these radiations from 'natural' sources in outer space are shielded from us by ionising layers high in the earth's upper atmosphere. 'Man made' sources are used under strictly controlled conditions for medical or industrial purposes.

Electro-magnetic radiation within the narrow band 400–700 nm has the ability to stimulate the retina at the back of our eyes giving the sensation of light. Hence such radiation is known as *Visible Light*.

Radiation beyond 700 nm and up to about 1/10 mm in wavelength no longer stimulates the eye but becomes increasingly apparent to the skin as a sensation of heat. This is known as *Infra Red* radiation and radiant heat. Beyond 1 cm in wavelength the radiation gradually changes in nature to a form used in *Radar*. Such radiation can only be sensed by electronic equipment, although some of the longer wavelength Radar radiation can be harmful to body tissue. It is dangerous to approach a powerful radar transmitting dish. Radiation of wavelength beyond 10 m is employed progressively as short, medium and long *Radio waves*.

It seems strange that we are unable biologically to detect so much of the vast electromagnetic spectrum. However, with most naturally occurring radio, infra-red, ultraviolet, X-ray and gamma-ray wavelengths from space shielded from us, man has evolved without need of detection devices (or biological defences) for these types of radiation. Beings on another planet, with different environment, might well have evolved with organs capable of sensing, say, radio waves but completely 'blind' to visible light as we know it!

The Visible Spectrum

Light, as recognised by our eyes, is a comparatively narrow band of electromagnetic energy radiated with wavelengths from about 400 nm to 700 nm. But within this 'visible

spectrum' each wavelength produces a slightly different stimulus at the back of our eyes. Each type of stimulus is recognised by the brain as a 'colour'. A mixture of all or most visible wavelengths is recognised as 'white' light.

Imagine you are in a darkened room looking at a source which will radiate light of just one wavelength at a time, but can be varied throughout the entire visible spectrum. Working at 400 nm the light appears a dark rich violet, growing increasingly bluer as the wavelength is changed towards 450 nm. At 500 nm blue is giving way to blue-green; between this wavelength and about 580 nm your impression of green becomes less blue and increasingly yellow. At 600 nm the yellow is growing orange and at about 650 nm orange has lost yellow to give way to red. This red grows less yellow, richer, darker . . . until at 700 nm it becomes as dim and difficult to distinguish as the deep violet light of 400 nm.

The visible spectrum is seen to give a continuous 'blending' of colour impressions without abrupt divisions at set wavelengths. However, for convenience we usually assume that 'Violet' is a band of wavelengths between about 400–450 nm, 'Blue' from 450–500 nm, 'Green' from 500–580 nm, 'Yellow' from 580–610 nm and 'Red' from 610–700 nm. These colours – V.B.G.Y.R. – and their approximate wavelengths are important to remember. (A jingle such as 'Very Big German Yacht Races' may help.) We shall later be using various forms of diagrams and graphs where colours are most conveniently quoted in terms of wavelength figures. It is useful to be able to 'colour label' these units.

Summing up the most important aspects of light therefore:

- (1) Light is a form of 'energy in transit' a comparatively narrow band of electromagnetic radiation between ultra-violet and infra-red.
- (2) Its speed varies with the density of the medium it is passing through.
- (3) Light waves travel on an overall straight-line path with a waveform pattern of electro-magnetic force the length of wave being measured in nanometres.
- (4) Mixed together in suitable proportions, wavelengths between 400 nm and 700 nm create a sensation of 'white' light. Narrower bands are recognised as Violet, Blue, Green, Yellow, Red in order of increasing wavelength.

Illumination Fall-off

Because light travels in straight lines, rays from a point source spread farther and farther apart as their distance from the light source increases. In other words they diverge. Due to this steady divergence a small surface held near the light source will receive the same amount of light energy as a larger surface held farther away. The closer the small surface is held to the light source the more rays it intercepts. Try a simple experiment. Hold a $15 \text{ cm} \times 15 \text{ cm}$ piece of white card 30 cm from a bright but small light source (such as a 100-W clear bulb). Take a meter reading of the light reflected from this card. Now move the card until it is 60 cm from the lamp and take another meter reading. You will find that the second meter reading is one quarter of the first.

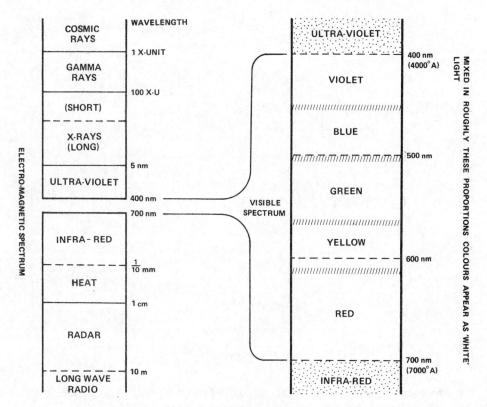

Fig. 1.2. The visible spectrum.

The reason for the fall-off is that the light which was captured by the $15 \text{ cm} \times 15 \text{ cm}$ card surface at 30 cm has diverged to spread over a surface 30 cm \times 30 cm by the time it is 60 cm from the lamp. Our card has not changed in size, and occupies only one-quarter of the total area now illuminated – therefore it receives only one-quarter of the original light.

This rate at which light intensity reduces with distance has important practical applications. It enables us to calculate changes in exposure when moving studio lamps or flash units. It means that (taking the lens to be a point light source within the camera) we must give extra exposure when photographing close objects — as the lens is racked out farther than usual from the film. We shall meet these and other applications in later chapters. For the moment it is sufficient to remember the rate and cause of this light reduction. Its broad effect is summed up in *The Inverse Square Law* which states:

'When a surface is illuminated by a point source of light, the intensity of illumination at the surface is inversely proportional to the square of its distance from the light source.'

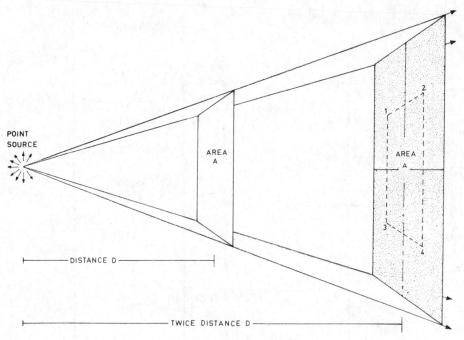

Fig. 1.3. Inverse square law.

It is pointless to learn this physical law parrot fashion without understanding what is being stated. Taking the law section by section:

'When a surface is illuminated by a point source of light...'

The law applies to small sources from which light rays rapidly diverge as from a point. It does not strictly apply to lamps in reflectors. The sun is a case of a source such a great distance away that the difference between any two surfaces it illuminates on earth is negligible compared with their distance from the sun.

"... the intensity of illumination is inversely proportional..."

The greater the distance the less the illumination on the same sized surface.

... to the square of its distance from the light source...'

Doubling the distance results in not half the original illumination level, but $(\frac{1}{2})^2 \dots$ or one quarter.

Changes When Light Meets a Surface

What happens when light energy finally reaches the surface of a material? You probably recall that among other things light may be:

- (a) Absorbed
- (b) Reflected (specular or diffuse)

- (c) Transmitted (direct or diffuse)
- (d) Refracted
- (e) Dispersed

ABSORPTION. Since energy cannot be destroyed, the apparent 'stopping' or absorption of light by an opaque material such as black cloth is really a wavelength conversion. Light photons absorbed are converted into heat. Thus a black car heats up more rapidly in sunlight than a white one; in a projector, dark transparencies become hotter than light transparencies. Light energy absorbed may also cause chemical changes. Our photographic materials undergo chemical change; dyestuffs change or lose colour; 'photo-electric' exposure meters produce electricity.

REFLECTION. Light may be 'specularly' reflected when it strikes smooth surfaces such as water, glass, polished chromium plating, etc. Each ray reaching the surface is reflected in one direction determined by its 'angle of incidence'.

If an imaginary line is drawn at right angles to the surface where a light ray is received, then the angle between this 'normal' line and the ray is called the angle of incidence. The ray leaving the surface, having been specularly reflected, forms an angle of reflection with the normal equal to the angle of incidence.

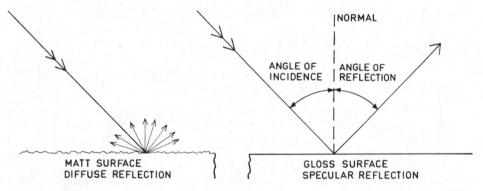

Fig. 1.4. Reflection of light.

Knowledge of this simple law is photographically useful in lighting and choice of viewpoint. Lamps or flash units can be instinctively positioned where their reflected light from windows and showcases will not reach the lens. Shop windows at night may be photographed from a predetermined angle at which lights from across the street will not be reflected at the camera. An enlarger should not be so placed in a darkroom that glossy wall surfaces reflect any stray light from the lamp-house down on to the printing paper.

'Diffuse' reflection takes place from irregular or 'matt' surfaces. It can be considered as specular reflection from an infinite number of differently inclined surfaces. This scatters or breaks up the original light beam, reflecting it evenly in all directions. Light falling on the surface of this page, on matt white photographic paper, or on cloud sur-

faces lit by the sun is mostly diffusely reflected. (Notice how light is mostly specularly reflected from the smoother paper on which the photographs appear in this book.)

The property of diffuse reflectors of scattering incident light is particularly useful in relieving harsh shadows cast by spotlights or sunshine. A large sheet of matt white paper placed to reflect this harsh directional lighting scatters it into dark areas of the subject without itself producing extra shadows. Specular and diffuse reflection from various surfaces of photographic printing paper has an important influence on print quality. This will be discussed in chapter XVIII.

Many surfaces have the property of reflecting only certain wavelengths and absorbing the remainder. Hence they appear coloured. We should think of, say, a bright red material as absorbing violet, blue, green and yellow from white light and reflecting the remaining wavelengths. It is a 'selective' reflector. The appearance of the material will vary with the wavelength of incident light — if our red material is illuminated by only blue wavelengths it cannot reflect any of the radiation and so appears black.

Transmission. Light transmission or passage through a non-opaque substance is said to be diffuse when the rays are scattered in many directions. This occurs in translucent materials such as ground glass, tracing paper and opal plastic. Because of this scatter, direct light rays from a small source can be spread by a translucent material. As shown in Fig. 1.5, the emerging light appears to viewers who may be out of the direct

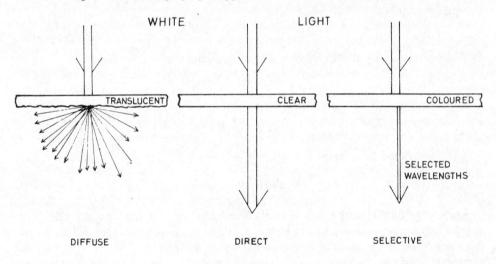

Fig. 1.5. Transmission of light.

path of the original light. Hence translucent screens are used to give an even back up for colour transparencies in hand viewers. As backgrounds lit from below they offer an even, shadowless surface for still-life product photography. Enlargers fitted with diffusion screens between lamp and negative provide even illumination without the necessity for a tall lamphouse to separate light source and negative.

Light is said to be 'directly transmitted' when able to travel through a transparent material without scatter. Examples are of course clear glass, air, water etc.

Light is 'selectively transmitted' (diffusely or directly) by coloured materials which absorb certain wavelengths. Deep green glass absorbs red and blue wavelengths from white light, transmitting mostly green. As in the case of colour reflectors, colour transmitting materials change their appearance with the wavelength content of the incident light. Thus, blue stained glass, for example, appears black when viewed against the orange of the setting sun.

REFRACTION. A property of light which is of first importance in photography is seen when a ray of light passes obliquely from one transparent material into another. The change of direction which then occurs is known as 'refraction'.

Each light ray, although travelling in a straight line, also has a wave motion. Its 'wave front' can be drawn as a line at right angles to the overall direction of travel – rather like a wave ridge moving over the ocean. We mentioned earlier in this chapter that the speed of light varies with the material through which it is passing. It is fastest when transmitted through a vacuum (186,000 miles per second) slightly slower in air, still slower in glass. The denser the material the slower the speed of light.

When light passes from air at right angles into a block of clear glass its whole wavefront is equally slowed up. There is no change of direction – only imperceptible slowing. But note what happens when a light ray passes obliquely from air into clear glass. One side of the wavefront reaches the denser material first and slows up. The opposite end of the front continues at the original speed for a little longer – enough to 'heel over' the wavefront and therefore 'bend' the direction of the light ray away from the boundary. This is rather like a line of bathers running diagonally into the sea – those reaching the water first slow up, swinging the direction of travel of the line.

The refraction of light is the key to photographic optics, for without it lenses would be unable to bend light to form images.

How can we measure the amount by which light is bent? Supposing we project a narrow beam of light obliquely into a glass block. The positions of the air/glass surface and direction of incident and refracted light can be recorded by tracing them down on to a piece of paper. A 'normal' line is drawn at right angles to the glass surface at the point of contact. As in the case of reflection, the angle made by the approaching ray with this normal is termed the 'angle of incidence'. The angle made by the refracted ray to the normal within the glass is known as the 'angle of refraction', which, because glass is denser than air, is less than the angle of incidence.

The amount by which this glass has bent light towards the normal depends upon its 'refractive index'. This is the ratio of the sine of the angle of refraction to the sine of the

angle of incidence.
$$\left(\text{Sine} = \frac{\text{Opposite}}{\text{Hypotenuse}}\right)$$
 Refractive index can be calculated by marking

off two points on the ray path, equal distances either side of the air/glass boundary. The ratio of distances from these points to the nearest part of the normal line represents the refractive index.

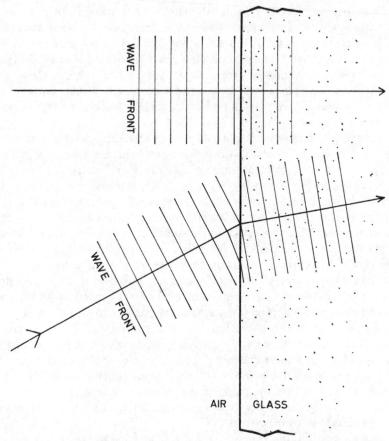

Fig. 1.6. Refraction. The speed of light slows when passing from air into glass. This diagram shows the uneven slowing of wavefront when light reaches glass obliquely.

N.B. Strictly speaking the refractive index of a material should be calculated from measurements made when light passes from a vacuum into the material. The speed of light in air is so little different from its speed in a vacuum that refractive index figures are virtually the same.

The 'light bending power' of a transparent material can therefore be said to be indicated by its refractive index. Typical values of modern optical glasses are between 1.5 and 2.0. However, the amount by which light is refracted at a boundary also depends upon its angle of incidence. Light striking the surface of the new material at right angles (i.e. travelling along the normal) is not refracted at all, as its wavefront is evenly affected. As the angle of incidence to the normal increases, the change in direction by refraction becomes greater.

One further point. So far we have referred to 'light' being refracted. White light is a band of wavelengths, each of which is refracted by a slightly differing amount. Refrac-

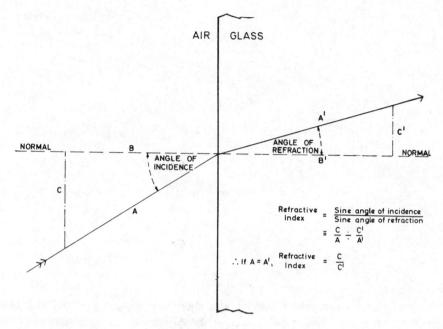

Fig. 1.7. Measurement of refractive index.

tive index figures are therefore normally quoted for wavelengths in the middle of the visible spectrum (green). Blue wavelengths are refracted slightly more and red slightly less.

All the features of refraction can be built in to the following:

Definition: 'Refraction' – the bending of light passing obliquely from one transparent medium to another of different density. Light bends towards the normal in the denser medium.

The overall change in direction of light path depends upon:

- (1) The type of material (its refractive index).
- (2) The direction from which light reaches the material (angle of incidence).
- (3) The wavelength of the light.

DISPERSION. The separate treatment of wavelengths by refraction, although slight, 'disperses' white light into its component colours of the spectrum. The rainbow is a classic example of dispersion. Sunlight passing through rain is refracted by this denser medium, its blue content taking on a more altered course than red wavelengths. This dispersed colour is therefore made visible as separate bands.

From the point of view of the lens designer, dispersion is an unfortunate side-effect of refraction. It causes blue light to be brought to a different point of focus from red light. The resulting image has colour fringes around white objects – particularly near the edges of the picture. This effect can be neutralised by use of several lens elements made of different glass. Dispersion is one of the chief reasons why we cannot use a simple single lens for serious photography.

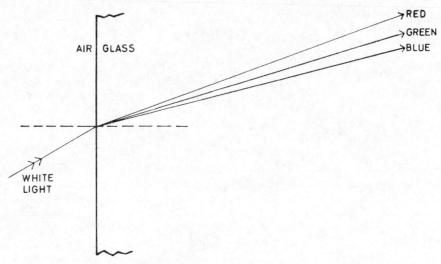

Fig. 1.8. Dispersion of white light.

For convenience we have been looking at some of the changes produced in light by Absorption, Reflection, Transmission, etc., as though they occur quite separately with particular materials. In fact, it is never possible to produce one of these phenomena without at least some of the others. Look at some familiar materials. White paper may reflect 90 per cent of light incident upon it – the remainder being absorbed into heat or transmitted to a surface below. A camera focusing screen transmits most light, reflects some back into the camera and absorbs the rest. A red colour filter transmits most red wavelengths (refracting oblique rays), reflects some of this red light and absorbs a little. Other wavelengths are mostly absorbed, a percentage reflected, and perhaps a tiny percentage transmitted. The outside surface of the camera absorbs most light, reflects some and (we hope!) transmits none.

Chapter Summary - Basic Properties of Light

- (1) Electro-magnetic energy is radiated in waves along a straight-line path.
- (2) Visible light is electro-magnetic energy between wavelengths of about 400 nm and 700 nm.
- (3) Within this visible spectrum individual wavelength bands produce the sensation of colours; mixed together they appear 'white'.
- (4) The illumination produced on a surface falls off in proportion to the square of the distance of the surface from the source.
- (5) Light energy reaching the boundary of a new material may be Absorbed, Reflected, Transmitted, Refracted or Dispersed, usually simultaneously.
- (6) Refraction depends upon type of transmitting medium, direction and wavelength of light.

Questions

- (1) Explain what is meant by the 'Inverse Square Law'.
- (2) (a) Name in their correct order the colours that can be seen in the spectrum formed from white light
 - (b) Which of these wavelengths is that of yellow light -400 nm, 580 nm, 680 nm?
- (3) With the aid of diagrams illustrate the following:
 - (a) Diffuse transmission,
 - (b) Refraction,
 - (c) Specular reflection of light from a coloured surface.
- (4) Give two examples of units used to express the wavelengths of visible light.

II. LENSES AND IMAGES

Now we can begin to apply some of the properties of light to evolve a lens - and so form images. It should be possible to see how and where images are formed under various practical photographic conditions.

In order to make images there must be some method of restricting light reflected to us from the subject. If someone just faces a piece of film or white screen towards a subject and expects it to show an image he is being optimistic . . . to put it kindly! The reason of course is that every point on the subject is reflecting light towards every part of the screen. The jumble of light rays simply illuminates it overall.

Pinhole images

We know that light rays travel in straight lines. By making light from the subject pass through a small hole before reaching the screen each part of the screen will only be able to 'see' light from one part of the subject. This is the principle of the 'pinhole camera'.

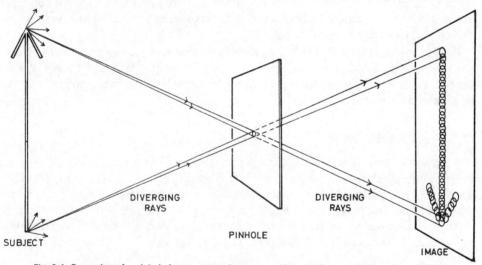

Fig. 2.1. Formation of a pinhole image - note that rays continue to diverge, creating discs of light.

The 'image' of the subject thus created has three interesting features:

- (1) The image is upside-down; due to the straight-line path of light.
- (2) The image is very dim; most light has been prevented from reaching the screen.
- (3) The image is not very sharply defined. This is because light rays diverging from each point on the subject continue to diverge after passing through the hole, reaching the screen to reproduce these points as tiny discs of illumination.

How can image brightness be improved? The hole could be enlarged – but this reduces image clarity by expanding each disc of light. Making two holes produces two overlapping images, as light from each point on the subject is received at two places on the screen. Image clarity might be slightly improved by moving the screen closer to the pinhole: but this makes the image smaller.

Making the pinhole smaller seems an obvious move to improve clarity. Unfortunately very small pinholes only reduce the light without improving clarity, due to diffraction. Light rays passing through an aperture near its very edge are slightly deflected away from the aperture centre due to uneven 'drag' on their wave-front. The effect is in some ways similar to refraction. Normally, the number of rays affected in this way is small compared with the rays passing cleanly through the aperture. With very small apertures, however, these 'diffracted' rays make up a large proportion of the total light, causing a significant spread of illumination. Because of diffraction, manufacturers limit the size to which a lens iris diaphragm will close. Few improvements are therefore produced by alteration of pinhole size or distance — a pinhole image is inherently dim and unsharp.

Its practical limitations are easily tested. Remove the lens from a single lens reflex or sheet film camera and fit a sheet of aluminium kitchen foil in its place. Pierce the foil cleanly with a medium darning needle. (Strictly the pinhole should have a diameter one twenty-fifth of the square root of the pinhole-to-film distance.) Distant sunlit subjects exposed in a camera with this pinhole require an exposure of between 30 secs and 4 mins on fast film (see plate 1, opposite page 72).

Results can be at least as good as a cheap box camera, but are of course well below professional standard ... and the exposure time is hardly practical for portraiture! Surely there is a means of bending light passing through a large aperture — so producing a bright and clear image?

The Simple Positive Lens

Light, as we have seen, is refracted towards the normal as it passes obliquely into a denser medium. If passing into a less dense medium (e.g., from glass into air) light accelerates, its wave-front 'skews' and its direction is bent away from a normal drawn at the point of contact. Therefore, if we pass a beam of light rays through a parallel-sided glass block they bend towards a normal at the first boundary and away from a normal at the second. The beam's path has been displaced but remains parallel to its original course.

When we pass light obliquely into a non-parallel-sided glass block such as a prism rays perform in the usual way – bending towards, then away from the normals. However, since these two boundaries are not parallel an *overall change* in the direction of the ray is produced.

By shaping a block of glass into a disc with non-parallel spherical surfaces a beam of diverging rays from a point on the subject can be made to converge together. Such a lens is known as a *simple converging* or 'positive' lens. Notice (Fig. 2.2 centre) that each

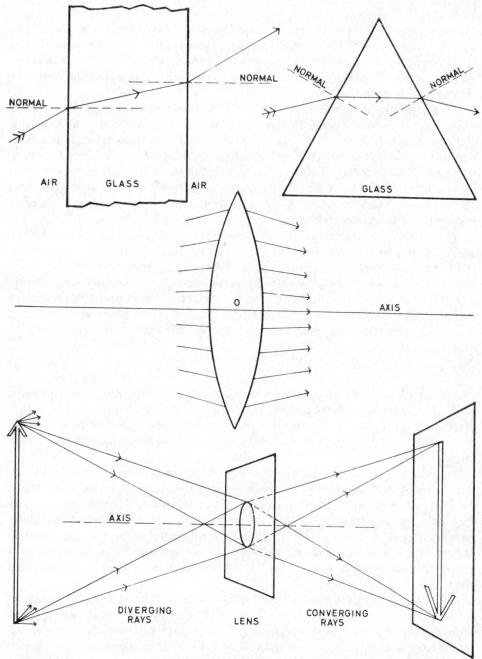

Fig. 2.2. Evolution of the converging lens. Top left: Refraction through a parallel sided glass block. Top right: Refraction through a prism creates an overall change of light direction. Centre: Diverging rays from a subject point are caused to *converge* by a lens. Bottom: Converging lens collects more light, creates brighter, sharper images than any pinhole.

ray must obey the laws of refraction at the two boundaries. Only one ray which approaches both glass boundaries at right angles is transmitted without refraction.

Every lens has an axis passing through its optical centre. Both glass surfaces are shaped as parts of spheres and the lens axis can be defined as joining the imaginary centres of the two spheres.

Light rays which diverge from a point on a subject are converged together by the lens to one point of focus, creating an image of the subject point. A screen or photographic film placed across the axis at the point of focus is said to be in the focal plane for this particular subject. Other subjects the same distance from the lens but above or below the axis will also be sharply focused in this focal plane. (Strictly speaking the term 'focal plane' applies only to the image plane of subjects an infinite distance away. However, photographers normally extend the term to refer to the plane of a sharp image of whatever they are photographing.)

Having evolved our simple lens we can substitute it for the original pinhole and check image improvement. Immediately the image appears very much brighter because the large aperture gathers more light rays from the subject. It appears sharper, too, as the lens recreates subject points as points. But at the same time the image is only sharply produced (in focus) at a particular lens-to-focal plane distance, for every distance of subject. Image sharpness can be checked on a focusing screen positioned in the focal plane. Try doing this using a cheap magnifying glass and a piece of tracing paper.

Why Focusing Screens?

It is worth pausing here to see just how a focusing screen functions. Many cameras allow us to critically check the position of the sharp image of a subject through the back of a finely ground glass screen. This is so arranged that when ready for exposure we can place a sheet of film exactly the same distance from the lens and know that it too will receive a sharp image.

The ground glass is only a means to an end – something for our eyes to focus on and a surface which will reveal the whole image. You can prove that the image is still formed without a screen by first focusing a large format camera on a subject and then removing the whole focusing screen. Place the tip of your finger in the original plane of the focusing screen and view it so that the finger tip is silhouetted against the circular patch of light coming in through the lens. Still keeping your eye focused on the finger, notice that around its perimeter you can see the original image that appeared on the ground glass. This is the 'aerial image'.

We cannot easily view an aerial image because our eyes have difficulty in focusing on a point 'in space' and tend to wander off to something more substantial, like the inside surface of the bellows. In a way this is a pity, for a ground glass screen absorbs and reflects almost as much light as it transmits – if we could do without it, and reliably focus the aerial image in the required plane, the image would be seen far more brightly.

There is another inconvenience too. We can see the aerial image only when we are directly in line with light coming through the lens; to see the image at the edge of the pic-

ture format we must move until this edge lines up with the lens. But, if a diffusely transmitting ground glass is used, some of the light from the image formed at the picture edges will be directed towards the eye, even when we are centrally viewing the focusing screen. We can see the image over the whole format at once. Our focusing screen has virtually become a viewfinder as well as a focusing device.

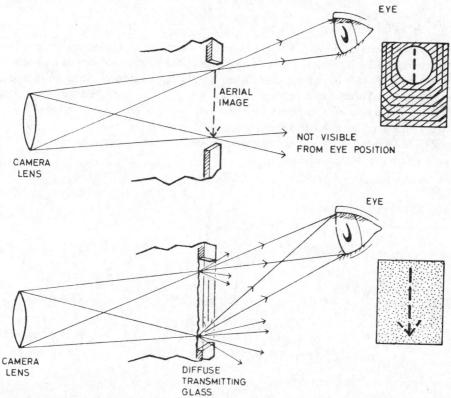

Fig. 2.3. Function of the focusing screen. Ground glass scatters light to the photographer from all parts of the image. The screen also offers a tangible surface on which the eye may focus.

The more the ground glass diffuses and scatters the light the more evenly but dimly illuminated the image appears. In practice, then, ground glasses chosen for focusing screens must be a compromise – they usually give somewhat uneven illumination but a reasonably bright image. Brightness can be improved at the cost of evenness by rubbing oil (or even water) into the ground surface to reduce its granularity. This finer texture also aids really critical focusing. Small format cameras may have a variety of types of interchangeable focusing screens. It is also possible to incorporate special 'Fresnel screens' to improve evenness without losing light (discussed on page 133).

Remember that if an accident occurs to a glass focusing screen on location a sheet of tissue taped across the camera back in exactly the same plane as the original ground

surface will solve the emergency. Also, if you are straining to see a very dim image on the focusing screen under difficult conditions, the screen can be removed and replaced with a sheet of clear glass. A few lines drawn in wax crayon on the side facing the lens will give you something to focus the eye on, but these must be viewed directly in line with the lens aperture.

Focal Length

The 'light bending power' of a lens is a combination of all the factors which control refraction – refractive index, angle of incidence, wavelength. We can take it that the effect of wavelength is in practice nullified by the use of several elements in a 'compound' lens, and need not be considered at the moment. For a set distance of subject the light bending power of a lens depends upon:

- (1) The refractive index of the lens glass, and
- (2) The non-parallelism of the front and back surfaces (controlling the angle of incidence at each boundary).

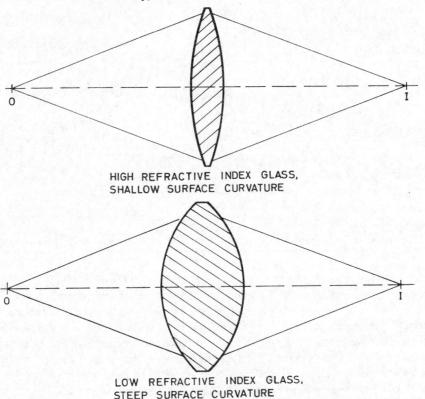

Fig. 2.4. Top: Lens of high refractive index glass but shallow curvature may have the same overall light bending power as the (lower) lens of low refractive index glass, steep curvature.

Glass of low refractive index made into a 'thick' lens may therefore produce the same overall light bending as a high refractive index glass in the form of a 'thin' lens. Refractive index alone then is no guide to the bending power of our lens.

Instead we combine both shape and refractive index in a new unit – 'focal length'. Suppose a lens is used to converge light from an object such a relatively great distance away that rays reach the lens virtually parallel (an object 'at infinity'). The point at which these rays are brought to focus is known as the 'principal focal point' of the lens. Measuring the distance between the focal point and the centre of a simple positive lens as illustrated gives us the focal length of the lens. A magnifying glass, for example, when

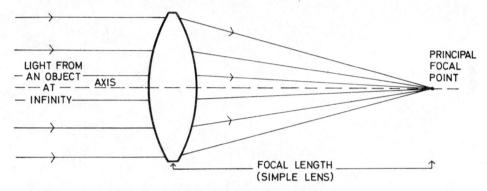

Fig. 2.5. Measuring the focal length of a simple positive lens.

focusing the sun's rays to burn a piece of paper must be at its focal length from the paper. (In passing it should be noted that the focal length measurement point within a compound lens is not precisely at its centre, and this is discussed in chapter III.) Definition: Focal Length – a measure of the light bending power of a lens, taking into account refractive index and shape. In the case of a simple positive lens it can be taken to be the distance between the lens centre and the point at which parallel incident rays are brought to a focus. (See also page 52)

Image Size

For the same distance of subject, a shorter focal length lens produces a closer and therefore *smaller* image than a long focal length lens. The image size is in direct proportion to focal length when the subject is at or near infinity.

For example, three lenses – of 10 cm, 20 cm and 30 cm focal length – are separately focusing light reflected from a distant tree. If the image of the tree with the 10 cm lens measures 1 cm high, the 20 cm lens will provide an image 2 cm high, due to the fact that light is brought to a focus twice as far from the lens. Similarly, the 30 cm lens will form a 3 cm high image. This explains why small format cameras need lenses of shorter focal length than large cameras to include the same area of subject.

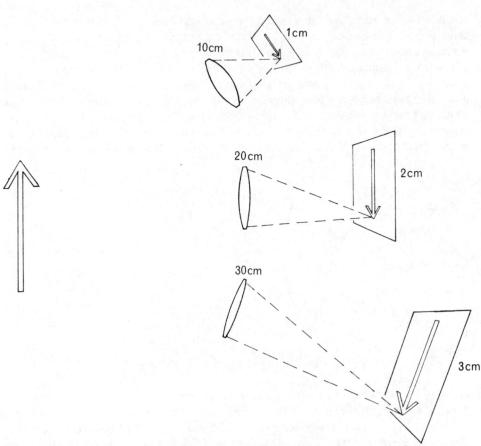

Fig. 2.6. Image size. For a distant subject, image size is proportional to focal length.

Image distance, and therefore size, is also altered by the distance of the subject from the lens. As a subject approaches the lens, light rays diverging from any subject point reach the lens at increasingly steeper angles of incidence. As the lens has a set bending power it must produce a less converging beam of refracted light: the position of the image becomes farther from the lens (and the image becomes larger in size) as the subject approaches. Before looking at the image positions and sizes produced under various conditions of photography, it might be worth summing up what has been discussed about lenses so far:

Summary

- (1) A lens is a glass disc with non-parallel, normally spherically curved surfaces.
- (2) As light travels in straight lines a lens must project an inverted image of the subject.

- (3) A lens is termed 'positive' if it converges light.
- (4) The light bending power of a lens depends upon its refractive index and the relative steepness of surface curvatures. Both factors are considered in the term 'focal length'.
- (5) The greater the light bending power of the lens the shorter its focal length, and the closer and therefore the smaller are the images it forms.
- (6) For the same distance of subject, image distance and size are proportional to focal length.
- (7) As a subject approaches the lens its image is formed farther away from the lens and therefore grows larger.

Focusing Zones

Given a lens, we can predict the type, position and size of an image under any set of conditions by simple drawing. Having some knowledge of image distance is useful in

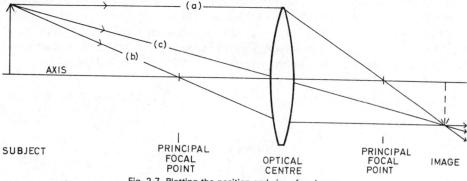

Fig. 2.7. Plotting the position and size of an image.

setting up cameras, enlargers, projectors, etc. It can help avoid minutes of fruitless focusing whilst the image remains stubbornly unsharp.

The 'geometrical construction' of an image is quite simple. Knowing the focal length of our lens we can draw the lens shape and mark the principal focal point on the axis in both directions. The object can now be shown on the axis (taking care accurately to record distance and height in the same scale as the drawing shows focal length). Figure 2.7 represents a 5 cm high subject 20 cm from a lens of 7.6 cm focal length. Three possible 'ray paths' will lead to the image:

- (a) A ray from the top of the subject approaching the lens parallel to the axis must be refracted through the principal focal point. All parallel light rays pass through this point.
- (b) Another ray from the subject passing downwards through the principal focal point in front of the lens must be refracted to emerge parallel to the axis. This is an opposite case to (a).
- (c) A ray from the top of the subject passing directly through the optical centre of the

lens meets in effect two parallel glass surfaces. It is therefore unaltered in overall direction.

Rays (a), (b) and (c) should all cross at one point below the lens axis. This must therefore be the point at which the top of the subject is sharply imaged. The remainder of the subject will be imaged between this point and the axis. We therefore know the height of the image and its distance from the lens.

The ratio of the height of the image to the height of the subject is referred to as the magnification produced.

$$M = \frac{Image\ height}{Subject\ height}$$

In photography 'magnification' is accepted as meaning *linear* magnification and is not measured in terms of area.

A 5 cm high subject imaged 15 cm high represents a magnification of 3.

A 60 cm subject imaged 10 cm high has received magnification of 1/6.

A 7.5 cm subject imaged 7.5 cm high has a magnification of 1. This is usually expressed as a one-to-one, or 'same size' image ratio.

To return to image plotting. Instead of drawing three rays each time to map image position, any two of (a), (b) or (c) will pinpoint image information. Look at the various positions and sizes of images we can expect under different practical conditions:

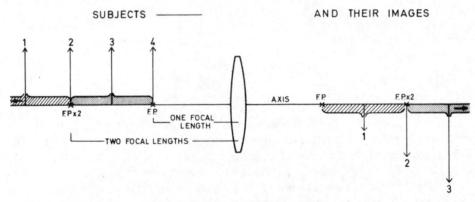

Fig. 2.8. Image size and location, relative to different subject distances.

DISTANT PHOTOGRAPHY. When the subject is farther than two focal lengths from the lens the inverted image is formed in a zone between one and two focal lengths behind the lens. It is smaller than the subject. Therefore a camera which allows a total focusing movement of one focal length for its lens can handle photography of subjects down to two focal lengths distant. Notice that the shorter the focal length of the lens the less the focusing movement required. The movement of a lens when focusing a 35 mm camera is hardly detectable compared with the inches of racking necessary on a large-format camera.

SAME-SIZE PHOTOGRAPHY. A subject two focal lengths from a lens forms a unique image. The inverted image is the same size as the subject, and located exactly two focal lengths behind the lens. When handling same-size copying therefore, we should set up the camera with the lens extended about two focal lengths from the focusing screen. If the copy original is also about this distance in front of the lens, the image on the focusing screen will be found to be approximately the correct size and reasonably sharp—all ready for final adjustment. Cameras with sufficient bellows to allow same-size reproduction are sometimes quoted as offering 'double extension'.

ENLARGING. Subjects between two and one focal lengths from the lens are imaged beyond two focal lengths behind the lens. They are inverted and magnified in size. These are the optical conditions under which enlargers or projectors function. The negative (or transparency) is placed upside-down and positioned between one and two focal lengths from the projection lens. An upright enlarged picture is then sharply projected some considerable distance from the lens.

(*Note:* The above image positions do not strictly apply in the case of special lens constructions such as telephoto and inverted telephotos.)

Two further subject positions deserve mention.

If the subject is exactly one focal length from the lens – at the principal focal point – no image can be formed. Remembering that light rays parallel to the lens axis are brought to a focus at the principal focal point (Fig. 2.5), it follows that when light is made to travel from this point to the lens it must be refracted into rays parallel to the axis.

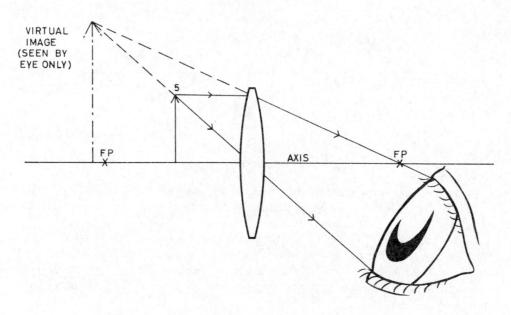

Fig. 2.9. Case 5: formation of a virtual image by a simple positive lens.

When the subject is so close to the lens that it is less than one focal length distant a 'virtual' image is formed. This is an image which can be seen by looking directly at the subject through the lens (see below) but unlike a 'real' image cannot be formed directly on a focusing screen or film. What happens is that the eye, receiving diverging light through the lens, assumes that they proceed from a 'subject' behind the glass, which is upright and larger than the real subject. The lens is in fact functioning as a magnifying glass. The closer the subject now approaches the *smaller* its virtual image becomes. It is important to see why this virtual image *cannot* be shown on a focusing screen — it is an 'optical illusion' of the eye.

Check the above five cases for yourself. Holding, say, a 15 cm lens at arms length look through the glass at a clock face on the other side of the room. It appears tiny and inverted (case 1). Approach the clock slowly and notice how the figures rapidly enlarge, although remaining inverted (cases 2 and 3). At one critical point everything becomes blurred (case 4). Closer still, and the figures are now the right way up, and becoming smaller (case 5).

Conjugate Distances - Calculation

It is often useful to be able mathematically to calculate image size, focal length, object distance or image distance under various practical circumstances. This is considerably quicker than drawing scale diagrams.

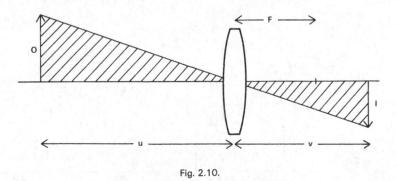

Figure 2.10 shows the generally used designatory letters for object height (O); image height (I); object distance (u); image distance (v); and focal length (F). It is important not to confuse use of the letters u and v.

Object distance from the lens is known as the *object conjugate* and image distance from the lens as the *image conjugate*. For a given focal length the two conjugates have a direct relationship to one another ('Conjugate' = 'yoked together'). The relationship between conjugate distances and focal length is expressed by the familiar optical formula

 $\frac{1}{u} + \frac{1}{v} = \frac{1}{F}$

Practical Lens Formulae

If we examine figure 2.10 it can be seen that the two shaded triangles are similar and we can say that

$$\frac{I}{O} = \frac{v}{u}$$

and, since $\frac{I}{O} = Magnification$

$$M = \frac{I}{O} = \frac{v}{v} \tag{1}$$

Further useful practical formulæ can be derived from the lens equation for conjugate distances:

$$\frac{1}{u} + \frac{1}{v} = \frac{1}{F}$$

Multiply through by v

$$\frac{\mathbf{v}}{\mathbf{u}} + 1 = \frac{\mathbf{v}}{\mathbf{F}}$$

Multiply through by F

$$F\left(\frac{v}{u}+1\right)=v$$

But
$$\frac{v}{u} = M$$
, therefore $v = (M + 1)F$ (2)

Similarly by multiplying the original lens equation throughout by u and by F we arrive at

$$\mathbf{u} = \left(\frac{1}{\mathbf{M}} + 1\right)\mathbf{F} \tag{3}$$

Formulae (1), (2) and (3) will lead to the solution of most simple optical calculations we may meet in general practical photography. (*N.B.* Although we assume the use of thin lenses, measurements from compound lenses should be made strictly from object and image 'principal planes' within the lens system. These are discussed in chapter III.) The following examples typify use of the formulae.

CALCULATION EXAMPLE I. Using a camera with maximum bellows extension of 35 cm and a lens of 10 cm focal length, what is the largest image which can be formed of a 2 cm high stamp?

$$F = 10 \text{ cm}$$

 $v = 35 \text{ cm}$

Using the formula containing v and F

$$v = (M + 1) F$$
 and substituting,
$$35 \text{ cm} = (M + 1) 10 \text{ cm}$$

$$\frac{35}{10} = M + 1$$
 therefore
$$M = \frac{7}{2} - 1$$

$$= 2\frac{1}{2}$$

The stamp could be imaged $2\frac{1}{2} \times 2$ cm = 5 cm high.

EXAMPLE II. Using an 8 cm focal length lens in an enlarger, how far must the lens be raised above the baseboard to produce a 50 cm wide image from a 5 cm wide negative?

Substituting in the formula

$$M = \frac{I}{O}$$

$$M = \frac{50}{5} = 10$$

Choosing the formula containing v and F

$$v = (M + 1)F$$
substituting,
$$v = (10 + 1)8 \text{ cm}$$

$$= 88 \text{ cm above the baseboard}$$

EXAMPLE III. How far from a 3 m high subject must a 15 cm camera lens be placed in order to form an image 7.5 cm high on the focusing screen?

$$F = 15 \text{ cm}$$

$$M = \frac{I}{O} = \frac{7 \cdot 5}{3 \times 100} = \frac{1}{40}$$

Using the formula containing u and F

$$u = \left(\frac{1}{M} + 1\right) F$$

substituting,

$$u = \left(\frac{1}{1/40} + 1\right) 15 \text{ cm}$$

= $(40 + 1)15 \text{ cm}$
= $615 \text{ cm} = 6 \cdot 15 \text{ m}$

Lens Shapes

To finish our discussion of simple positive and converging lenses it is worth recognising some of their more characteristic shapes. All positive lenses are thicker in the centre than the edges – otherwise they would be unable to converge light. All these lens element shapes and many others are built into the modern highly corrected 'compound' lenses. Some lenses contain over eight elements.

Fig. 2.11. Some positive and negative components of compound lenses. A: Plano-convex; B: Double convex; C: Converging meniscus; D: Plano-concave; E: Double concave; F: Diverging meniscus.

So far we have looked only at simple positive lenses. 'Negative' or diverging lenses cannot be used alone to make photographs, as the images they produce are always virtual. Notice how all negative lens shapes are thinner in the centre than at the edges. Some of these negative lens elements are used within compound lenses to help reduce image defects or 'aberrations'. They must always be weaker than the positive elements of course — otherwise the compound lens as a whole would not converge light. Negative lenses are also used in viewfinders.

Negative Lens Properties

Conforming to the properties of refraction, and because of their shape, negative lenses cause light rays diverging from the subject to diverge more acutely. An eye looking through the lens imagines that the steeply diverging rays are proceeding from a point on the same side as the real subject and closer to the lens.

To find the focal length of such a lens, rays of parallel light from an object at infinity are allowed to pass through the lens. Unlike the action of the positive lens, these rays will not pass through a common point. Instead we can only track the refracted rays backwards to find the point from which they appear to emerge. This is the principal

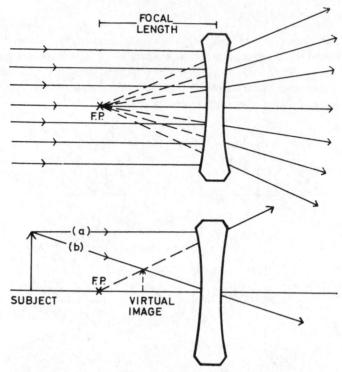

Fig. 2.12. Top: Locating the principal focal point of a diverging lens. Bottom: Plotting the position and size of an image. (Note: Virtual image always remains upright and smaller than subject.)

focal point and its distance from the lens centre can be taken to be the focal length of the lens.

The position and size of image formed by a negative lens can be plotted by two rays.

- (a) A ray from the top of the subject moving towards the lens parallel to the axis is refracted upwards and appears to come from the principal focal point.
- (b) A ray from the same subject point passing through the lens centre is unaltered in direction.

An eye looking through the lens would imagine that both rays diverge from the point at which (a) appears to cross (b). This point marks the top of the image.

As a subject approaches a negative lens, the only change discernible in the image is that it grows slightly closer and larger – but never as large as the subject. The image always remains upright.

This 'upright-but-diminished' property of negative elements makes them ideal for viewfinders. Large distant areas of subject appear in miniature just in front of the viewer. Rectangular pieces of glass ground to negative shape and used with a weak positive lens (to reduce eyestrain) form the basis of many modern direct vision optical viewfinders.

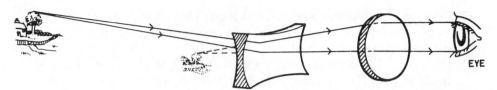

Fig. 2.13. The diverging lens used as a direct vision optical finder. The photographer sees a bright, 'miniature' close image of his distant subject. Finder will carry lines indicating the area viewed by the camera lens.

Chapter Summary - Lenses and Images.

- (1) Pinhole images based on restriction of diverging rays are inherently poorly illuminated and unsharp.
- (2) Lenses form images due to their density (refractive index) and spherical surfaces. Light bending power is expressed by the term focal length.
- (3) Positive lens elements converge light have focal length based on the distance to the focal point of parallel rays.
- (4) Image size depends upon (a) size of subject (b) subject-lens distance (c) focal length of lens.
- (5) Magnification expresses linear ratio of image to subject.
- (6) To be imaged at same-size reproduction a subject must be two focal lengths from a positive lens. If closer, lens acts as a projector.
- (7) Positive lenses form inverted, photographically usable images, *except* when the subject is less than one focal length from the lens. They then become magnifying glasses.
- (8) Object to lens (u) and lens to image (v) distances are known as 'conjugate distances' and bear a definite relationship for a lens of given focal length. Practical working formulæ

$$M = \frac{I}{O} = \frac{v}{u}$$
 $u = (\frac{1}{M} + 1) F$ $v = (M + 1) F$

(9) Negative lens elements diverge light – and cannot be used alone for making photographs due to the virtual images they form. Applications: Compound lens components and viewfinders.

Questions

- (1) Draw clear diagrams showing:
 - (a) The path of a ray of light through a thick slab of glass with parallel sides, the ray being incident upon the surface at an angle.
 - (b) The formation of an image by a simple lens.
- (2) What is the difference between a real and virtual image? Is it possible to form a virtual image using a convergent lens, and if so, what could be made of it in practice? Diagrams should be included in your answer.

- (3) With the aid of a diagram calculate what magnification is produced when a converging lens is positioned $1\frac{1}{2}$ focal lengths from the subject. Indicate a photographic assignment where this might occur.
- (4) Draw labelled diagrams showing how the image of an object is formed by:
 (a) A pinhole (b) A positive lens (c) a negative lens.
- (5) Complete the following table for a positive or converging lens:

Focal length	Lens-to-subject distance	Lens-to-image distance	Linear magnification
20·3 cm		40.6 cm	
25 cm	75 cm		1/2
20 cm	20 cm		
		30 cm	2
	50 cm	50 cm	

- (6) A projector for 5 cm × 5 cm (picture size) slides fitted with a 10 cm lens is to be used to show pictures on a 2⋅5 m wide screen. Calculate how far from the lens the screen must be positioned.
- (7) Your 35 cm camera has a 50 mm focal length lens, also three extension tubes allowing the lens to be extended 25 mm, 50 mm, or 75 mm forward from its normal position. Tubes can be used singly, in pairs, or all together. Which tube(s) would you use for:
 - (a) copying a colour transparency, same size?
 - (b) making a 1 cm diameter image of a 2 cm diameter coin?
 - (c) making a 2 × 2 cm image of a 1 cm sq area of the coin?
- (8) A camera with a lens of 250 mm focal length is used to copy a plan at a linear magnification of \times 2.5. What will be the distance from the camera focal plane to the copy board? Show your working (ignore internodal distance).

III. LENSES AND ILLUMINATION

So far we have evolved our simple lens and located the image it forms under various conditions. Now we can become more realistic and take an initial look at the lenses we actually use on our camera – compound lenses. This is also a good point at which to start thinking about control of the amount of light passing through the lens. What exactly is the effect of the aperture on image brightness? Why do f-numbers have such a curious numerical sequence? And why must exposure time be increased when the subject is very close?

To answer these and other points we shall have to use our inverse square law, some simple geometry and maths. First, however, to become a little more realistic over lens construction...

Compound Lenses

Up to now text and diagrams have assumed lenses to be simple elements. This made it easier to see how images are formed, for image/object zones and magnification hold good for both simple and compound lenses.

Unfortunately, the poor image *quality* produced by a simple lens makes it impractical as a photographic objective. This can be checked by substituting a reading glass for the camera lens and looking at the resulting image on the focusing screen. It certainly produces an image . . . of sorts. The image cannot be made sharp at the edges and centre of the focal plane at the same time; white objects have colour fringes; straight lines are bowed; and the whole image has a 'misty' appearance. These are the combined effects of several lens defects or 'aberrations'.

Fig. 3.1. Compound lens for a 5 in × 4 in camera, showing layout of components (Schneider 'Xenotar').

No single lens element can be 'cured' for aberrations. The best that can be done is to use light passed through the central area of the lens where aberrations are less extreme. This is why simple cameras which use a single lens element (sometimes moulded plastic) have to have very small apertures.

A modern lens for professional quality work is a conplex optical instrument, and consequently expensive. The choice of glass, curvature of surfaces and spacing for each element is now frequently calculated by computer. Final exact positioning of each element in the lens 'barrel' calls for precision engineering of a high order.

Improvements in photographic lenses depend upon progress in the chemistry of new optical glasses, the mathematics of design and the engineering of assembly. This is one reason why quality photographic lenses tend to be manufactured in only a few highly developed countries.

Focal Length of Compound Lenses

Physically our compound camera lens can be several inches 'thick' between front and back glass surfaces. Within the lens barrel are several positive and negative elements, each with a focal length of its own, collectively producing a focal length for the lens as a whole. From what point in this barrel of glass elements do we measure overall focal length? The centre of the barrel, the surfaces of the front or rear components, or somewhere else? It would be a major task to track the path of light rays through so many refracting surfaces.

We can solve our measurement point problem more simply. If parallel light rays are allowed to pass into the front of a compound lens, a converging beam will appear from the rear. If we draw lines tracking the incident rays forwards and the refracted rays backwards we shall find that they meet at an imaginary plane within the lens.

Of course we know really that refraction has taken place at many surfaces inside the lens, but for convenience we can say that the light has been bent on t is one imaginary 'image Principal Plane' of refraction.

At the place at which the image principal plane crosses the axis we find the rear 'Nodal Point' – the focal length measurement point we are looking for. The distance between the rear nodal point and the point at which light rays parallel to the axis are brought to focus is the 'Equivalent Focal Length' of the compound lens. The word 'equivalent' creeps in because the principal plane is after all *imaginary*. We can only say that the plane is equivalent to the position at which a simple lens of this focal length would have to be placed in order to refract light in the same way.

N.B. Strictly speaking, 'equivalent' focal length should always be used in connexion with a compound lens. In practice, however, we tend to drop this first word.

Definition: Focal length of a compound lens. The equivalent focal length of a compound lens is the distance from its rear nodal point to the focusing screen when the lens is sharply imaging an object at infinity.

The rear nodal point will be mentioned again later when we look at camera movements (chapter VI).

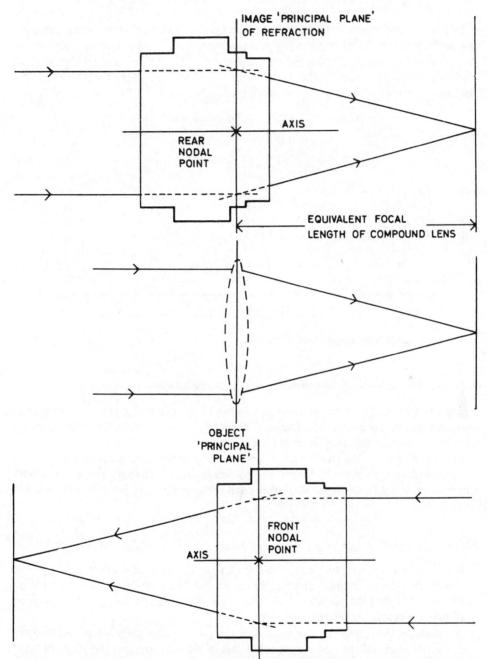

Fig. 3.2. Top: Parallel light rays are refracted by a compound lens as if from an imaginary 'image principal plane'. Centre: A simple lens of identical focal length positioned at the image principal plane would similarly refract light. Bottom: By passing parallel rays through the rear of a compound lens object principal plane and front nodal point may be established.

In passing, it is worth noting that if parallel light is passed into the *rear* of our compound camera lens another principal plane can be established nearer the front of the lens. This is the *object* principal plane. The *front* nodal point is found where the plane crosses the lens axis — and is the measurement point for equivalent focal length of the compound lens when light passes in this direction.

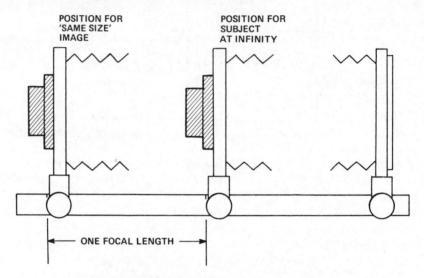

Fig. 3.3. The comparative method of measuring the focal length of a compound lens.

A compound lens is therefore assumed to have object and image principal planes and front and rear nodal points. Most general purpose (not telephoto) photographic lenses have identical front and rear focal lengths.

Beware, however – camera lenses are often designed to have maximum aberration correction when the subject is distant, and the image close to the lens. A normal camera lens may therefore be disappointing when used for very close subjects, or when used in an enlarger.

Finding the Focal Length of a Compound Lens

If it is ever necessary to check focal length (in the case of erasure or suspected damage). One simple method gives accurate results. The problem is that we have no quick way of finding the position of the rear nodal point. But we can avoid this step by working on a system of comparison, viz.:

- (1) With the lens fitted in a camera, focus sharply a distant subject (parallel incident light). Mark off the position of some part of the movable lens panel on the fixed camera baseboard or monorail.
- (2) Focus the camera lens panel forward to image some convenient object same-size. (With one ruler set up as subject you can use another ruler to check the image.)

Mark where the same part of the lens panel is now positioned on the baseboard.

(3) The distance between the two baseboard marks equals the focal length of the lens.

At stage (1) the lens is so positioned that its rear nodal point is one focal length from the focal plane. At stage (2) its position is such that the rear nodal point is two focal lengths from the focal plane. Therefore the movement of the lens between the two positions must have been one focal length.

Summary

- (1) Compound lenses are necessary because single lens elements cannot be highly corrected of aberrations.
- (2) Compound lenses consist of positive and negative elements, neutralising many of each other's aberrations, producing a combined result equal to an almost 'perfect' positive lens.
- (3) A lens is corrected to give best performance under set working conditions.
- (4) For convenience we say that incoming parallel rays are bent at an image 'principal plane' of refraction.
- (5) In photographic lenses the image principal plane crosses the lens axis at the rear 'nodal point' measurement point for 'equivalent focal length'.
- (6) The photographer can most easily establish focal length of a compound lens by comparing infinity and same size lens-image positions.

Image Brightness

Before the birth of photography, lenses were used to project images on to paper which were then traced over by hand. The brightness of the image projected was relatively unimportant, providing the eye could make out sufficient detail. Photography, on the other hand, is a chemical process demanding full control over image brightness. An exposure meter will tell us the brightness of our subject; but the same subject can be imaged at greatly varying brightness levels by different lenses.

For the same subject conditions, the image brightness provided by a lens depends upon two main factors:

- (a) Diameter of the light beam entering the lens.
- (b) Distance between lens and image.

Take these one at a time.

(a) is the most obvious influence. The amount of light entering a lens can be restricted and controlled by an aperture or 'stop'. This circular hole, usually of adjustable diameter, is positioned between components at about the centre of the compound lens.

Although the aperture controls the light beam entering the lens it is itself usually of narrower diameter than this light beam. The reason for this is that most front lens components are positive, converging a wide beam of light to fill the aperture. As the aperture closes the diameter of this incident light beam or 'Effective Aperture' narrows propor-

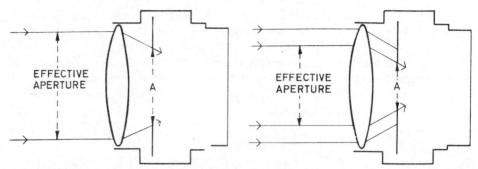

Fig. 3.4. Left: (Effective Aperture) is greater than A (Diameter of Physical Aperture) when components in front of the stop have a converging effect. Right: As the lens is stopped down effective aperture reduces proportionally.

tionally. It will, however, always remain of different diameter to the aperture, except in the unusual case of an aperture mounted in front of all the lens components.

Definition: 'Effective Aperture' – the diameter of the incident light beam which, entering the lens, completely fills the real aperture or 'stop'.

The amount by which the image dims as aperture reduces is explained by simple geometry. If the diameter of a circle is halved, its area is reduced to one quarter. This means that each time the effective aperture is halved the quantity of light rays able to enter the lens is quartered.

Recapping: Image brightness is reduced to one-quarter as effective aperture is halved.

(b) But aperture is only one of our two factors. To prove this, try setting up two identical cameras side by side viewing the same distant subject. Fit one with a 30 cm lens and the other with a lens of half this focal length (15 cm)... but set both diaphragms to the same diameter. (Do this by comparing the two lens openings – ignoring any figures.) Both lenses are now accepting the same amount of light.

However, the focusing screens reveal that the 30 cm lens image is considerably *less bright* than its 15 cm companion, and has twice the magnification. In fact if we were to make exposures the first image would require four times as much exposure as the second to give the same blackness of negative.

A clue to the reason for this difference is given by comparing lens-to-image distances of the two cameras. The 30 cm lens, having weaker refractive power, needs twice the distance to bring light to focus than the 15 cm lens. Light passing through the 30 cm lens travels twice as far and therefore forms an image twice as high and four times the area. The focusing screen in the 30 cm camera, which is the same size as in the 15 cm camera, therefore receives only one quarter of the illumination — much of the rest of the light being projected into the camera bellows.

Recapping: Image brightness is reduced to one quarter as lens-image distance is doubled.

But we have just agreed too that image brightness is also reduced to one quarter as effective aperture is halved. There must be a way of combining these two variables into a single unit – just as before we combined refractive index and curvature into 'focal length'.

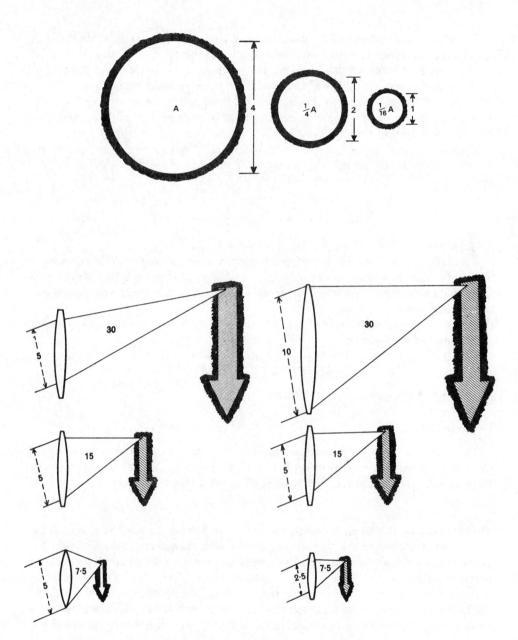

Fig. 3.5. Top: Halving the diameter of a circular aperture reduces its area to one quarter. Bottom left: Lenses of the same effective aperture image a distant subject with four-fold increase in brightness as focal length is halved. Bottom right: By maintaining a *constant relationship* between effective aperture and focal length each lens yields an image of equal brightness. (These lenses all have a relative aperture of f/3.)

For most distant photography the lens-image distance is about the focal length of the lens. Image brightness decreases with focal length and increases with diameter of effective aperture ... a constant ratio between the two must mean constant brightness.

For example: our 30 cm lens if used with 5 cm effective aperture, and our 15 cm lens if used with a 2.5 cm effective aperture

both use effective apertures one sixth of focal length and will be found in practice to give images of a subject at equal brightness.

Effective aperture expressed relative to focal length in this way is said to be the 'Relative Aperture' of the lens. In the above cases relative aperture might have been written '1/6 of f.1.' but abbreviations

$$\frac{\text{'f.1'}}{6} \cdots \frac{\text{f}}{6} \cdots$$

bring us down to 'f/6.' Hence the use of 'f-numbers'.

A lens set to a relative aperture of f/6 will image a common subject at the same intensity as any other lens 'stopped down' to f/6 – from a 45 cm lens on a 10×8 in camera to a minute 6 mm lens for a movie camera. We have evolved a useful measure of lens light passing power.

Definition: 'Relative Aperture' – The relationship of effective aperture to focal length, expressed as an 'f-number'.

$$\frac{Focal\ Length}{Dia\ of\ Effective\ Aperture} = f\text{-number}$$

f-numbers are a measure of the light passing power of a lens.

F-Number Scales

The larger the f-number the smaller the light beam entering the lens and the dimmer the image formed. We now require a useful working series of f-numbers with which to mark up the aperture control. The obvious choice is a series

The disadvantage is that each change would involve halving the effective aperture, and as we agreed, each time the diameter is halved illumination drops to one quarter. The above f/number scales would therefore give a quartering of illumination for each increase of f-number.

It would be photographically more useful to have an illumination 'halving' scale. This can be done by adding more f/numbers to the scale at intermediate positions. Instead of a times-two progression we can increase the f-number each time by the square root of two $(\sqrt{2} = 1.4)$. Thus the above scale becomes:

$$f/1$$
; 1.4; 2; 2.8; 4; 5.6; 8; 11;* 16; 22; 32; etc.

with each f-number now progressively halving illumination. This is the standard series adopted internationally.

Unfortunately, another scale originating on the Continent was in use until recently and may still be discovered on lenses. Although based on the same \times 1.4 principle the series began with f/1.1 giving:

f/1.1; 1.6;* 2.3;* 3.2; 4.5;* 6.3;* 9; 12.5;* 18; 25; 36, etc.

Other f-number values not shown above are frequently used by manufacturers to indicate their lenses' widest relative aperture setting. Obviously, having formulated a lens with sufficient aberration correction to give acceptable image quality at, say, f/1.8, a manufacturer would be foolish to market the lens stopped down to f/2 – just to conform to scaling.

Equivalent focal length (light bending power), maximum relative aperture (illuminating power), and the name of the lens are normally all engraved on the front of the lens barrel together with the serial number of the particular lens, thus:

135 mm f/2·8 SMC Pentax 1234567'

Continental lenses normally quote maximum relative aperture as a ratio followed by the focal length in millimetres (25.4 mm = 1 in) thus:

Fig. 3.6.A: Waterhouse stops; B: Rotating stops; C: Iris diaphragm.

^{*} To the nearest convenient figure.

Mechanical Control of Aperture

Apertures in early lenses were controlled with a set of individual metal plates, each stamped through with a hole of suitable diameter. These were known as 'Waterhouse Stops' after their originator, John Waterhouse. The required Waterhouse stop would be inserted into the lens through a 'letter box' slot in the barrel. (A photographer would tell his assistant to 'pass me the f/16'.) Stops of this kind are still used for process cameras in the printing industry.

Aperture control became slightly more sophisticated with the introduction of a single metal disc carrying a series of aperture holes. This could be rotated to bring any desired stop into the light path within the lens. 'Rotating' stops are still found in simple box cameras, owing to their cheapness, and in fisheye and other lenses where optical space is extremely limited.

Both Waterhouse and rotating stops are clumsy, and, of course, only allow set f-numbers to be used. Hence the almost universal use of the 'iris diaphragm' – a cleverly designed series of leaves infinitely variable between f-number settings.

With the development of exposure meters directly linked to the lens, several lightweight aperture controlling leaves have been devised. One popular system uses two overlapping spanner-shaped leaves moved by the meter galvanometer itself. In 'fully automatic' amateur cameras f-numbers may not appear at all.

F-numbers and Exposure Time

We have established that the standard series of f-numbers each progressively reduce image intensity to one-half. As photographic exposure can largely compensate for a dimmer image by a longer exposure time, it is not difficult to work out the time increase required as a lens is 'stopped down'. If a meter indicates $\frac{1}{2}$ sec at f/8 this implies 1 sec at f/11, 2 sec at f/16, etc.

This rule-of-thumb method becomes unwieldy, however, where large changes of fnumber are involved or we wish to compare exposure times on cameras calibrated on different f-scales. Fortunately, we can compare exposure times required by simply squaring f-numbers:

f/1 1·4 2 2·8 4 5·6 8 11

relative exposure time required:

1 2 4 8 16 32 64 132 units

This also allows us to compare exposure time required at apertures in both British and Continental series.

EXAMPLE. If a subject requires 1-sec exposure at f/2, how long should it be given using another lens set to f/11?

The ratio between these f-numbers is 2^2 : 11^2 , i.e., 4:132, or approximately 1:33. Therefore the exposure time required at $f/11 = 33 \times 1$ sec. This comparison of squares can be built into the following working formula:

When changing f-numbers,

New exposure time required = Original exposure time $\times \frac{\text{New f-no.}^2}{\text{Old f-no.}^2}$

Close-Up Work

The f-number system of scaling lens image brightness leaves one vulnerable loophole when working with close subjects. In defining relative aperture we assumed that (p. 58) 'for most distant photography the lens-image distance is about the focal length of the lens'.

Now unlike the bulk of amateur photography, much of the professional's studio work requires him to use his camera close to subjects – small still-life objects, copying, etc. We saw earlier that as a subject approaches a lens, its image is formed increasingly farther behind it. And as the lens-image distance increases for close focusing the image brightness is reduced. At two focal lengths from the image illumination is quartered.

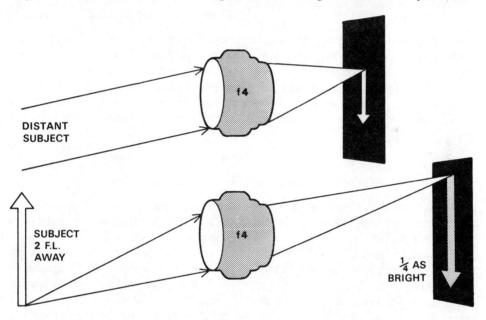

Fig. 3.7. When working close to a subject the lens forms a larger and therefore *dimmer* image, at the same engraved f-numbers no longer reliably indicate image brightness.

We therefore have a situation where two lenses set to the same f-number will produce images of entirely different intensities, if one views the subject from a distance and the other images it same-size. External exposure meters read correct exposure assuming the lens to be about one focal length from the image, so we have to make adjustment to the exposure indicated.

Intensity is inversely proportional to square of distance. The lens-image distance, normally one focal length, has been increased to two focal lengths. So if we square these two distances and compare them we shall find the reduction in intensity. We can write the ratio in a more useful form:

$$\frac{Actual\ exposure}{time\ required} = \frac{Meter\ indicated}{exposure} \times \frac{Total\ bellows\ extension^2}{Focal\ length^2}$$

EXAMPLE I. In copying a photograph the 9 cm lens on the camera is racked out 15 cm from the focusing screen. A meter reading indicates an exposure of 12sec at f/16. What exposure time should be given in practice?

Required exposure time = 12 sec
$$\times \frac{15^2}{9^2} = \frac{\overset{4}{\cancel{12}} \times \overset{5}{\cancel{13}} \times \overset{5}{\cancel{13}}}{\overset{5}{\cancel{13}} \times \overset{1}{\cancel{13}}} = \frac{100}{3} = 33\frac{1}{3} \text{ sec}$$

: Exposure given in practice = 33 sec.

Alternatively, it is sometimes more convenient to work purely on the basis of magnification. For same-size work (M=1) exposure must be increased four times. Under any conditions therefore:

Actual exposure time required = Meter indicated exposure $\times (M + 1)^2$

EXAMPLE II. You are asked to copy a 2 cm high stamp so that it appears 8 cm high on your negative. An exposure meter reads 2 sec at f/16 – what exposure time is actually required?

$$M = 8 \div 2 = 4$$

$$\therefore \text{ Required exposure} = 2 \times (4 + 1)^2 = 2 \times 25 = 50 \text{sec.}$$

The formula shows that the exposure increase required in close-up photography remains relatively insignificant until the subject distance is less than five times the focal length from the lens (or M rises above one quarter). See Appendix B.

There is a third method of calculating the actual exposure time required – by establishing the 'effective' f-number in use. Imagine for example that a 10 cm lens set to f/8 is racked 15 cm from the focusing screen to image a close object. The diameter of the light-beam entering the lens is $\frac{1}{8}$ of the focal length (= 1·25 cm). The lens-image distance is 15 cm, so that the 'effective' f-number at which the lens is working is $15/1\cdot25 = f/12$. Exposure time for f/12 can then be read from the meter.

Definition: Effective f-number
$$=$$
 $\frac{\text{Lens-image distance}}{\text{Effective aperture}}$

You probably noticed the similarity between the formula for exposure alteration with change of f-number and for increased bellows extension. Due to this common basic formula we are able to use the calculator dial found on most exposure meters to discover correct exposure time when working close-up.

Fig. 3.8. Use of an exposure meter calculator dial to find exposure time required when shooting close up. If lens focal length is 8 cm and exposure time for distant subjects 3 seconds, dial shows that when lens—image distance is 14 cm an exposure time of 10 seconds is required. (Method works because the formula used is identical to exposure alteration when changing f-numbers.)

METHOD. Move the dial until an f-number of equal numerical value to the lens focal length is opposite the exposure time for distant objects. Actual exposure time required will now be found opposite the f-number of equal numerical value to the total bellows extension.

This can be extremely useful in practical work, although of course you cannot expect every bellows measurement to correspond to a figure on the dial. It is also necessary to remember why exposure increase is needed, and the underlying calculations.

(Exposure Values are discussed on page 119.)

Chapter Summary - Compound Lenses and Image Brightness

- (1) To reduce aberrations, high-quality lenses are of compound construction.
- (2) Light passing through a compound lens is assumed to be bent at one of two principal planes of refraction.
- (3) A compound lens has an equivalent focal length measured from its rear nodal point.
- (4) This focal length can be checked by comparative lens positions.
- (5) Aberrations are highly corrected for only a limited range of object/image ratios.
- (6) For the same subject, the brightness of image varies with the diameter of the light-beam entering the lens and with the lens-image distance.
- (7) Diameter of stop controls but seldom equals effective aperture.
- (8) Original Waterhouse and rotating stops are now superseded by the iris diaphragm or meter-operated leaves.
- (9) Assuming lens-image distance is normally the focal length, relationship of effective aperture to focal length (relative aperture) expresses lens light passing power as a number.

- (10) f-number in a series increase by $\sqrt{2}$ to give calibrations which progressively halve image illumination.
- (11) Exposure requirement ratios between relative apertures are shown by the square of their f-numbers.
- (12) In close-up photography f-numbers no longer give a proper indication of the light passing power of a lens, due to increase in lens—image distance beyond one focal length.
- (13) Close-up exposure increase can be calculated by comparing squares of focal length and image distance, by magnification, or estimating effective f-number operating in practice.

Questions

- (1) Examining 5-cm and 6-in lenses both set at f/8, the 5-cm lens is found to have a far smaller diaphragm opening yet shooting the same subject both images require the same exposure time. Why is this?
- (2) An exposure meter reading indicates that the correct exposure for a small still-life object is 1 sec at f/6.3. You observe that the image on the screen is the same size as the object.
 - (a) What exposure time would you give at f/6.3.
 - (b) You decide to stop down to f18. What will be the new exposure time? (Calculations to be shown.)
- (3) Explain the following terms:
 - (a) Effective Aperture,
 - (b) Effective f-number,
 - (c) Relative Aperture.
- (4) What is the meaning of the term 'focal length'? Given a camera with a focusing screen and a lens which is unmarked, describe one method of using it in the camera to determine the focal length.
- (5) You have to make two copy negatives of a small diagram on one the image must be the same size and the other should just fill the negative area. You find that your same-size negative required 8 sec exposure at f/16. To focus up the second negative the focusing screen must be racked 38 cm from the 152mm lens. What exposure will the second negative require at the same aperture?
- (6) Explain why additional exposure is often needed when working close-up.

IV. ANGLE OF VIEW

We now know a little about a photographic lens — a compound team of light refracting elements with a collective bending power or focal length. For a particular object distance the focal length determines position and therefore size of image. The amount of light entering the lens is controlled by variable aperture, and the light-passing power of the lens (for distant objects) is indicated by f-numbers.

The next aspect of performance to establish is the actual *area* of image the lens will produce. This will tell us with what size negative it can be used, and the amount of subject it will include on this negative. We shall then be able to discuss why the professional finds it worth going to the expense of a range of lenses for his camera — and the effect these can have on the photographs he produces.

Covering Power

Unfortunately, even a compound lens forms an acceptable photographic image over only a limited area of the focal plane. We can see this by fitting up a stand camera looking out through a window. Draw across opaque curtains and pin them around the camera to block out all illumination except light passed through the lens. Rack the back of the camera close behind the lens and remove the focusing screen. Now, holding up a large ($50 \text{ cm} \times 40 \text{ cm}$) sheet of white card or tracing paper as a screen, carefully examine the image projected.

The lens will only image the scene outside within a circular patch of illumination – rather like a view through a porthole. All about the centre of this patch, on the lens axis, the image is clearly defined and undistorted. Moving across the focal plane into zones farther away from the lens axis, however, image detail deteriorates and illumination drops steeply.

There are three reasons for this 'fall-off'.

- Lens aberrations can only be corrected to a limited degree across the focal plane.
 Rays imaged near the lens axis are more easily corrected than oblique rays reaching outer zones.
- (2) Light from the lens to outer image zones travels a greater distance than light to the central area. Each object point imaged obliquely in the outer zones is therefore made increasingly larger and *dimmer* (inverse square law).
- (3) Seen obliquely from the outer image zones the lens diaphragm appears as an ellipse instead of a circle. The depth of the metal lens barrel also blocks illumination increasingly until all extreme angular rays are obscured. This effect is known as 'vignetting'.

If we stop down the lens most lens aberrations are reduced and image quality in outer zones may be seen to improve steadily. Vignetting is also somewhat reduced as most rays normally only received by central image areas and obscured from outer zones are now stopped by the aperture.

A lens will, therefore, produce acceptable image definition and illumination over only a limited area of the focal plane. This area is known as the field 'covered' by the lens. The field covered by a lens must of course be greater than the size of negative with which it is intended to be used. On the other hand, it would be foolish to pay for corrected aberrations which were unnecessary by using a lens with excessive 'covering power'. Such a lens would spill much of its illumination into the camera bellows — where some light may be reflected to fog the film.

Fig. 4.1. Lens covering power. This lens is unsuitable for negative size 'A', which would show poor definition at all corners. Negative size 'B' is sufficiently covered only when centrally aligned with the lens. Used with negative size 'C' the lens may be non-centrally positioned (essential for most camera movements). Lower left: The rear of the lens seen from X, showing lens barrel vignetting. See also plate 16.

A lens must be designed for a particular negative format. It should cover this format at widest aperture with reasonable area to spare, in order that we may use camera movements (see chapter VI). A lens quoted as '15 cm $f/4\cdot5$ ' therefore has only a limited specification ... is it designed as a long-focus lens to cover just 6 cm sq, or has it specially wide covering power for use with 18×24 cm $(8 \times 10 \text{ in})$ negatives? A full catalogue specification for such a lens is more likely to read

15 cm f/4.5 to cover 4 in \times 5 in

This question of sufficient covering power for an intended negative size is of great importance in buying second-hand lenses, since this information is not actually engraved on the lens mount. It is advisable either to carry out the above visual test, or, better still, to take an actual photograph with the lens in a camera of far larger format than the camera in which it will finally be used. N.B. Covering power should always be checked

at widest aperture using *distant* subject matter. When a lens is racked forward to focus on near objects the demands on its covering power are lessened—the more oblique rays are no longer used on the negative format.

Definition: 'Covering Power' – Refers to the area of the circular illumination patch projected by a lens within which it can yield images of acceptable definition and illumination. The field covered by a lens (at widest aperture and focused for infinity) must exceed the negative format in use – generously so if camera movements are to be used.

Angle of View

In chapter II it was shown that the shorter the focal length of a lens, the nearer (and therefore smaller) are the images it forms. Suppose we set up a subject and image it using two lenses of different focal lengths, each the same distance from the subject and in identical format cameras. The image produced by the shorter focal length lens will be seen to include a greater subject area than its companion (assuming the covering power of the lens is sufficient). This must be so because images from the short focus lens are smaller, allowing more of the subject to be included within the same format.

Now imagine that we have two lenses of identical focal length and fit them into cameras of widely differing format. Once again assuming sufficient lens covering power, the larger format camera will include a greater subject area. Both lenses of course give the same size images, but the larger camera reveals more of the subject over its larger focal plane.

We can, therefore, say that the amount of subject viewed by a camera a set distance away depends upon two factors:

- (a) The lens-image distance (controlling size of image).
- (b) The size of the camera format.

If we trace the path of light rays from the limits of the subject area just included by a lens/format combination we can draw two imaginary lines denoting the camera's 'angle of view'. In photography, angle of view is accepted as referring to a lens focused for infinity and relative to the diagonal of the negative format. This is because when the lens is focused for close subjects lens-image distance increases and its effective angle of view becomes less. Most negative sizes are rectangular, so that the horizontal angle of view differs from the vertical angle of view. To avoid confusion and the need to quote two figures, angle of view therefore refers to the negative diagonal.

Definition: 'Angle of View'. The angle made between the lens and the most widely separated parts of a distant subject which it will just image within the negative diagonal. The angle varies with lens focal length and the diagonal of formats within its covering power.

The angle of view of a lens relative to a range of usable formats is quoted by the manufacturer. Alternatively, the angle of view for any lens/format combination can be quickly established by drawing a triangle to scale in which the negative diagonal forms the base and focal length the height. The apex angle is then the angle of view of the combination.

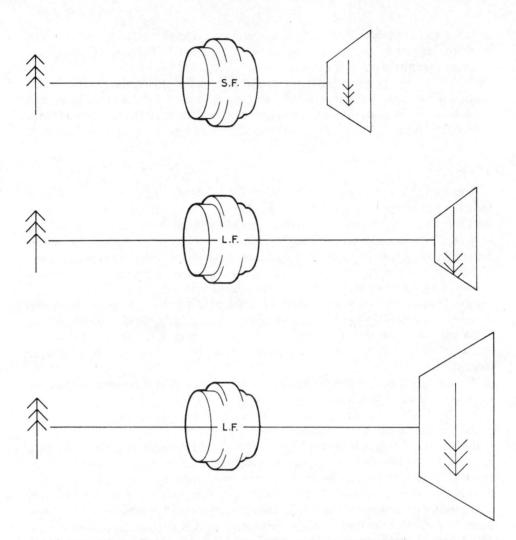

Fig. 4.2. A short focus lens (top) includes more of the subject than a long focus lens (centre) used on the same format. The same long focus lens will however include more subject when used on a larger format (bottom). 'Subject inclusion', therefore, varies with lens—image distance and size of negative format.

Most general-purpose lenses are designed to provide an angle of view of about 50°. Special short-focus wide-angle lenses cover 100° or more. Note: a lens which has insufficient covering power when used for a *distant* subject may be satisfactory for *close* up work because the of the reduced effective angle of view then required.

Since angle of view changes with focal length, a range of lenses allows the photographer to:

(a) vary the amount of subject included from the same distance, or

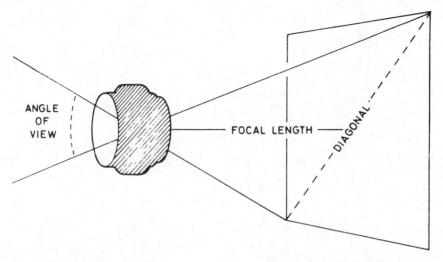

Fig. 4.3. Angle of view of a lens/format combination. Angle of view widens with increase of negative format and decrease of focal length.

(b) allow the same subject inclusion from varying distances. We shall return to these important points shortly.

Perspective

Variation in the apparent size of objects due to their relative distance from the viewer is known as 'perspective' effect. For example when looking obliquely at the wall of a house the near end appears considerably taller than the distant end. We know that the wall is of uniform height but this perspective effect provides us with a visual indication of the 'depth' of the house.

The variation between near and far heights is in direct ratio to their distances from the viewer. If the near end is 3 m away and the far end 12 m away the ratio between the two ends is 4:1 – perspective is 'steep', the wall gives a strong impression of depth. If we now move away to a viewpoint 30 m from the nearest end of the wall, the far end must be (30 m + 9 m) = 39 m distant. Ratios are now 39:30 or approximately $1\cdot3:1$ – perspective is 'flatter' and the distant wall gives less visual impression of its depth (see Fig. 4.4).

Angle of View and Perspective

Subject perspective is altered by distance of viewpoint. Changing focal length allows the same subject inclusion from varying distances. These two facts can be linked together. The photographer may alter the perspective of his subject by moving nearer (or farther away) – then *disguise* viewpoint change by changing to a lens of shorter (or longer) focal length.

Fig. 4.4. Visual perspective. An oblique wall will appear to have 'steep' (left) or 'flat' (right) perspective, depending upon viewing distance.

Let's go back to the house example. A photograph is taken with a 7.5 cm lens from the close (3 m) viewpoint. Next we move back to the 30 m viewpoint but, by changing to a narrower angle 75 cm lens, image the *near end* of the wall the same size as before. These manœuvres provide us with two pictures both 'apparently' taken the same distance from the subject. In one the wall looks enormously long due to its steeply converging horizontals; in the other front-to-back depth is relatively 'compressed'. (See also plates 6-8.)

This control over image size and perspective by focal length and viewpoint is extremely important, as the normal camera gives a two-dimensional record of the original three-dimensional subject. The viewer of the final photograph has to assess the 'depth' of the subject by guesswork – based largely on the relative sizes of foreground and background objects. He is easily deceived. There are many commercial applications of this control:

IMAGE FORMATION

Plate 1 (Top) Photograph taken with a pinhole—4 minutes exposure.

Plate 2 (Bottom) Substituting a lens for the pinhole—1/100th second exposure at f/5.6. Note that the sharpness improvement is zonal—near objects are less sharp. Racking the lens forward will sharply record the window frame but lose detail in the buildings. See Figure 2.1. (G. Herring)

CHANGE OF LENS

Plates 3-5 (Left) top—28 mm lens, middle—55 mm lens, bottom—135 mm lens. Shooting from the same viewpoint with various focal length lenses merely alters magnification. Perspective remains unchanged in these pictures.

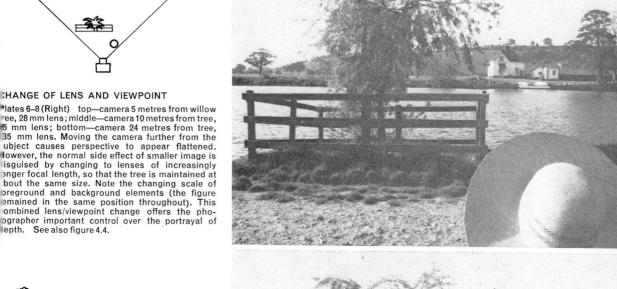

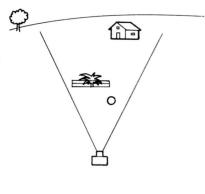

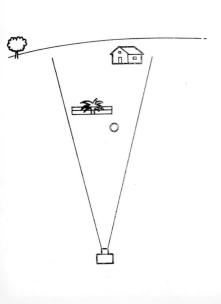

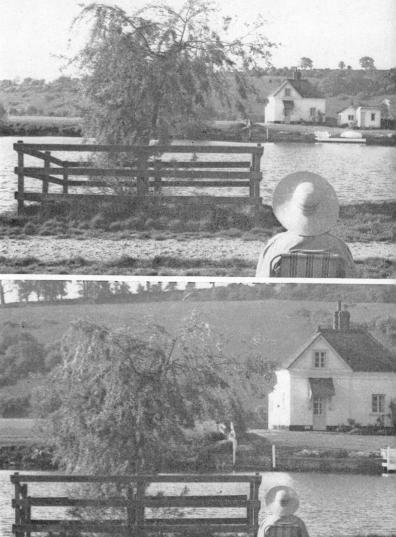

DISTORTION

Plate 10 Distortion given by an extreme wide angle lens is all too apparent when circular objects are placed near the corners of the format.

Plate 11 (Bottom left) A portrait taken from a fairly distant viewpoint using a long focus lens.

Plate 12 (Bottom right) Here the camera was only one-tenth its previous distance from the sitter, using a wide-angle lens one-tenth the focal length. This is a similar situation to plates 6 and 8 but in macro form, and further disguised by the plain background.

JSE OF 'FLATTENED' PERSPECTIVE

Plate 13 Imaginative use of a long focus lens from a viewpoint so distant that perspective is compressed —essential to the 'hemmed in' mood of this shot. (A. Clifton)

USING RESTRICTED DEPTH OF FIELD

Plate 14 (Above) The pocket calculator is resting on clear glass about 12 cms above crumpled aluminium kitchen foil, lit by a distant spotlight. 5×4 camera with 180 mm lens at f 8. At this aperture depth of field renders the calculator sharp throughout. However, foil highlights are sufficiently out of focus to spread into overlapping, nebulous discs of light. A glamourising technique much used for cosmetics etc.

Plate 14a (Left) Exactly the same set up, now stopped down to f 45. $\,$

Plate 15 (Right) Use of differential focus to accentuate the key part of the picture, yet still give a readable background image (B. Braham).

LENS COVERING POWER

Plate 16 The total image patch projected by a lens. Only the area within the broken line has acceptable definition. Beyond this zone lens abberations cause deteriorating image definition and distortion, until vignetting by the lens barrel extinguishes the image completely. (B. Prosser)

'STEEPENED' PERSPECTIVE (CLOSE VIEWPOINT, WIDE-ANGLE LENS)

- (1) To give extreme depth effects, e.g., exterior views of property shot from within its garden the house appears distant beyond vast stretches of lawns, with looming foreground flower-beds.
- (2) To give dramatic emphasis to part of the subject by exaggerating its relative size, e.g., a boxer's clenched fist held out at the camera; a worm's eye view of a massive golf ball with tiny background golfer; a bird's eye fashion shot of hat the model beneath it tapering away out of the picture.
- (3) To give steeply converging horizontal or vertical lines, e.g., low-angle shot of a car making it look faster and longer; an effects shot looking up at a figure climbing a pylon exaggerating height.

'FLATTENED' PERSPECTIVE (DISTANT VIEWPOINT, NARROW-ANGLE LENS)

- (1) To reduce depth effects, e.g., reducing protrusion of the nose which would otherwise occur from close viewpoint in shooting portraiture heads; giving a 'crowded in' appearance to a group of objects stretching away from the camera such as the row of parking-meters in plate 13.
- (2) To record objects as nearly as possible in their true relative proportions, with minimum perspective influences, e.g., products in varying sized containers displayed in tiered rows; sets of crockery; shoes.

All the above could be termed 'controlled perspective distortion'. A photograph can only truly reproduce the perspective which the eye would have seen under one set of conditions. This condition is met when a viewer examines a contact print from a distance equal to the focal length of the original taking :ens (or views an enlargement from focal length \times degree of enlargement distance). Check this out for one of your own enlargements.

Fortunately, in practice, we don't have to adhere too closely to this 'correct' perspective reproduction. Extreme variations (extreme disguise of viewpoint) do, however, become noticeable, the viewer having an uneasy suspicion that 'something is wrong' with the photograph.

LENS SETS

In order to have full control over image size (and indirectly perspective) it is obviously helpful to have wide-angle, normal, and narrow-angle lenses for each camera.

Wide-Angle Lens

This must be a comparatively short focus lens of considerable covering power. Its front-to-back thickness will have been kept to a minimum or lens mount carefully designed to avoid vignetting. Aberration correction for outer zones of the focal plane must be of a high order.

Since aberrations are reduced by stopping down, wide-angle lenses are generally of smaller maximum aperture than 'normal' lenses. Good wide aperture wide-angle lenses

are expensive. A few wide-angle lenses have one maximum aperture for focusing only and another (smaller) aperture which is the largest considered aberration safe for actual photography.

To be termed 'wide-angle' a lens is generally expected to provide an angle of view of over 70° – typical focal lengths being

28 mm on 24×36 mm format (73°) 50 mm on 6 cm square format (77°) 90 mm on 4 in \times 5 in format (80°)

The main uses of a wide-angle lens are:

- (a) To include the whole of the subject when working under imposed cramped conditions interiors of rooms, cars, etc.
- (b) To allow a close viewpoint to be chosen in order to steepen subject perspective.
- (c) To produce maximum magnification in shooting close-up subjects with a camera of limited bellows extension. Here we use the lens for its short focal length (the greater number of focal lengths to which the bellows extend the greater the magnification possible, see Fig. 2.8).

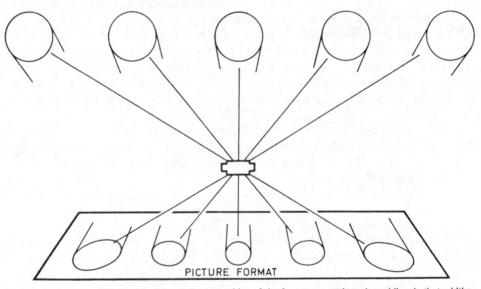

Fig. 4.5. 'Wide angle distortion.' Images at the extremities of the format are projected so obliquely that widths thicken and circles pull into ellipses. (See also plate 10.)

WIDE-ANGLE DISTORTION. In the case of (a) and (b) we have to beware of an inherent type of image distortion produced by wide-angle lenses. This occurs solely because of the close positioning of lens to focal plane and should not be confused with perspective distortion.

Imagine we are photographing a row of cylindrical canisters standing at right angles to

the lens axis. Since the wide-angle lens is so close to the centre of the focal plane, images of the end canisters are projected *obliquely* towards the edges of the film. If an image is projected obliquely at a surface its shape is elongated. (We can see this distortion when a slide projector is aimed towards a screen at an angle.) the wide-angle lens therefore 'stretches' objects shapes near the edges of its field of view. Our end canisters may look 50 per cent fatter than those in the centre of the row. (See also Plate 10.)

The same effect can be disastrous to the faces of people near the edges of a group photograph. Clock faces and circular ceiling lights in interior shots may be pulled into ellipses, chairs stretched into settees and so on. For this reason wide-angle lenses call for very careful selection of viewpoint.

In composing the picture we should try to avoid including objects which may noticeably distort close to the edges of the format, particularly the corners. Plain ceiling, curtains, wall or carpet surfaces are less likely to cause trouble. Wide angle distortion is less troublesome with modern 'retrofocus' designs for small format single lens reflex cameras than with wide angle lenses for view cameras. (Retrofocus wide angle and fish-eye lenses are discussed in *Advanced Photography*, chapter 2.)

'Normal'-Angle Lens

A 'normal'-angle lens is a compromise between the all-embracing wide-angle and the selective long focus lenses. Its angle of view is often about 45–50°. This could be said to approximate normal eye vision, in the sense that if you look through the pentaprism eyepiece of a 35 mm single lens reflex camera with a normal lens, keeping the other eye open, the images received by both eyes are similar in size. Typical 'normal' focal lengths are

50 mm on 24×36 mm format (45°) 80 mm on 6 cm square format (50°) 150 mm on 4 in \times 5 in format (45°)

(As a rough guide to typical focal lengths for a camera of known format:

The short side of the negative format = wide-angle focal length.

The diagonal side of the negative format = normal-angle focal length.

Twice the long side of the negative format = long focus focal length)

Where a camera has a 'non-interchangeable' lens this is of course usually of a focal length giving normal angle of view.

Long Focus (Narrow-Angle) Lens

A narrow-angle lens is a relatively long focus lens of limited covering power, i.e., with aberrations corrected to give highest optical performance near the lens axis. These lenses are usually not of such wide aperture as normal angle lenses owing to the glass diameter entailed. Wide aperture long focus lenses tend to be both bulky and expensive.

The angle of view of a long focus lens varies considerably but is normally categorised

as such if it images about 35° or less.

Typical focal lengths:

9 cm on 24×36 mm format	(28°)
16 cm on 6 cm square format	(28°)
28 cm on 4 in × 5 in format	(32°)

The principle uses of a long focus lens are:

- (a) To produce a usefully large image when a subject is unavoidably distant natural history, sports photographs, etc.
- (b) To allow a distant viewpoint to be chosen, in order to flatten perspective particularly for portraiture.

The term 'telephoto' is often loosely applied to long focus lenses. A telephoto is a particularly compact form of long focus lens design. We should not, however, use the term to describe *all* long focus narrow-angle lenses.

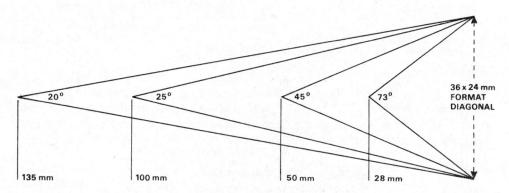

Fig. 4.6. Angles of view given by four typical 35 mm camera lenses.

Care of Lenses

The lens is the most important and probably the most expensive item of our camera equipment. Control of the image depends directly upon its properties and efficiency . . . it deserves care in handling. Optical glass is appreciably softer than normal glass which we meet. Moreover, every modern lens surface carries a thin transparent film or 'coating' designed to reduce the proportion of light reflected. If either coating or glass is damaged by scratches from grit, or accumulated dust or grease, image definition immediately suffers. Haloes form around highlights; light areas of the image spread into the shadows, giving them a foggy appearance. Sometimes the effect is quite subtle – until negatives or prints are compared.

A lens fitted to a camera should be protected by an every-ready case or lens cap. Interchangeable lenses left around on shelves or in camera cases are particularly vulnerable and should have two well-fitting caps or a dust-tight box. Similarly, they

should be stored away from excessive heat, damp or chemical fumes; these may warp or corrode the lens barrel, or decompose the Canada balsam which cements elements in contact with each other. (*Note:* Camera-lenses should not be used in tungsten enlargers, owing to the heat they may thereby receive.)

Condensation of moisture on lens surfaces is another – more temporary – cause of image deterioration. During winter a lens or camera brought into a warm building from the cold boot of a car frequently 'mists-over'. It cannot be used until the moisture has evaporated, and in the case of a separate lens this can be hastened by carrying it around for a while carefully wrapped in an inside breast pocket.

A most infuriating form of condensation can happen when a loaded camera fitted with a non-removable lens undergoes the above temperature rise. Moisture may condense on the lens surface facing the film – where it remains invisible to the operator. When processed, the pictures on the film show less and less diffusion as the condensation slowly evaporated during shooting, until the last shots are comparatively clear. (But as luck will have it, the first pictures are often the most important.)

Avoid

- (a) sudden temperature or humidity changes. Give the lens time to match the temperature of its surroundings.
- (b) touching the lens surfaces, leaving grease and perspiration.
- (c) rubbing grit across the glass. A handkerchief straight out of the pocket is one of the worst scrapers.
- (d) damp or chemically contaminated storage.
- (e) knocks to the lens barrel.

Dropping or any other rough treatment may slightly mis-align the elements, giving greatly increased aberrations. Never buy a second-hand lens with any sign of a dent in its barrel. If an accident does occur, pay for a properly equipped optical repairer to report on any image defects. You *must* have confidence in your equipment.

When eventually a lens does accumulate dust it can be cleaned with a dust-free camelhair brush (kept in a special case). Debris can be lightly brushed to the lens rim and removed with a crumpled piece of cleaning tissue. Final cleanliness is conveniently checked by looking through the lens at a dark background, with light striking the glass from the rear. Any really persistent dust or marks should be left for a specialist to remove by fluid cleaners. A small sum spent on the maintenance of a costly item of equipment like a good lens makes economic sense.

Summing Up Chapter IV

- (1) A lens is corrected to give acceptable image quality or 'covering power' over a predetermined area.
- (2) Focal length relative to the diagonal of negative format controls 'angle of view' (within the covering power of the lens).
- (3) Change of focal length alters image size and therefore angle of view. Change of viewpoint alters perspective.

- (4) Perspective in a photograph may be steepened or flattened by changing view-point, then regaining image size by change of focal length.
- (5) 'Correct' visual perspective is recreated only if a print is viewed at camera focal length × enlargement distance.
- (6) A set of lenses enables a photographer to control image size at various view-points ensuring useful subject inclusion or manipulating perspective. Extreme viewpoint 'faking', however, gives noticeably distorted perspective.
- (7) A wide-angle lens must always be used with discretion owing to inherent image shape distortion near the edges of its field of view.
- (8) Take precautions against dust, grease and grit scratches on the comparatively soft surface of optical glass. Beware of condensation, particularly in wintertime. Don't risk expensive damage by over-enthusiastic cleaning learn how to remove dust safely and leave the rest to experts.

Questions

- (1) A house is photographed using a lens of focal length 25 cm. Without moving the camera front the same house is again photographed using a lens of focal length 12.5 cm. Discuss the effect this will have on
 - (a) Perspective.
 - (b) The size of the image.
- (2) Why are long focus lenses often used for portraiture and 'wide-angle' short focus lenses used for architectural interiors?
- (3) A compound lens is listed in a catalogue as having the following specification: F.L. 18 cm f/4.5 for 5 in \times 4 in (43°). Explain the meaning of *each* of the above figures.
- (4) Using a 5-in \times 4-in camera, three oblique views are taken of a new garage:
 - (a) Using a 7.5 cm lens, the image just filling the negative area.
 - (b) Using a 30 cm lens, camera position being adjusted until the image once again fills the negative area.
 - (c) Using a 7.5 cm lens, the camera remaining in the same position as (b). Comment on the differences you would expect to see in the contact print proofs.
- (5) What is meant by the following?

Wide-angle distortion, Covering power of a lens, Angle of view, 'Steep perspective' in a photograph?

- (6) It is often said that 'Changing to a wide-angle lens steepens perspective'. Comment on this statement.
- (7) Give the focal lengths of a set of three lenses which you would take with your $6 \text{ cm} \times 6 \text{ cm}$ camera to handle *all* the following assignments:
 - (a) The interior of a watch, imaged as large as possible.
 - (b) A head-and-shoulders portrait of an executive, for press reproduction.
 - (c) A prospectus picture showing a school and its playing-fields.

- (d) A shop front facing a busy main road with wide pavements for an estate agent.
- (e) A series of sports-day pictures.
- (f) A still-life catalogue shot showing a range of chisels. Which lens might be used for each assignment? Give reasons for your choice.
- (8) Which of the following points has the greatest influence on the perspective in a final print:
 - (a) camera lens
 - (b) viewpoint
 - (c) negative format
 - (d) degree of enlargement?
- (9) A lens is often an expensive item. Discuss possible defects you would look for in the condition of a second-hand lens offered for sale. How would you remove a thin layer of dust from the surface of a valuable lens?
- (10) Given that you have a 35 mm camera and standard lens, specify the first additional lens you would wish to purchase. Explain your choice of focal length in terms of practical photography.

V. DEPTH OF FIELD - DEPTH OF FOCUS

Before leaving lenses as such, one very practical aspect of image forming must be looked at more closely. This is the fact that the image given by a lens need not be critically sharp to be accepted as *visually* sharp. There is some latitude allowable in focusing, and in the distances of subjects which can all be sharply imaged at one focusing setting. We need to determine just how accurate our focusing has to be — and what effect aperture, focal length and subject distance have on this 'latitude'.

Standard of Sharpness

Imagine you set up a camera so that the focusing screen is too close or too far from the lens to receive a sharply focused image. Looking on the screen you can see that light reflected from each highlight on the subject is reproduced as a disc or circular patch of illumination. In fact all *points* on the subject are represented as overlapping *circular light patches*, giving of course an overall 'blurred' effect. An out-of-focus image is really a mass of such 'circles of confusion'.

The farther the focusing screen is from the position of sharp focus for a subject the larger the circles become. Highlights in an out-of-focus background can appear as large nebulous discs of light — much used for effect in advertising photography.

For example, suppose a product – a perfume bottle – is positioned on a glass sheet well in front of a crumpled sheet of kitchen foil. The creases in the foil reflect light in intense individual highlights – and if the lens is focused on the perfume these are sufficiently out of focus to spread to large but still separable overlapping discs of light. The effect gives a visual impression of sparkle, mystery, glamour (see Plate 14).

On the other hand, most technical subjects demand overall sharp imaging ... but how in-focus must a 'sharp' image be? Fortunately, the eye has a limited resolving power. An image may be acceptably 'in focus' even though each point on the subject is

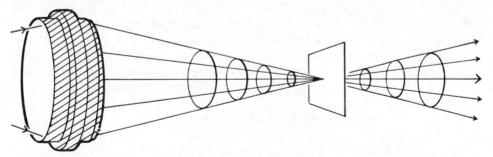

Fig. 5.1. Circles of confusion. If the film is placed in any position other than the plane of sharp focus, image points (for example, specular highlights) spread to circular *discs* of light. 'Unsharp' images are composed of a confusion of these circles.

in fact reproduced by a tiny circular patch of light. This allows us an important flexibility in focusing.

Definition: 'Circles of Confusion' - Circular patches of light representing each point of light on the object which, overlapping, make up 'unsharp' images. Providing circles of confusion are of sufficiently small diameter the eye accepts them as points, and the image appears 'acceptably sharp'.

The maximum permissible circle of confusion visually acceptable on a photograph as a point must depend of course on the viewer's eyesight and his distance from the print. A penny seen from 90 m away can look more like a speck than a grain of sand viewed from 15 cm. It is generally accepted that for most adults a circle 0.25 mm diameter appears, from normal viewing distance (about 25 cm), to be indistinguishable from a point.

Remember, however, that most prints are enlarged from smaller negatives. Small format negatives call for higher standards of sharpness than larger format negatives if they are to give acceptable equally sized prints. As some form of guide, we can say that maximum permissible circle of confusion (c. of c.) diameter in a negative should be $0.25 \text{ mm} \div$ the degree of enlargement anticipated, i.e.:

Acceptable 8-in \times 10-in enlargements from 24-mm \times 36-mm negatives (magnification approximately = 8 \times) limit maximum permissible c. of c. on negative to 0.25 mm \div 8 = 0.03 mm.

Acceptable 8-in \times 10-in enlargements from 4-in \times 5-in negatives (magnification = 2 \times) limit maximum permissible c. of c. on negative to 0.25 mm \div 2 = 0.125 mm.

Acceptable $40.6 \text{ cm} \times 50.8 \text{ cm}$ enlargements from $4-\text{in} \times 5-\text{in}$ negatives (magnification = $4\times$) limit maximum permissible c. of c. on negative to $0.25 \text{ mm} \div 4 = 0.06 \text{ mm}$.

These figures can only be an indication, particularly if really big display prints are being made – as these may be viewed from all sorts of distances. They are further affected by the graininess of the film and the type of subject. 'Clinical' technical records will be expected to stand up to closer scrutiny than say, photojournalistic or 'atmosphere' advertising work.

Depth of Focus

Provided a point on the subject is represented by a light patch no bigger than the maximum permissible circle of confusion, our focusing need not be exact. In fact, the focusing screen or film can be moved towards the lens, away from the point of truly sharp focus, until the cone of refracted light widens to the diameter of the maximum permissible circle of confusion. Reversing its direction, the screen can be moved away from the lens, through the point of sharp focus, until the cone of light again widens to maximum permissible diameter.

This latitude in movement of the film whilst preserving acceptably sharp focus is known as 'depth of focus'. If we can imagine two cones placed horizontally, with apexes touching, this 'depth' can be simulated by the distance a small ring will move along the cones before jamming tight. Depth of focus always extends as far in front of the plane of critical focus as behind it.

Fig. 5.2. Depth of Focus. Top: If C represents the maximum permissible circle of confusion, depth of focus extends over distance D. Depth of focus is increased A: when lower standards of sharpness and therefore larger circles of confusion are acceptable; B: when the lens is stopped down; C: when the subject is *closer*, or a *longer* focal length is used.

Definition: 'Depth of focus' – The distance along the lens axis through which the film may be moved before the image of a point on the subject becomes noticeably unsharp.

Greatest depth of focus occurs when -

permissible circle of confusion is large; the f-number is high; focal length is long; and subject is close.

Circle of Confusion: The larger the diameter of light patch acceptable as sharp, the greater the movement of the film before the light cone expands to this diameter.

f-number: As the lens is stopped down the converging cone of light rays directed towards the film becomes narrower. The film can therefore be moved farther before reaching maximum permissible diameter.

Focal length: The longer the focal length the farther from the lens the point of sharp focus for an object is positioned. This has no effect on depth of focus whilst the lens is focused on infinity, for at the same f-number the light cone is scaled down proportionally to the light cone of any other lens focused on infinity. Focused for closer objects, however, the long focal length lens issues the narrower light cone ... and produces a greater depth of focus.

Subject Distance: As the subject approaches a lens its sharp image is formed farther from the lens. This causes the light cone to narrow, increasing depth of focus.

Practical Significance

- (1) When focusing a camera or enlarger the lens should be set at widest aperture. Quite apart from increased image illumination, this reduces depth of focus and allows more critical visual focusing. When focusing a camera, a magnifier used to view the image on the ground glass enlarges the image circles of confusion which would previously have appeared sharp. Focusing is thus made more critical. (N.B. A magnifying glass also aids focusing by magnifying the apparent quantity of light reaching the eye from the part of the screen under observation.)
- (2) In 35 mm and smaller cameras accurate positioning of film relative to lens is of paramount importance. With its combination of small permissible circles of confusion, short focal length lens and frequently wide apertures, such equipment has severely restricted depth of focus. Quality small format cameras must therefore be manufactured to high precision standards. The position of the lens relative to the film is particularly critical when focused for infinity. Hence, most miniature cameras are rigidly constructed with lens focusing by helical screw mount instead of bellows.
- (3) Large-format cameras are more tolerant in their film positioning (a point which can be borne out by feeling the amount of 'wobble' possible with the back of some cameras). This is one reason why large-format cameras can still be acceptably manufactured in wood. Even more important, the comparatively great

depth of focus of large cameras allows us to swing the camera back independently from the front and assists other 'camera movements' (chapter VI).

(4) When focusing close objects (i.e. copying) with a large-format camera it is possible to rack the back of the camera literally for inches without appreciably affecting image sharpness. More critical—certainly less frustrating—focusing is achieved by moving the whole camera bodily backwards and forwards from the subject. This is in fact focusing by exploiting the limited depth of *field* under such conditions, discussed below.

Depth of Field

Depth of focus related to permissible movement of the *film plane*. Depth of field is concerned with the distances between nearest and farthest *subjects* which can all be brought to acceptable focus on the film at the same time.

Imagine we have three subjects A, B, and C placed at increasingly greater distances from our camera which is sharply focused on B (Fig. 5.3). C, being closer, will be sharply imaged farther from the lens than B. Therefore refracted light rays from a point on C will not have fully converged by the time they reach the film. C is therefore recorded as a circular patch of light. On the other hand A, farther from the lens, is imaged nearer the lens than B or C. Its rays will have come to focus and diverged again by the time they reach the film. Like C, A will record as a patch.

But circles of confusion are acceptable as sharp if sufficiently small. If the patches representing A and C are just within the permissible maximum circle of confusion we can say that 'depth of field' under these conditions extends through from subject C to subject A. Subjects nearer the lens than C or farther away than A are imaged increasingly unsharp.

In practice, depth of field for subjects about 8 focal lengths distant and beyond extends farther behind the subject than towards the lens. For example, when a 12 cm lens is focused on a subject 6 m from the lens depth of field may extend from 4.5 m to 9 m. This has given rise to the maxim 'focus one-third in', i.e. focus on a point one-third inside the depth of field required.

Definition: 'Depth of field' – the distance between nearest and farthest parts of the subject matter which can be brought to acceptable focus on one common plane.

Greatest depth of field occurs when:

permissible circle of confusion is large; f-number is high; focal length is short; and subject is distant.

Circle of Confusion: The larger the permissible circle of confusion, the larger are the light patches representing subjects at the limits of depth of field which can be tolerated. Subjects can be imaged at positions even farther from the film plane and still appear acceptably sharp on this plane. Subjects nearer and farther from the lens are therefore drawn into the depth of field.

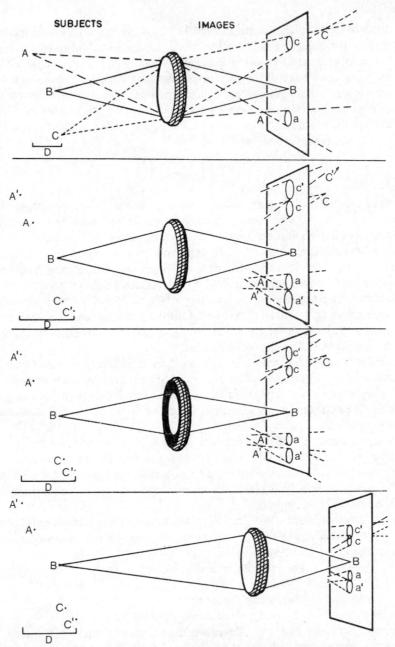

Fig. 5.3. Depth of Field: Top: If image circles C and A are equivalent to the maximum permissible circles of confusion, depth of field (D) extends from subject A through to subject C. Depth of field is increased (upper centre) when standards of sharpness are lowered – if image circles C' and A' are acceptable, depth of field extends from subjects A' to C'. Lower centre: stopping the lens down brings image circles C' and A' within the original maximum circle of confusion. Bottom: the effect of more distance subjects, or shorter focal length.

f-number: As the lens is stopped down all ray cones are narrowed. Light patches representing subjects at the previous limits of depth of field are made smaller. Light patches from subjects previously too close or too far from the lens are now acceptable as 'points'. Depth of field extends to include these subjects.

Focal length: If we change to a shorter focal length in effect our subjects at all distances become a greater number of lens focal lengths from the lens. Their sharp images are therefore formed nearer to the lens and more closely grouped (see fig. 5.3). This closer grouping has a decisive effect in reducing light-patch diameters at the focal plane – allowing nearer and farther subjects to be considered 'sharp'.

Subject distance: As a group of subjects becomes farther from the lens their sharp image positions close in one to another and also approach the lens. Like change of focal length this closer grouping allows a wider depth of subjects to be considered sharp.

Practical Significance

Real control over depth of field is a major weapon in the photographer's armoury. With this control we can *emphasise* important subjects, *suppress* unwanted irrelevancies, *suggest* environment. This is achieved by purposely restricting depth of field to significant subjects only.

On the other hand we can give equal emphasis to all parts of the subject, recording every detail with an exactitude beyond any artist. This is the result of extending depth of field to include the whole picture content. Let's look at the two needs separately.

MINIMUM DEPTH. A photograph in which only a limited zone of subject matter appears sharp is said to be differentially focused. We all know of pictures which have been differentially focused by accident! But because most types of 'record' photography have to be sharp overall this certainly doesn't imply that all photographs must be handled in the same way. Photojournalistic and advertising photographs in particular can lose much of their impact by too much 'clinical' detail.

Differential focus forcefully accentuates the key point of the picture – one subject among many or one key part of a subject. A bottle of sherry with an out-of-focus background of a party in progress, and glasses and food out-of-focus in the foreground is a typical example of differential treatment. The photographer's skill is to produce the right degree of unsharpness – enough to give differentiation and ensure that the surroundings and environment are 'lost' to the required degree.

The easiest way to restrict depth of field is by shooting at a wide aperture. This of course has the side effect of brightening the image so that either a fast shutter speed, low sensitivity film or low level of lighting must be used. The only difficulty arises when shooting under bright uncontrollable sunlight, where the fastest shutter speed will still produce too much exposure for the film in use. Under these conditions we can use a grey 'neutral density' filter glass over the lens to reduce its light passing ability without increasing depth of field.

In addition, or as an alternative to aperture change, we could reduce our depth of field by making any change which makes the image of a given subject larger. We might

change to a longer focus lens – remembering that this has the side effect of giving a narrower angle of view. Alternatively, we could move closer to the subject – remembering that perspective will become steeper.

A better scheme is to keep viewpoint unaltered and change to a larger format camera offering the same angle of view. (The wider circles of confusion acceptable for a large format have less influence on depth of field than focal length change) – Practical figures bear this out:

4-in × 5-in camera, 150 mm f/4 lens 3 m from subject (max c. of c. 0.25 mm÷ 2)

Depth of field from 2.82 m to 3.22 m

10-in \times 8-in camera, 300 mm f/4 lens 3 m from subject (max c. of c. 0.25 mm) Depth of field from 2.87 m to 3.17 m

Recapping: For minimum depth of field the most useful line-up is a large format camera with its lens used at wide aperture. Depth is even less when the subjects can be close to the lens, provided the resulting steeper perspective is acceptable.

Some of the best contemporary examples of skilful differential focusing are found among advertising photographs of cigarettes, cosmetics, etc., and evocative mood pictures for editorial illustration.

Practice at controlling the limits of depth of field, using the various permutations of lens, f-number and distance. Notice the variable 'plastic quality' of the outlines of subjects rendered unsharp – here is a quality essentially photographic. Try, for example, photographing a small object, crisply imaged against a background of other identical objects which are sufficiently unsharp to be unobtrusive yet remain recognisable and attractive.

MAXIMUM DEPTH. Photographs which are visually sharp throughout have been aptly described as 'maximum information' pictures. Maximum depth of field is of greatest value when a photograph is essentially intended to record information ... the appearance of a new building, the contents of a radio chassis, the method of assembling a product ... in fact the bulk of objective commercial photography.

Such pictures do not dictate to the viewer. His eyes can concentrate on any part of the subject in a similar manner to viewing it in real life. (The human eye, like the camera lens, has a restricted depth of field. However, it automatically and rapidly focuses on subjects of interest to us. We therefore more objectively recreate a subject if our photograph records it sharply throughout.) Just remember that a picture with full front-to-back sharpness may show up with embarrassing clarity unwanted information in the foreground or background of the picture — things which might not otherwise compete for attention. Check this out carefully on the focusing screen with the lens at the actual aperture to be used for photography. On a small format camera this means pressing the pre-view button, see page 138.

Depth of field can be increased most easily by stopping down the lens – provided of courses we are willing to compensate reduction in image brightness by giving longer exposure, using a more sensitive film or increasing subject lighting. When aperture limits have been reached, camera movements may help effectively to increase depth of field over certain parts of the subject (chapter VI).

TABLE 5.1

COMPARATIVE EFFECTS OF F-NUMBER, CIRCLE OF CONFUSION, FOCAL LENGTH AND SUBJECT DISTANCE ON DEPTH OF FIELD

Notes	1.64 m 'Standard' image (for comparative pur-	Longer exposure required	Flatter perspective. Smaller image*	(more subject included)	Small image* (more subject included)	Large image (less subject included)	Flatter perspective	Steeper perspective	Less subject included	Similar subject inclusion and perspective	to standard image
8 Depth of field (approximate)	1.64 m	5.4 m	8.31 m		4.17 m	.72 m	3.97 m	m 6·	.36 m	20.17 m	
6 7 Distance to earest Farthest harp sharp	5·19 m	8·12 m	13.24 m		7.07 m	4.42 m	9.8 m	2.56 m	4.19 m	22.66 m	
6 Dista Nearest sharp point	3.55 m	2.72 m	5.93 m		2.9 m	3.7 m	5.83 m	1.66 m	3.83 m	2.49 m	
5 Relative aperture	8/J	f/22	8/J		8/J	8/J	8/J	8/J	8/J	8/J	
4 Subject distance	4 m	4 m	8 m		4 m	4 m	8 m	2 m	4 m	4 m	
3 Focal length	150 mm	150 mm	150 mm		75 mm	300 mm	300 mm	75 mm	150 mm	35 mm	
2 Maximum c. of c. to give acceptable 10-in × 8-in print	.125 mm	.125 mm	·125 mm		·125 mm		·125 mm	•	·03125 mm	·03125 mm	
1 Format	$4 \text{ in} \times 5 \text{ in}$	$4 \text{ in} \times 5 \text{ in}$	$4 \text{ in} \times 5 \text{ in}$		$4 \text{ in} \times 5 \text{ in}$	$4 \text{ in} \times 5 \text{ in}$	4 in × 5 in	$4 \text{ in} \times 5 \text{ in}$	24 × 36 mm	24 × 36 mm	

* N.B. If neg. is enlarged to match 'Standard', c. of c. should be 0.0625 mm and D. of F. is halved.

By comparing columns 6 and 7 with column 4 note that it is good practice with most subjects to focus 'one third in'. Thus, if the subject extends from 3.5 m to 5 m from the camera, focus the lens for 4 m.

Depth of field can also be increased by any change which makes the image of a given subject smaller. If you find yourself in the position of having insufficient depth of field, even at smallest aperture, try.

(a) changing to a lens of shorter focal length – remembering, however, that this gives

wider angle of view, or

(b) moving away from the subject – bearing in mind the flattening effect this will have on perspective. Better still,

(c) try changing to a smaller camera.

All these methods give a smaller image which calls for a small circle of confusion, but even when the negative is enlarged the depth of field improvement is still notable. See Table 5.1 on previous page.

Imagine two photographers working side by side, one with a 35-mm camera (5 cm lens) and one with a 4×5 in (20 cm lens). Both include the same amount of picture, but the photographer with the smaller camera has over four times as much depth of field at his disposal. This is one of the greatest advantages of the miniature camera.

One note of warning should be sounded here. At the moment we are only dealing with the optical side of photography. Our small format camera with its short-focus lens may enjoy more depth of field, but in enlarging its small negative we also enlarge the grainy structure of the chemically recorded image. Since final sharpness in a photograph is influenced by graininess as well as by considerations of depth of field, this deprives the small camera of some of its advantages.

Comparing Depth of Field and Focus

The two 'depths' are constantly confused. In conversation and in a surprising amount of technical literature depth of focus is used when photographic depth of field is meant. It is a good move to discipline yourself in using these terms. To keep them mentally separated their main differences can be summarised as follows:

(1) Depth of focus applies to movement of the image plane: depth of field concerns

zones within the subject.

(2) As a subject approaches the lens, depth of field within the subject decreases: depth of focus for its image increases. (Depth of field exactly equals depth of focus when subject and image are the same distance from the lens – giving same-size subject reproduction.)

(3) When the image of a subject is made larger - whatever the cause - depth of field

decreases, depth of focus is increased.

- (4) If the image of a subject is decreased in size depth of field increases, depth of focus is reduced.
- (5) Both depth of field and focus improve when the lens is stopped down.
- (6) Both depth of field and focus improve when standards of sharpness are lowered.
- (7) Depth of focus is mostly concerned with camera manufacturing tolerances depth of field with subject appearance.

Depth of Field Calculators

Lenses on precision cameras which are fitted with a scale of focusing distances frequently incorporate a depth of field calculator. This is useful when depth of field cannot be visually checked on a focusing screen. The calculator is based on a set circle of confusion considered suitable for an 'average' size enlargement from the camera negative format. It also applies to one particular lens. Thus only two variables need be incorporated — subject distance and f-number.

Calculators vary physically, but in most cases distance focused upon is set against an arrow. Distances of nearest and farthest sharp objects can then be read off opposite lines labelled with the f-number in use. Depth of field calculators are usually:

- (a) engraved around the camera focusing knob. Where lenses are interchangeable a separate scale for each must be incorporated, often colour coded.
- (b) engraved on a moving part of the focusing mechanism—i.e., the bed rails of a large format camera. Once again separate scales are necessary for every lens.
- (c) engraved on the lens mount itself, where this features some form of focusing movement.
- (d) as a separate item movable scales either secured to some convenient part of the camera body, or in the form of a pocket calculator.

All depth of field calculators should be considered purely as guides. Being based on an arbitrary standard of sharpness they cannot always agree with visual requirements for different types of photographs and differing sizes of final point.

When we have to focus by scale it is worth remembering the need to focus on a point about one-third inside the zone of subject we hope to render sharp (zone focusing). As mentioned previously, this will not strictly apply to close subjects (where depth extends towards and away from the lens equally in both directions) but forms a good practical guide.

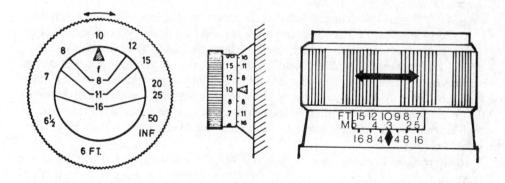

Fig. 5.4. Depth of field calculators (for predetermined focal length and circle of confusion). Left: A disc on the camera body with movable outer ring. Centre: Incorporated in the focusing knob. Right: Incorporated in a focusing ring on the lens mount.

Hyperfocal Distance

In discussing depth of field we agreed that it is unnecessary for a lens to focus exactly every part of a subject. Provided all parts of the subject lie somewhere within the depth of field they are visually just as acceptable as the one distance 'clinically' focused. Therefore, if we are photographing distant subject matter, i.e., landscapes and general views, we are wasting some of this valuable depth by setting the focusing scale on 'infinity'. What is happening is that our depth of field is extending back to a point nearer the camera and forwards beyond infinity.

Why lose this latter zone? Why not focus on some nearer point which allows depth of field to extend back just to infinity and towards us to include even more of the scene nearer the camera. We can do this by focusing the lens on the point which marked the

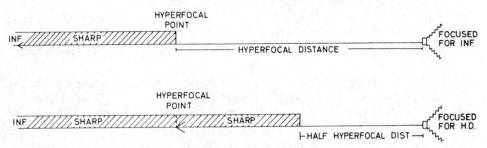

Fig. 5.5. Depth of field gained by focusing for the hyperfocal distance.

nearest limit to depth of field when the lens was earlier focused on infinity. This is known as the 'Hyperfocal Point' and its distance from the lens as the 'Hyperfocal Distance'. If our lens is focused for a subject at the hyperfocal distance from the lens, depth of field will extend back to infinity. It will also extend forward to a point half the hyperfocal distance from the lens.

Definition: 'Hyperfocal distance' – the distance between the lens and the nearest point of acceptably sharp focus when the lens is focused for infinity. When focused for the hyperfocal distance depth of field extends from half this distance to infinity.

This exploitation of depth of field (a sort of optical 'cheating') is an intelligent manœuvre to increase foreground sharpness when focusing by scale. Also, it is more useful for lenses of fixed focus – such as those in inexpensive cameras – to be set by their manufacturers for hyperfocal distance rather than infinity. Aerial cameras and optical instruments for distant work are also often set for hyperfocal distance at their widest aperture.

The hyperfocal distance varies with every f-number as well as focal length and the acceptable circle of confusion diameter. The following formula gives us the hyperfocal distance in whatever common units we quote focal length and circle of confusion.

$$\frac{Focal \ length^2}{f/no. \times dia. \ of \ c. \ of \ c.} = Hyperfocal \ distance$$

Notice that the two factors which increase depth of field as they increase in numerical value lie beneath the line. The factor which decreases depth of field as it increases in value is above the line.

Taking a practical example, a 15 cm lens at f/8, required to give circles of confusion no larger than 0.125 mm has a hyperfocal distance of

$$\frac{15^2}{8 \times 0.0125} \text{ cm, or } \frac{15^2}{8 \times 1.25} \text{ m} = \frac{\cancel{15} \times \cancel{15}}{\cancel{8} \times \cancel{1.25}} = \frac{\cancel{9}}{\cancel{.4}} = 22.5 \text{ m}$$

With the lens focused on this distance, depth of field extends from $11 \cdot 25$ m to infinity. Stopped down to f/22 the same lens has a hyperfocal distance of

$$\frac{15^2}{22 \times 0.0125} \text{ cm, or } \frac{15^2}{22 \times 1.25} \text{ m} = \frac{3}{15 \times 15} \frac{3}{15} = \frac{9}{1 \cdot 1} = 8.18 \text{ m}$$

With the lens focused on 8.18 m, depth of field extends from 4 m (approx) to infinity. Hyperfocal distance shrinks as depth of field increases.

CALCULATING DEPTH OF FIELD. Having established hyperfocal distance (H.) depth of field for any set of subject conditions can be calculated from the formulae:

Distance to nearest point sharp
$$=\frac{H. \times u}{H. + u - \text{focal length}}$$

Distance to farthest point sharp =
$$\frac{H. \times u}{H. - u - \text{focal length}}$$

u = distance (from front nodal point) of lens to the subject

(Alternative formulae - one offering greater accuracy, the other simpler but less exact - appear on page 404 of 'Advanced Photography'.)

Chapter Summary - Depth of Field, Depth of Focus

- (1) Out-of-focus image points form discs of light known as circles of confusion. These circles, overlapping, make up unsharp images.
- (2) Circles of confusion below a certain diameter are acceptable to the eye as points. Maximum permissible size varies with degree of negative enlargement, and distance of viewing: General guide − 0·25 mm on the negative divided by expected degree of linear enlargement.
- (3) Permissible movement of the image plane before a subject point appears noticeably unsharp is known as depth of focus.
- (4) Permissible movement of the subject towards and away from the lens before its image on a focal plane appears noticeably unsharp is known as depth of field.

- (5) Both depths vary with circle of confusion, f-number, focal length and subject distance, but as image size increases depth of focus increases, depth of field is reduced. Minimum depth of field gives emphasis to a subject, maximum depth gives overall information.
- (6) Under similar conditions the smaller camera offers greater depth of field, but because of its restricted depth of focus must be precision-constructed.
- (7) Depth of field calculators are used as aids for scale-focused cameras.
- (8) For maximum depth of field stretching back to infinity under given conditions, the lens should be focused on the hyperfocal point. Depth then extends to half the hyperfocal distance.

Questions

- (1) It is customary when focusing a camera or enlarger to do so with the lens at its maximum aperture. Explain with the aid of a diagram why this should be so.
- (2) 'Depth of field' and 'depth of focus' are often confused. Explain (with diagrams) what these terms mean. Point out any differences in the practical factors controlling them.
- (3) Draw diagrams to illustrate:
 - (a) depth of field,
 - (b) the image formation of an object situated at a distance of twice the focal length from a convex lens.
- (4) (a) What two fundamental properties of glass make it suitable for photographic lenses?
 - (b) What is meant by the refraction of light?
 - (c) How is maximum depth of field achieved in a camera with fixed focus lens?
 - (d) Using a 50-mm lens the size of the image of a distant object is 10-mm. What would the image size be with a lens of
 - (1) 100 mm (2) 170 mm
- (5) A group of chocolate-boxes is photographed in the studio using a 4-in \times 5-in camera with 20 cm lens. Describe the differences you might expect to see between a 10-in \times 8-in print from this negative and 10-in \times 8-in print from:
 - (a) a negative made with the same $4-in \times 5-in$ camera without moving its position but using a 30 cm lens.
 - (b) a negative made with a $10-in \times 8-in$ camera and 40-cm lens in the same position.
 - (c) a negative made with a 35-mm camera and 6-mm (40°) lens in the same position.
 - (d) a negative made with the 4-in \times 5-in camera using a 40-cm lens and moving position to include the same subject area.
 - (e) a negative made with a 35-mm camera with 20-cm lens from the same position.
 - (All negatives were exposed at the same f-number.)

- (6) (a) Explain the term Hyperfocal Distance.
 - (b) Using a 5-cm lens at f/16, how far from the lens is the nearest point of acceptably sharp focus if subjects on the horizon are also to appear sharp? (Maximum permissible circle of confusion may be taken to be 0.0625 mm.)
- (7) Discuss the practical effects of both Depth of Field and Depth of Focus when
 - (1) Using a large format camera, (a) to image distant subjects, and (b) for close-ups larger than actual subject size.
 - (2) Using an enlarger to make (a) big enlargements, and (b) to make prints *smaller* than the negative.

VI. CAMERA MOVEMENTS

We must now take a closer look at the rather ambiguous 'camera movements' mentioned in several previous chapters. Although we have not yet discussed camera design, if some conclusions can be reached about camera movements now we will be in a better position to weigh up the advantages of cameras offering these facilities in chapter VIII.

What are camera movements? Essentially, they are controlled independent movements of lens or film plane which enable us to form a more useful image under a particular set of conditions. They enable us, for instance, to increase depth of field over important parts of the subject, change image shape, and use images of subjects well above, below or to the side of the lens.

Camera movements offer us all sorts of image controls, from simple square-on views of mirrors without the camera showing, to a complete change in the apparent perspective of a building. Here, indeed, is valuable 'professional magic'.

The Physical Movements Themselves

First, we need to be clear about the terms we shall use for the various camera movements. Some form of glossary would be helpful.

Camera movements are said to be 'neutral' when the camera lens panel is parallel to the film plane, the lens axis coincides with the centre of the negative format, and both lens panel and film plane are at right angles to the camera base. When initially setting up any camera fitted with movements it is, of course, essential to check that everything is in fact neutral — and locked in that position. Many surprising results have originated from the fact that the photographer did not bother to check whether the last user of the camera had returned everything to normal.

Starting each time from neutral, the main movements are as follows:

- (1) Upward movement of the lens, parallel to the film plane, is known as rising front.
- (2) Downward movement of the lens, again parallel to the film plane known as drop front.
- (3) Horizontal left or right movement of the lens, parallel to the film plane known as *cross front*.
- (4) Pivoting of the lens around an imaginary horizontal axis drawn through the lens at right angles to the lens axis. This we shall call swing front (horizontal axis).
- (5) Pivoting of the lens around a similar but this time vertical axis swing front (vertical axis).
- (6) Pivoting of the film plane around an imaginary horizontal axis drawn across the face of the film at right angles through the lens axis swing back (horizontal axis).

(7) Pivoting of the film plane around a similar but vertical imaginary axis – swing back (vertical axis).

N.B. If the camera is used on its side, movements which were previously horizontal swings must become vertical swings and vice versa.

Other camera manipulations – drop baseboard, revolving back, panning, tilting, front and back focusing can be technically described as camera movements, but are not normally thought of as such by the working photographer. They will, therefore, be examined in chapter VIII when we discuss cameras.

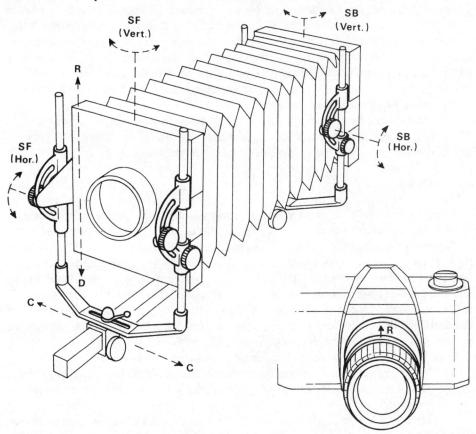

Fig. 6.1. Main camera movements. SF: Swing front (about a vertical or horizontal axis), SB: Swing back, R: Rising, D: Drop and C: Cross front. Bottom right: Several small format cameras accept a 'shift lens' mount. This positions a wide covering power lens eccentrically—turning or racking the mount gives rising, cross, or drop front movements.

In practice, an assignment often calls for the use of several camera movements simultaneously, and this will be considered towards the end of the chapter. For the moment it is easier to become familiar with each movement individually. As we do you will find it helpful to have at hand a camera fitted with movements — each effect and use can then be checked visually as it is described.

Rising Front

Effect: As the lens is raised vertically the image it forms shifts upwards on the focusing screen; i.e., since the image is upside-down some of the bottom of the subject no longer appears, but an equivalent extra area at the top of the subject is now seen.

By raising the lens say, 1 cm, the image is raised 1 cm. In most photography the image is smaller than the subject and this shift therefore creates a shift of several metres subject inclusion – far more than if the whole camera were raised vertically 1 cm. In fact the amount of subject top newly included by a set amount of rising front is in the same ratio as lens-to-subject distance: lens-to-image distance. Just slight rising front will therefore include a great deal more of a distant subject top when using a short focus lens; when working close up the camera will be required to offer extensive rising front for quite modest shift of subject inclusion.

Use: Rising front is used to include more of the subject well above the lens axis (losing an equivalent strip of subject below the axis) without having to tilt the camera upwards. The objection to tilting the camera is that vertical lines then appear to converge towards the top of the subject, e.g.: tall buildings shot from street level or cylindrical containers photographed from low level in the studio, look triangular.

It can be argued that this is precisely how they appear when we look up at a subject. However, our two eyes also give us stereoscopic vision which helps us to accept the converging uprights as perspective effect – the top of the subject being more distant than the base. The fact that we *physically* look upwards also contributes to this acceptance. On a two-dimensional photograph the subject can be misinterpreted as having non-parallel sides, particularly when they appear just slightly out of true. Clients such as architects and container manufacturers will certainly not tolerate this 'distortion' effect if the photograph is intended as an objective record.

In handling, say, the tall building assignment, you would carefully set up the camera at the viewpoint selected for perspective and subject inclusion, with the focusing screen parallel to the face of the building. Only this will ensure that all upright lines are reproduced parallel. Adjustment is really critical and it is wise to use a small spirit level pressed against the focusing screen to ensure that this is in fact vertical.

After focusing the image, slowly raise the lens panel, watching for the top of the building (imaged at the bottom of the focusing screen) to move into sight. You may find that too much of the base of the building has now been lost — which means either changing to a shorter focus lens or moving farther back and accepting the flatter overall perspective produced.

Drawback – Every camera movement offers a potential ill-effect for every potential advantage. The hidden ill-effect of rising front is connected with the fact that the lens axis is now well above the centre of the negative format. Beware – the film may no longer be within the covering power of the lens. Watch the bottom corners of the focusing screen with a magnifier for any sign of image deterioration or vignetting (often collectively termed 'cut-off'). Photographs taken using rising front beyond the ability of lens coverage are characterised by blurred tops to subjects, or may even appear to have been shot through some form of foreground 'arch'. (See Plates 17–20.)

Fig. 6.2. The effects of rising, drop and cross front. Left: Amount of subject included with no movements—lens is central to film and the camera back vertical. Right: The amount included when (R) the lens is shifted upwards. (C) shifted sideways, or (D) shifted downwards. Using a camera without movements area R could only be imaged from this position by tilting the camera upwards, causing the vertical buildings to appear to taper towards the top, like Plate 18. To include area D the camera would be tilted downwards, causing buildings to taper towards the base. And to include area C the camera would have to be panned sideways, making horizontal lines taper slightly and shifting the perspective 'vanishing point' to the right.

Drop Front

Effect. By lowering the lens panel, images move downwards on the focusing screen – revealing more of the bottom of the subject and less of the top.

Use. Whenever you wish to image a subject well below the lens axis, without tilting the whole camera and causing upright lines to appear non-parallel. Drop front is a particularly useful movement in the studio. Often we have to shoot looking slightly downwards on upright objects – tins, packets, bottles, etc. – to record detail of their tops as well as sides. If the camera back is made to remain parallel to subject uprights, the camera front can be dropped to include their lower portions. Both top and sides of the containers will still be shown, but without the diverging upright lines which tilting the camera would have produced.

Drawback – This time the lens axis is shifted below the centre of the format. Watch the top corners of the focusing screen for possible image deterioration.

Cross Front

Effect. Moving the lens panel left or right laterally shifts the image – revealing more on one side of the subject and less on the other.

Use. When it is necessary to produce a 'square-on' image of a subject from an oblique camera viewpoint. For example, you may have to photograph a shop window square on

Fig. 6.3. A high viewpoint may be necessary to show the top as well as sides of a container. Drop front allows the whole subject to be included without tilting the camera back and so converging vertical lines. Beware of signs of cut off at the *top* of the focusing screen.

but find that a white poster across the street is glaringly reflected from the glass. Moving the camera slightly to the left may prevent this light being reflected to the lens. Keeping the camera back parallel to the window and crossing the front to the right includes the whole window from this viewpoint, but without converging horizontals. The picture appears to have been taken squarely in front of the window.

Similarly we can photograph subjects carrying plane mirrors (e.g., dressing tables) apparently straight from the front, but in fact from one side, to avoid including a reflec-

Fig. 6.4. Use of Cross Front to give a 'square on' image from an oblique viewpoint. Top: Pillar obstructs poster from a normal angle lens at viewpoint A; the camera placed at B will require a very wide angle lens to include the poster; the camera moved to C gives a tapering image. Bottom: By keeping camera back *parallel* to the poster and crossing the front to the right, a square on image (1) is seen on the focusing screen; but if lens coverage is insufficient the screen will show 'cut off' (2).

tion of the camera in the photograph. Notice too, how shifting the front causes lines that normally converge to a 'vanishing point' at the centre of the picture to converge off centre.

Sometimes, obstructions may prevent the camera from being sited for the desired viewpoint. A pillar may obstruct the camera's view of a large painting — but to get between pillar and painting would demand a very wide angle lens. Instead, the photographer can position his camera to one side of the pillar. Like our shop window example the camera back is kept parallel to the painting and cross front is used to 'slide' the image onto the focusing screen.

Drawback – Watch for image deterioration at top and bottom corners on the opposite edge of the focusing screen to the direction of cross front.

Main Features of Rising, Drop, Cross Front

- (1) These movements all shift image position.
- (2) They all alter effective *coverage* of the negative, by shifting the lens axis away from the centre of the film. A lens of ample covering power is therefore essential.
- (3) They allow subjects either above, or below, or to one side of the normal field of view to be included without having to tilt the camera back and cause parallel lines to converge.

N.B. These shift movements are all useful for final image positioning in copying. If the image is not central on the focusing screen it is often easier to adjust it with a front movement than to unpin and adjust the original. Obviously, this must not be abused — a lazy operator can find himself with an insufficiently covered negative.

Swing Front (horizontal or vertical axis)

Effect. Swinging the lens produces both the following effects:

- (a) Effective negative coverage is altered, owing to the tilt given to the lens axis by this movement.
- (b) The plane over which the subject is sharply imaged is tilted.

To explain (b) we must remember that a lens is so constructed that light from a subject plane at right angles to the lens axis is sharply focused on the image plane also at right angles to the axis. This is the position, for example, in copying — subject, lens panel and film all parallel. If the lens is swung, however, the subject plane is viewed obliquely by the lens. One part of the subject plane which is now closest is brought to focus farther from the lens. The whole plane on which the subject is brought to sharp focus is pivoted to become very much less parallel to the subject.

Uses. We can use swing front to produce the effect (a) above, in which case (b) provides the drawback and limits the movement. Alternatively we can use it for (b), but find ourselves limited by (a). Let's look at practical examples of each.

EXAMPLE I

You have to photograph a tall object (Fig. 6.5) and wish to avoid convergence of verticals. The camera is set up with its back parallel to the subject plane, and rising front is used until the top of the subject appears on the screen. You now notice, however, that the lens has insufficient covering power for this amount of rising front – there are telltale

Fig. 6.5. Swing front to improve negative coverage. When used with rising front, lens has insufficient covering power (A). Swinging the lens about a horizontal axis returns the lens axis to the centre of the negative – coverage is improved but as the subject plane is now oblique to the lens, depth of field deteriorates (B). The lens must now be well stopped down (C). (See accompanying plates 21–23). Similarly, swing front will aid coverage when using drop or cross front.

signs of 'cut-off' in the bottom corners of the focusing screen.

Now loosen the swing front locking screws and, taking hold of the *top* of the lens panel, gently pull it *towards* the back of the camera (swinging the lens upwards about a horizontal axis). This tilts the lens axis down the focusing screen to a more central location. Effective coverage is improved and cut-off miraculously disappears.

Drawback – The lens is now viewing the subject obliquely, and sharply imaging it over an image plane which lies at quite an angle to the back of the camera. On your focusing screen you will find it impossible to focus sharply the top and bottom of the subject at the same time – unless the lens is well stopped down to increase depth of field and focus (see Plates 21–22).

EXAMPLE II

Now imagine another assignment, helped by use of swing front for opposite reasons. This time you are photographing an expanse of wood block flooring extending into the distance. The camera is set up viewing the floor obliquely – but even at smallest aperture depth of field will not extend sufficiently to image the whole floor sharply. Taking the top of the lens panel you now swing it slightly away from the back of the camera (i.e., swing the lens downwards about a horizontal axis). The lens now views the floor less obliquely, achieving a better optical compromise between the floor and the plane of the film. The adjustment of swing is critical, but depth of field is seen to be appreciably increased.

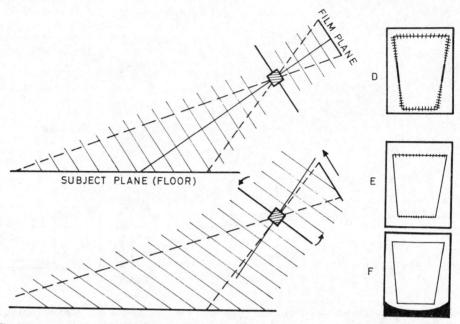

Fig. 6.6. Swing front to improve depth of field. With neutral camera movements subjects at right angles to the lens axis may be sharply imaged on the film plane. When the subject is very oblique depth of field is very shallow (D). By swinging the lens about a horizontal axis a better compromise between subject and film planes is achieved and depth of field increases (E). However, the lens axis is no longer central on the film plane and if coverage is poor 'cut off' may appear on the lower part of the focusing screen (F). See also Plate 28.

Drawback – Your lens axis is no longer aligned with the centre of the negative format; in fact, it has tilted considerably higher. Therefore, there is a risk that unless the lens has good covering power signs of cut-off will appear at the bottom of the focusing screen.

In both the above imaginary assignments swing front will probably give some image shift as it moves the lens axis across the focusing screen – for this is only completely avoidable if the lens swings about an axis passing through its rear nodal point. Image shift is a nuisance which requires readjustment to the focus or the whole tilt of the camera. Cameras which allow lens swing at about the nodal point rather than the bottom of the lens panel therefore offer a useful practical advantage.

So far examples of the use of front swings about a *horizontal* axis only have been discussed. The same principles of course apply to *vertical* axis swings. Their use in equivalent circumstances would be to improve negative coverage at extreme cross front; also to increase depth of field over an obliquely viewed vertical surface such as the long wall of a building.

Main Features of Front Swings

(1) They alter the lens's effective coverage of the negative.

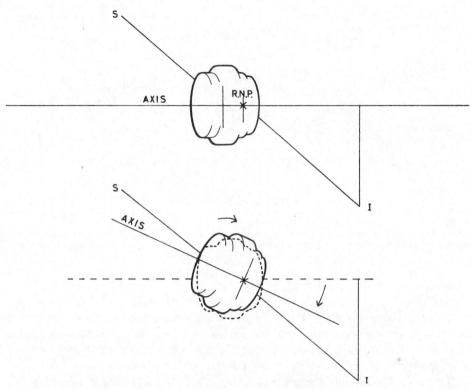

Fig. 6.7. Provided the lens swings on or about its rear nodal point it will not cause appreciable image shift.

- (2) They pivot the plane of sharp focus.
- (3) They produce some image shift unless swung exactly at the rear nodal point of the particular lens.
- (4) They enable us to increase depth of field over a plane sloping into the distance (at the risk of insufficient negative coverage).
- (5) They can be used in conjunction with rising, drop or cross front to improve effective coverage (at the risk of insufficient depth of field).

Later, we shall discuss important ways in which swing front can be used in conjunction with the next movement – Swing Back.

Swing Back (Horizontal or Vertical Axis)

Effect. Unlike all the previous camera movements, swinging the film plane has no effect on coverage of the negative. It cannot alter the position of the lens axis. What it will do is to:

- (a) swing the film out of or into the plane of sharp focus for a subject, and
- (b) alter the shape of the image.

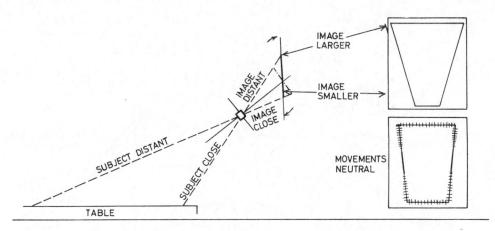

Fig. 6.8. The effects of using swing back alone. Nearer parts of the subject come to focus farther from the lens. Swing back allows the film to be brought into coincidence with the plane of sharp focus for an oblique subject – at the cost of shape distortion.

Uses. Once again we can use this movement primarily for (a) and suffer (b), or vice versa. As an example of the first case imagine that you have to photograph a long table laid out with cutlery and mats. The camera must view the table top obliquely so that it tapers away into the distance, and appears sharp all the way. Depth of field – even at minimum aperture – is insufficient to give this overall sharpness.

Of course, in detail, the sharpness problem is basically this — the front part of the table, being closer to the lens, comes to focus some way behind the lens. (We can check this by racking the back of the camera away from the lens until the image near the top of the focusing screen is sharp.) The rear part of the table top, being farther from the lens, comes to focus closer to the lens. (Checked by racking the back of the camera toward the lens until the image near the bottom of the focusing screen is sharp.)

If we therefore swing the back of the camera so that the *top* of the focusing screen is some way from the lens and the *bottom* fairly close, we have virtually *put the screen into the plane of sharp focus*. Depth of field is now greatly extended, and may prove ample even at wider apertures.

Drawback – The part of the image formed some way from the lens will be considerably larger than the image formed near the lens. The front part of the table will reproduce broader than it appears to the eye, the distant part reproduces narrower. Perspective has been steepened along the plane of the table, giving it a noticeably distorted shape (see Fig. 6.8).

Notice that the above use of swing back to increase depth of field over an oblique subject imposed no strain on lens covering power. You could have used swing back for that previous wood block floor assignment, had the lens had insufficient covering power for swing front – provided the resulting distortion of floor shape would have been acceptable.

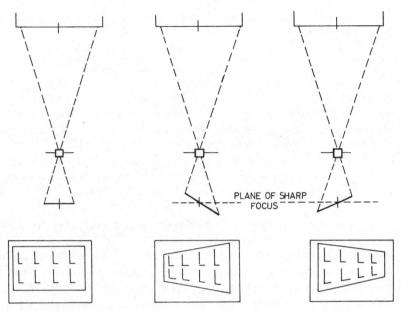

Fig. 6.9. By purposely making the camera back nonparallel with a subject false perspective may be created. But as the film is now oblique to the plane of sharp focus a small aperture is essential. (See Plates 24–26.)

Now imagine another assignment where this time you are *purposely* aiming for distortion. The new wing to a building must be photographed obliquely so that it tapers away to the left-hand side of the picture, 'leading the eye' to an ornamental fountain at the far end of the wing. Unfortunately, on arrival you find that the building is hemmed in by other property. The only available viewpoint to include all the subject matter even with your widest angle lens is opposite the centre of the wing. From this square-on position it appears rectangular.

After setting up the camera, however, you swing the back to bring the right-hand side of the focusing screen closer to the lens, and the left-hand side farther away. The image of the left-hand side of the building is thus made smaller and the right-hand side larger – the wing tapers as planned.

Drawback – The camera back has now been swung out of the plane of sharp focus for the building (which was at right angles to the lens axis). The lens will need to be well stopped down for sufficient depth of focus for this inclined film plane (see Fig. 6.9).

Main Features of Back Swings

- (1) They have no effect on negative coverage.
- (2) They swing the film relative to the plane of sharp focus thus altering the shape of the image it records.
- (3) They enable us to increase depth of field over an oblique surface at the risk of exaggerating perspective along this plane.

(4) They enable us to create apparent perspective across a flat plane, at the risk of diminished depth of field.

Combined Use of Movements

As you have probably concluded, there is often a *choice* of camera movements to solve any one visual photographic problem. Selection is usually a matter of deciding which drawback is the least objectionable. Sometimes we can utilise the common advantages of two movements and reduce their individual drawbacks.

Going back, for example, to our wood block floor; we could create sufficient depth of field for the whole floor by using a little of both front and back swings — thus combining their depth of field advantages and reducing their drawbacks. The back is swung about a horizontal axis just enough to improve depth of field without noticeable shape distortion. Next, the front is swung about a horizontal axis just enough to extend depth of field farther to the whole floor area without creating coverage losses. Notice that the subject plane (the floor), the film plane (camera back) and the lens panel plane can all be visualised as meeting at the same imaginary point (beneath the camera). This meeting of planes at some common point is the best compromise position of front and back to give maximum depth of field over the subject plane. It is known as the Scheimpflug principle and is worth remembering as a guide to the correct direction of swings for overall sharpness when shooting oblique subjects (see Fig. 6.11 and Plates 27–29).

Sometimes, two movements may have to be combined to give *maximum* collective effect: If a *very* oblique surface must be rendered sharp, swing front or swing back alone, or moderate use of both, may not sufficiently improve depth of field. In such a case you may consider it justified to use both swings at maximum – producing the vital depth of field but risking image shape distortion *and* signs of insufficient coverage. Camera movements call for the weighing up of priorities.

Sometimes two movements are combined simply to produce or increase a third movement. For example, the back is swung about a horizontal axis so that it is closer to the lens at the top than at the bottom. The front is next swung about its horizontal axis so that the lens panel is parallel to the camera back. If the camera base is now tilted until camera front and back are vertical ... we have produced rising front. Added to any existing rising front the camera may offer this gives considerable total lens shift; similarly with drop or cross front.

Deciding Which to Use

It is nonsense, of course, to imagine that every assignment demands the use of a camera movement. Equally, the photographer handicaps himself by ignoring all movements beyond the obvious and simple rising front. The great thing is to control them – and not let them control you. Camera movements are intended to let you put the film where the required image happens to be. They cannot be learnt by reading alone but must be checked and practised with an actual camera. See what each movement will

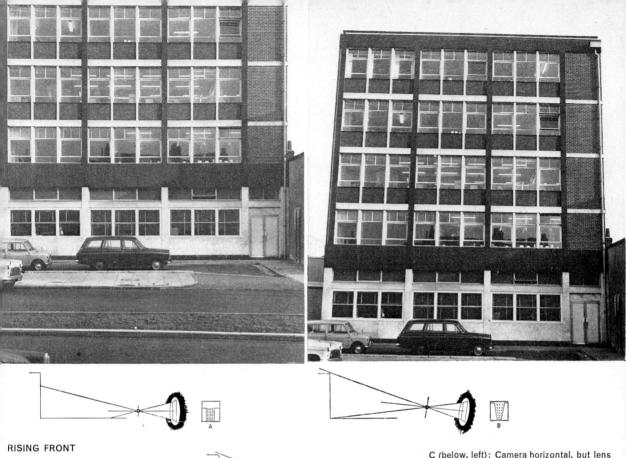

Plates 17–20. Using rising front to eliminate converging verticals when shooting from a close, low viewpoint. A (above): No movements, camera horizontal. B (right): Camera tilted to include top of building.

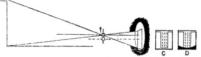

C (below, left): Camera horizontal, but lens panel now raised to shift image of whole building onto the focusing screen. However this makes the lens axis no longer central on screen—if lens has poor coverage signs of 'cut off' (D, below) may appear.

SWING FRONT

Swing front to improve negative coverage (see page 100).

Plate 21 (Top left) 'Cut off' due to insufficient lens coverage when using rising front.

Plate 22 (Top right) Swinging the lens about a horizontal axis improves effective coverage, but tilts the plane of sharp focus.

However, Plate 23 (bottom), overall sharpness may be achieved by using a small lens aperture. In this case stopping down to f 45.

SWING BACK

Swing back used to alter image shape. The camera position remained unaltered for all three pictures.

Plate 24 (Top) No movements.

Plates 25 & 26 (Centre and lower) Camera back swung about a vertical axis, in opposite directions. A small aperture is essential to provide sufficient depth of focus. See diagrams, page 105.

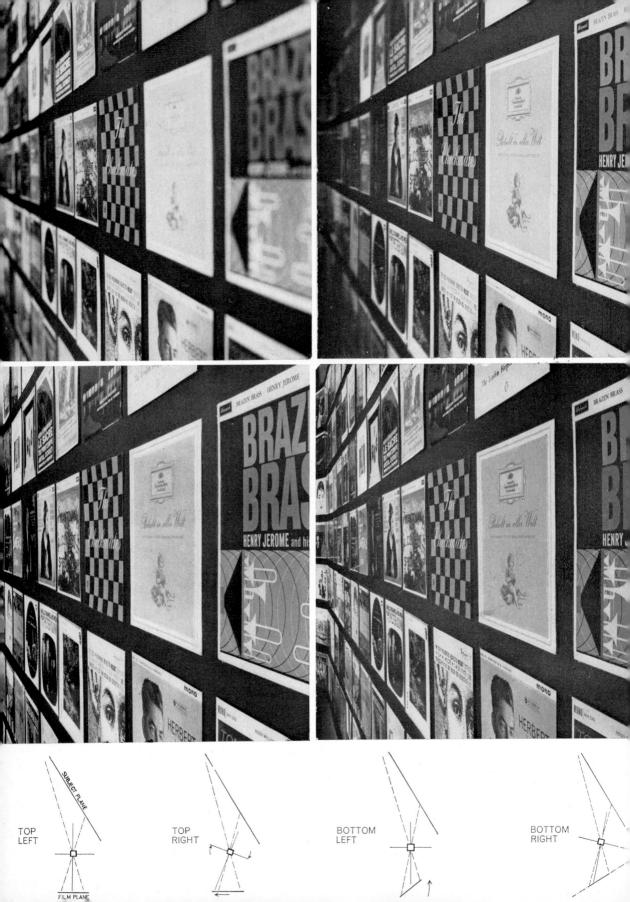

COMBINED MOVEMENTS

Opposite: Plate 27 (Top left) Camera movements neutralseverely limited depth of field.

Plate 28 (Top right) Swing front (vertical axis) in-creases depth of field, but is limited by 'cut off' if lens has limited covering power.

Plate 29 (Bottom left) Swing back (vertical axis) increases depth of field, but steepens apparent perspective-compare the heights of near and distant records with Plate 28.

Plate 30 (Bottom right) Some swing front com-bined with some swing back gives maximum depth of field with minimum coverage and distortion ill effects. Planes of subject, lens panel, and film should meet at one common point. (All illustrations were shot at the same aperture.)

BLUR-VISUAL SYMBOLISM OF MOTION

Plate 32 (Above) Use of blur to convey speed—with strong reader/driver associations. Notice the increase in blur towards the edges of the picture, i.e. As the movement becomes more oblique to the lens axis. Shutter speed 1/10 sec. (E. Pritchard)

Plate 33 (Top right) Blur suggesting motion as experienced by the passengers on the platform. Shutter speed 1 sec. (N. Slaney)

Plate 34 (Bottom right) Blur used to isolate. Half a second exposure in a crowded street.

BLUR-VISUAL SYMBOLISM OF MOTION

Plate 35 Blur suggesting motion as experienced by the cyclist—the camera has been panned with the subject. Shutter speed 1/25 sec. (A. Williams) See Fig. 7.6.

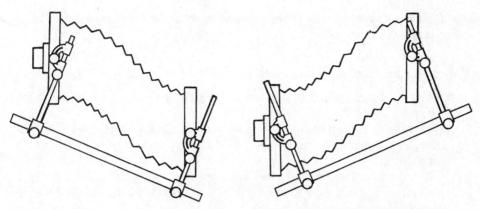

Fig. 6.10. Combined use of horizontal axis swing front and back to achieve (left) extreme rising front, or (right) extreme drop front.

do individually, then in combination – no actual photography is needed, for results are immediately visible on the focusing screen.

Obviously, there are limits to camera movements – particularly when a subject has equally important horizontal, vertical and oblique planes. Movements to help one will usually worsen another. Again, the camera may not allow the physical movement optically necessary, the bellows may crinkle and obstruct light. That lens hood, which is essential to shield direct sunlight, may cause vignetting when you use front movements . . .

Then there is the mental approach. Beware of acquiring a 'parallelity complex' – a desire to reproduce all converging lines as parallel. *Think* what correction is *really* required. Does the client expect the verticals on those boxes to be reproduced as such,

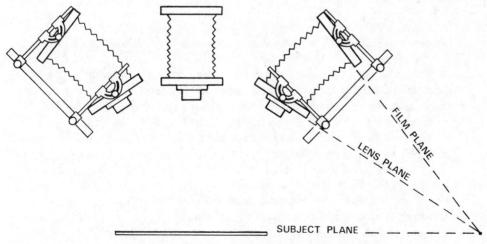

Fig. 6.11. The Scheimpflug correction for maximum depth of field.

or is it important to show more of the tops and have the sides tapering away with normal or exaggerated perspective to give an impression of height?

Chapter Summary - Camera Movements

- (1) Camera movements allow the photographer to align the film with the most useful image of a subject.
- (2) Front sliding movements all shift image position, alter effective coverage of film; they are commonly used to include subjects otherwise demanding oblique angling of camera.
- (3) Swing front movements alter plane of sharp focus and effective coverage of film; they are commonly used to increase depth of field over oblique subjects or improve film coverage.
- (4) Swing back movements swing the film in or out of the plane of sharp focus and alter image shape. They are commonly used to improve depth of field over oblique subjects or alter perspective over one plane.
- (5) Every camera movement used creates a potentially unwanted side-effect.
- (6) Remember the Scheimpflug principle lines drawn through the subject, lens panel and film planes should all meet at one point to give greatest depth of field.
- (7) For full use of camera movements a lens of good covering power and a camera physically offering a wide range of movements are interdependent.
- (8) On every assignment the correct use of movements is a matter of intelligently assessing the corrections required and weighing up priorities.

Questions

- (1) The design of a technical camera includes the following movements:
 - (a) Swing back.
 - (b) Falling front.
 - Draw simple diagrams of these camera movements. Briefly describe a typical situation when EACH would be used.
- (2) When photographing a row of terrace houses with a view camera, the only suitable viewpoint is at street level, at one end of the row. Explain what camera movements would be necessary from this oblique viewpoint to avoid convergent or divergent verticals, and to ensure that all the houses are in focus.
- (3) In photographing a tall building with a horizontally placed camera at ground level, list of the effects you would expect to observe on the focusing screen in using each of the following movements *individually:*
 - (a) Tilting the whole camera upwards,
 - (b) raising the lens panel vertically, parallel to the focal plane,
 - (c) tilting the lens panel about a horizontal axis.
- (4) Discuss and illustrate with diagrams the principal movements on a camera suitable for commercial still-life photography.

- (5) An engineering company requires a general view of a new 100 m × 25 m machine shop showing the floor space available, while the shop is in busy use. The only suitable vantage point is a gallery about 6 m above floor level at one end of the shop. Your exposure meter reads 15 sec at f/22; depth of field is just sufficient at this aperture. Suggest how use of camera movements could effectively reduce this exposure time.
- (6) In recording a two-dimensional image of three-dimensional reality we can communicate depth by differential focus, lighting, or the 'steepness' of perspective. Explain how the photographer can effectively alter the perspective appearance of his subject to make it seem 'steeper' or 'shallower':
 - (a) by manipulation of viewpoint and focal length,
 - (b) by use of swing back only.
 - Would there be detactable differences between the two methods on the final prints?
- (7) (a) Show with the aid of diagrams the full range of movements desirable on a technical camera.
 - (b) Discuss, with diagrams, the advantages and disadvantages of a technical camera designed so that the swing movements are about the centres of both the lens panel and the film plane.
- (8) On a large format camera with back and front swing movements, which controls image shape?

and the control of th

VII. CAMERA SHUTTERS

So much for lenses, for the moment. But we can hardly discuss the lens without some mention of the shutter with which it is physically so closely associated. Shutter characteristics and exposure period offer us several important controls over the final recorded image – sloping, stretching, contracting and blurring it in ways which give a variety of visual impressions. What are the differences in results given by a shutter at the front of the camera compared with one at the back? How do the more common shutters function and what are their image influences in practice? All these points will have to be borne in mind when evaluating camera equipment.

Shutter Construction

BACKGROUND. Photographic exposure is the combined effect of image intensity and the time this energy is allowed to act on the film. Within limits, this is rather like filling a tank with water, where we have the choice of using a small-bore hose for a long period or a wider hose for a shorter time. Accurate control of duration is therefore obviously as important as image intensity control.

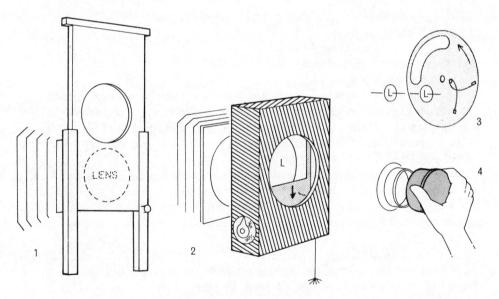

Fig. 7.1. Early forms of shutter: 1. Drop shutter. 2. Roller-blind shutter. 3. Sector shutter (still used in cheap box cameras). 4. Lens cap.

In the early days of photography shutters were a rarity. With exposures running into minutes and even hours for the relatively insensitive plates and small aperture lenses then available, a lens cap (or even the photographer's hat over the lens as he drew the dark slide) was quite adequate. But plates became so fast and subjects so impatient that our great-grandfathers had to devise more mechanised shuttering devices.

Some of the early shutters were more spectacular than efficient. The 'drop' shutter for instance consisted of a rectangular plate sliding between vertical grooves in front of the lens. The plate contained a cut-out area which allowed light to enter the lens as the shutter dropped under its own weight.

The roller blind shutter, another early commercially made device, consisted of an opaque fabric blind with a square cut-out section running between rollers at top and bottom of a mahogany box about the size of a small packet of cigarettes. The box had a large circular aperture in each of its front and back surfaces. If one of the rollers was tensioned and released, the blind flew from top to bottom of the box, its cut-out section briefly allowing light to pass between the apertures and into the lens (see Fig. 7.1). The roller blind box either had a rubber ring around one of the apertures so that it could be pushed on to the front of a lens or it was built into the lens panel having the lens mounted in front.

These and other curious shutters are today found in collections such as the South Kensington Science Museum and the Kodak Museum at Harrow. Even the oldest established studios have despaired of their inconvenience and unreliability. The professional has too many variables to weigh up when on an assignment to afford time nursing such an inefficient component.

Our requirements of an ideal photographic shutter are that it should:

- (a) evenly affect the image,
- (b) offer a wide range of useful speeds,
- (c) be consistent in its timing,
- (d) be silent and vibration free,
- (e) be economic, i.e., low initial cost, and interchangeable for a range of lenses.

No shutter at present efficiently meets all these requirements, but we can use the ideal as a standard to evaluate shutter types used today. These can be divided into three: (1) the simple lens cap, (2) bladed shutters on or near the lens, and (3) focal plane shutters positioned just in front of the film.

LENS CAP. If ever a shuttering device has been misused it is the lens cap or focusing cloth. Some photographers think that light must be stopped from entering the lens in the same way as a water pipe is blocked. Cloths are screwed up into balls and tightly jammed against the front lens surface ... lens caps are jerked away leaving the lens panel vibrating.

In the first place, since light travels in straight lines, any opaque matt black surface held about 5 mm in front of the lens will absorb light from the subject. A lens cap should be eased off the lens barrel and held blocking the light but just out of contact for a few seconds before exposure is made. These simple precautions enable the camera to settle any vibrations prior to exposure – vibrations which are particularly prevalent when the

Fig. 7.2. Typical bladed and focal plane blind shutter positions.

lens is racked well out for close-up work. Despite the cheapness and possible convenience of lens caps/focusing cloths for static photography such as copying and still-life work, any conditions demanding exposures of less than about 1 sec obviously make this form of shutter impractical.

Shutters Within or Near the Lens

This general term is applied to shutters using one or a series of blades, normally positioned between elements of the lens near the diaphragm. They are most often used on large format cameras and cameras with non-interchangeable lenses.

SECTOR. The simplest form of between-lens shutter is a circular metal plate with an elongated aperture. This is positioned at right angles to the light path and makes one rotation when operated. Speed is controlled by a simple spring, usually tensioned by the first part of the release lever movement (see Fig. 7.1 (3)).

Sector shutters are inexpensive and therefore often fitted to cheap cameras. Inconsistencies over a period of time and severely limited speed range discount the sector as a professional quality shutter. In a more sophisticated form, however, it is used for cine and some recording cameras.

BLADED, OR DIAPHRAGM SHUTTER. The most commonly used type of photographic shutter consists of from three to five thin metal or vulcanite blades opening and shutting across the light path like the leaves of the lens diaphragm. The blades themselves are shaped like cutlasses, designed to minimise the time taken in the opening and closing stages of the exposure cycle. Since the shutter opens outwards from the lens axis as a growing star-shaped aperture, the image is affected evenly.

Each shutter blade is pivoted at its outer edge and linked to a ring which is rotated to open the blades. Power for this rotation and the means of controlling accurately the period the blades remain fully open is provided either mechanically or electronically. On a mechanical shutter as shown in figure 7.3 blades are powered by a main driving spring

Fig. 7.3. Bladed shutters. Left: A mechanically timed bladed shutter for a large format camera. Blades open and close by movement of a ring as shown in sequence (right). Longer exposure settings are timed by an escapement of gears, just visible at the bottom of the cutaway drawing.

which must first be set — either by separate lever, or by movement of the release lever in the opposite direction to firing. Some shutters, built into a camera body, are tensioned by the action of winding on the film. Such a tensioning system enables a more powerful and reliable spring to be used, yet allows the shutter to be released with only light pressure.

An escapement of gearwheels which delays the shutter in the open position is controlled by a cam linked to the shutter speed setting ring. On many models the cam brings an extra spring into play when the fastest shutter speed is selected. The design of the setting cam has practical importance in that if the cam is of continuous shape the shutter can be used set at positions in between the marked speeds to give intermediate speeds (up to the point where the extra spring is brought into play). If the cam is 'stepped' speed changes are abrupt and the shutter should be set to marked speeds only. Shutters intended for sheet film cameras usually have a 'press focus' catch allowing the shutter blades to be opened fully for checking focus without disturbing whatever speed has been set.

Electronically-controlled bladed shutters use a solenoid system which holds open the blades while a capacitor is slowly charged from a small battery, the charging rate being controlled by one of a range of transistors. Altering the speed selector ring switches in a different transistor. The shutter is therefore relatively quiet with no 'buzzing' at slow speeds. It also offers timed exposures up to 10 seconds or more. Above all an electronically controlled shutter has fewer moving parts to wear and is easily linked to a light sensitive measuring cell within the camera itself, as discussed in chapter XIV.

All modern diaphragm shutters contain internal electrical contacts which close at the appropriate part of the exposure cycle to fire flash illumination synchronously. Connection to the flash gun is made via a nipple protruding from the shutter casing.

If the shutter is synchronised for flashbulbs as well as for electronic flash it will contain two sets of contacts, either of which may be brought in circuit with the nipple by an external 'XM' switch. On many German-made shutters the switch has three positions—'V.X.M.'. V stands for *Verzögernung* (German for delay), and when set to this position the switch brings a special train of gears into mesh to enable delayed action exposures to be made. If the shutter is tensioned and released these gears delay the blades from opening for 10–15 sec. V shares the same switch as X (electronic) and M (Medium delay peaking flashbulbs), for the reason that flashbulb synchronisation utilises part of the same gear train to delay the shutter briefly until the bulb is fully alight.

Delayed action has a number of uses beyond the obvious one of allowing the photographer to be included in the picture. It gives time for the lens to settle down vibrations after pressure of the release lever, should a cable release not be available. The delay also gives a single-handed photographer time to reach a lamp or background he may wish to move (and so blur) during the exposure.

Bladed shutters have the advantage of being fairly compact, offering a usefully wide range of speeds (commonly $1 \sec - 1/300$) and acceptable reliability for professional work. Inevitably, they are complex mechanisms, and reliable shutters of this type are therefore expensive.

Most bladed shutters form an integral part of a lens. This is particularly useful for a wide-angle lens since most other forms of front shutter would protrude into its field of view. To the user of a camera with a range of interchangeable lenses an integral shutter with each lens is an obvious disadvantage — adding unnecessarily to cost. Some shutters of diaphragm type are, therefore, made for clipping directly in front or behind a lens, allowing the one shutter to be used for most of the photographer's lenses.

Since a lens is usually wider across its front or back surfaces than at the diaphragm, shutters for external use must be built with a wider maximum diameter – the blades larger, the mechanism more powerful, the fastest speed frequently more limited. In some smaller format cameras behind-lens diaphragm shutters are used so that lenses can be changed at any time, without allowing light to fog the film. The argument for having one interchangeable diaphragm shutter is complicated by the fact that few lenses are at present marketed without integral shutters.

Focal Plane Shutters

Opaque fabric or slatted metal blinds on spring-loaded rollers can be used as shutters at the back of the camera, just in front of the sensitive film. The blind contains a slit which, passing across the face of the film, creates the exposure. Exposure duration is controllable by adjustment of slit width, or blind speed, or both together.

Fig. 7.4. Principle of the focal plane shutter (35 mm camera). Two separate opaque blinds A & B run parallel and close to film surface C. Usually the camera shutter speed setting knob alters the 'slit' width, the blind speed remaining constant.

Some of the older focal plane shutters carry a sequence of three or four slits of different widths on a continuous blind, any one of which can be used to give a particular exposure. More frequently, the shutter consists of two blinds, one following the other after a predetermined gap. With either system, arrangements are made for the slit to be covered or closed ('capped') when being wound across the film into the tensioned position prior to exposure. This is carried out by the film-wind lever on most small format cameras.

Shutters which have both variable slit width and blind tension are sometimes found on old large format cameras. A table of figures has to be included on the side of the camera to indicate the exposure that various permutations of these controls will allow. Most focal plane shutters fitted to small format cameras have a constant tension spring and therefore a fixed blind speed. Only the slit is adjustable by the exposure control knob. For long exposures, one blind opens to reveal the whole film surface – the second blind follows after a delay created by an escapement of gears or (electronic types) by capacitor charging.

The physical construction of the focal plane shutter gives it special advantages:

- (1) Being in independent mechanism it can be used for a complete range of unshuttered lenses.
- (2) Being located at the back of the camera it allows the use of mirror systems between lens and emulsion, for reflex focusing until the moment of exposure (single lens reflex). This way you do not have to keep opening the shutter.
- (3) You can change lenses at any time without fogging the film.
- (4) Since exposure duration at any point on the film depends upon slit width as well as blind speed, shutter speeds of 1/1000 sec are easily attainable without the need of particularly fast blinds and powerful springs.

The fact that at moderate and fast speeds a focal plane shutter does not expose the whole film surface at the same time creates certain disadvantages and curious effects. For example, any acceleration or deceleration of the blind will give one area of the film more exposure than another. When using flash bulbs a 'long peaking' bulb may be necessary to maintain the same illumination level whilst the blind crosses the film – particularly rollfilm cameras where total travel may be 5–6 cm.

Electronic flash imposes problems because of its short duration. If fired at any time during slit travel the flash 'freezes' the position of the slit, giving a negative which looks as if it were photographed through a letter box. Synchronisation for electronic flash is therefore possible only at the slower shutter speeds, where the gap between blinds is so great that at one point the whole of the film surface is uncovered. On most 35 mm cameras this occurs at 1/60 sec or longer.

FOCAL PLANE IMAGE DISTORTION. Image shape may be distorted by a focal plane shutter if the subject is rapidly moving across the field of view. Imagine that a racing

Fig. 7.5. Image distortion by focal plane shutter. When shooting moving subject matter (top right) a narrow slit focal plane shutter will expose top and bottom of the image offset relative to each other, owing to image movement during blind travel (right). The result is a distorted photographic image (bottom left). The distortion of shape varies with image and blind directions.

cyclist is photographed so that his inverted image is crossing the film from left to right. If the shutter slit passes from top to bottom of the film it will record the bottom of the wheels when they are well to the left of the picture. By the time the slit lowers to the level of the handlebars, however, the bicycle image will have moved appreciably to the right.

The upper parts of the bicycle will progressively record farther ahead than the wheels, giving a forward slant to the whole image.

In true cartoon symbolism the forward slanting bicycle will give the impression of accelerating madly. But if it is photographed so that the image moves from right to left (or the shutter slit moves from bottom to top) the bicycle slope will be backwards, and the visual impression one of frantic braking. If the shutter slit runs in the same direction as the image movement the subject appears expanded; if running in the opposite direction to the image the subject appears compressed. Focal plane distortion can also cause whirling aircraft propellers to photograph as ridiculously uneven shapes.

To check this, try photographing an electric fan with a focal plane shutter set to a fast speed. Light it with a frontal spotlight so that a hard shadow is cast behind; the fan and the shadows are imaged at opposite ends of the negative. If the camera is used so that the shutter slit runs from side to side the fan blades and their shadows are shown in differing positions because of the time lag between the two ends of the picture being exposed.

The dangers of focal plane distortion are easily over exaggerated — it does after all occur only accidentally with a limited range of subjects. In knowledgeable hands distortion can intentionally create spectacular close shots of motor racing, etc., where impression is more important than factual record.

Disadvantages of the focal plane shutter can be summarised as:

- (1) Difficulty of flash synchronisation.
- (2) Comparative bulk and noise, particularly on 6×6 cm or large format cameras.
- (3) Uneven exposure across the film if wear or other factors cause erratic blind speed.
- (4) Unintentional distortion of close, rapidly moving subjects.

Shutter Speeds and Their Selection

The standard sequence of shutter speeds offered by bladed and focal plane shutter is B, 1, 1/2, 1/4, 1/8, 1/15, 1/30, 1/60, 1/125, 1/250 sec

some models have a maximum speed of 1/300, 1/500, or 1/1000 sec.

'B', standing for 'Brief', holds the blades open only as long as the release remains pressed. The majority of diaphragm shutters are made for rollfilm cameras, in which the shutter release is linked to the film wind in such a way that only one release pressure can be made before the film must be wound on ('double exposure interlock'). Such a system makes it undesirable for the shutter to offer a 'T' setting which requires one pressure to open the blades and another to close them.

For economic reasons this same shutter design is used in the majority of small-diameter professional lenses – but often with a locking button added so that although only offering 'B', the blades may be locked in the open position. Shutters with larger diameters for which there is no market as an integral part of an exposure interlocked camera are still made with a 'T' setting.

Most shutters manufactured prior to the mid 1950s were speed scaled at 1, 1/2, 1/5, 1/10, 1/25, 1/50, 1/100, 1/250 sec, etc. As can be seen, such a scale is uneven and the

standard sequence used today gives a more exact progressive halving of the exposure. The purpose of the present sequence is to allow the shutter to be mechanically linked to the aperture control so that when the lens is stopped down by one stop, the shutter speed is changed to twice its former duration. In this way the exposure effect of the combination remains the same.

Exposures Values

Direct linkage between aperture and shutter speed to give consistent exposure level can prove quite useful when photographing a range of subjects under the same lighting conditions. For example, general coverage of a sports day may call for a sudden change from shots of a 100 m sprint (briefest shutter speed) to general views of the crowd (aperture for greatest depth of field). Linked aperture and shutter allows this change with one quick movement of either control, knowing that the other is automatically compensated.

The point at which f-numbers and speed controls are intermeshed can be given an 'Exposure Value':

```
An Exposure Value of 6 will set 1/4 @ f/4, 1/2 @ f/5.6, 1 sec @ f/8, etc.

An Exposure Value of 7 will set 1/8 @ f/4, 1/4 @ f/5.6, 1/2 sec @ f/8, etc.

An Exposure Value of 8 will set 1/15 @ f/4, 1/8 @ f/5.6, 1/4 sec @ f/8, etc.

An Exposure Value of 9 will set 1/30 @ f/4, 1/15 @ f/5.6, 1/8 sec @ f/8, etc.

An Exposure Value of 10 will set 1/60 @ f/4, 1/30 @ f/5.6, 1/15 sec @ f/8, etc.

An Exposure Value of 11 will set 1/125 @ f/4, 1/60 @ f/5.6, 1/30 sec @ f/8, etc.

and so on.
```

Thus a linked lens and shutter can be calibrated in the one simple scale; and meters need only give one figure for the exposure required.

Exposure Values are not used with large format cameras but are frequently found on exposure meters and on the simpler small format cameras. Many photographers consider them a nuisance—just another scale which alone offers no guidance on depth of field, subject stopping ability, etc. However, most hand precision cameras still carry f-numbers and shutter speeds in addition to Exposure Values, and are likely to continue doing so.

Speed Selection

Like so many other aspects of photographic technique, selection of the most suitable shutter speed for a particular set of circumstances calls for a weighing up of several sometimes conflicting requirements. Main considerations are: the total exposure required; aperture required; and any likely movement of the image during exposure (caused by subject movement and/or camera shake).

Total exposure required. Perhaps lighting conditions and film speed demand a long exposure at maximum aperture (or shortest exposure at minimum aperture).

APERTURE REQUIRED. How critical is the required depth of field. Will it include

enough of important parts of the subject . . . or will it include too much for the desired effect?

SUBJECT MOVEMENT. How fast is the subject moving – and is the movement across the lens axis and near the camera (maximum image movement) or is the subject directly approaching the lens at a distance (minimum image movement). How much blur is required for the purpose of the photograph – are you trying to imply the speed of a vehicle or detail of the driver's expression? (See Plates 32–35.)

Try photographing moving objects at various shutter speeds and build up a visual library of the *quality* of blur under daylight and night-time conditions, using cars, animals, people. Some subjects move so much during the exposure that they just do not appear on the negative. This can be exploited when photographing a building across a busy main street, with traffic and pedestrians constantly moving in the way. During an exposure of a minute or more (using a combination of slow film, small aperture and possibly a grey neutral density filter) these mobile obstructions eliminate themselves. The street appears empty. At night-time this technique is satisfactory for pedestrians, but the lens has to be temporarily capped when vehicles pass, as their front and back lights are usually sufficiently bright to record as streaks.

CAMERA SHAKE. Is the camera to be used on a tripod? Is floor vibration likely – people walking on floorboards near the camera, heavy duty machinery in use, etc. Cameras and the photographers using them vary, but the majority of operators prefer not to use a hand-held camera at shutter speeds longer than 1/60 sec. Sometimes you may be able to brace yourself against a wall or other support and gamble exposures of 1/2 sec. or so, but in such a situation, each picture should be shot several times for safety.

Far from contributing to blur, movement of the camera is one method of compensating for subject movement. For example, a racing car moving at speed across the camera's field of view would probably blur even at 1/1000 sec. But if the camera itself is swung about a vertical axis ('panned') to keep pace with the moving car, an almost stationary image can be created on the film, even at 1/250 sec. It is now the background which, moving during the exposure, reproduces blurred. Handled successfully, the car (with the exception of its spinning wheels) appears crisply imaged against a sea of blurred spectators. Thus, an impression of speed as seen from the driver's point of view is created; as opposed to the blurred car which is the spectator's predominant impression. Which do you require – the first effect may be more acceptable in a motor sport journal, the second in a picture magazine.

Panning moving objects is a technique to be practised (Fig. 7.6 and Plate 35). The panning motion should be started when the subject is still some way off, and the shutter released just at the moment the sweep of the lens equalises with the subject itself. The commonest fault is to overpan, resulting in blur which sometimes suggests that the subject is speeding backwards!

ADDITIONAL FACTORS. The most common of these is when using electronic flash with a focal plane shutter camera -1/60 sec may be the fastest speed you can use to produce a full image (see page 117).

Fig. 7.6. Panning a moving subject. Swinging the camera can result in a relatively stationary image of a moving subject, allowing sharp results at modest shutter speeds. Background (and local parts of the subject not moving in quite the same direction) photograph blurred. The camera must start to pan early to achieve smooth movement at the right speed when the shutter is fired (S). See Plate 35.

Chapter Summary - Camera Shutters

- (1) Ideally a shutter should act evenly, consistently, silently and without vibration. It should be interchangeable, economic and offer a wide speed range.
- (2) The simple lens cap forms an adequate means of making time exposures, but most shutters today are either bladed units in the lens or a pair of blinds in the focal plane.
- (3) Precision bladed shutters offer wide speed range, reliability, compact construction, and ease of synchronisation. Disadvantage: usually built into one lens.
- (4) Focal plane shutters allow interchangeability of lenses, enable reflex focusing device to fit behind the lens, offer fast speeds. Disadvantages: synchronisation

- difficulties, bulk, noise, distortion of some fast images, mechanical risk of uneven exposure.
- (5) Both types of shutter may be timed mechanically or electronically. The latter offer a wider timing range, have fewer moving parts and link easily to exposure measuring cells, etc.
- (6) Shutter speeds are scaled to progressively halve exposure, so linking with the fnumber scale.
- (7) The combined exposure effect of shutter and aperture is given an 'Exposure Value'. Each 'Value' determines the point at which both controls are meshed.
- (8) Shutter speeds are usually selected on the basis of exposure level required, aperture, likely movement of subject or camera.
- (9) Type of image blur depends on the relative effects of shutter speed, subject and camera movement.

Questions

- (1) Explain with the aid of a diagram how image distortion may occur when using a focal plane shutter.
- (2) List five causes of lack of sharpness in a negative, other than incorrect focusing of the lens.
- (3) Compare the advantages and disadvantages of camera shutters used:
 - (a) between the lens components
 - (b) in front of, or behind the lens
 - (c) in the focal plane.
- (4) Describe
 - (a) An assignment where blurred reproduction of some or all of the subject would be desirable.
 - (b) An assignment where blurred reproduction is highly unacceptable. In each case list the steps you would take to control your result.
- (5) What is meant by each of the following:
 - (a) Double exposure interlock
 - (b) Panning a moving subject
 - (c) Exposure Value
 - (d) Sector shutter
 - (e) Electronic shutter.

DIRECT VISION FINDER CAMERAS:

Commercial examples - (35 mm) Leica, Baldamat, Contessa, Canon, etc.

General Construction

The term direct vision finder camera refers to all those designs having a viewfinder (usually on top of the camera) through which the photographer has a direct sight of the subject. They are essentially rigid body, non-bellows cameras for eye-level use. More expensive 35-mm models accept interchangeable lenses, offer rangefinder focusing, and have either a focal plane shutter or a permanent built-in diaphragm shutter behind the lens position. A few designs use a built-in diaphragm shutter and rear lens component, the forward lens component being removable and interchangeable.

The majority of direct-vision cameras now have some form of automated link between an integral exposure meter and diaphragm or shutter controls. This can usually be de-coupled for manual control of exposure level (see chapter XIV).

Viewfinding

Some form of direct optical finder is built into the camera body. This consists essentially of a negative lens and positive eyepiece, at either end of a matt black tunnel. The inside glass surface of the negative lens is usually made slightly reflective towards the eyepiece. By this means a white frame outline marked on the inside of the viewfinder surrounding the eyepiece is reflected to the eye, superimposed over the subject scene. Such a viewfinder is known as a 'suspended frame' or 'Albada' type.

The angle of view of the finder is slightly greater than that of the camera lens so that a margin of subject matter is always visible outside the frame line. This is useful in photographing a moving subject which can thus be seen in the viewfinder before it enters the field of view of the lens.

Albada-type finders are often made to reflect additional information to the eye – the exposure meter reading, lens focusing setting, number of exposures remaining, etc. Where a camera allows interchangeable lenses their respective fields of view, marked with focal length, appear as concentric formats within the viewfinder.

The inch or so variation between the viewpoint of the finder lens near the top of the camera and the actual taking lens is insignificant for distant subject matter. With closer subjects, however, their parallel but separate viewing positions (their 'parallax' separation) can mean that the taking lens will include more of the bottom and less at the top of the subject than is shown in the viewfinder (see Fig. 8.6).

Camera manufacturers compensate for parallax differences of field in various ways, ranging from a mark on the suspended frame denoting the top of the picture included at minimum focusing distance, to an optical tilting arrangement for the whole viewfinder. Unfortunately, although 'parallax compensation' may correctly match limits of the picture seen through the finder with the picture limits recorded on film, variations in subject

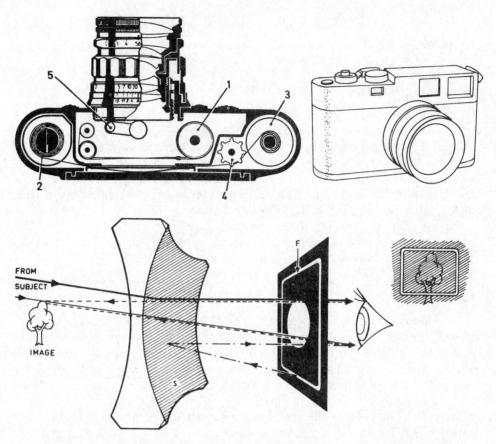

Fig. 8.2. High quality 35 mm direct vision type camera: 1. Dual-blind focal plane shutter; 2. 35 mm cassette; 3. Take-up spool (usually permanent) connected to an external wind on/shutter setting lever via a slipping clutch; 4. Sprocket wheel engaging with the perforations to transport the film and operate a frame counter; 5. Rangefinder link arm, riding on the rear edge of the helical focusing lens barrel. Bottom: A 'suspended frame' direct vision finder. The inner surface of the diverging lens is semi-silvered (S). Viewed through rear aperture an image of the distant tree is enclosed by the reflection of painted white frame line F (see right).

appearance due to *viewpoint difference* remains, i.e., in looking down obliquely on a cube, even a parallax corrected viewfinder must see slightly more of the top surface than the taking lens.

Focusing

The majority of direct vision finder cameras are of 35 mm or smaller format. Their comparatively short focus lenses require only a short focusing movement usually achieved by a fine pitched helical screw lens mount. Twisting of a collar gently draws the whole lens forward. Many relatively inexpensive cameras focus by a screw thread which actually separates the lens elements to alter the focal length of the lens. One

objection to this method is that it can upset carefully balanced lens aberration corrections, with the result that image quality may vary with subject distance. Nevertheless, the method gives satisfactory results for many purposes.

In either case, distances (down to subjects about 1.8 m away) are scaled on the focusing ring – the lens is 'scale focused'. Cameras with interchangeable lenses allow the attachments of metal extension tubes or bellows to move a lens still farther from the

Fig. 8.3. Screw focusing mounts. Left: A front element focusing lens. Right: A helical screw mount allowing focusing of the whole lens.

focal plane, for close-up work. Parallax problems then become very acute and special viewfinding arrangements such as a reflex system are needed.

The great depth of field of a short focus lens means that broad zone focusing by scale is quite adequate for fairly distant subjects and moderate apertures. However, wide maximum apertures are usually demanded by users of these cameras — and when such apertures are combined with close subjects, focusing can be critical. A rangefinder is the normal method of increasing focusing accuracy.

RANGEFINDER. The basic principle of the rangefinder is that when a subject point is looked at from two separate positions, the lines of sight from each of the two positions are not parallel, but converge. The closer the subject, the more steeply the lines of sight converge.

We can prove this by holding a ruler horizontally at arms length, using the left eye only and lining up our view of a subject with the extreme left-hand edge of the ruler. Keeping the ruler still, open the right eye and close the left... and the subject now coincides with some point along the ruler scale. If marked with distance this would form a crude visual rangefinder. (See figure 8.4).

Photographically, a more convenient system is used by which the eye sees the subject direct through a narrow-angle optical sight. The sight contains a semi-silvered mirror at 45° which superimposes another view of the subject as seen from a point on the camera some inches to the left or right. This second view is conveyed via a tube set in the camera top at right angles to the taking lens axis, with a pivoting fully silvered mirror and lens element at its far end.

When both mirrors are at 45° to light paths, direct and indirect sightings are parallel and subjects at infinity appear to superimpose. As a subject approaches the direct sight the fully silvered mirror must pivot about a vertical axis if the subject is to remain within view of the indirect sighting. The closer the subject the greater the mirror rotation — the necessary adjustment giving a measure of subject distance. Rotation can either be linked to a scale of distances or, more usefully, direct to the lens-focusing mechanism.

Often the rangefinder optical system is incorporated into the centre of the optical finder, giving a central focusing 'spot'. For users who have difficulty in superimposing the two images of the subject upon which they are focusing, each sight may be given a pale contrasting filter colour. Alternatively, one sight shows the *top* half of the subject only, the other the *bottom*. The subject then appears split horizontally, with one half movable into alignment by the action of focusing. This latter 'split field' system of coincidence gives a more obvious image shift but can make focusing difficult for a subject containing mostly horizontal lines.

The accuracy of a rangefinder increases with close subjects (greater deflection required). This is fortunate, as depth of field is then at its minimum and critical focusing is most needed. The accuracy of a rangefinder is greatest if it has wide separation between the two sighting positions – hence the provision of a long base rangefinder is a point worth noting when purchasing.

A pivoting mirror requires only the slightest movement to give a massive sweep to subject sighting. This gives it mechanical disadvantages – reduction gear is needed for usefully long movement of the coupling arm and any slackness gives considerable inaccuracy. As an alternative, the mirror may be fixed, and light deflected by a rotating glass wedge which requires more total shift to cover the required focusing range. Such shift allows more appropriate and accurate physical linkage with the camera lens focusing movement. (A special no-moving-parts rangefinder for focusing screen use will be described when we look at single lens reflexes.)

Film Arrangements

Although a few small format direct-vision cameras still use rollfilm, daylight loaded under the protection of its attached backing paper (see page 175), most cameras use perforated 35-mm film in cassettes. Such cassettes are velvet light trapped and intended to be expendable – or are of a reloadable pattern which is arranged to open when inside the camera. The standard picture format is 36×24 mm on 20 or 36 exposure lengths of film, or (half frame cameras) twice this number 24×18 mm. Some direct vision cameras for amateurs produce 17×13 mm pictures on 16 mm wide films.

Film wind-on between exposures is usually by a quick-flip lever which also sets the shutter and moves an exposure counter. Cassette loading cameras normally have an open take-up spool permanently in the camera. When all exposures have been made, an external handle must therefore be used to rewind the film off the take-spool back into the cassette before opening the camera. Alternatively the camera body contains no spools, but accepts a drop-in plastic 'cartridge' (Fig. 9.8) containing feed and take-up com-

Fig. 8.4. Rangefinder principles: a. Simple rangefinder. Using the left eye line up near and distant subjects with datum line on ruler. Right eye will view near subject (ii) behind a different position on the ruler than the distant subject (iii). Closer subjects cause steeper convergence. b. Optical rangefinder using semi-silvered mirror S and pivoting mirror M. Photographer sees uncoincided images either split (half masked mirrors), or overlapping (one entry lens coloured). c. An alternative to mirror M. Glass wedges rotate about a horizontal axis in front of a fixed mirror. For a given shift of sight the wedges require greater rotational movement than a pivoting mirror, thus adding to rangefinder accuracy. d. A coupled rangefinder system using a semi-silvered glass block and a prism mirror pivoting with movement of the lens barrel.

partments. After exposure the whole cartridge is removed without rewinding and broken open in the darkroom to remove the film.

Operational Advantages and Limitations

- (1) For their format size direct vision finder cameras are small and unobtrusive, and almost immediately ready for use. Shutters are often very quiet in operation.
- (2) The finder gives a bright, sharp image at all times. Many allow the subject to be seen before it comes 'into frame'.
- (3) Very wide aperture lenses are available, as coverage need not exceed negative format and glass diameter is physically within bounds. An aperture of f/2·8 is considered normal for most 35 mm camera lenses; lenses of f/1 are increasingly available.
- (4) Most people find rangefinder focusing easy, even in the most dim conditions.
- (5) In common with all small-format cameras the short-focus lenses used give considerable depth of field. However they also have little depth of focus alignment of lens to film is critical and only a precision camera can meet professional requirements.
- (6) Being unable to view the image produced by the camera lens we cannot critically check (a) depth of field, (b) the exact amount of subject included at close distances (parallax differences and the problem that angle of view decreases as a lens focuses forward).
- (7) No manipulation of image shape or depth of field is possible by camera movements.
- (8) A direct vision finder is difficult to use for low-level shots.
- (9) There are flash and image distortion disadvantages on those cameras fitted with focal plane shutters.
- (10) Small formats (35 mm particularly) demand extra care in processing and handling. Strict controls are necessary at all stages if quality big enlargements are to be produced on a regular basis. Retouching on the negative is extremely difficult.
- (11) It is not practical to process the negatives produced individually.

Main Uses

With suitable accessories precision direct vision finder cameras can handle a very wide range of assignments. Typical professional uses of this design (without extras) are:

- (1) Press photography demanding fast reaction.
- (2) 'Feature' photography, sports pictures and all forms of photo-journalism requiring rapid sequences, unobtrusiveness, and ability to shoot under low-level illumination.
- (3) Natural history photography (other than close-ups) in black and white and colour.

TWIN LENS REFLEXES

Commercial examples: Rolleiflex; Mamiyaflex; Minolta Autocord; Pontiac, etc.

General Construction

Designed to combine the advantages of a focusing screen with the speedy convenience of a film always located behind the lens ready for exposure, the twin lens reflex is really two separate cameras. One is used for focusing and viewfinding on a ground glass screen, the other for photography.

Focusing and exposing 'cameras' are mounted one above the other in a box-like metal body with their lenses located on a common panel which focuses backwards and forwards by rack and pinion controlled from a knob on the camera body. Some models allow lens interchangeability either by replacement of the whole lens panel, or by fitting supplementary optical systems over the existing lenses. Most twin lens reflexes today are rollfilm cameras, producing square pictures, although one or two large format types are also made.

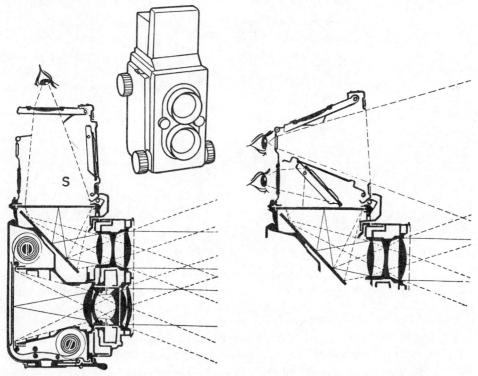

Fig. 8.5. Left: Optical and mechanical layout of the twin lens reflex type camera. A folding magnifier is used to view the focusing screen S. Right: By folding a square aperture out of the hood the camera can be used at eye level. A supplementary mirror may also allow image sharpness to be checked over the centre of the screen.

Viewfinding and Focusing

Both the top (viewing) lens and the lower (taking) lens are of compound construction and have identical focal lengths. But whereas the lower lens has an iris diaphragm, between lens shutter, and exposes directly on to film, the top lens has none of these controls and, as previously stated, forms its image on a focusing screen. The focusing screen could be at the back of the camera, but this would leave little room for the film spool chambers unless the whole camera were made larger. It would also be inconvenient to view in such a position, and the image, of course, would be upside-down.

Instead, the image is reflected upwards by a 45° metal mirror just behind the top lens to a horizontal focusing screen on the camera top. In this position it is not only more

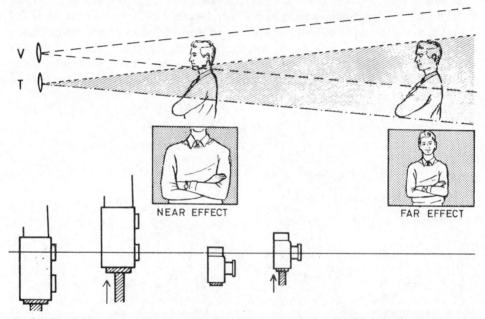

Fig. 8.6. Top: Parallax separation between viewfinder (V) and taking lens (T) causes variations between what is seen and what is photographed. With distant subjects this difference is not great but (inset), close up work results in major inaccuracies. Bottom: If the nature of the subject allows, parallax and viewpoint differences can be fully corrected by raising the tripod.

convenient to examine, but is now *upright* (although reversed left to right). The screen itself is shaded from external light by a hood which collapses over it for protection when not in use.

The designer is, of course, careful to arrange that the overall distance between the rear nodal point of the viewing lens via the mirror to the lower etched surface of the focusing screen is the same as that between the rear nodal point of the taking lens and the film. In this way, when the image is sharp on the focusing screen it will also be sharply focused on the film.

Since the focusing screen is the same size as the film format the angle of view of the

two lenses is identical. However, there still remains an inch or so parallax error between the taking and viewing lenses. Upper parts of subjects closer than about 6 ft may appear on the focusing screen but not be included by the taking lens. On some models a small blind moves under the focusing screen to obscure this top part of the image as the lens is racked forward; on others the lens is tilted very slightly downwards. Although these 'parallax corrections' restore true indication of the amount of subject included, viewpoints will always remain slightly different (as with optical direct-vision systems). Shooting through wire netting for example the focusing screen may show an unobstructed view while the negative proves that a strand was in fact in front of the lower lens, and so on.

Square apertures forming a simple 'frame finder' open out of the hood (see Fig. 8.5) for photography at eye level or for panning fast-moving objects. (Panning is difficult to carry out, viewing on a focusing screen, due to reversal of movement from left to right.) As it is even farther displaced from the taking lens, the frame-finder gives even greater parallax error than the reflex system.

Some twin-lens reflex cameras have a simple inclined mirror in the hood which flaps down at 45° to allow the focusing screen to be seen at eye level through the frame-finder. This is more of a focusing check than a viewfinding system as the image appears upside-down. Double-reflecting optical accessories are made which replace the hood and offer an upright image for viewfinding and focusing.

The viewing lens of the camera, although not as highly corrected as the taking lens, is a compound system giving acceptable visual coverage over the whole focusing screen. It has a fixed aperture which is slightly *wider* than the maximum aperture of the taking lens. There are two reasons for this:

- (a) Depth of field and depth of focus are reduced, making the point of critical focus more obvious.
- (b) A bright image appears on the focusing screen.

To make the image brighter still the focusing screen is finely and lightly etched, minimising light absorption. Such a screen has limited diffusion properties, and thus makes the image brighter in the centre where more direct light reaches the eye than at the edges of the screen (see page 37). A transparent 'Fresnel screen' is therefore often positioned under the focusing screen to direct more light from the corners towards the eye and so even up illumination.

The Fresnel screen is a plastic sheet carrying a sequence of concentric rings each of which is so moulded that light cones coming to focus near the edges of the picture are bent inwards just before the point of focus. The position of the focal plane is unaffected but light passing up through the focusing screen is now preferentially scattered toward the centrally placed eye or focusing magnifier.

The space around the double-lens panel and the camera body must be filled with a light-tight seal which nevertheless allows focusing movements of the panel. Some twinlens reflexes use light-trapped metal sleeving – others more conventional black bellows. Cameras fitted with bellows allow considerable movement of the lens forward of the focal plane for close subjects. Close focusing is also possible by using matched positive

Fig. 8.7. Fresnel screen. (Left) Very finely ground focusing screens allow critical focusing of the miniature image given by a small format camera, but result in uneven illumination. Much light near the edges of the screen is directed away from the eye. (Right) A thin Fresnel lens more evenly distributes the scattered light as seen by the eye.

lens elements on viewing and taking lenses. These make light rays diverging from close objects less divergent and therefore able to be brought to focus by the main camera lenses.

Twin-lens reflex cameras with interchangeable lenses have an internal light-proof blind which is drawn behind the taking lens before removing the whole front panel. This prevents film fogging and so allows lenses to be changed even when the camera is loaded. Each interchangeable unit consists of a taking lens and its shutter and the associated viewing lens mounted on a panel. Other camera models having fixed lens panels can be fitted with pairs of three or four element lenses specially computed to marry in with the existing lens, to give a new focal length. Whichever system is used appropriate metal masks must be fitted to the direct-vision frame-finder built into the hood, for, unlike the focusing screen, its field of view will not automatically alter with change of lenses.

Film Arrangements

Roll film, once loaded and set for the first exposure, is wound through the camera by a large folding handle or knob. This usually locks automatically after appropriate film shift for one exposure and cannot be moved further until the shutter is fired. Similarly, the shutter has a double exposure prevention device and cannot be fired more than once before the film is wound on. On some models these interlocks can be disconnected for special effects work.

Accessories are sometimes available to convert the camera back, spool chambers and

focusing screen format to accept 35-mm film. With 35-mm film a rectangular instead of square format is used – the camera held normally gives an upright picture, for horizontal pictures it must be used on its side. The inconvenience of the twin-lens reflex camera when used on its side is one of the main reasons why a square rather than rectangular format is chosen for its normal picture size. A square format also, of course, makes more efficient use of the circular covering power of a lens. Large format twin lens reflex cameras use normal sheet film holders (see Fig. 8.14).

Operational Advantages and Limitations

- (1) A full-size image is seen at all times, even during the moment of exposure.
- (2) Critical focusing is possible down to subjects a foot or so from the lens.
- (3) Physically the camera allows a wide range of viewpoints from an inch above the ground to high over the operator's head (the camera upside-down, focused by looking up at the ground glass screen).
- (4) Rollfilm models offer the improved quality of relatively large negatives, yet have greater depth of field and allow more pictures at one loading than large format cameras.
- (5) Although a depth of field calculator is always built into the camera, no visual check on the depth of field given by the taking lens is possible.
- (6) Parallax error must always be borne in mind, particularly in close work or when using the direct-vision frame-finder. (Used on a tripod you can eliminate parallax by framing up and focusing then raising the whole camera bodily upward for the 4 cm or so necessary to bring the taking lens into the exact position previously occupied by the viewing lens.)
- (7) No camera movements.
- (8) The square body and double-lens systems make the camera comparatively bulky for its format size.
- (9) Really wide-angle lenses are not yet available.
- (10) Interchangeable lenses are relatively expensive using this camera design, for a pair of lenses must be purchased each time.
- (11) The picture is reversed left-to-right on the focusing screen; panning moving subjects is only really possible using the frame finder.
- (12) The position of the focusing screen so convenient for waist-level use of the camera can lure the photographer to shoot all his pictures from the same monotonous viewpoint.
- (13) Some photographers object to a square format, arguing that part of the negative will be wasted when printed on rectangular paper sizes. More photographs are sold and reproduced with rectangular formats.

Main Uses

Twin lens reflex cameras are still fairly popular among professional photographers

for general hand-camera assignments where rollfilm negatives offer a good compromise between 35 mm and 5×4 in, and a very wide-angle of view or camera movements are unnecessary. For example:

- (1) Wedding photography, where numerous pictures must be taken quickly. Sometimes cameras are used in pairs, shooting colour and black and white.
- (2) Industrial photography of operatives at work, and all forms of prestige photography in the Works where flexibility and speed of use are important.
- (3) Fashion, portraiture, and advertising photography. Used in the studio and on location the camera allows rapid sequences of pictures. This, and the ability to observe facial expressions even at the moment of exposure helps photographer and model in creating the one spontaneous picture that exactly sums up the required spirit.
- (4) Newspaper press and feature photography. Mechanically simple and robust it is a compromise between the slowness and bulk of a larger camera and film holders, and the 'kid glove' treatment 35 mm negatives demand.

SINGLE LENS REFLEXES

Commercial examples:

(35 mm) – Leicaflex, Exacta, Pentax, Nikon, etc. (Rollfilm) – Hasselblad, Bronica, Rollei SL66, etc. (Large format) – Plaubel, Arca Swiss, Soho, etc.

General Construction

This is the world's most popular camera design. A single lens is used both for taking and for reflex viewing the image on a focusing screen – thus eliminating parallax error. Today, most single-lens reflexes are 35-mm cameras, although several are made for roll film and a few for large formats. Yet the basic design is developed from single-lens reflex plate cameras of the pre-war era.

Fundamentally, a 45° hinged mirror behind the lens reflects the image up to a focusing screen on the camera top. As the shutter release is pressed the mirror flaps upwards to

- (a) move out of the way of lens and film and
- (b) form a seal under the focusing screen, preventing light from entering the camera through the ground glass.

When the mirror reaches the horizontal position it fires what is usually a focal plane shutter just in front of the film. Distances are of course arranged so that lens-mirror-focusing screen distance equals lens-film distance and anything sharply imaged on the screen appears in focus on the negative.

In its simplest form, this basic design suggests disadvantages, i.e. having to focus at the aperture required for photography, waist-level viewing, loss of focusing screen image just before exposure, focal plane shutter space demands and synchronisation limitations. We shall see how modern designs have eliminated most of these drawbacks

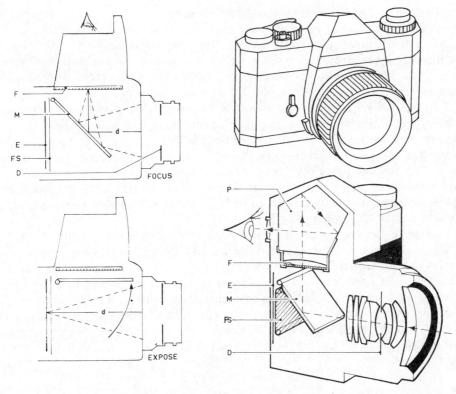

Fig. 8.8. Single lens reflex. Left: Basic Principle. Right: Modern derivative (35 mm pentaprism type). D, lens diaphragm; M, hinged, front-silvered mirror; F, focusing screen; P, pentaprism; FS, focal plane shutter; E, film

at the cost of added mechanical complexity. Today, the pentaprism type single-lens reflex, in particular, is among the most highly developed cameras made.

Viewfinding

The dual use of the taking lens not only eliminates parallax error, it means that the full-size focusing screen automatically shows correct field of view for *any* lens we care to fit. The exact effects of close focusing, stopping down, use of extension tubes, etc., are visually and accurately seen. The camera may be attached to auxiliary equipment such as a telescope, or microscope, with the knowledge that the field appearing on the focusing screen can be recorded on film.

Older large-format reflexes had a tall hood reaching up like a chimney from the waistlevel camera to the photographer's eyes. This was necessary in order that he might see the dim image when the lens was stopped down. Smaller format reflexes followed the same pattern (but with shorter hoods). A logical improvement was to keep the focusing screen shaded and at the same time allow more convenient eye-level use of the camera by an enclosed reflecting hood and eyepiece. However, since a single 45° reflection of the focusing screen gives an *inverted* image, the image on the screen must be reflected twice. This has the added convenience of providing a longer optical path between focusing screen and the user's eye, which means less eyestrain.

Two separate mirrors could be used to achieve the required double reflection, but these are expensive to assemble and may become out of delicate alignment. A pentaprism glass block with two reflecting surfaces is therefore used. The bottom of the pentaprism may be ground to form the actual focusing screen, but more often a magnifying lens is inserted between screen and pentaprism — so that seen through the final eyepiece the screen appears two to three times its actual area. Most pentaprisms used today incorporate a third reflecting surface (see Fig. 8.9) which presents an upright image corrected left to right.

Pentaprism viewing systems are too heavy and expensive for large-format reflexes which are still essentially waist-level cameras. Cost, weight and bulk have kept pentaprisms to accessories rather than permanent features of roll film single-lens reflexes. Here they form an alternative to waist-level use, or eye-level viewfinding using direct frame-finder apertures in the folding hood. Scaled down to the small focusing screen size of 35-mm cameras, however, the pentaprism is now almost universally used, built as an integral part of the camera body. This makes the camera immediately ready for shooting, and (if the pentaprism is corrected left to right) easily usable on its side for upright pictures.

Focusing

Focusing is either by rack and pinion bellows movement (large formats) or by helical focusing mount. One of the advantages of single-lens reflex design is that depth of field can be checked on the screen as the lens is stopped down. However, once the lens is stopped down ready for photography refocusing or even viewfinding is dim and difficult, and makes the camera slow to use. Roll film and 35-mm models therefore incorporate a 'pre-selector' iris diaphragm — which remains at wide aperture until the mirror rises just prior to exposure. A coupling between lens and camera body then snaps it to the f-number which has been selected for photography. At any time during setting-up and focusing the photographer can press a preview button to check depth of field etc. at his chosen aperture.

FOCUSING SCREEN RANGEFINDER. One focusing problem with the 35-mm reflex is the very smallness of the focusing screen. Optical magnification helps, but only up to the point where the grain of the screen becomes objectionable. In any case, adjusting the lens to bring an image to maximum sharpness on a focusing screen is for many people a longer business than bringing two images together in a rangefinder.

For these reasons many single-lens reflex cameras have a special type rangefinder built into the focusing screen itself. The centre of the focusing screen contains two small

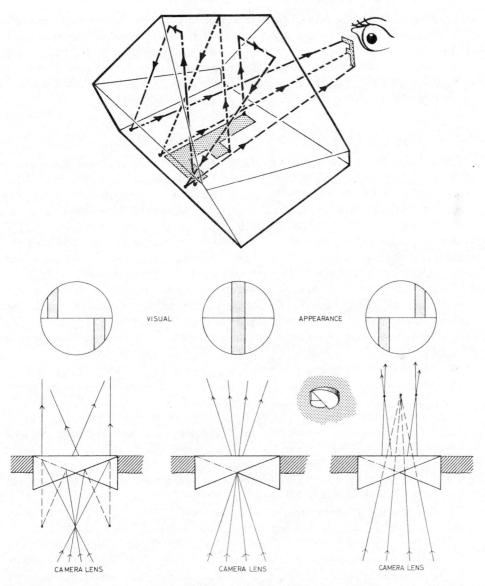

Fig. 8.9. Top: Action of pentaprism fitted with a 'roof' prism, as found on most single lens reflexes. Image on focusing screen (lower surface of pentaprism) is upright but laterally reversed. Reflection across 'roof', then from front surface of pentaprism delivers an upright and laterally corrected view to the eye.

Bottom: Focusing screen split-image rangefinder. A fixed double wedge (see insert perspective view from beneath) located in the focal plane of the focusing screen. Whilst the lens is focused on the plane in which the two wedges meet the image appears continuous. If the lens is otherwise focused pencils of rays fall on (left) thin, or (right) thick ends of the wedges, creating mutually displaced images. Accuracy increases with the width of the light beam from the lens.

semicircular glass wedges. Any image seen through this circular area which is not exactly in focus on the ground glass appears split into two displaced halves. The halves join up as the image is brought into focus, in the same way as a split-image optical rangefinder. Notice that this focusing screen rangefinder has no moving parts and operates for all the normal range of lenses. Its accuracy, however, is not as great as a normal optical rangefinder (see Fig. 8.9).

Film Arrangements

Large format single-lens reflex cameras $(9 \times 12 \text{ cms}, 4 \times 5 \text{ in}, \text{ etc.})$ accept individual sheet films in light-tight holders (see Fig. 8.11). A roll film back may also be fitted (containing spool chambers and wind-on mechanism). Since these cameras shoot rectangular pictures, a vertical turntable is provided at the back of the camera ('revolving back') to enable the sensitive material to be rapidly changed from the upright to the horizontal position. Outlines on the reflex focusing screen show the user how much of the image is used in each position. Roll film single-lens reflex cameras use square or nearly square formats. 35 mm models may be cassette or cartridge loading, either full or half-frame. On most rollfilm reflex cameras the film is housed in interchangeable magazines which quickly clip on to the back of the camera, allowing change of film type halfway through a roll. A light-tight sheath is inserted at the front of the magazine before the removal from the camera. Similar backs for Polaroid instant picture film are available.

Most small-format reflex cameras have a fixed speed, variable slit focal plane shutter set by the film winding mechanism. Some models have a diaphragm shutter between or behind the lens elements instead. This simplifies layout of the camera body, lowers cost (the manufacturer can obtain the shutter ready made) and offers a full range of flash synchronised speeds. On the other hand, each lens may have to have its own shutter – specially modified to open and close for focusing.

Taking a picture with an eye-level small-format single-lens reflex camera with the above diaphragm type of shutter – mechanically the most complex form of reflex camera – typically involves the following operations:

- (a) Aperture and shutter speed are preselected.
- (b) The image is framed up and focused—using ground glass and split image facilities (the iris diaphragm can be stopped down, by means of the preview button, to check depth of field at this stage).
- (c) As the release is pressed the shutter blades close; the diaphragm stops down; the mirror rises; a capping plate rises which covers the film from stray light when focusing; the shutter fires.
- (d) The film wind lever is operated, moving the film on to the next frame; lowering the capping plate; lowering the mirror; opening and tensioning the shutter; opening the iris diaphragm.

The camera is now ready for the next subject. Models differ in their exact sequence of events, but all involve complex mechanical linkages.

Operational Advantages and Limitations

- (1) No parallax error; the screen shows full size exactly what will appear on the film.
- (2) Critical focusing is possible for any subject at any distance which can be imaged by a photographic lens or any other optical system with which the camera may be used.
- (3) Depth of field can be checked visually.
- (4) A wide range of interchangeable lenses are available. (However, really short-focus wide-angle lenses are limited; unless they are of special 'retrofocus' construction they must be so close to the film that the mirror has no room to move.)
- (5) Convenient, accurate eye-level focusing by pentaprism and focusing screen rangefinder. A wide range of viewpoints are therefore possible. Moving subjects can be panned.
- (6) Magazine loading on some models speeds film changing.
- (7) Most small format SLR cameras have built-in through-the-lens exposure meters (see page 258).
- (8) Loss of image at the moment of exposure.
- (9) Noise, bulk, synchronisation limitations of a focal plane shutter when fitted.
- (10) Mechanical complexity of the design particularly with pre-set diaphragm bladed shutter, etc.
- (11) Most cameras offer no movements, but may accept a shift lens (Fig 6.1). Some large-format models have rising front; further movements are possible on special monorail mounted reflexes. See Fig. 8.14.

Main Uses

The vast range of high quality lenses and special accessories available for the precision single lens reflex camera makes its applications almost universal. The design is particularly popular for:

- (1) Fashion and editorial illustration, where camera movements are seldom needed and exact composition and degree of 'differential focus' must be checked.
- (2) Technical work, e.g. scientific, medical or natural history photography, where the camera must be used close up without producing parallax error. Also when it forms part of a microscope, telescope etc.

TECHNICAL (BASEBOARD) CAMERAS

Commercial examples: Linhof Technika, Grover, M.P.P. Technical, Deardorff, Speed Graphic, etc.

General Construction

A large-format (9 cm \times 12 cm up to 4 in \times 5 in) metal and bellows folding camera with

a hinged baseboard on which the lens panel pulls out on runners like railway lines (see Fig. 8.10). Interchangeable lenses are available, each with its own between lens shutter. The camera is just small enough to be manageable and reasonably fast to operate in the hand, yet has a number of features – movements, double extension, direct focusing screen – more common to a camera used on a stand.

Fig. 8.10. Technical baseboard camera with coupled rangefinder. This one has a clip-on optical direct vision finder and anatomical hand grip with shutter release. Top right: 5 × 4 in sheet film holder.

Focusing and Viewfinding

With the baseboard open at 90° to the back of the camera, the 'front standard' carrying the lens panel slides forward on the runners, and may be locked to them at some convenient position. The camera manufacturer usually notches the runners at three infinity positions – for normal, wide angle, and long focus lenses respectively (for example 90 mm, 150 mm, and 210 mm for $4 \text{ in} \times 5 \text{ in}$). Locked at its appropriate notch the lens diaphragm shutter is opened, together with the focusing screen hood at the back of the camera ... revealing distant subjects sharply focused. For closer subjects a focusing wheel on the baseboard operates a rack and pinion movement to bring the whole set of runners forward.

The camera will accept any lens which covers its format, each being mounted on interchangeable standard metal lens panels which quickly clip to the front standard. The bellows limit the shortest focal length wide-angle lens the camera will accept as, when folded up, they usually prevent movement of the lens standard closer than $1\frac{1}{2}$ in $-2\frac{1}{2}$ in from the focusing screen. This blockage is somewhat overcome by use of a cupped or 'recessed' lens panel which positions the lens farther into the camera.

When using wide-angle lenses in a baseboard camera the lens will be right at the inner end of the runners. The end of the baseboard, jutting well forward of the lens, is almost certain to appear within its wide-angle of view. The camera therefore has a second, 'drop baseboard' position, in which the baseboard hinges down below the horizontal and out of the field of view of the lens. The runners are usually hinged for this movement, so that the lens can still be focused by rack and pinion.

THE CAMERA FOR THE JOB

Plate 36 Hardly an occasion for the time-consuming use of a stand camera, even though this is a set-up picture, using paid models. Magazine feature picture photographed with a 6 cms square single lens reflex, by John Hedgecoe.

Plates 37 and 38 (Opposite) Typical work handled by large format stand cameras. (Top) Architecturali nteriors require the lens and camera movement versatility of monorail apparatus. (Bottom) Macrophotography—subjects for which large format negatives offer maximum resolution. For similar reasons much advertising still life photography is still handled on large format cameras.

Plate 39 (Above) The type of action industrial photography requiring speed, manoeuvrability, low viewpoint and observation up to and including the moment of exposure. Shot with a 6 cms square twin lens reflex.

Plate 40 (Overleaf) Technically photojournalism is often a compromise between quality and the ability to shoot quickly under poor lighting conditions. 35 mm cameras, with their very wide aperture lenses. have obvious advantages. One of a series on Tinkers in Britain photographed with a 35 mm direct vision camera. (Richard Rogers)

For the other extreme – really close work – the lens standard is pulled to the front end of the rails. On most models the rails themselves are in two or three sections lying beneath one another and can slide out to give extra extension. The limit here is again the bellows . . . the longer the bellows the greater magnification possible, but the greater blockage caused when the photographer is trying to bring a wide-angle lens close to the focusing screen. Bellows length on this design of camera is therefore a compromise between the two needs.

Apart from a focusing scale on the track and visual check of the focusing screen, some technical baseboard cameras allow focusing by a rangefinder fitted to the camera body and coupled to the focusing track. Since the physical focusing movement necessary for short-focus lenses is proportionally less than for lenses of long focal length, a cam on the rangefinder linkage must be changed for each lens used. The rangefinder is, of course, primarily used when the camera is hand-held.

A wire frame-finder is frequently fitted for viewfinding under hand-held conditions; it consists of a format size outline mounted over the lens standard, and a peep sight above the focusing screen. Since the wire outline moves forward with the lens, change of focal length and the reduced angle of view as the lens is racked forward for nearer subjects are automatically compensated.

Other models have either built-in or accessory optical direct-vision finders of the suspended frame type (see Fig. 8.10), marked off in appropriate angles of view. One technical camera has a complete reflex housing with lens and focusing screen which clamps over the lens standard and the camera body, turning it into a large format twinlens reflex camera.

Most technical baseboard cameras offer rising-, cross- and swing-front movements, and rather more restricted drop-front and swing-back movements. Existing movements can be increased by improvisation, however; for example, used with a normal angle lens the baseboard may be dropped and the lens panel swung to return parallel to the focusing screen, giving increased drop front. Only very limited movements are physically possible with wide-angle lenses owing to their positioning inside the camera body and the compressed surrounding bellows.

Film Arrangement

Cameras of this type accept double-sided holders for sheet film. The focusing screen is spring loaded and need not be removed to receive the holder — which push-inserts between it and the camera back. The sensitive surface of the film thus occupies the exact position previously held by the etched surface of the screen. A 'light-trap' functions around the edge of the holder pressed to the camera so that with the shutter closed the front dark slide may be drawn from the holder and the exposure made without light fogging the film.

(N.B. It is not good practice to leave the dark-slide projecting from the holder on the assumption that this prevents fogging light reaching the film. The holder should have a

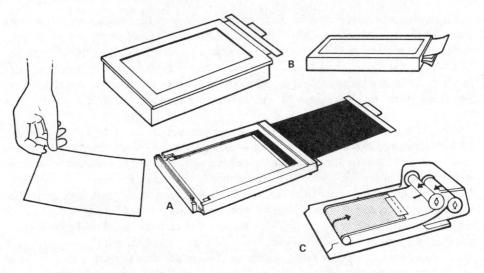

Fig. 8.11. Some sensitive material holders for large format cameras. A: Double-sided sheet film holder. B: Polaroid back designed to accept (right) instant picture film pack. C: 120 Rollfilm back.

perfectly good internal velvet light trap. The dark-slide can so easily block image light reaching one end of the film or be knocked or blown by the wind, perhaps pulling the holder momentarily away from the back or shifting the camera.)

As an alternative to sheet film a film pack adaptor (page 174), a rollfilm holder, or a holder for Polaroid instant picture film can be substituted (see Fig. 8.11). Most technical cameras have a revolving back for quick change from horizontal to vertical formats and vice versa. This is useful when the camera is used on a tripod and it is inconvenient to mount it on its side. More than this, the revolving turntable back is used when setting the camera up on uneven ground; whatever the position of the baseboard, the back can be turned until the edges of the picture run horizontally and vertically.

Press Versions of Technical Cameras

A number of special versions of technical cameras are marketed as 'Press' cameras. The name has lost much of its meaning these days when so many press photographers are using small-format cameras. A press version of a technical camera, like a racing car, is stripped of all inessentials. Bellows, runner extensions and camera movements are more limited. A focal plane shutter is usually fitted for its faster speeds, and, in addition, the camera has a flash synchronised bladed diaphragm shutter. (One must be set open whilst the other is used, of course.)

The focusing scale – the most popular means of focusing cameras of this type – is enlarged and may be fitted on the top edge of the lens panel for visibility while using the wire frame-finder. The rangefinder may have a battery operated lamp which fits over the eyepiece so that under poor lighting conditions two light beams like tiny searchlights

project forward at the subject. As the camera is focused the beams swing towards each other – the plane of the subject on which they meet is the plane of sharp focus.

Several other press camera designs are on the market. In general, they are all related to the technical camera and direct vision viewfinder camera, and are made to function quickly with the minimum of impedimenta to go wrong.

Operational Advantages and Limitations

The technical camera is probably the nearest approach to a 'universal' camera — one camera with which we can make an attempt at all forms of photography. It does not offer all the features of specialist cameras — in fact it is essentially a compromise. Camera movements are not as great as a monorail but the camera can be used in the hand: it is not as portable as a small-format reflex but it has some camera movements . . . and so on.

Main points to remember are:

- (1) It has extreme hand and stand versatility, ranging from press to architectural assignments, but is not ideally designed for any one specialisation.
- (2) It offers three alternative methods of focusing focusing screen, scale and rangefinder.
- (3) It commonly offers three methods of viewfinding wire frame finder, optical direct vision finder or focusing screen.
- (4) The camera accepts a wide range of lenses: for example on a $5 \text{ in} \times 4 \text{ in model}$ the bellows allow lens positioning anywhere between about 7.5 cm and 50 cm from the focal plane.
- (5) Its movements are more limited than true stand cameras severely so when using wide-angle lenses.
- (6) Visual check of depth of field is difficult when using this camera in the hand.
- (7) As a hand camera it may prove inconveniently heavy to carry, particularly if many film holders are needed on a job. For similar reasons the camera can be awkward to use when shooting rapid sequences.
- (8) It offers front focusing only. Focusing on close subjects where reproduction is about the same size can be irritatingly slow as movement of the lens panel alters both subject-lens and lens-image distances. Frequently, the image will be found to become larger or smaller without becoming appreciably sharper.
- (9) Using sheet film a wider range of emulsions is available (page 180) and pictures can be processed one at a time.

Main Uses

- (1) Wherever a photographer can afford only one large format camera and with it wishes to cover as wide a field of commercial photography as possible.
- (2) For studio still-lifes and other 'constructed' pictures where elements are

meticulously related to each other and can be composed on the (large) focusing screen.

(3) Hand camera assignments where camera movements may also be necessary, i.e. architectural building site progress pictures.

Up to this point we have been discussing camera equipment which can be used in the hand. The remaining cameras to be described in this chapter are designed exclusively to be used on some form of support or tripod, and are therefore known as STAND CAMERAS. They are not normally fitted with viewfinders.

TECHNICAL (MONORAIL) CAMERAS

Commercial examples: Sinar, Cambo, De Vere, Karden Color, Plaubel Peco, Graphic View, etc.

General Construction

Monorail cameras are technical cameras, usually of 4 in \times 5 in to 8 \times 10 in format, which, instead of having a rigid body or folding baseboard, are designed on the principle of an 'optical bench' – having a metal rail or bar on which various supports can be accurately centred and moved. The rail itself may have any convenient form of cross section – square, triangular, hexagonal, circular. A few 'monorail' cameras use twin parallel rails. Camera parts are assembled on the rail as individual independent units and consequently the design allows almost unlimited physical use of camera movements.

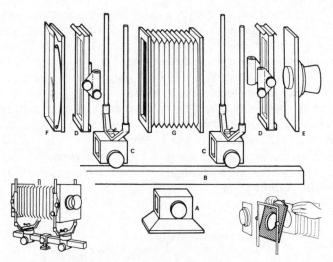

Fig. 8.12. Monorail camera. A: Clamp, bushed for attachment to a tripod. B: Monorail. C: Identical frame supports fitted with drive and locking mechanism. D: Pivoting frames to accept lens panel, focusing screen or bellows. E: Lens panel. F: Spring back focusing screen. G: Standard bellows. (Bottom right) A bladed shutter which fits between the standard lens and bellows to serve all lenses.

In the simplest type of monorail camera two 'frames' only are fitted on to the rail. Each has a friction drive or pinion wheel which engages with a rack on the rail and allows the frame to be precision wound backwards and forwards, and locked as required. On the more versatile models the frames are identical and will accept either the lens panel or the focusing screen.

Next, the type of bellows for the assignment are chosen and clipped between the two frames to form a more recognisable camera. If a wide-angle lens is used 'bag' bellows are chosen. These have very little front-to-back extension so that bunching up of bellows will not occur with the lens close to the focal plane — yet they are baggy enough to allow plenty of lateral movement for rising, cross, drop front, etc.

If, however, the assignment calls for close-up work such as macrophotography, long folding leather bellows would be used. If necessary, two sets of these bellows can be used – one stretched from the lens to a centre supporting frame and the other from this frame to a third frame carrying the focusing screen. In fact this 'adding of bellows' can continue indefinitely, providing a long enough rail is available. Some rails can be extended by screwing together sections, using several tripods to support the final tunnel-shaped camera.

For most assignments a camera built up with two frames and a bag or triple extension bellows is adequate. The rail itself is supported by means of a clamp fixed to it at the point nearest the centre of gravity of the components in use. The clamp is attached to the top of a heavy-duty tripod or studio column stand.

Monorail cameras accept shutterless or diaphragm shuttered lenses on interchangeable panels. On some cameras an independent bladed shutter built into a panel can be inserted between the lens carrying frame and the bellows, for use with practically all lenses, see Fig. 8.12.

The focusing screen is of the spring-loaded pattern, accepting the same range of film holders as baseboard cameras; sometimes a detachable hood is fitted but more often the camera is intended for use with a focusing cloth. Certain monorail camera systems allow the use of larger-sized rear frames to give larger-format pictures, linked by tapered bellows to the same front components (e.g. a 4-in \times 5-in camera with a 8-in \times 10-in back).

All frames – front, back and centre (if any) – swing about vertical and horizontal axes, sometimes through 360° . Very generous rising, drop and cross sliding movements are also built into every frame. In practice it is only the fact that lens and film must be linked by some form of light-tight tunnel which physically limits movements.

As both the front and back frames and the whole rail can be racked backwards and forwards at will, the camera is easy to focus in close-up subject work. Racking the whole camera speeds focusing by giving dramatic change of sharpness (utilising shallow depth of field under these conditions). Alternatively, when the size of image is reasonably correct but not quite in focus, the back of the camera can be racked, slowly 'sharpening up' the image without appreciably altering image size.

Operational Advantages and Limitations of the Monorail Camera

- (1) Unrivalled for its range of camera movements and range of lens-film distances.
- (2) It accepts almost any lens capable of covering its format (but a lens of outstanding covering power is desirable in order to obtain full benefit from the physical movement the design offers).
- (3) Unit construction allows the photographer to 'build' the camera to suit his assignment.
- (4) The camera is of simple (although precision) construction. Any damage is easy to locate and during repairs an unserviceable part can be replaced as a unit to keep the camera operational and earning money.
- (5) The camera is relatively heavy for its format size, and must be used on a substantial tripod. It cannot be used in the hand or for moving subjects.
- (6) It takes more time to assemble and dismantle than many other cameras.
- (7) The many locking screws for movements, racks, etc. (twenty or more on occasions) increase the risk of some being left unlocked and thereby producing unsharp results.
- (8) The focusing screen must be checked every time you focus the camera, and a black cloth is usually needed over your head in order to see the dim image clearly.

Main Uses

The technical camera of monorail design is essentially a professional optical tool; it has practically no amateur applications. It is unmatched wherever critical control over image size, shape, and depth of field are priority requirements. Assignments which it is particularly well designed to handle are:

- (1) Architectural interior and exterior views.
- (2) All forms of studio still life photography. However its movements may be considered too cumbersome and operational speed too slow for studio portraiture.
- (3) Advertising photography (particularly 10×8 in format) where minimum depth of field is required for effect or large colour transparencies are needed.
- (4) Macrophotography. Used with a short focus lens for records of small objects, calling for highest definition particularly where large-format colour transparencies are required.
- (5) Any job requiring special emulsions (e.g. high contrast) and individual processing of negatives.

Obsolescent Stand Cameras

In the past, 'field' (also known as 'view') camera has been a name used for all large-format folding stand cameras which are portable enough to be used away from the studio. With the development of the more advanced metal cameras, however, we now tend to limit this name to mahogany and brassbound cameras of simple construction. The cameras are still made by a handful of craftsmen and range from 4×5 in to

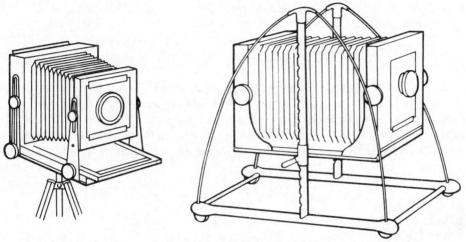

Fig. 8.13. (Left) A wooden folding view or field camera (Right) A studio 'portrait' camera, originally designed to make negatives up to 12 × 10 in but often adapted down to 5 × 4 in.

 8×10 in. They can be described as a simpler form of baseboard technical camera without viewfinder or rangefinder and sometimes with fewer movements.

On many models the camera front slides forward on grooves or is simply erected upon the open baseboard. On others the front is locked rigid at right angles to the baseboard and the camera back slides backwards on simple rails. Front and/or back focusing is by rack and pinion movement. The camera may have a hinged ground glass and accept double dark 'bookform' wooden plate holders – today containing adaptors for sheet film. The holders are so named because they open in the centre like a book for loading. Other models have the springback focusing screens of more modern designs. Although this camera type is now passing into history, most of today's successful photographic businesses have been technically founded on such equipment. Many field cameras are still giving good service.

Another camera type occasionally found in old-established portrait business is the studio portrait camera (see Fig. 8.13). This special purpose piece of equipment was designed like a large almost indestructible version of a square bellows field camera, often made of mahogany and built into its own stand — on wheels for easy movement around the studio. Originally it accepted 10-in \times 12-in plates but was later adapted down to 4×5 in. Extensive large bellows are fitted for the long focus lens used by portraitists and the camera may still be used with a silent pneumatic bladed shutter.

It is unusual for camera movements to be provided – they are generally limited to a little horizontal axis swing front to bring sitter's face and hand into common focus. The whole camera has rise and fall and tilting mechanisms built into its integral stand, and these are operated by handles at the back of the camera. Other handles control rack and pinion back and/or front focusing.

Studio cameras were designed for 'conventional' studio portraiture, where big negatives are an advantage owing to the retouching demanded by clients. The market for this type of portraiture has fallen off in recent years and portraitists working in

advertising and for magazines long ago opted for the flexibility and speed of smaller format equipment. Large studio cameras are therefore rarely manufactured today.

UNUSUAL DESIGNS AND SPECIAL CAMERAS

Manufacturers of 'main stream' cameras occasionally bring out unusual design variations. These may be special versions of their standard camera, perhaps to do a particular job, or a hybrid design which aims to combine the advantages of two normally different cameras (see Fig. 8.14). Sometimes a new and popular camera is evolved this way; sometimes these eccentricities quietly vanish from the market to be replaced by others.

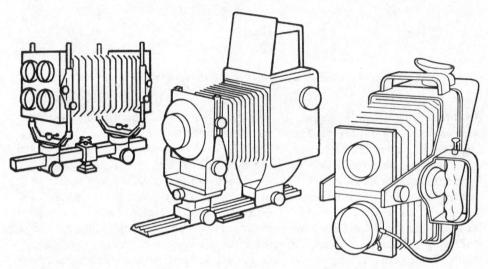

Fig. 8.14. Left: 5×4 in sheet film monorail camera with four-lens panel for identity card portraits. Centre: Monorail mounted 5×4 in single lens reflex. Right: 5×4 in twin lens reflex.

To take one example, larger format $(9 \text{ cm} \times 12 \text{ cm} - 4 \text{ in} \times 5 \text{ in})$ single-lens reflexes have been introduced mounted on monorails (*Arca Swiss, Plaubel*, etc.). The box-like container for mirror, focal plane shutter and focusing screen is mounted separately on the rail and linked by bellows to the front-lens-carrying frame. Back and front can therefore move relative to each other, with most of the swings and sliding movements of the technical monorail camera – yet retain the rapid working convenience of the reflex camera.

The large format twin lens reflex shown in Fig. 8.14 uses an enlarging lens for its top (focusing/viewfinding) lens. An extra 45° mirror in a housing with a magnifying eyepiece attaches behind the focusing screen to give a right-way-up picture. Some large format cameras use multi-lens panels to take multi-image portraits. Special dividers are pushed into the bellows so that each lens forms its own separate image on part of the

film without interference from the others. By using one large shutter behind all the lenses four identical small portraits are produced — as required for passports etc. Identification cameras frequently use Polaroid backs to give instant prints.

Many other camera types exist for specialist purposes – in fact, it is difficult to keep pace with new designs and decide whether they are strictly cameras or just film-holding attachments to some other apparatus. Specialist cameras include:

PROCESS CAMERAS — used for copying photographs, drawings etc., which are to be mechanically printed in books and publications. These cameras are mounted horizontally on rails, with built-in lamps and a copyboard. Often the camera is so big that its rear protrudes through a hole in the darkroom wall. Here the operator can load film direct into the focal plane, and has controls for focusing, exposure timing etc. The size of the camera allows up to 8 or 16 pages of illustrations to be copied at one time on film 20×24 in or larger.

AERIAL CAMERAS – most frequently used for making aerial survey photographic mosaics prior to mapping an area. Such cameras are usually vertically mounted, use 7 in wide rolls of film, and record altitude, speed, and other data alongside each picture.

Instrument cameras – automatic or remotely controlled cameras, often of small format, for recording instrument panels of aircraft or engines under test, etc. Also for recording traces of cathode ray oscilloscope tubes.

HIGH-SPEED CAMERAS – for recording explosions or fast-moving experiments – either as a single short-duration picture or short sequences of pictures exposed at rates of well over a million per second. Both are used for analysis purposes.

MOTION PICTURE CAMERAS – for slower, sustained sequences of still pictures which, projected at similar speed, recreate subject motion.

MACRO CAMERAS – permanently set up cameras for close-up direct photography of objects. Such cameras are vertically bench-mounted, with long bellows and short focus macro lenses. A magnification of up to \times 10 on a 9 cm \times 12 cm or 4-in \times 5-in negative may be possible.

MICRO CAMERAS – permanently set up copying units for recording books, documents, large plans etc. on fine-grain 35 mm or 16 mm microfilm. Standardised lighting, exposure measurement and motorised film-wind makes these cameras easy to use for unskilled personnel.

PANORAMIC CAMERAS — designed to cover a large, typically 180°, horizontal field of view by means of a lens which rotates about its rear nodal point. Usually the film is held in a curved plane, and a moving slit sweeps across it in tandem with the lens. These camera use standard 35 mm or rollfilm. They are used for large groups, landscapes, etc. and can be excellent for room interiors.

POLAROID CAMERAS – available as both direct-vision and SLR types, or as a special back for a technical camera or other medium and large format camera (see Fig. 8.11). The Polaroid process allows a small finished black-and-white or colour print to be produced within seconds (see page 322). Its main professional application is as a check on lighting, exposure, and composition – particularly when working on location or shooting pictures to suit 'tight' page layouts.

Underwater cameras – are watertight and resistant to water pressure up to a certain specified depth. They may be specially constructed cameras or – more often – special housings for conventional type small format or movie cameras. All camera controls are extended through to enlarged controls on the outside of the housing, and this usually carries a large wire direct vision framefinder.

The Camera for the Job

As we have seen, there is no one camera technically 'best' equipped for every job. One camera may be *just* usable for every assignment – another ideal for a narrow range of subjects. Then the photographer's own personal preference in handling has to be considered – do you feel more confident with a twin lens rather than a single lens reflex . . . and so on. It is therefore not surprising that most professionals use at least two cameras (usually one small, one large format) to undertake general commercial photography. Remember too that most high quality professional type cameras today are based on

Fig. 8.15. Part of the Hasselblad 6 × 6 cm SLR camera system. (A) Motor drive body; (B) Wide angle direct vision finder body; (C) 40 mm; (D) 120 mm; (E) 250 mm; (F) 500 mm lenses. Magazines for (G) twelve (H) seventy and (I) five hundred exposures. (J) Eye-level pentaprism. (K) Rapid wind crank. (L) Sports finder. (M) Pistol grip. (N) Ring flash. (O) Close-up bellows. (P) Underwater housing.

'systems' of which the camera body is only one part (see Fig. 8.15). To make fullest use of your chosen camera system you need to build up a range of lenses, backs, viewfinding aids, close-up attachments etc. according to the needs of the business. You are therefore making an important commitment when you first decide which cameras to adopt.

In deciding the equipment to use for a particular assignment it is essential first to find out as much about the purpose of the picture as possible. A full briefing is vital – the photographer must try to start off with a firm concept of the *type* of picture needed (even if the client is unsure of his needs). Only then can we decide:

- (a) Does the job demand a hand-held camera?
- (b) Will it require speedy focusing and rapid picture sequences?
- (c) Are individually processed negative desirable?
- (d) Are camera movements necessary?
- (e) Will the assignment limit me to a particular negative size (large or small)?
- (f) Are special close-up focusing and viewfinding facilities likely to be needed?
- (g) Is a range of focal lengths advisable if so what?
- ... and finally not forgetting -
 - (h) Which of the camera types that meet the above needs do I prefer to use, can afford, or have available?

In answering these questions different individuals will come to different conclusions. Nevertheless, there are no fixed rules to say which camera you should choose – only some which are more suitable for a particular job than others. The photographer can be so attached to one camera that he uses it for all his work . . . and 'gets away with it'.

One final warning. Remember that the camera is only a means to an end. Don't become so absorbed in the various models available that photography becomes camera-keeping. The biologist does not see his work as collecting microscopes; the writer won't worry if his typewriter is not this year's model. Cameras are tools to make photographs – learn how to use them thoroughly, then concentrate on the photography.

Chapter Summary - The Camera as a Whole

- (1) Choice of camera depends upon the purpose of the picture, conditions of use, and individual preference.
- (2) Direct vision cameras are principally 35 mm, allowing us to view by optical finder and focus by scale or coupled rangefinder. Operational features compact size; quiet shutter; bright 'suspended frame' finder; depth of field and wide aperture lens advantages of small format cameras; but parallax error; no visual check of focused image.
- (3) Twin-lens reflex cameras are principally built for roll film, square-format pictures, using matched focal length lenses. Some have interchangeable paired lenses. Operational features: visual check of image sharpness but not depth of field; image seen even during exposure but is reversed left to right; parallax error; bulky; limited range of lenses.

FORMAT:	35mm	ROLLFILM	4x5in	8x10in	PARTICULARLY POPULAR FOR:-
DIRECT VISION	<i>\\</i>	LIMITED RANGE			PRESS SPORT PHOTO- JOURNALISM
TWIN-LENS REFLEX		11	LIMITED RANGE		WEDDINGS PORTRAITURE PRESS FEATURES
SINGLE-LENS REFLEX	11	11	LIMITED RANGE (NO PENTAPRISM)		ADVERTISING GENERAL WORK CLOSE-UPS
TECHNICAL		ROLLFILM BACK	11		SINGLE-CAMERA COMMERCIAL PHOTOGRAPHY
MONORAIL		ROLLFILM BACK	11	11	ARCHITECTURAL
TYPICAL LENS SETS: W. ANGLE NORMAL L. FOCUS	28mm 50mm 100mm	50mm 80mm 150mm	90mm 150mm 280mm	200mm 300mm 500mm	

Fig. 8.16. Summary of camera types, formats and principal applications. The most popular combination is a small format single lens reflex and a large format monorail system.

- (4) Single-lens reflex cameras are available in varied formats, most being 35-mm pentaprism types. The image is reflected by a hinged mirror; usually a focal plane shutter; pre-set diaphragm and screen rangefinder focusing aids. Operational features: No parallax error; visual check of depth of field; wide range of lenses; loss of image during exposure; mechanical complexity.
- (5) Technical (baseboard) cameras a large-format hand and stand type with front frame focused by rack and pinion on baseboard. Double/triple bellows extension; ground glass or rangefinder focusing; film loaded in holders. Press versions with additional focal plane shutter; scale focusing; frame finder. Operational features: Extremely versatile; some movements; wide range of emulsions and lenses (limited wide angle use); front focus only.
- (6) Technical (monorail) camera optical bench unit construction, using whatever components are required for an assignment. Operational features: unrivalled movements; accepts a wide range of lenses and emulsions; slow to use; stand essential.
- (7) Most modern camera units are parts of 'systems' intended to give maximum versatility. Components are seldom interchangeable with other systems so choose carefully in the first instance and build up the kit best suited to you and your work.

Questions

- (1) You are given the choice of two cameras of equivalent quality. One is a twinlens reflex with a between-lens shutter, and the other a single-lens reflex with focal plane shutter.
 - (a) Draw a clear, neat annotated diagram of adequate size showing the lens and mirror system in each camera.
 - (b) List the advantages and disadvantages of each camera.
 - (c) State your preference, giving principal reasons for your choice.
- (2) List in your own order of practical usefulness all the 'movements' you would expect to find on a monorail camera. Taking the first two camera movements on your list discuss the ways in which each will modify the image.
- (3) Two types of cameras are commonly used by professional photographers: the 5 × 4 technical camera and the 35-mm SLR. Give one example of the type of work usually associated with each, and explain, very briefly the advantages of each camera for its particular type of work.
- (4) Approximately what focal length of lenses would you consider suitable for use on a 4 in \times 5 in camera for making
 - (a) portrait heads,
 - (b) architectural interiors at close quarters,
 - (c) general outdoor scenes and landscapes.

In each case indicate the approximate maximum aperture you would expect in the lenses of your choice.

- (5) With the aid of diagrams describe the function of:
 - (a) An 'Albada type' viewfinder,
 - (b) a pentaprism viewfinder,
 - (c) bag bellows.
- (6) You are setting up a small photographic department from scratch. The department will be required to handle the following types of work:
 - (a) General catalogue illustration of small packages and containers in the studio.
 - (b) Copying diagrams to size.
 - (c) Regular progress pictures of a new factory extension.
 - (d) Colour slides of individual lathes at work, for projection at training lectures. You are allowed to order two different cameras with a maximum of two lenses for each. Write a short report describing the type of equipment you wish to buy and justify your choice.
- (7) What is 'parallax error'? Under what working conditions must the photographer remember to make allowances for this error, and how might the allowance be made?
- (8) Briefly indicate the relative merits and limitations of a 4-in \times 5-in monorail camera and a 6 cm square twin-lens reflex, both for use in general commercial photography.
- (9) What are the main design and operational differences between a long base coupled rangefinder and a focusing screen rangefinder. On what type of cameras would each be found.
- (10) List the size and type of camera together with focal length of lenses likely to be required for:
 - (a) Architectural photography.
 - (b) Portraiture (children) in the studio.
 - (c) Macrophotography.
 - (d) Studio commercial still life.
 - (e) Industrial (technical record).
 - (f) Feature photo-journalism.
- (11) Draw simple diagrams labelled to show the essential optical and mechanical principles of the following:
 - (a) A single lens reflex camera with pentaprism viewfinder.
 - (b) A camera suitable for architectural photography.
- (12) State the area of professional photography in which you are most interested. Describe one camera system you consider most suitable for undertaking this work. Assuming you first buy the standard body and lens, list *in order of priority* other items in the system you could justify purchasing. In each case explain your choice.

REVISION QUESTIONS COVERING SECTION 1 LIGHT, OPTICS, CAMERAS

- (1) Write a short essay describing the controls a photographer can exert over the final photograph by means of camera optics.
- (2) You are provided with a print from a photograph of a church which has been taken with a lens of 20 cm focal length. Could you re-photograph the church using a lens of 15 cm focal length to produce a visually identical result?
- (3) Discuss, with diagrams, the function on field cameras of the following:
 - (a) Swing front,
 - (b) rising front,
 - (c) back focusing,
 - (d) double extension.
- (4) Compare the advantages and disadvantages of camera shutters used:
 - (a) between the lens components,
 - (b) in front of or behind the lens,
 - (c) in the focal plane.
- (5) Using library references describe in about 500-750 words the general trends in camera design during the past ten years.
- (6) Define (a) Photomicrography
 - (b) Micro-photography
 - (c) Negative lens
 - (d) Positive lens
 - (e) Depth of focus
 - (f) Depth of field
- (7) Draw a diagram showing the principle of a single-lens reflex camera. What are the good points of this design?
- (8) A small object is being photographed and an exposure meter shows a reading of 4 sec at f/16. If the image as measured on the focusing screen is twice the size of the object (linear dimension), what would the actual exposure time need to be? (Calculations to be shown.)
- (9) Assuming sufficient coverage, calculate the lens focal length necessary to image a 15 mm object 12 cm high, using maximum bellows extension of 68.6 cm.
- (10) Using library references discover and briefly describe the uses of each of the following special purpose cameras: Endoscope camera; Periphery camera; Photo-finish camera. Include a simple diagram showing how each camera functions.

Section II

RECORDING THE IMAGE

First a piece of glass he coated With Collodion and plunged it In a bath of lunar caustic Carefully dissolved in water – There he left it certain minutes . . .

IX. THE SENSITIVE MATERIAL — MANUFACTURE

Having formed a controlled image of our subject – controlled that is in sharpness, size, shape and brightness – we require a convenient chemical method of recording it permanently.

There are many substances which are altered by the action of light (i.e., are 'light sensitive') and could therefore conceivably be used for photography. Some substances, such as dyes, are bleached by light; printed curtain fabrics are a familiar example. Other substances either darken, harden, soften or otherwise physically or chemically undergo change triggered by radiant energy. Some of these changes are particularly convenient for processes such as making printing plates, instrument recordings, and reproducing documents.

But as photographers seeking to record camera images under all sorts of conditions we require a substance which has very great sensitivity to the visual spectrum, reacting to it to give a finely detailed and permanent form of record. From the earliest days of photography, the most efficient chemicals to meet this specification have been the salts of silver. They remain the keystone to the chemical aspects of photography.

Silver Halides

In 1727 Johann Schulze, a German chemist, discovered that silver dissolved in nitric acid (silver nitrate) mixed with chalk visibly darkened under the action of light. He was able to place paper stencils around a bottle containing a solution of these chemicals; after leaving the bottle in sunlight for some time, the silver nitrate was shown to have recorded the pattern of the stencil. What in fact was happening was that the silver nitrate slowly 'decomposed' under the action of light to form very finely divided 'grains' of black metallic silver, which showed up darkly against the white chalk.

The early nineteenth century pioneers of photography, first attempting chemically to record camera images, soon found that silver nitrate alone was too slow in its reaction to light to be practical. However, increased sensitivity to light was noted when silver is combined with a *halogen* element (i.e., chlorine, bromine, iodine, etc.). Such a combination or 'compound' is known as a *silver halide*. *Examples*: silver chloride, silver bromide, silver iodide.

Furthermore, it was found unnecessary to wait the lengthy exposures for light to decompose these silver halides into sufficient darkened silver to be visible. The chemical image recording could take place in more convenient stages:

- (a) Just sufficient exposure to light for photons to form a few atoms of metallic silver invisible to the eye. (Minute quantities of halogen are also released at this stage.)
- (b) Amplification or 'development' of these few atoms by a suitable chemical solution, to form a strong visual image blackened in proportion to light struck areas.

(c) Chemical removal of all remaining silver halide which was not light struck and did not therefore develop, but which would otherwise slowly blacken as the image is examined in white light ('fixation' of the image).

Binder and Support

The practical form in which silver halide is presented to the camera image is a problem in itself. Obviously, the chemical compound must be spread over some suitable support such as film base or paper. Silver halide in a solution of water forms a virtually

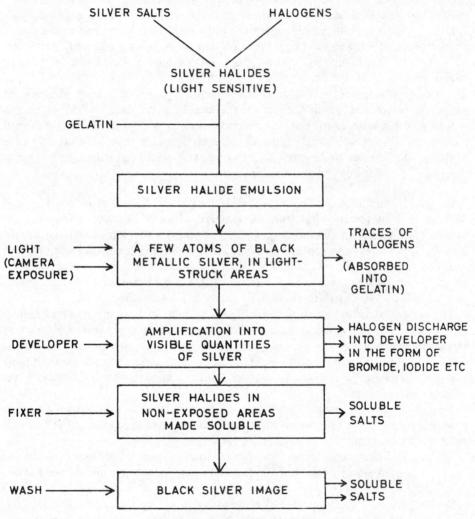

Fig. 9.1. The role of silver in photography.

insoluble creamy 'curd', consisting of millions of minute crystals clotted or 'coagulated' together. In this form it is impossible to spread them evenly over the support (essential if the material is to be evenly sensitive to light across its whole surface). When dried, the halide will also crystallise out and leave the support. Again, application of any developing solution is almost certain to dislodge halide crystals.

It is therefore necessary to use a 'binder' – an inert transparent substance which will envelope the silver halide crystals – commonly called 'grains' – holding them evenly suspended and attached to the support. Yet, like a sponge, the binder must allow entry and removal of processing liquids without dislodging any grains.

After decades of individual attempts to use binder substances ranging from white of egg (albumen) to gun cotton and ether (collodion), *gelatin* was found to combine ideal properties. Since its first suggested use by Dr. Maddox, writing to the 'British Journal of Photography' in 1871, research has yet to yield a more suitable binding colloid. The particular advantages of gelatin are:

- (1) Gelatin prevents coagulation of the silver halides, suspending them more or less evenly throughout the binder.
- (2) Warmed, gelatin forms a convenient liquid for mixing and coating on to the support yet it quickly sets ('gels') when chilled or dried.
- (3) Gelatin is highly transparent, grainless and virtually colourless.
- (4) Gelatin increases the speed of silver halides. This is thought to be due to its absorption of the minute quantities of halogen liberated when atoms of silver are formed during exposure. Without this absorption some halogen and silver would tend to recombine shortly after exposure a 'back-reaction' cancelling out some of the effect of light.
- (5) Gelatin is permiable, swelling when placed in solution to allow penetration of chemicals to the silver halides, and removal of any soluble compounds by washing, i.e., fixer dissolved halides. At the same time the silver halides themselves are unaltered in position at normal working temperatures.
- (6) Gelatin is easily obtainable and does not readilly deteriorate.
- (7) Processed and dried silver images held in gelatin are sufficiently tough to stand up to reasonable handling as prints, negatives, motion picture film, etc.

The combination of silver halides suspended in gelatin is known as 'silver halide emulsion'. In the pioneering days of photography individual workers would prepare and coat their own light-sensitive emulsions. Later certain businesses were established for the sale of emulsions in jars, for home coating on to glass or paper. But, as knowledge of emulsion preparation increased, refinements were added which took practical manufacture of light-sensitive materials out of the hands of the individual.

Today, the preparation of general purpose photographic materials has been wholly ceded to large organisations. Backed by extensive research, these are able to manufacture under ideal conditions and above all with *greater consistency* than the small firm or individual. Perhaps some of the magic of photography has been lost . . . but the average photographer who is more interested in visual images than emulsion chemistry welcomes the freedom this has given him.

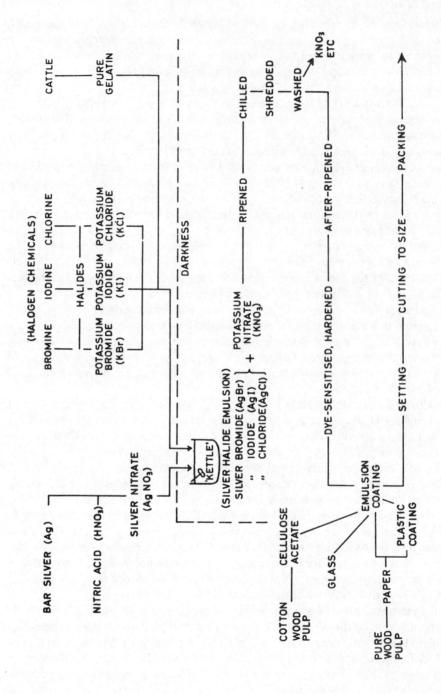

Emulsion Preparation

The photographic manufacturer requires a varied assortment of raw materials. These include large quantities of silver (the photographic industry being one of the world's largest users of silver). Photographic gelatin supplied from animal hides must be a controlled, consistent quality far higher than the type used for making jellies for human consumption. Even the type of grazing given to the cattle has a bearing on the final characteristics of the emulsion! Alkali halides, film base, chemically inert paper, and ample water supplies are also essential.

Silver halide may be formed by the action of a halogen gas direct on to silver. Iodine vapour condensed on a silver surface for instance forms silver iodide. This, however, is impractical for manufacturing purposes and instead both silver and halogen are converted into more convenient forms.

Bar silver is easily dissolved in dilute nitric acid to form the soluble compound silver nitrate. Silver nitrate crystals form a colourless solution in distilled water. The most photographically useful halogens, chlorine, bromine, and iodine are handled in the form of alkali salts or 'halides' – commonly potassium chloride, potassium bromide and potassium iodide. These also are white soluble crystals each of which dissolves to give a colourless solution.

According to the formula of the emulsion to be manufactured, the appropriate halides are dissolved together with gelatin in a large stainless steel container known as a 'kettle'. (A name derived from the popular use of kettles by early photographers to pour a coating of emulsion over their glass plates.) White lights are switched out and the silver nitrate solution added to the kettle. Immediately a white creamy 'precipitate' of millions of silver crystals forms.

Assuming that potassium bromide is the soluble halide in use, this rather spectacular creation of a thick white mixture from two clear solutions is chemically:

Silver Nitrate (AgNO₃) + Potassium Bromide (KBr)
$$\rightarrow$$
- soluble - - soluble -

Silver Bromide (AgBr) + Potassium Nitrate (KNO₃)
- soluble - - soluble -

(It is easy to make this simple emulsion yourself using 2 gm of silver nitrate in 20 cc of water and adding this to 5 gm of Potassium Bromide in 20 cc of warm water with a little powdered gelatin added. Spread over a sheet of blotting paper this crude light-sensitive coating will slowly darken under a white light. A drop of developer will cause the light struck halide it meets to blacken almost immediately.)

The actual preparation of a commercial emulsion calls for the addition of several other components formulated to improve the characteristics of the final material. The whole mixing process is strictly and accurately controlled in order to achieve consistency between different emulsion batches. Broadly, the type of silver halides formed are shown on the following page:

Emulsions for negative-making contain silver bromide and silver iodide
Emulsions for enlarging papers contain silver bromide
Emulsions for contact printing papers contain silver chloride
Emulsions for 'warm tone' enlarging papers contain silver bromide and silver chloride.

As formed in the 'kettle' the emulsion is still practically unusable. It is extremely 'slow' or insensitive by modern standards; it is very contrasty — unable to reproduce a range of greys between white and black; it is sensitive only to the blue end of the spectrum; and it contains many impurities and by-products (such as potassium nitrate). Further stages are necessary to improve its performance according to the final purpose of the product. All these stages must be carried out under appropriate safe-lighting.

RIPENING. This 'Ostwald' ripening or 'grain development' increases emulsion speed and in doing so lowers its contrast. The emulsion as originally formed contained very small equally sized silver halide crystals. As light sensitivity is directly related to halide size these small crystals made the emulsion 'slow'. All the crystals were equally light-sensitive, and up to a certain level of illumination none would form sufficient atoms of silver to become developable – but beyond this point *all* would be developable. This 'all-or-nothing' response made the emulsion develop either dense black or remain unaffected; in other words it was highly contrasty.

Now, in the ripening process, the emulsion is heated to a temperature of around 90°F and maintained there, sometimes for several hours. During this period some of the silver halides dissolve and re-form with others as larger grains, giving an emulsion containing a *mixture* of crystal sizes. The presence of these grains increases emulsion sensitivity and lowers contrast. (See plate 42.)

The reason for lowered emulsion contrast due to ripening can be simplified as follows. If the crystals are of mixed sizes (and therefore varied sensitivity) small quantities of light will affect large grains only, more light will affect large and medium sizes, and still more light will affect large, medium and small crystals. Thus these variations in light dosage reproduce in the developed emulsion as light grey, dark grey and black respectively, i.e., less contrasty performance.

This association between crystal size distribution, speed and contrast explains why fast emulsions often give 'grainy' low contrast negatives and 'fine grained' emulsions are often slow, with rather greater contrast.

'Washing'. After ripening, the silver halide emulsion is chilled to set it to a stiff jelly. The jelly is then shredded by passing it through a perforated plate. The 'noodles' or tiny pieces of gelled emulsion thus formed are then thoroughly washed in cold water to remove all soluble chemical by-products.

AFTER-RIPENING, OR DIGESTION. The emulsion is remelted and subjected to further heat treatment, similar to original ripening, but without the various by-products present. This increases speed and contrast up to a fixed maximum at which 'fog' (overall darkening of even unexposed silver halides) becomes noticeable.

Speed improvement is due to the action of sulphur impurities in the gelatin forming minute silver sulphide 'sensitivity specks' on the crystal surfaces. These improve the ac-

SILVER HALIDE GRAINS

Plate 41 (Right) Emulsion grains after emulsification ×2,500. As represented in the figure below, an emulsion consisting of small, equal sized grains has very slow, contrasty characteristics—all grains become developable at one exposure level.

		IM	AGE	BR	IGHT	NESS		
	ļ	111	##	Щ	###	ЩЩ		
	Δ	Δ	Δ	Δ	Δ	\triangle	•	•
>	Δ	Δ	Δ	Δ	Δ	\triangle		•
7	Δ	Δ	Δ	Δ	Δ	\triangle	A	•
SENSITIVITY	Δ	Δ	Δ	\triangle	\triangle	\triangle	•	•
SEN	\triangle	\triangle	Δ	\triangle	\triangle	\triangle	•	•
AL	\triangle	\triangle	\triangle	\triangle	\triangle	\triangle	•	•
EQUAL	Δ	Δ	Δ	Δ	\triangle	\triangle	•	•
			,					

Plate 42 (Right) Emulsion grains after full ripening ×2,500. A mixture of large as well as small grains is not only faster but can produce a range of densities reproducing a tone range image. See page 166.

Plate 43 Emulsion grains during development, showing development centres. (Approx. ×2,500.) (F. S. Judd, Research Laboratory Kodak Ltd., London)

CONVERSION TO LINE

Plates 44 & 45 Use of high contrast material to reduce a continuous tone subject to powerful graphic shapes of black and white. (R. Gothard)

IRRADIATION

The effect of irradiation (exaggerated by overexposure) in line copying.

Plate 46 (Top) The original scraper board drawing.

Plate 47 (Centre) Overexposure in negative making—'spreading' the whites of the final copy.

Plate 48 (Bottom) Overexposure in printing from a correctly exposed negative—'spreading' the *blacks* of the final copy.

GRAIN

Plate 48a (Overleaf) Coarse grain structure used for graphic effect. Original image midtones are generally most broken up. This picture of Cologne cathedral was enlarged from a portion of overdeveloped 400 ASA 35 mm film, and printed on very hard bromide paper.

tion of light in forming silver atoms during exposure.

DYE SENSITISING. Next, small traces of special dyes are added. These extend the emulsion's response to light of green and red wavelengths. Other 'doctor' solutions are added at this stage to make minor improvements to emulsion properties. The emulsion is now ready for piping to the base-coating machine.

Recapping the contents of a photographic emulsion:

- (1) The most used light-sensitive chemicals are compounds of silver with halogen elements chlorine, bromine and iodine. These compounds are known as silver chloride, silver bromide and silver iodide – collectively termed 'silver halide' crystals.
- (2) Silver chloride is used for contact printing papers and used with silver bromide in warm tone enlarging papers. Silver bromide, being faster, is used for enlarging (bromide paper), and used with silver iodide for negative materials.
- (3) In order to coat these crystals evenly on a base, and later allow them to be acted upon by liquid chemicals without washing away, gelatin is mixed with a silver halide as a binder. It also improves the silver halide's response to light.
- (4) For manufacturing convenience, silver in the form of soluble silver nitrate, is mixed with a soluble salt of the halogen known as a 'halide' (e.g., potassium chloride, potassium bromide, potassium iodide) and gelatin. This 'precipitates' silver halide crystals.
- (5) After mixing in a 'kettle', the silver halide grains are ripened by heat treatment; this increases grain size and speed, and lowers contrast. Chilling and shredding allows the removal of unwanted chemical by-products by washing. After-ripening increases speed and contrast by forming 'sensitivity specks' on the crystals. Finally dye-sensitising extends sensitivity to light of longer visual wavelengths than blue.

Coating

Together with the emulsion-preparation department, the coating track used in photographic materials manufacture is one of the most clinically clean industrial processes. The whole coating plant is housed in an air-conditioned building in which temperature and humidity levels are critically monitored. Dust is rigorously cleaned from incoming air and all operatives must change into special lintless clothing from head to foot before entering critical areas. Standards of cleanliness must be as high as those in an operating theatre or pharmaceutical laboratory – chemical or physical impurities of many forms could otherwise cause the scrapping of thousands of pounds worth of coated material.

Paper or film base is usually coated in rolls 120 cm wide and 600 m long. Methods of applying the emulsion to the base vary. In one type of installation the prepared base is looped under a roller which brings its surface just in contact with warm emulsion piped into a shallow stainless steel trough. Drawn under the roller and up out of the trough, the base picks up an appropriate coating of emulsion – a coating which must be of even,

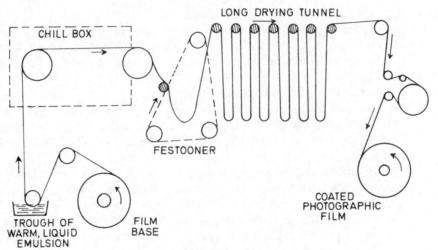

Fig. 9.3. Film coating machine layout.

specified thickness, free of air bubbles, impurities and abrasions. To form 600 m of consistent photographic material is no mean achievement, particularly, as in the case of fast films, when all operations must be carried out in total darkness.

From the coating trough the coated base passes through a chilling chamber where refrigerated air sets the emulsion to a stiff gelatin, after which it has to be dried. In one widely used type of installation drying is achieved by passing the coated base in festoons down a drying tunnel some 100 m long, until the emulsion is sufficiently hardened for the coated material to be wound on a spool, ready for cutting to size.

Although emulsions today are coated on bases ranging from plastic to paper laminated to metal foil, the two which the general photographer is most likely to handle remain – film and paper.

FILM. The earliest filmbase used in photography was cellulose nitrate, which was both highly inflammable and inclined to deteriorate after a few years. Today we use two types of 'safety film' which are so slow-burning as to be virtually non-inflammable. These are (a) polyethylene terephthalate (a polyester plastic better known as Kodak 'Estar' base), which is tough and dimensionally very stable. It is used for most sheet films where its flatness or rigidity is important; and (b) cellulose triacetate, which is thinner and more flexible and is used for the majority of roll and 35 mm films where long lengths must be accommodated in small spools or cassettes. The manufacturer first 'keys' both sides of the film base or coats them with a foundation layer of gelatin and cellulose estar known as the 'subbing' layer. Next, the emulsion is coated over the subbing on the face of the film (sometimes several layers of differing emulsions are coated, according to the required overall characteristics of the film).

When dry a thin top or 'supercoat' of gelatin is added. Silver halide grains become developable after the action of light and also if they receive abrasions. Without the protective layer of gelatin friction from packing material or handling by the

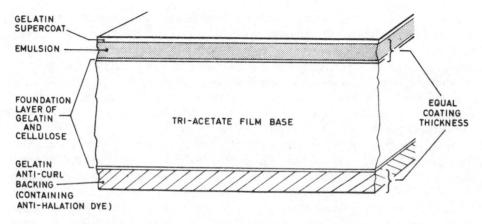

Fig. 9.4. A cross-section of photographic film.

photographer would cause silver halide grains at the top of the emulsion to later develop, giving black 'abrasion marks'. Even the supercoat has its limitations, and care should always be taken when handling photographic materials to avoid rubbing or scratching the light-sensitive surface.

If emulsion and supercoat was applied to one side of a film base and allowed to dry, the base would become tightly curled, owing to the 'pull' of the contracted coating on one surface only. Therefore, a thick gelatin 'anticurl' layer is coated over the keyed or subbed *back* of the film. The thickness of this layer is matched to that of the emulsion-plus-supercoat, evening out the relative pull on the two surfaces of the film base.

The anticurl backing layer usually contains a dye designed to absorb image light which, having passed through the emulsion, might otherwise be reflected from the film/air boundary back to the emulsion. Such reflection would form 'halos' around image highlights. The dye is therefore known as 'anti-halation' backing (see Fig. 10.1 on page 181). The backing is destroyed during processing.

Sometimes a grey anti-halation dye is incorporated instead in the film base itself. Here it also prevents 'light piping' fogging effects when light strikes the edges of the film, e.g. through the end protruding from a 35 mm cassette. Dye in the base remains present in the processed negative but its even, overall density has no effect on image quality.

Fig. 9.5. Typical edge notch coding for (left) Kodak B & W negative; (centre) Ilford B & W negative; (right)

Daylight Ektachrome sheet film.

From our own point of view film as a base has many practical features. It is flexible, robust, lightweight and compact. The last two are particularly important if you have several thousand negatives in your files — in the old days of glass plates these could take up an entire room.

It is easy to locate the emulsion surface of sheet film in the dark because of a notch cut into the film edge (see Fig. 9.5). When the film is held with the notch at the top right hand corner the emulsion faces the operator. Most manufacturers *shape* the notch to denote the type of film according to a published code. Some sheet film intended for copying and safe to handle in relatively bright safelighting may not be notched.

Modern polyester based film is also dimensionally stable for the vast majority of professional applications and will not appreciably change in size within normal variations of temperature and humidity.

GLASS PLATES. Before the invention of film base all photographic camera materials were coated on sheet glass and were known as 'plates'. Glass plates were still in regular use for large format cameras as late as the 1950s and many secondhand field cameras are still found with plate rather than film holders. Fortunately most can be adapted. Plates are inconvenient because they are heavy, easy to break, awkward to handle and process, and expensive to manufacture. A few are still made for specific scientific applications of photography where a rigid base, dimensional stability, and resistance to decomposition are important.

PAPER. An obvious requirement of paper base for photographic materials is that it should be capable of undergoing liquid processing and washing without disintegrating. It must also be as free as possible from any chemical traces which may interact with silver halides. Such paper is specially milled for photographic manufacturers, with a range of thicknesses or 'weights'. In addition the paper base is of two main kinds; fibre and plastic-coated fibre. Each of these is differently structured and also has to be

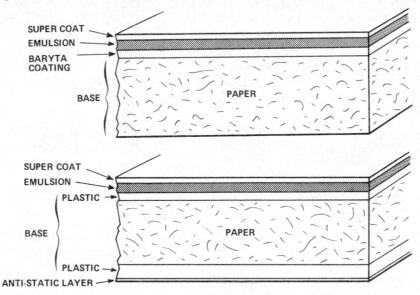

Fig. 9.6. Enlarged cross sections of (top) paper base single weight bromide paper, and (bottom) plastic coated base bromide paper. Note plastic is thicker on rear surface of paper to counteract 'pull' of emulsion layer etc., and so prevent paper curl.

handled rather differently by the photographer in processing and drying (see page 345). *Non-plastic-coated paper* receives a layer of barium sulphate ('baryta coating') before being emulsion coated.

This is a dense, intensely white chemical which serves four purposes:

- (1) It increases the reflectance or whiteness of the base, thereby extending the range of tones in the highlights which the photographic print can reproduce.
- (2) It acts as an inert seal between the emulsion and any paper base impurities or harmful photographic chemicals, which, absorbed into the paper during processing, are not fully removed by washing.
- (3) It forms a subbing layer for the emulsion.
- (4) By treating the baryta in various ways, papers of various surface textures are formed (see page 331).

After emulsion-coating a gelatin supercoat is added, which may be of extra thickness if the paper is intended for eventual glazing (see p. 348). The fibrous nature of paper means that it has sufficient 'give' to accept the baryta, emulsion and supercoat without appreciable curling, making anit-curl backing unnecessary. This flexibility also means that a paper print will change in dimensions slightly during processing and drying – an image measured to an exact size under the enlarger can turn out larger or smaller on the final print.

Plastic-coated paper (also known as RC or PE paper) consists of paper fibre coated front and back with a waterproof polyethylene resin. Photographic emulsion is coated over the top resin surface and a supercoat added. There is no baryta layer. An anti-static, anti-curl layer is added to the back resin surface. The reasons for resin coating paper base are:

- (1) The paper will not absorb processing solutions, so that washing and drying times are dramatically reduced.
- (2) The material is much more dimensionally stable, and dries flat even when airdried.
- (3) It is possible to manufacture a really smooth top surface to glossy papers so that air-drying only is needed to give a perfect glazed surface. A glazing machine is not required.
- (4) Plastic coated paper is well suited to processing by machine, using high temperature solutions and automatic washing and drying stages.

Some printing papers are coated with an emulsion that has a developing agent added. Such papers are designed for rapid 'stabilisation' processing, explained on p. 346. Whilst the vast majority of printing papers are white based it is possible to add dye to the baryta layer in manufacture and so produce a colour-tinted base. Some manufacturers therefore offer photographic paper in a range of colours, from gold to fluorescent green, p. 333.

Size Cutting

Film, paper, etc., coated in rolls are cut into standard sizes before packing. Materials

sold in sheet form are available in a wide range of sizes, as reference to any current catalogue will show. Any special sizes up to the maximum width the manufacturer is able to coat can be supplied in sheets or rolls, provided a set minimum quantity is ordered. The most commonly used formats are as follows and it will be noted that many of them run in 'families':

TABLE 9.1
POPULAR SIZES OF PAPER AND FILM

Paper (Previous equivalent size in brackets)	Sheet Film*	Obsolescent† Sizes
9 × 14 cm (Postcard)	$9 \times 12 \text{ cm}$ $10 \cdot 2 \times 12 \cdot 7 \text{ cm } (4 \times 5 \text{ in})$	$3\frac{1}{4} \times 4\frac{3}{4}$ in (Quarter Plate) $4\frac{3}{4} \times 6\frac{1}{2}$ in (Half Plate)
$20 \cdot 3 \times 25 \cdot 4 \text{ cm } (8 \times 10 \text{ in})$	$20.3 \times 25.4 (8 \times 10 \text{in})$	$6\frac{1}{2} \times 8\frac{1}{2}$ in (Whole Plate)
21×29.7 cm (A4)		
$24 \times 30.5 \text{ cm} (10 \times 12 \text{ in})$		
$30.5 \times 40.6 \text{ cm} (12 \times 15 \text{ in})$		
$40.6 \times 50.8 \text{ cm} (16 \times 20 \text{ in})$		
also rolls up to $135.9 \text{ cm } (53\frac{1}{2} \text{ in})$ wide, 30 metres long		

Roll & Miniature Film

Maximum Width of Picture (Nominal)	Size Coding	Notes
13 mm	110	Single perforation, in cartridge
24 mm	135	Double perforation, cassette loaded
28 mm	126	Single perforation, in cartridge
4 cm	127	Unperforated, rolled in backing paper
	(120	Unperforated, rolled in backing paper
6 cm	620	(220 is double length, allows
	220	twice the number of frames)
6cm	70 mm	Double perforation, for cassette loading
	of Picture (Nominal) 13 mm 24 mm 28 mm 4 cm	of Picture (Nominal) 13 mm

^{*}The actual cut size of sheet film is minutely smaller, to slip into holders.

Metrication has created problems in reconciling long-established British and Continental paper and sheet film sizes. Nominal metric dimensions for future materials have been agreed internationally (some differ from the table above) but have not yet all been generally adopted.

Film destined for roll, miniature, or motion picture film use is slit to the appropriate

[†]Intended to be phased out gradually over the years as fewer cameras for these sizes are used.

width and perforated as required. The table opposite lists sizes most frequently used for still photography, with codings where used. Only the maximum width of roll film picture can be quoted, as the other dimension depends upon the camera and the number of shots per roll it is designed to allow.

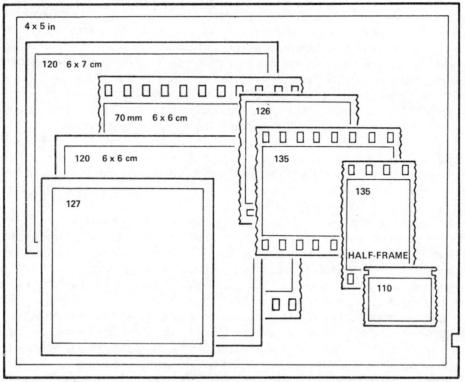

Fig. 9.7. Commonly used picture formats on various film sizes, drawn here full size.

Anyone who has to pay for his materials is tempted to use every square inch of emulsion. But this can lead us to the pitfall of composing pictures to fit manufacturers' sizes of film or paper. Why should a photograph just fill a 21×29.7 cm, 30.5×40.6 cm or some other standard format? Why not 30×10 cm or 30 cm square, or any other shape which suits the picture content. Often enough the client stipulates format proportions, to suit a layout or frame. But when he leaves this to the photographer, be influenced by the picture rather than the manufacturers stock list. There is enough conformity in photography without stereotyping picture shapes too.

Packing

SHEET FILM. Sheet, also known as 'cut' or 'flat' films are most commonly marketed in boxes containing 25 sheets (10 sheets in the case of colour material). All sheets are

wrapped in one package with the emulsion facing the same way and in some cases interleaved with a sheet of black paper the same size as the film. A sheet of cardboard backs up the pile as a stiffener.

As shown on p. 169, most sheet film is notched for identification of emulsion position and type. Nevertheless, in the dark it is still possible for the inexperienced worker to load a film together with an interleaving sheet (over the emulsion surface!) into a film holder. By feeling around the notch always check whether the film is completely free of such paper. In some countries, such as the USA, sheet film is also marketed in film packs. Packs contain up to 16 thin sheets of film, each sheet being attached to a piece of backing paper about twice the long side of the film, with a numbered tab protruding out of the film pack through a light trap at one end. For use the pack is placed in a film adaptor which then fits a large format camera like any sheet film holder. The pack is so assembled that having exposed the first sheet of film tab 1 is pulled to transport the sheet into the back half of the pack. This leaves sheet 2 facing the camera lens. The long paper tab now hanging from the pack is torn off and you are ready for the next exposure. (Exposed film is finally removed from the pack in the darkroom, each sheet being separated from its backing paper before processing in the same way as other sheet film.)

Instant picture (e.g. Polaroid) film is sold in a special form of 8-exposure pack. This fits in a film pack adaptor – similar to the one described above but with a pair of spring-loaded rollers to crush and spread a pod of chemicals as each exposed sheet of film, faced with its receiving paper, is pulled completely out of the pack (see p. 322).

ROLL FILM. This is essentially a length of film attached at its leading end to a backing paper considerably longer than the film itself. Wound up tightly on a spool with solid flanges this allows the film to be loaded into a camera, and removed after full use, in subdued daylight (not sunlight). Numbers on the rear of the backing paper viewed through a suitable window in the camera back indicate the correct amount of wind-on between exposures. Roll films sold to professional users are packed in packs of five.

35 mm FILM. Perforated 35 mm film for still photography is most frequently supplied either in 5- or 15-metre bulk lengths or shorter 36 exposure refill lengths, or loaded in light-tight cassettes of 36 or 20 exposures. These use no backing paper – the first few inches of 35 mm film itself protruding out of the velvet light trap of the cassette being fogged by light when the camera is loaded. This length must therefore be wound on after the camera back is closed and before exposures commence. The number of exposures made is indicated on a counter built into the camera and linked to a toothed wheel which engages with the perforations and rotates as the film is wound on.

The film as exposed is taken up on an open spool fixed within the camera. Since there is no backing paper the film would fog in this position if the camera back were opened after the last exposure. The film must therefore be *rewound* into the casette before opening the camera.

35 mm film is also marketed attached to backing paper in a quick-loading cartridge. This consists of a light-tight plastic housing containing feed compartment, film plane and format aperture, and take-up spool. The whole pack simply drops into the back of

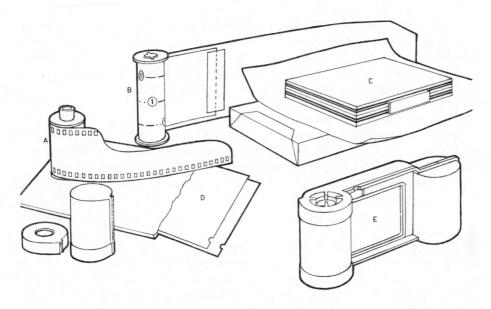

Fig. 9.8. Packing of negative materials. A: 35 mm 36 or 20 exposure cassette – this type contains a velvet 'light trap' at the feed slot and is not intended for reloading. B: 120 rollfilm, showing leading edge of film attached to the backing paper. C: Glass plates – emulsion surfaces are separated by cardboard spacers. Three packets of four plates are packed to a box. D: Sheet film. E: Disposable plastic cartridge containing single perforated 35 mm wide film with backing paper.

specially designed cameras and engages with a film transport system. At the end of shooting no rewinding is necessary and the whole unit is removed and broken open in the darkroom for processing. Smaller cartridges are made holding 16 mm film for pocket size cameras.

PAPER. Printing paper is packed in a wider variety of sizes and quantities than film. Apart from rolls for bulk-printing machines or giant enlargements, paper in sheet form is marketed in packets of 10 and 25 sheets, and boxes of 50, 100 and 250 sheets. Cost per sheet is less when the larger quantities are bought.

Sheet paper is packed with the emulsion surfaces all facing one way and one top sheet facing the rest. Before packaging or boxing it is wrapped in a black moisture-proof plastic bag.

Storage

Conditions of storage are more important than length of storage. Light-sensitive materials will rapidly deteriorate if stored under humid, hot, fume-laden, chemically or radioactively contaminated conditions. Most manufacturers now market sheet and roll film in heat-sealed foil wrappings as standard, and all will supply their products specially 'tropically wrapped' to order.

Unless packaged in sealed foil envelopes or sealed cans, materials should be kept well away from areas in which chemicals are mixed or drying undertaken. They must be protected from coke boiler fumes and industrial gases, vapours emitted by many modern adhesives, mothballs, solvents and cleaners. The ideal storage place is in a refrigerator, which offers low humidity and chemical insulation as well as low temperature. It should be set to normal domestic requirement.

In practice, photographic materials are too bulky and refrigerators too expensive for storage of black and white materials. But use of a refrigerator is an economic proposition for costly colour materials, particularly colour paper, where utmost box-to-box consistency is vital. (When removing materials from refrigerated storage they should be left at least an hour at room temperature before use. Unless the contents are allowed to equalise air temperature in this way there is a risk of moisture condensing on the emulsion or base surface when the box is opened. This is rather like the case of condensation on camera lenses discussed previously.)

The next best storage place to a refrigerator is a well-ventilated cupboard, with slatted shelves, where the temperature is likely to remain below 65°F. No materials should be stored at floor level if there is any risk of a flood ever occurring from some nearby darkroom. The signs of unsuitable storage conditions vary from a grey veil of 'fog' on the processed emulsion, which may be caused by fumes, to a patchy mottle or even disintegration of gelatin resulting from extreme damp. In most cases the material is more affected around the edges than in the better protected central areas.

From the foregoing it can be seen that the expiry date appearing on some boxes of negative material is only a guide to their average life under storage conditions laid down by the makers. There is no question of the material suddenly becoming useless beyond this date, but given time, sensitivity will slowly reduce, fog level rise and contrast alterations take place. These effects are most noticeable with colour materials which carry several emulsion layers finely adjusted in their relative characteristics.

Very fast black-and-white negative emulsions and certain special materials such as infra red sensitised films may also change rapidly with time as well as storage. Under good conditions black-and-white printing paper alters least with time, and this explains why boxes of paper are not date-stamped. However, it is a sensible move to stamp the date on boxes of paper as delivered, in order to ensure that stock is 'rotated' – used up in correct order of age.

Take care to protect all materials from X-ray or other radioactive sources. As we saw on p. 21, these have a strong penetrative effect and will fog film or paper through all normal packaging. Risks may occur in hospitals, industrial plant and laboratories, or at airports where luggage undergoes X-ray inspection. Special lead-foil 'bag shields' can be bought to give protection.

N.B. The same reaction to unfavourable storage conditions applies to photographic materials which have been exposed and are awaiting processing. Even under good conditions there is some risk of 'loss' of exposure if processing is delayed. Colour materials may show apparent underexposure when processing is delayed for weeks. Black-and-white emulsions may similarly be affected over a period of months.

Chapter Summary - The Sensitive Material - Manufacture

- (1) Salts of silver are the most suitable photographic light-sensitive chemicals. Compounds of silver with halogen elements (silver halides) quickly decompose under light forming a few atoms of black metallic silver which can later be developed to give a visible chemical record.
- (2) The most useful *halogens* chlorine, bromine and iodine, are most often handled in the soluble alkali *halide* form, potassium chloride, potassium bromide and potassium iodide. Combined with silver, these form silver chloride (contact and warm-tone papers), silver bromide (enlarging and negative materials) and silver iodide (negative materials) respectively.
- (3) In commercial photographic material manufacture silver is first converted to silver nitrate, and the required halogen to an alkali halide. Mixed, together with gelatin, light sensitive silver halides are precipitated as myriads of insoluble crystals.
- (4) These silver halides are conveniently suspended in a gelatin binder. Gelatin prevents coagulation of crystals, is easily coated on to a base, allows entry of processing solutions, increases the speed of silver halide; it is transparent, grainless and fairly tough when dry. A suspension of silver halide in gelatin is termed a 'photographic emulsion'.
- (5) The emulsion is further ripened, chilled, shredded and washed, after-ripened and dye-sensitised prior to coating.
- (6) Emulsion preparation and the coating process demands exceptionally high standards of cleanliness, temperature and humidity to give reproduceable emulsion batches.
- (7) The emulsion is usually coated (a) on cellulose triacetate or polyester (with subbing, supercoat, anti-curl and anti-halation dye layers), (b) on paper (with baryta coating and supercoat), or (c) on paper coated both sides with plastic (plus supercoat, and anti-static/curl rear layer).
- (8) Triacetate film-based materials would be chosen whenever thinness, flexibility, and light-wieght are advantages. Polyester film has the added advantage of dimensional stability.
- (9) Plastic-coated (waterproof) paper washes and dries faster, and has greater dimensional stability than uncoated base paper. It dries flat and can provide a high gloss surface finish without glazing.
- (10) Emulsion deterioration is hastened by bad storage conditions. Materials should be stored in dry, cool conditions, well away from chemical fumes. Colour materials most rapidly react, revealing signs of staleness by their changed characteristics.

Ouestions

(1) Write a simple description of the preparation of a silver halide emulsion prior to coating.

- (2) What kind of photographic materials might be expected to be stored in a refrigerator, and why? What precautions if any should be taken when removing sheet film from the refrigerator for loading slides?
- (3) What is the practical purpose of each of the following:
 - (a) Baryta coating,
 - (b) emulsion supercoating,
 - (c) foil-sealed wrapping for photographic materials.
- (4) Once photographic materials for professional use were exclusively coated on glass plates. Most sheet negative material in 'medium format' $(9 \text{ cm} \times 12 \text{ cm} 4 \text{ in} \times 5 \text{ in})$ sizes used today is coated on a film base. Explain the reasons for this change, pointing out any potential disadvantages of film as a base.
- (5) Explain briefly why very fast photographic materials tend to be more 'grainy' and of lower emulsion contrast than slower materials.
- (6) What is the International paper size 'A4'?
- (7) What are the practical differences between printing papers which use a plastic-coated base, and those using a plain paper base?
- (8) Explain the following terms:
 - (a) film notch codings
 - (b) film packs
 - (c) 'rotation of stock'.

X. THE SENSITIVE MATERIAL – CHOICE OF EMULSION

However intriguing the preparation of light-sensitive materials, this is a field now well left to specialist manufacturers. As users, our interests lie in the actual *performance* of a photographic emulsion under practical conditions.

Which is the best emulsion for a particular assignment? Catalogues can be confusing and advertisements biased. As with the choice of a camera we have to correlate the type of subject and type of picture required with the material offering the most suitable allround characteristics. We really need to know at least four 'vital statistics' about a negative emulsion before judging its suitability. These are:

- (1) Contrast
- (2) Resolving Power
- (3) Speed
- (4) Sensitivity to colours

Directly linked to grain size.

Emulsion Contrast

The inherent 'emulsion contrast' of a photographic material means in simple terms the range of grey tones it is capable of forming between darkest black and almost complete transparency, given that it is correctly exposed and developed as recommended by the manufacturer. Films can be divided broadly into two contrast categories: low or medium contrast general purpose materials; and high contrast special purpose types. As we saw in the previous chapter (plates 41–2), the tendency is for low contrast emulsions to contain large as well as small grains and therefore to be faster and of coarser grain than high contrast emulsions.

Low (OR MEDIUM) CONTRAST EMULSIONS. Bear in mind that a negative is essentially an intermediate between camera image and final print. Most beginners in photography value a contrasty negative because it looks 'bright and clear'. But with experience, and remembering that the majority of camera subjects have a wide range of brightness between shadows and highlight, it is better to aim at a negative which may look rather 'flat' compared to a print or colour transparency. This is better able to contain a great variety of separable grey tones representing the most subtle variations in subject tone values. Later, in printing, contrast can be increased by using an appropriate grade of paper to expand (brighten) all or at least the most important of these tones. It is difficult to get a similarly good print from a contrasty negative which has very few greys between black and white.

Negative materials for the majority of general camera work are therefore of low contrast, although varying slightly according to their speed – fast films being of lower contrast than slow films. These materials are also used for the copying of continuous-tone

originals (e.g. paintings, photographs, artwork etc. having a more or less continuous range of tones from highlights to shadows).

HIGH CONTRAST EMULSIONS. With some subjects we are not much concerned with the rendering of grey tones, Printed text, plans, pen-and-ink drawings are all examples of originals which consist of simple black and white only. They are generally termed 'line' originals. We can therefore concentrate on rendering a dense rich black, plus a clean white. Now it is a fact of life that the black parts of line documents seldom, if ever, absorb 100% of the light used to illuminate them. Similarly white paper areas do not reflect 100%. For this reason — and because of some scatter of light within the lens itself — the optical image presented to the film has slightly diluted blacks and whites. It is therefore helpful to record this image on a high contrast emulsion designed (when exposed and developed as recommended) to give dense black or virtually clear film, with virtually no tone values in between.

Most line emulsions, and the more extreme contrast lith emulsions, are available on sheet film only. A few are also made in 35 mm. They are all relatively slow and fine-grain, and as they are mostly used in the copyroom or darkroom with subjects devoid of colour they are mostly insensitive to orange or red. This allows them to be handled under bright safelighting (p. 185).

Occasionally we may wish to convert a more normal camera subject or a continuous-tone photograph or painting into pure black and white. The result may be needed for graphic effect in a poster etc. (plate 45). It may be possible to work direct from the (low contrast) negative, printing on extremely high contrast paper. But more satisfactory results are usually possible by making a high contrast negative and then printing this. Since we have seen that these emulsions are really too slow and colour insensitive to use on everyday camera subjects — animate people etc. — it is usually better to photograph on normal film and make a continuous-tone print. The print is then copied on high contrast film. Of course, knowing that your final result will be simplified to pure black and white, it pays to take appropriate care in arranging and lighting the original subject. All details darker than mid-grey will be merged into black, while all lighter details will combine into white.

High-contrast emulsions are also useful for exaggerating very low contrast, barely visible tonal detail in technical subjects such as metal erosion, hair cracks, etc.

N.B. A more objective, analytical assessment of emulsion and negative contrast is discussed under gamma and contrast index, pp. 237 and 239.

Emulsion Resolving Power

The ability of an emulsion to resolve fine detail is of equal practical importance to lens quality. Emulsion resolving power is noticeably reduced as (a) grain size becomes coarser, and (b) emulsion thickness becomes greater.

Silver halide crystals are exceedingly small – one-tenth of a square inch of emulsion may easily contain more grains than the world contains people. But they are also coated up to fifty or more grains thick. Light passing into the emulsion is scattered by the

thickness of this overlapping grain population so that it effects a larger area of the film, slightly 'spreading' the recorded image. The effect of this '*irradiation*' is to make poorer the detail resolved in highlight areas. The more exposure the worse irradiation becomes.

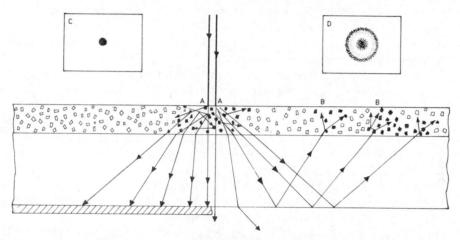

Fig. 10.1. Irradiation and Halation. Light from an image highlight is irradiated by grains within the emulsion at A. some scattered light is internally reflected at the rear surface of the base (film or glass) if this is unbacked, returning to the emulsion as a ring of halation at B. Top: Magnified image of a highlight made (C) on effectively backed thin emulsion film and (D) overexposed on unbacked thick emulsion material.

Some of the irradiated light passes through the emulsion and may be reflected back by the rear of the base as *halation*. Scatter may then occur again as the ring of reflected light is irradiated within the emulsion.

Definitions: 'Irradiation' - light scatter within the emulsion layer, causing spread of the recorded image. Irradiation is made worse by overexposure and the use of thickly coated emulsions.

'Halation' – light, noticeably from image highlights, reflected from the rear of the base back to the emulsion – forming 'halos' around each highlight. Halation is largely eliminated by anti-halation backing dye which either absorbs most of this light, or reflects back only wavelengths to which the emulsion is insensitive.

With most generally lit scenes the effects of strong irradiation and halation are simply to give a grey, degraded and poorly resolved negative. However, with subjects containing intense individual highlights, such as night scenes containing street lamps, these may record as 'cotton-wool balls' surrounded by geometrically perfect halos. If you are purposely aiming for this in an attempt to symbolise intensely bright light sources, use a thick emulsion (fast) film — backed up with a sheet of aluminium foil.

Whenever we require maximum emulsion resolving power — as when making detailed record photographs on small-format negatives — a fine-grained, thinly coated, efficiently backed emulsion is desirable. We should take care not to overexpose. Because of this influence of grain size and coating thickness on resolving power, high resolution emulsions are inevitably 'slow' in their sensitivity to light.

Emulsion Speed

The sensitivity of an emulsion to light is expressed by its 'speed'. The more highly responsive an emulsion, the 'faster' it is said to be — and the less exposure it requires to give an acceptable result. Speed is therefore inversely proportional to the exposure required. In order that we may accurately compare the light sensitivity of different materials, 'Speed Rating Systems' have been evolved by various independent bodies. Each system applies numbers to emulsions to denote their relative speeds. The higher the number the greater the speed, but the rate at which numbers increase with speed varies from system to system. The systems we are still likely to meet today are of two main kinds:

- (1) Arithmetical speed ratings doubling of speed is denoted by a doubling of the number. This is the basis of the ASA (American Standards Association) and BS (British Standard) arithmetical system, and of the GOST system used by the USSR and several East European countries.
- (2) Logarithmic speed ratings doubling of speed is denoted by a numerical increase of three. This is the basis of the *DIN* system of the German standards organisation, used extensively in Europe and elsewhere.

Although there are still minor differences between methods of defining speed numbers between the various systems, e.g. between ASA and GOST, direct conversions can be made as shown below:

TABLE 10.1
SPEED RATING EQUIVALENTS, B & W FILMS

Speed:	v. s	low	med	lium	fa	ist	V	. fast
ASA/BS/GOST DIN	16 13	32 16	64 19	125 22	250 25	500 28	1000 31	2000 34
Grain:	v.	fine	fi	ne	med	lium	c	oarse

The sequence of the two rows of numbers shows a progressive doubling of emulsion speed. Note how the fastest films have the coarsest grain. Most negative materials used on a general day-to-day basis for commercial photography have speed ratings between ASA 125 and ASA 400. It is possible to 'up-rate' most films (expose them as if they had a higher ASA rating) and then compensate by increasing development (or 'pushing'). However there are distinct limits to this technique (see p. 242).

Remember speed rating sequences and equivalents when using several emulsions.

EXAMPLE: If an exposure of 1 sec at f/8 proves correct on material of ASA 125, the same subject photographed on another emulsion of ASA 32 (one-quarter as sensitive) will require 4 sec. In calculating these exposure alterations first make a mental note of whether the new exposure should be longer or shorter (i.e., is the new emulsion slower or faster?). It is an easy mistake on seeing a lower speed number to assume that a shorter exposure time is required.

In practice, the speed rating of an emulsion can only be a guide. Apart from grain size and coating thickness *effective* speed varies with:

- (1) The colour of the lighting on the subject. All emulsions are highly sensitive to blue, but one which is also sensitive to red wavelengths might be almost as fast in reddish studio lighting as in daylight. Another film sensitive only to blue would be considerably slower than its daylight speed used under these conditions. Published speed ratings usually apply to daylight only. When using non redsensitive film (i.e. for monochrome copying) in the studio its daylight speed may be halved or even quartered.
- (2) The type and degree of development the film is to receive. Speed ratings hold good only for 'normal' development conditions. Some fine-grain developers for example effectively halve emulsion speed. Alternatively you may be intending to over-develop and increase effective speed. Influence of development is particularly pronounced with line materials this plus (1) above is why speed figures are seldom quoted for high contrast films.
- (3) The length of exposure. When exposing for longer than about one second (or shorter than 1/1000 sec) on most films the effective speed of the emulsion is found to be reduced. This is known as 'reciprocity law failure' (failure of the reciprocal relationship between time and intensity in affecting exposure) This explains why long time exposures can result in underexposure, despite the correct use of a meter.

INDICATED EXP TIME:

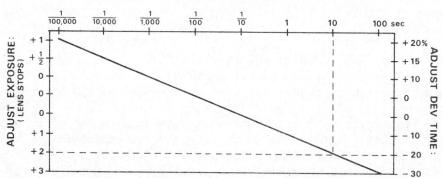

Fig. 10.2. The practical effect of reciprocity law failure. These figures are typical for general purpose black & white film but vary from one brand to another. As exposure time is increased less development is needed to give the same emulsion contrast — aperture adjustments suggested here assume that these development modifications are made.

Generally speaking, when shooting on negative formats from which high magnification enlargements are to be made high-speed emulsions should be avoided. Their coarser grain structure and usually thicker coating inevitably reduces recorded detail. Occasionally this is justified for visual effect. But, where subject conditions permit, it is more usual to exploit the detail which photography can so well record by using negative materials of medium speed.

TABLE 10.2

REPRESENTATIVE LIST OF NEGATIVE EMULSIONS IN TERMS OF SPEED

ASA Speed	Material	Contrast	Grain	Main Uses
3000	Polapan 3000	Medium	Coarse	Existing light photography
1250	Royal-X Pan	Medium	Coarse	under difficult conditions
1000	Kodak 2475 Recording	Medium	Coarse	(can be further up-rated).
	Film	Medium	Coarse	Also for grain effects
500	Ansco Super Hypan	Medium	Medium	General photography,
400	Agfapan 400	Medium	Medium	particularly on location
400	Kodak Tri X	Medium	Medium	
400	Ilford HP5	Medium	Medium	
125	Kodak Plus X	Medium	Fine	General studio photography
125	Ilford FP4	Medium	Fine	where quality is more
100	Agfapan 100	Medium	Fine	important than speed
100	Ansco Superpan	Medium	Fine	
50	Ilford Pan F	Medium	Very fine	For maximum resolution
40	Kodak Panatomic X	Medium	Very fine	& grain-free enlargement
25	Agfapan 25	Medium	Very fine	
About 5-20	Ilford Comm. Ortho	Medium	Very fine	Continuous tone copying
depending on	Kodak Process	Medium	Very fine	
developer	Kodalith	Very high	Very fine	Line copying

Colour Sensitivity

Colours reproduce as white, or varying tones of grey or black, according to the 'spectral sensitivity' of the black and white photographic emulsion used. We can hardly judge whether these tones are 'correct' without first analysing the spectral sensitivity of our eyes.

THE EYE. Which are the 'brighter' and which are 'darker' colours of the visual spectrum? The retina of the human eye contains many million rod- and cone-shaped receptors – able to react to light and send information signals via the optic nerve to the brain. Only cone-shaped receptors are sensitive to colours. Cone receptors are thought to be of three mixed types, one particularly sensitive to blue, another to green, and a third to red. The green receptors appear to be the most sensitive, closely followed by red receptors.

Since all receptor sensitivities overlap, yellow-green is seen as the 'brightest' colour in the visual spectrum. Shorter and longer wavelengths appear increasingly darker, into 'dark' violet and 'dark' red. We can draw a graph – a 'visual luminosity curve' – plotting luminosity or brightness against colours of the spectrum. This can be compared with the colour sensitivity curves of different emulsions. (*Note:* Under low levels of illumination maximum eye sensitivity shifts from yellow-green to blue-green – the 'Purkinje Shift'. For this reason blue-green is the most efficient visually for weak illumination such as

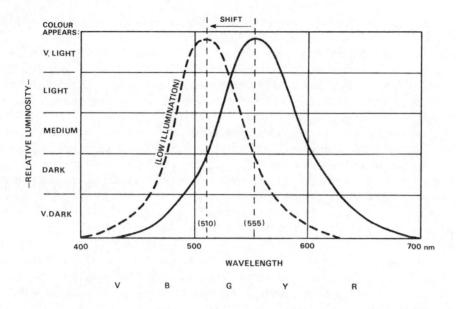

Fig. 10.3. Visual luminosity curves. Normally, yellow greens appear as 'brightest' colours of the spectrum. At low illumination levels, however, maximum eye sensitivity shifts towards blue-green (the 'Purkinje Shift').

safelighting. At extremely low levels of illumination the non-colour sensitive rods are almost the only receptors still able to send responses to the brain. Hence colours in landscapes, etc., under moonlit conditions are seen in various tones of grey only, or with a suggestion of green recognition.)

BLUE-SENSITIVE EMULSIONS. From the moment of their precipitation, all silver halides are 'naturally' sensitive to the longer ultra-violet wavelengths and violet and blue visual wavelenths up to about 500 nm. Such emulsions are called by manufacturers 'blue sensitive', 'ordinary', or (erroneously) 'non-colour sensitive'. They are unaffected by green-to-red wavelengths, so that subjects reflecting these colours do not darken the negative material and reproduce on the final print as black. N.B. In this book the tone in which a colour reproduces will be quoted as it applies to the *final print*.

Blue-sensitive emulsions were the only materials available to early photographers. For years it was accepted that photographs always reproduce blue skies as white, green grass and red flowers as very dark. This can be checked in old photographs prior to the turn of the century. The discovery of the 'colour sensitising' effects of certain highly diluted dyes by Dr. Vogel during the late nineteenth century led to the manufacture of 'orthochromatic' materials.

ORTHOCHROMATIC EMULSIONS. Strictly orthochromatic means 'correct colour', but from the colour sensitive curve of such an emulsion (see Fig. 10.5) you can see that it falls far short of matching eye response. Ortho emulsions are sensitive to ultra-violet, violet, blue and (maximum) green. 'Highly' orthochromatic emulsions are also sensitive

to yellow; no ortho materials respond to the orange and red wavelengths beyond about 590 nm.

Owing to their maximum response to green, ortho emulsions are often termed 'green sensitive'. They will reproduce red as largely indistinguishable from black (see plate 58). Remember too that blue-sensitive and ortho materials may function at as little as one quarter of their daylight speeds when used with tungsten lighting in the studio, owing to the high red content of the latter source.

PANCHROMATIC EMULSIONS. Later research into colour sensitivity yielded dyes with which emulsions can be made to respond to red as well as green and blue. Such emulsions are termed 'panchromatic' ('all colour' sensitive). Broadly, materials are either 'normal' pan with slightly more sensitivity to orange red than green and responsive to wavelengths up to about 660 nm. Other red-pan or hypersensitive pan materials are considerably more sensitive to red and respond up to 680 nm. The latter sensitivity is designed to boost effective emulsion speed when working under red-rich tungsten lighting.

Notice that even normal panchromatic dye sensitised materials do not match the eye's response to colour. They will record violet, and particularly red, lighter than they appear to the eye – and greens rather darker. Full matching can be achieved with the use of colour filters, as discussed in the following chapter.

The basic colour sensitivity graphs we have drawn can only be regarded as 'average'. As Fig. 10.5 shows, individual materials vary slightly in their colour response brand to brand within the general framework of blue-sensitive, ortho and pan.

Wedge spectrograms. An ingenious piece of optical equipment is used in the laboratory to test the spectral sensitivity of an emulsion, making it virtually 'draw its own curve'. First a 'spectrograph' is set up. This consists of a compact white light source which projects light through a narrow slit. Rays from the illuminated slit are received by a lens system and projected forward as parallel light through a prism. This 'disperses' the light – refracting each wavelength by varying amounts.

A second lens system converges the now separated, coloured images of the slit to points of focus some distance from the prism, in the form of a spectrum of colours – a man-made rainbow. (Instead of a prism an optical 'grating' may be used which consists of thousands of lines engraved on a glass plate. The lines 'diffract' the rays, bending them by amounts varying with wavelength.)

The optical system is enclosed in a light-tight boomerang-shaped container made to accept the photographic film in a holder at the spectrum end. But between the projected spectrum and the emulsion a grey scale or 'wedge' is inserted. This looks like a piece of smoked glass, very dark at one edge and graduating across the surface to clear glass. The grey wedge is positioned so that the direction of 'tailing off' is at *right angles* to the spectrum of colours. The emulsion receives V.B.G.Y.R. from left to right, each colour growing dimmer from bottom to top (see Fig. 10.4).

The equipment is now known as a 'wedge spectrograph'. If the emulsion under test is exposed in the wedge spectrograph and processed, the colours to which it was most sensitive will be seen to have darkened the emulsion almost from bottom to top. Other

colours, to which it was less sensitive, darken only at the bottom, where the light was brighter. It therefore draws its own 'graph', showing relative sensitivity (top to bottom) against colour (left to right). A print is usually made from such a negative on contrasty paper to show clearly the graphic outline. This is known as a 'wedge spectrogram'.

Wedge spectrograms for various commercial emulsions are shown (p. 188) as they appear in manufacturers' data sheets. The photographer should be familiar with 'reading' colour sensitive information from these graphs.

PRACTICAL USE OF COLOUR SENSITIVITY. If panchromatic emulsions are available why do manufacturers still make blue-sensitive and ortho materials? The answer is that

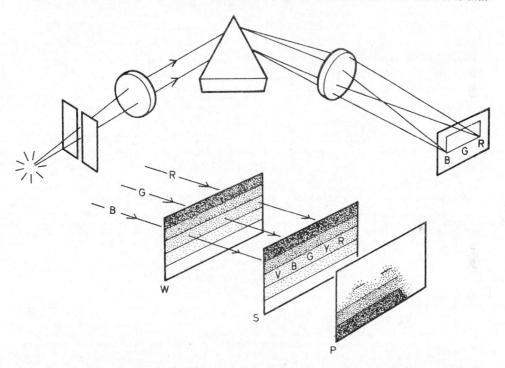

Fig. 10.4. Top: A Spectrograph. White light passed through a narrow slit is dispersed by the prism and brought to focus on a screen as a band of spectrum colours. Bottom: When a graduated grey scale or 'wedge' (W) with graduations running at right angles to the projected bands is added at the receiving end of the spectroscope a 'Wedge Spectrograph' is formed. An observer sees spectrum colours distributed horizontally across the screen (S), each growing dimmer vertically. A photographic film (P) exposed in this device and processed shows highest vertical density in the colour bands to which it is most sensitive. It therefore records its own sensitivity graph – a 'Wedge Spectrogram'.

many jobs can be handled more conveniently on non-panchromatic materials. By printing black-and-white negatives on to blue-sensitive bromide paper we can work under orange illumination without fogging the emulsion. Similarly, film with a blue sensitised emulsion will efficiently copy non-coloured continuous tone photographic prints, or line diagrams – again allowing conveniently bright 'safelighting' in processing.

Colourless metallic subjects such as silverware, are as equally well recorded on blue sensitive as pan emulsion. In many cases where we wish to distort tonal values of colours – darkening yellow lettering on a white background, lightening blues against reds, etc. – blue-sensitive materials provide a simple solution.

Orthochromatic materials will give a less bleached reproduction of lips in portraiture than pan emulsions and form a simple method of darkening reds in copying. Orthochromatic sensitising is given to certain high contrast materials just to increase their very slow speed. Such materials often require visual inspection during processing – made possible under a deep red safelight.

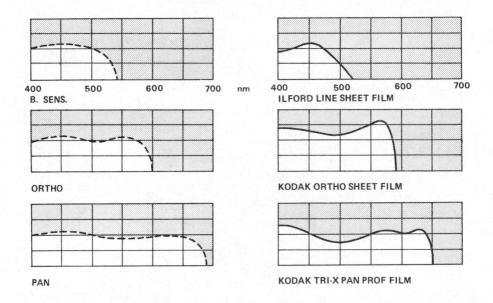

Fig. 10.5. Wedge spectrograms. (Left) 'Classic' curves for blue sensitive, ortho, and panchromatic emulsions. (Right) Typical commercial emulsions (to tungsten light). Graphs by different manufacturers should not be compared in detail, owing to slight differences in the light sources and the gradient of wedges used. (Emulsion sensitivity to low wave-lengths continues down to about 250 nm, beyond which the gelatine strongly absorbs U-V.)

Nevertheless, panchromatic negative materials are used for most jobs in general commercial photography. They are of course essential wherever the recording of multicoloured subjects calls for tonal values close to the visual luminosity of the original. Pan emulsions are also more flexible in that they can be used with a wide range of filters – filters which can, if required, convert them to the equivalent of ortho or bluesensitive materials (chapter XI).

The only working safelight for pan materials is a very dim olive green. This colour corresponds with maximum eye sensitivity under low illumination levels, and purposely built-in 'dip' in pan emulsion sensitivity. Apart from blue, ortho and pan emulsion sensitivity, other dyes have been formulated which extend emulsion response well outside

the visual spectrum into infra red. Such materials are largely used for scientific, aerial survey, medical and industrial photographic applications.

The 'Best' Emulsion for the Job

In looking back at the four aspects of emulsion performance – contrast, resolution, speed, and colour sensitivity – remember that only the first three are related in that they are all affected by grain size. In general, small grain size gives higher contrast, improved resolution and slower speed. Dye sensitising however, which takes place at the end of emulsion preparation, has no connexion with the other three except in its effect on speed when shooting with red-rich lighting.

There is, therefore, no reason why slow, high contrast line copying materials cannot be panchromatic – a few are. Similarly fast emulsions can be merely blue sensitive. The fact that *most* fast materials are panchromatic and *most* high contrast emulsions blue sensitive is deceptive.

The section overleaf is intended to indicate the 'thought processes' of a photographer equating the requirements of a job with the performance of emulsions at his disposal. But these are not the only answers. As with camera choice, personal preference may make a particular worker choose a slightly different emulsion with which he is more familiar, perhaps modifying it by controlled development. He may for instance habitually use contrasty subject lighting, but with low contrast film and curtailed development produce normal contrast negatives with reduced grain.

Accept nothing as inflexible. Try shooting portraiture on blue-sensitive film, copying on coarse grained fast pan, landscapes on bromide paper. Have you looked through a current catalogue to find what materials are available – particularly in the sheet film range? Experiment to find out what control of visual results is offered by emulsions; later this knowledge may prove commercially useful. Remember too the possibilities and practical convenience of Polaroid instant picture film (see p. 322).

On the other hand, for most of the run-of-the-mill photography calling for nothing more than normal contrast pan film, limit your choice to one or two emulsions and thoroughly learn their capabilities (and limitations). Then keep to these products as far as justified by assignment. Besides visual and technical ability the professional is selling reliability – a reliability that is more easily achieved by eliminating unnecessary variables.

Typical Emulsion Choices

ASSIGNMENT 1. A group of six white roses for a small black-and-white reproduction in a nurseryman's catalogue.

Visual requirement: Essentially a record picture demonstrating perfect form and texture. The roses will have to fill the format to reproduce these qualities in the final reproduction.

Emulsion requirement:

- (a) Moderately fast speed. Large images mean little depth of field unless the lens is well stopped down. This leads to long exposure during which living subjects such as flowers can appreciably move. However, too fast an emulsion may create grain problems and destroy texture.
- (b) Green sensitivity. Using a grey background ortho would be satisfactory, but pan emulsions are marketed with more suitable speed ratings.

Emulsion type: H.P.4., Tri X or equivalent, according to preference.

ASSIGNMENT 2. Copying an old faded sepia continuous-tone photographic print. The low contrast image is gingery brown on a slightly yellowed paper base.

Visual requirement: As far as possible, the recreation of the original (i.e., unbleached) tone range of the print in black and white.

Emulsion requirement:

- (a) Non-pan material to reproduce the red-rich image as if it were black. However, if the base is appreciably yellow, blue sensitive materials would not reproduce it white, and choice would switch to a highly orthochromatic emulsion.
- (b) Moderately high contrast to counteract the 'flat' tonal values of the faded original. Exact degree of contrast to be discovered by trial and error, probably by controlling development.

Emulsion type: G8.30 or Commercial Ortho with extended development, or an equivalent.

Assignment 3. Copying a small oil painting for reproduction in a magazine.

reproduce colours as black beyond 500 nm, 'ortho' emulsions beyond 590 nm. *Visual requirement:* A reasonably objective tonal reproduction of the colours of the original.

Emulsion requirement:

- (a) Pan sensitivity, owing to the multicolours involved.
- (b) Medium/slow speed. Fast materials risk wholly unnecessary grain, since this is an unmoving subject. Long exposure is no problem, provided a tripod is used.

Emulsion type: Slow normal contrast pan such as FP4, Plus X or equivalent film. (For exact black-and-white tonal reproduction of colours, emulsion and eye sensitivity must match, calling for use of 'correction' filters, see chapter XI.)

ASSIGNMENT 4. Photo-journalistic sequence of group of people celebrating in a public bar at night.

Visual requirement: Authentic, unstaged pictures recreating atmosphere of celebration.

Emulsion requirement: Speed has over-riding priority. Exposure duration must allow the camera to be hand-held under these low illumination levels. If, as is likely, a 35-mm camera is used to remain inconspicuous, grain may be apparent on enlargements.

Emulsion type: (35 mm) High Speed Recording Film, or equivalent. Assignment 5. Copying white lettering on an orange background. Visual requirement: Pure white letters, dense black background.

Emulsion requirement:

- (a) Blue-sensitive emulsion, insensitive to orange.
- (b) High contrast emphasising blackness of background, veil-free whites.

Emulsion type: Ilford line film, or equivalents.

Chapter Summary - Sensitive Material - Choice of Emulsions

- (1) Essentially, emulsion choice is a matter of comparing contrast, resolving power, speed and colour sensitivity against the required visual reproduction of the subject. The first three are interlinked, largely controlled by grain size.
- (2) Choice of emulsion contrast enables the photographer to extend or restrict the range of greys he records between black and white. Low contrast materials retain gradation of greys, high contrast emphasise black and white.
- (3) Emulsions best able to resolve fine detail are fine grained and thinly coated, therefore slow. Thick emulsions suffer increased irradiation, particularly if overexposed.
- (4) Light sensitivity is denoted by speed rating. ASA, BS, and GOST quote on arithmetical progression; DIN on logarithmic progression where + 3 equals double speed. Ratings are guides only emulsion response is affected by subject lighting (colour and contrast), development, and extremes of exposure timing.
- (5) No emulsion exactly matches eye colour sensitivity. 'Blue-sensitive' emulsions reproduce colours as black beyond 500 nm, 'ortho' emulsions beyond 590 nm. Pan is oversensitive to red and blue, less sensitive to yellow green than the eye. Exact colour sensitivity is shown on a wedge spectrogram, the photographic record made with the emulsion in a wedge spectrograph.
- (6) Pan has general applications; ortho and blue sensitive are used to distort tonal rendering of certain colours, or for convenience in darkroom handling.

Questions

- (1) A photograph is taken in daylight of a still-life group consisting of a number of ripe tomatoes and green leaves on a yellow plate, standing on a blue tablecloth. The group is photographed three times, on (a) a panchromatic, (b) an orthochromatic, and (c) an 'ordinary' film. Assuming that all these objects appear light to the eye, tabulate in terms of 'light' and 'dark' the appearance in each print of tablecloth, plate, tomatoes, and leaves.
- (2) Copy and complete the table at top of page 192.
- (3) Explain why the published speed ratings for some negative materials may no longer apply when they are used in tungsten light. Will ratings be higher, or lower?
- (4) Draw three diagrams showing the approximate colour sensitivities of:
 - (a) Ordinary emulsions

Film Speed	Relative Light Value	Stop (f/no)	Shutter Speed
400 ASA	400	f/22	1/250
400 ASA	200		1/250
400 ASA	100		1/250
400 ASA	50		1/250
400 ASA	400	f/16	
400 ASA	200	f/16	
400 ASA	100	f/16	
400 ASA	50	f/16	
200 ASA	400	f/16	1/250
100 ASA	400		1/60
25 ASA	400		1/60
5 ASA	13	f/22	

- (b) Orthochromatic emulsions
- (c) Panchromatic emulsions

Explain the meaning of these diagrams in words.

- (5) What is understood by the following terms:
 - (a) Resolving power
 - (b) Relative aperture
 - (c) Irradiation
 - (d) Graininess?
- (6) Name two systems of emulsion speed rating in common use. What are the approximate speeds on each system of:
 - (a) A high-speed pan emulsion?
 - (b) An emulsion one-quarter the speed of (a)?
- (7) List the most suitable types of negative material you would use in photographing:
 - (a) A black-and-white line copy.
 - (b) A continuous tone black-and-white glossy bromide print.
 - (c) A water colour painting.
 - (d) A showcard consisting of red letters on a yellow background. (The letters are to appear black on a white background in the final print.)
 - (e) A sepia-toned glossy bromide print.

Give reasons for your choice.

(8) In every-day commercial photography excessive final contrast is often undesirable, and assertive grain size a distraction. However, outline an assignment in which both these effects might be used to *visual advantage*.

XI. THE EFFECT OF COLOUR FILTERS

The fact that monochrome materials can record only optical images of our subject in terms of black, white and various tones of grey is a handicap with which we have to learn to live. With some subjects the handicap is severe: food, flowers, and most landscapes, have colour as one of their chief qualities. For example, to convey the qualities of an orange (colour, juiciness, form and texture) in a black-and-white photograph we have to work almost wholly through the last two visual aspects. With some other subjects colour is less important; its non-reproduction is actually an asset. We can concentrate interest on shape, size, texture, etc. But whatever our subject, it is useful to be able to control just what tone between black and white one colour is recorded relative to another.

As discussed in the last chapter, we can do this in a rather crude way by choice of blue-sensitive, ortho, or pan emulsion. Now, with the aid of 'colour filters', we shall see how much more subtle control over the tone reproduction of colour is possible. In this chapter we can also discuss how certain colour filters can be used for safelighting.

Colour 'Performance' of a Filter

A filter of any sort is a device for selecting and removing something from a general flow – impurities from water, dust from air, etc. A light filter simply absorbs certain wavelengths from incident light, transmitting the remainder. Usually, it consists of a piece of dyed and lacquered gelatin, or gelatin sandwiched between pieces of glass, or glass dyed in its molten state.

The effect of a filter on colours can be checked by comparing the amount of light of a particular wavelength entering the filter with the amount that is transmitted through to the other face. For example, in testing a filter with red light of 650 nm we may find that of 100 units of light incident on the filter only 20 units are transmitted. Its 'transmission' at this wavelength is

$$\frac{\text{transmitted light}}{\text{incident light}} = \frac{20}{100} = \frac{1}{5} \text{ or } 20\%$$

(conversely its 'absorption' is said to be 80%).

In order to obtain an overall indication of the effect of this filter on the whole visual spectrum we should need to quote per cent transmission for every few wavelengths – a specification running to dozens of pages. Instead, it is more convenient to show this information in the form of a graph. A horizontal axis is drawn and calibrated in V.B.G.Y.R. visual wavelengths; the vertical axes in per cent absorption and per cent transmission. (Notice how the per cent transmission increases as we go down this axis,

the reason is explained later.) Now the percentage absorption and transmission measurement for different wavelengths can be marked in and joined up as a continuous line. This type of graph is known as the absorption curve of a filter.

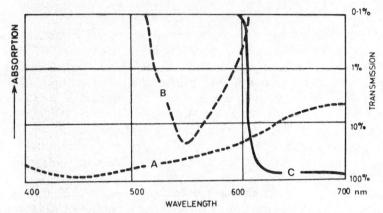

Fig. 11.1, Filter Absorption curves. A: A light blue filter. B: A deep green 'narrow cut' filter. C: A red 'narrow cut' filter.

Makers of filters publish absorption curves for all their products and it is useful to be able to read practical information quickly from these graphs. We can see from the position and shape of the three curves shown above for example:

- (1) The predominant colour of the filter the colour it transmits most is shown by wavelength position of maximum 'dip'.
- (2) The steepness of filter 'cut off', i.e., the suddenness with which its ability to transmit is reduced with wavelength. Filters which give high transmission to a band of wavelengths, dramatically reverting to high absorption of the remainder, are termed 'narrow cut'. This is shown by the vertical steepness of the curves B and C.
- (3) The relative density of the filter. Filters which are dark in appearance have low maximum transmission values.

Filters as Safelights

The effect of a light filter on a photographic emulsion depends very largely on the colour sensitivity of the emulsion itself. We should, therefore, compare the filter absorption curve with the emulsion spectral sensitivity curve with which it is to be used.

Figure 11.2 shows for example that a yellow-brown filter used with a blue-sensitive emulsion, will transmit only light to which the material is insensitive. It would be useless over the lens of a camera, virtually acting as a lens cap. But placed in front of a tungsten light-source in the darkroom the filter creates a 'safelight'—light of wavelengths to which our eyes are usually sensitive, but which has no effect upon the emulsion.

This is one instance of the convenience of aligning the two graphs with their common

axes, and the downward extending filter curve. Provided no overlap is shown between spectral transmission and spectral sensitivity (i.e., the filter curve 'fits' into the sensitivity graph) the filter will form a safelight.

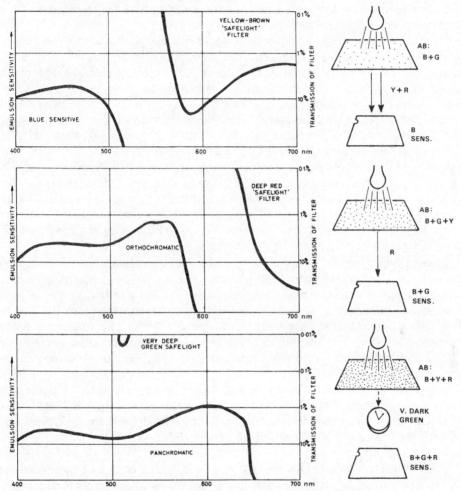

Fig. 11.2. Comparison of emulsion colour sensitivity (to tungsten light) and the absorption curves of filters which may be used for 'safelights'. Diagrams (right) show colours absorbed by safelight filters. The deep green panchromatic safelight is really only safe to illuminate the clock.

By comparing filter absorption and emulsion spectral curves we see that our yellow-brown filter transmits enough yellow-green to affect orthochromatic materials. Ortho emulsions require a deep red filter for safelighting. It can be seen that this filter would also serve for safelighting blue-sensitive materials.

Panchromatic materials are more of a problem. A filter transmitting wavelengths beyond about 680 nm may be safe, but useless in practice owing to the insensitivity of

our own eyes to the extremes of the visual spectrum. Notice that the slight 'dip' in bluegreen emulsion sensitivity coincides with maximum eye response (see Fig. 10.2). A very dark green (maximum transmission approximately 0.05%) filter could therefore be used to illuminate, say, the darkroom clock. As the emulsion is in fact sensitive to these wavelengths direct lighting must be avoided.

In practice, a pan safelight gives so little useful light and the faster emulsions are so easily affected, that most photographers prefer to work in total darkness. By comparing the pan filter curve with the sensitivity of ortho materials it can be seen that these are as equally likely to fog under the green safelight as pan emulsions.

The use of an appropriately coloured filter as safelight is no automatic guarantee of freedom from fogging. Manufacturers quote the maximum wattage lamp (normally 25 W), minimum emulsion distance (about 1 m) for a reasonable handling period of 'safe' safelighting. In the first instance we must remember that a tungsten lamp emits wavelengths of the whole visible spectrum. No filter dyes are 100% efficient, but will transmit a very small percentage, say 0.0001% – of all wavelengths (one reason why the transmission axis on a filter curve does not commence at zero). Consequently, use of a tungsten lamp which is too bright will increase the small amount of 'unsafe' as well as 'safe' illumination to a level at which fogging will occur. Positioning of the safelight too close to the emulsion will create fogging for the same reason.

Where a bright form of safelight for blue sensitive materials is necessary, a sodium vapour lamp—the orange lamp used in street lighting—can be used. Unlike normal tungsten lamps, which emit many wavelengths only to be absorbed by the safelight filter, sodium tubes emit no U-V, violet and blue light and very little green. It is easy to fit a filter using a dye which effectively absorbs this green. The sodium lamp can therefore quite safely be much brighter than its tungsten equivalent. Also, more useful light is created from the electricity consumed, making sodium lamps comparatively cheap to run.

Key positions for safelights are: in passages and light-traps; close to the clock; over the processing bench. One of the best ways to create general lighting (for locating switches, taps, working surfaces, etc.) is to point the safelight upwards and reflect light off the whole ceiling. This indirect ('bounce') safelighting will usually allow a brighter bulb to be used.

When installing a safelight for the first time, or in investigating a cause of emulsion fogging, tests should be made using the fastest photographic material we intend to handle in the darkroom. The emulsion should first be given an exposure (i.e., under an enlarger) sufficient to reproduce a mid grey tone if developed. Before processing, place the material on a work bench, or wherever else it is likely to be handled in practice, with part of the emulsion covered by a coin. Leave the material at least as long under the safelight as it would undergo in practice—then give normal processing and visually check for signs of coin outline.

The reason for giving an exposure first is that a latent image makes the emulsion slightly faster. The exposure has formed developable atoms of silver in the larger silver halide grains and a very few atoms – insufficient to be developed – in some of the

smaller grains. Any subsequent slight safelight fogging which would not affect unexposed material can be just enough to 'tip the balance' and make some of the smaller grains developable. This overcoming of 'exposure inertia', making *exposed* material more susceptible to safelight fogging, should always be remembered when testing the safety of darkroom lighting. Fogging risks are greater just before processing than when first taking the material from the box.

Summing Up Filters so Far:

- (1) A light filter is a dyed gelatin or glass sheet, capable of selectively absorbing certain wavelengths.
- (2) Its main uses are (a) to alter the tonal reproduction of various colours by an emulsion, (b) to create darkroom illumination which is visually useful yet will not 'fog' sensitive materials.
- (3) The performance of a filter is usefully shown by its 'spectral absorption curve' in which wavelength is plotted against per cent Absorption and per cent Transmission.
- (4) By comparing a filter absorption curve with an emulsion sensitivity curve we can determine whether a filter will act as an efficient safelight screen.
- (5) Yellow-brown or sodium safelights are used for blue-sensitive materials, deep red for ortho or blue-sensitive materials. A very deep green-blue safelight may be used for clock illumination with slower pan materials.
- (6) Safelights are most critically checked by means of a sheet of normally exposed material, which will thus have less 'exposure inertia'.
- (7) Safelight filters can be expected to be safe only when used with lamps of recommended wattage and positioned sufficiently far from the material.

Filters on the Camera

Colour filters used on the camera for black-and-white photography are almost invariably used with panchromatic emulsions. They can broadly be divided into three categories – 'Correction', 'Contrast', and 'Special Purpose' filters.

Correction Filters

As we saw in chapter X, even panchromatic emulsions will not reproduce colours in tones truly representing their relative brightness to the eye. Filters intended to correct this deficiency – in effect changing pan sensitivity to match eye sensitivity – are called 'correction filters'. For example, comparing the daylight spectral sensitivity of the eye with that of most normal pan emulsions we see that the material will reproduce greens too dark, blues too light, and reds also rather light. In particular, blue sky will photograph lighter than it appears to the eye, with little tonal difference to separate sky from clouds. However, if we use a yellow-green filter over the lens this will absorb some

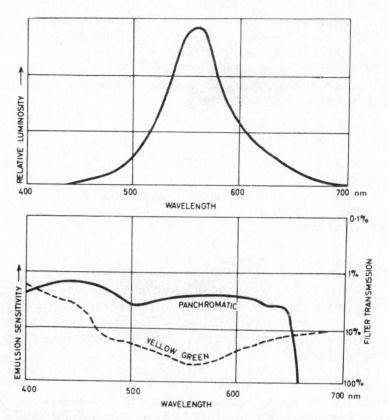

Fig. 11.3. Top: Visual response to colour under normal illumination conditions. Bottom: Daylight colour response of a panchromatic emulsion and (broken line) the absorption curve of a suitable yellow-green 'correction' filter for this material. The filter/emulsion combination reproduces colours in final tone values approximating their visual luminosities.

of the blue and a little of the red, but leave the green largely unaffected. It absorption effectively reduces the sensitivity of the emulsion to blue and red. Exact filter hue for *full* correction will, of course, vary with spectral response of the particular film being exposed.

Yellow-green correction filters for pan film in daylight are often used where oil paintings, etc., must be copied under this illumination with critically correct tonal reproduction of colour. As such filters usually require an increase of exposure by about 2–3 times, for less critical work a pale yellow filter is often used instead. This gives 'partial' correction – namely meeting the most urgent requirement by darkening blue, but without demanding much increase in exposure.

A rather differently dyed filter is needed for matching pan response to that of the eye when shooting under tungsten light conditions. Normal tungsten lamps emit more red than blue wavelengths. If we are to record colour brightnesses as they would appear to the eye in daylight, our filter must absorb rather more red than blue, but still transmit

most green wavelengths. Bluish-green correction filters are therefore required for pan materials under tungsten conditions. Such filters are often referred to as 'half-watt' filters.

Exact correction given by a half-watt correction filter depends upon whether the emulsion with which it is to be used is normally or highly panchromatic; film manufacturers' recommendations should be followed. In practice, full tungsten light colour correction is seldom essential – this requirement is generally limited to facsimile copying and other critical record work.

The increase in exposure (about two-three times) necessary with a full correction filter makes it unpopular for portraiture. However, some portraitists like to make some correction for pan recording of 'washed out' lips without turning to ortho materials. They may then use a pale greenish-blue filter for *partial* correction.

Contrast Filters

In recording a camera image on black and white material you have probably noticed how objects which were visually separable from their surroundings by their different colours are disappointingly 'lost' on the monochrome photograph. Object and surroundings have reproduced in similar tones of grey. Greens and reds, in particular, are prone to record in the same monotonous tones on unfiltered pan materials; similarly blues and greens on ortho emulsions. Any filter which is used to increase tonal contrast between colours which would otherwise record with similar photographic density is known as a 'contrast' filter.

Contrast filters are stronger colours than correction filters and made in a wide spectral range. By looking at the function of six of these filter colours we can gain some idea of the effect of other contrast filters which are either mixtures of these colours or diluted versions. *Reminder:* The terms 'dark' or 'light' used below refer to the final *print* appearance.

RED. A strong red filter transmits about one third of the visual spectrum (red) and absorbs most of the remainder (blue and green). Used with pan film it therefore lightens red and darkens blue-green; if particularly 'narrow cut', red may be reproduced indistinguishably from white and blue-green from black. This filter cannot, of course, be used with ortho or blue-sensitive emulsions as it acts as a safelight.

GREEN. A strong green filter transmits its own approximate third of the spectrum and absorbs most of blue and red. Used with pan film it lightens green and darkens blue and red. On ortho film it darkens blue, red being 'naturally' reproduced dark.

BLUE. A blue contrast filter transmits its own third of the spectrum and absorbs mostly green and red. Blues record light, greens and reds (including yellow) dark. Deep blue filters are the least used in photography, since with pan and ortho materials they give the same tonal reproduction as a blue-sensitive emulsion. It is generally more sensible to use the blue-sensitive emulsion without a filter, thus avoiding any risk of optical deterioration from the filter, and allowing convenient use of safelights in the darkroom. N.B. Red, green and blue filters which each transmit equal thirds of the spectrum, are

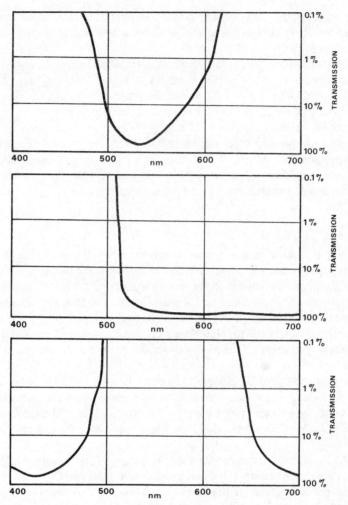

Fig. 11.4. Absorption curves of typical contrast filters. Top: Green. Centre: Deep Yellow. Bottom: Deep Magenta.

sometimes referred to as 'tricolour' filters. Tricolour filter sets have important uses in certain colour processes.

CYAN (GREEN-BLUE). Transmits about two-thirds of the spectrum (green and blue) and absorbs the remainder (red). This filter is therefore 'complementary' to red, reproducing it as dark on pan materials. In most cases the same effect can be achieved on ortho materials without a filter.

MAGENTA (BLUISH-RED). Transmits the blue and red two-thirds of the spectrum and absorbs most of the remaining green third (see Fig. 11.4). It is complementary to green reproducing it dark on pan and ortho materials. In effect it converts ortho to blue sensitive.

YELLOW. Transmits the green and red two-thirds of the spectrum and absorbs much of the remaining blue. It is complementary to blue and reproduces it as dark on pan or ortho, acting as a safelight on blue-sensitive materials. Notice how this filter used on ortho gives similar results to a strong green filter used on pan – both blue and red being reproduced as dark.

TABLE 11.1
EFFECT OF CONTRAST FILTERS WITH PAN MATERIALS

Colour of filter	Final (print) tone reproduction of:					
used over lens	Blue	Green	Yellow	Red		
Deep Red	Very Dark	Dark	Light	Very Light		
Deep Green	Dark	Very Light	Light	Very Dark		
Deep Blue	Very Light	Dark	Dark	Very Dark		
Deep Cyan	Light	Light	Dark	Very Dark		
Deep Magenta	Light	Very Dark	Light	Light		
Deep Yellow	Very Dark	Light	Very Light	Light		

Practical Use of Contrast Filters

So much for the effects of six main contrast filters. Together they give us as much control over the tonal reproduction of colour as camera movements give us control of image shape and sharpness. Practical application depends upon the needs of the job. First decide what you are trying to achieve, then from your knowledge of the combined effects of filter transmission and emulsion sensitivity select the appropriate technique.

Remember basically that a filter lightens its own colour, and darkens the remaining parts of the spectrum. You can always check the effect of a filter by viewing the subject through it and observing which objects are made darker and which lighter — bearing in mind any main differences between visual sensitivity and the emulsion you intend to use.

Here are some case histories:

EXAMPLE 1. A diagram consisting of blue lines and black lines on white paper must be copied so that all the lines appear black on a white background. Problem – Either an emulsion must be used which is insensitive to blue (none are) or a filter which absorbs this colour and therefore makes it reproduce darkly. A deep red filter was in fact chosen, on pan material. As an alternative a deep yellow filter on pan or even highly orthochromatic film might have proved satisfactory. The pan emulsion used was of course high contrast, to reproduce dense lines with a clean white background.

EXAMPLE 2. A continuous-tone photographic print which had come into contact with green ink had to be copied to eliminate these stains. A green filter was chosen which most closely matched the ink stain visually. The picture was shot using the filter on a normal contrast pan emulsion. (Ortho material would also have been suitable.) On the final copy the green-stained paper was indistinguishable from the white paper areas.

EXAMPLE 3. A close-up of red blooms against green foliage must be taken in the

client's garden to illustrate an article on their cultivation. On normal pan they will record in very similar tones. Printing on hard contrast paper would help separate these tones but such harsh contrast would destroy the velvet quality of the flower petals themselves. By use of filters either flowers or foliage can be reproduced lighter. Which shall it be? 'Warm' colours such as red are generally more acceptable as a lighter tone than foliage. Therefore a *pale* magenta or red filter is used with pan material – pale because we want the flowers to be lightened in tone, but not 'bleached' white.

Special Purpose Colour Filters

VIEWING FILTERS. In order to remove some of the guesswork from estimation of colour reproduction in terms of grey, the photographer can visually check his subject through a viewing filter. This is essentially dark in tone (because under dim conditions the eye itself is less sensitive to colour, more able to see things in monochrome, p. 185). It is usually somewhat purple in hue, to absorb some green, 'correcting' the eye's colour sensitivity and matching it to the response of normal pan emulsions. The 'darkness' and 'lightness' of tonal values seen through the filter gives some indication of colour reproduction of the final print. These filters are only used for *viewing*, not for photography.

GRADUATED SKY FILTERS. Filter discs which, when held vertically, appear colourless at the bottom, becoming increasingly yellow dyed towards the top. Used just in front of the lens the intention is to filter light from a blue sky in landscapes, without affecting the rest of the picture. You can achieve a cruder but similar effect holding a yellow filter half way across the lens.

HAZE FILTER. The haze we see in distant landscapes is due to scatter of light by particles in the atmosphere forming mist (not to be confused with fog largely composed of smoke and other pollution). Shorter wavelengths are more readily scattered than long, giving haze a bluish appearance. Although invisible to the eye, ultra-violet wavelengths are even more readily scattered, and as all emulsions are sensitive to these radiations haze is generally exaggerated in photographs. If this exaggeration is not required, an ultra-violet absorbing haze filter is useful. The filter absorbs light to which our eyes are insensitive; it therefore appears virtually colourless. N.B. A yellow filter will also act as a haze filter – another instance of the general usefulness of this colour filter.

COLOUR SEPARATION FILTERS. If three photographs are taken, one through each of blue, green and red filters, the three resulting negatives separately record blue areas of the subject, green areas and red areas. Such a set of colour separation negatives can be printed in appropriate dyes and superimposed to recreate all the colours of the original subject. Filters are specially matched in sets for colour separation work. They are used in making printing plates of colour pictures and for photographic colour processes such as dye transfer.

Other, colourless, filters include neutral density (grey) filters which reduce image brightness without affecting colour reproduction. These are useful when a long exposure

time is desirable (e.g. plate 34) but you do not wish to stop down, or have already stopped down fully but would still be over-exposed. Colourless *polarising filters* provide control of reflections and have scientific analytical uses. See *Advanced Photography* p. 407.

Filter Factors

The function of every filter is to absorb certain light rays. Therefore, some of the image-forming energy which would have originally entered the lens has been lost, and exposure must be increased accordingly. The factor by which exposure time must be multiplied to give the same general level of exposure (i.e., same reproduction of greys) as when no filter is used, is called the 'filter factor'. Factors are written as \times 2, \times 3, \times 4, etc. The filter factor under any set of practical conditions depends upon:

- (a) The type of illumination on the subject. The factors of red filters are less when the subject is lit by red-rich tungsten lighting than in daylight. Factors of blue filters are oppositely influenced.
- (b) The density of the filter. Whether it is a 'dark' or 'pale' filter, irrespective of colour.
- (c) The actual colour hue of the filter dye its wavelength absorption.
- (d) The spectral sensitivity of the emulsion.
- (c) and (d) are, of course, intimately linked.

Manufacturers of filters therefore supply a list of factors for a particular filter relative to (a) and (d). Instructions with sensitive materials usually include factors for the most commonly used filters, giving either an exposure multiplication factor or an amended film speed. For example, when using a \times 2 yellow filter you either give 1/60 instead of 1/125 sec or rate the film at half its normal ASA figure. In most cases these calculations are already taken into account by a through-the-lens meter, which of course can read through the filter as well (see p. 265).

Filter Qualities and Care

The usual position for a colour filter is just in front of or behind the lens. Here it can be of smallest physical size able to affect the whole image. One disadvantage if used on a lens is that any optical defects in the filter will upset image quality. Greasy fingermarks, scratches, etc., will have the same effect as if they occurred on the lens itself.

To avoid creating abrasions, dyed gelatin filters are best stored between a sheet of folded paper. If a gelatin filter must be cut to shape it should be trimmed while still wrapped in its paper sandwich. Filters in this form are either slipped into push-on holders or attached by a tape hinge to flap over the front or back of the lens. When using a stand camera, particularly out-of-doors, the gelatin filter is safer at the back of the lens – protected from wind or the photographer's fingers. Gelatin filters are so thin that they have no appreciable effect on the position of image focal plane and can therefore be fitted after focusing the lens. They are also cheap enough to throw away after a few uses.

When a filter is likely to be used frequently, the handling inconvenience and susceptibility to damage of lacquered gelatin makes a glass sandwiched filter a more practical proposition. Dyed gelatin can be obtained cemented between glasses of three qualities – optical flats, optically worked glass and non-photographic glass.

Optical flats, which are finished with the same care and accuracy as are given to top lenses, are extremely expensive. They are used when glass filters giving maximum resolution are required.

Optically worked glass (known also as 'B' quality glass) is plane-parallel glass of good quality which is quite suitable for the majority of general photograph work.

'Non-photographic' glass, as the name implies, is intended for viewing filters.

Some filters are available as 'dyed in the mass' glass (dyed in its molten state). The quality of such filters is equivalent to optically worked glass, and, since no cementing work is necessary, their cost is less. However, only a limited range of pigments are suitable, and to be economical these filters have to be made in large quantities — absorbing complete batches of coloured glass. They are therefore made in only a few 'popular' colours, such as yellow-green and red, which can be expected to have mass sales to amateur photographers.

Whatever the glass quality, the fact that the glass or sandwiched filter has an appreciable thickness will slightly shift the plane of sharp focus given by a lens. The effect is particularly noticeable when the filter is put behind a lens imaging a distant subject, or in front of a lens imaging a very close subject. Focusing should always be finally checked after fitting a glass filter. (The same shift-focus effect applies when using a thick red plastic safelight filter under the lens of the enlarger. But in this case always focus without the filter in place because of course it will be removed when the exposure is actually made.)

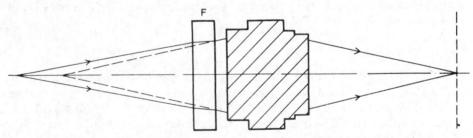

Fig. 11.5. The effect of a thick glass filter (F) on the subject plane sharply imaged by a lens.

Handle and use the same care in cleaning cemented or glass filters as the lens itself. In particular, be careful not to allow moisture (or lens cleaning fluid) to reach the rim of a cemented filter, where it may be absorbed into the exposed edge of the gelatin. Fluid reaching the gelatin may swell and split open the 'sandwich'.

As an alternative to filtering light at the lens, filters can be used in front of studio light sources. Dyed acetate sheets for this purpose must of course be larger and tougher than camera filters – but do not require high optical qualities. Special care is necessary to

prevent overheating and therefore buckling and bleaching of such filters. They should be fitted in appropriately designed holders *spaced away* from the lighting unit. Colour filters must not be used for any period over light sources which are pointing upwards, owing to the overheating they will receive by convection.

Chapter Summary - Colour Filters

- (1) A light filter is a device to selectively absorb certain bands of wavelengths. Intelligent choice of filter and emulsion colour sensitivity enable us to control the black and white tonal reproduction of colours.
- (2) Filter performance is conveniently shown by its spectral absorbtion curve, plotting per cent absorption or transmission against wavelength.
- (3) The colour sensitivity of an emulsion limits the filters with which it can be used (some act as safelights).
- (4) The absorption curve of a filter intended as a safelight for an emulsion must not 'overlap' the colour sensitivity of the emulsion, i.e., yellow brown for blue sensitive, deep red for ortho, no light or indirect dark green for pan.
- (5) Safelight tests are more critical when made on already normally exposed materials. The emulsion is thereby faster, having overcome its exposure inertia.
- (6) Even if of the right colour, dyed safelights may still fog if used too close to the photographic material, or with a lamp which is too bright.
- (7) 'Correction filters' are most often used to compensate the difference between panchromatic and visual response to colours, i.e., a pale yellow-green in daylight, bluish-green in tungsten lighting.
- (8) 'Contrast filters' absorb wavelengths to make colours which would otherwise record as similar tones of grey reproduce in contrasting tones.
- (9) A contrast filter *lightens* the reproduction of its own colour, *darkens* the remaining spectrum.
- (10) Filtration is always necessary to darken blue. But with other colours beware of using pan emulsion plus filter if the same effect could be achieved more easily by an unfiltered non-pan emulsion.
- (11) A filter factor the amount by which exposure time must be multiplied when using the filter varies with subject illumination, density and hue of filter and colour sensitivity of the emulsion.
- (12) When using cemented or other 'thick' filters focusing should be checked with the filter in the position it will occupy when the actual exposure is made. This is unnecessary with plain gelatin filters. All filters warrant careful handling.

Questions

- (1) Draw diagrams to illustrate the following:
 - (a) The colour sensitivity of an ortho emulsion.
 - (b) The transmission of a safelight which would be suitable for use with the same emulsion.

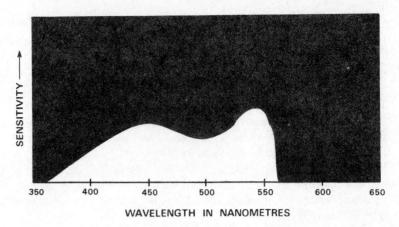

Fig. 11.6.

- (2) Study the figure above and then answer these questions:
 - (a) What is this diagram called?
 - (b) What type of film is represented?
 - (c) What colour safelight would you recommend to be used in handling this film?
 - (d) State which of the following filters could be used on the camera with this film and which could not: Ultra-violet filter, tri-colour red, tri-colour green, tri-colour blue, a polarising filter, a yellow filter, an orange filter.
- (3) (a) Suggest an assignment where filters would be used to give objective reproduction of visual colour values in monochrome tones.
 - (b) Outline an assignment where filters would be chosen to grossly distort monochromatic colour reproduction, for graphic effect.
- (4) The safelight in your printing room is a possible cause of veiling on prints: list three possible reasons for this veiling. Describe how you would make reliable tests of the safelight.
- (5) You are given a poster to copy which has black, red, and green letters on a white background. The red must reproduce as black and the green lettering should not appear as far as possible. Suggest two alternative techniques to achieve the required result. Which one would you actually use? Give reasons for your choice.
- (6) Using a normal pan emulsion which colour contrast filter would you use to produce each of the following results on the final print:
 - (a) Slightly darken a blue sky.
 - (b) Blacken a green background behind a white metallic subject.
 - (c) Darken yellow curtains shown against blue sky.
 - (d) Eliminate a magenta stain on a monochrome copy original.
 - (e) Exaggerate the appearance of rust on chromium plating.
 - (f) Make an orange boiler appear darker than a deep blue sky.

- (7) What choice of black and white emulsion, lighting and filter, if any, would you make in order to copy a multiple coloured oil painting. It is important to maintain 'correct tonal reproduction'.
- (8) Copy the following table and complete it:

Colour of filter	Absorbs	Transmits
Blue	Green and Red	Blue
Yellow		Yellow
Magenta		
Faint pink		Blue, green, red
(Haze filter)		
Cyan		

XII. SUBJECT LIGHTING – EQUIPMENT AND HANDLING

Subject lighting is one of the most important and stimulating aspects of photography. Unlike the artist, the photographer normally has to use a real subject; much of his influence on this subject will therefore be through viewpoint and lighting. Subject lighting is particularly critical, as the emulsion chemically records so much detail that direction of shadows, position of highlights and even subtle tone differences will be almost unalterable once exposure has been made.

Beginners often consider lighting to be a complicated area of photography. The equipment itself is so varied—from small flashbulbs to large dish floods, and from daylight to sealed-beam spots. The art of lighting too seems to have its own mystique. However, there is a logical pattern to all this machinery, and well proven principles to its use. This chapter introduces the type of lighting equipment we will most frequently meet as professionals and suggests some of the things it can do.

Quantity and Quality

The first and most important step we should make is to differentiate clearly between quantity of light and quality. Photography is traditionally linked with powerful, bright lighting, largely because of the desire to give short exposures on fine grain film with the lens stopped well down for depth of field. But with modern emulsions and lenses there is much more flexibility in the quantity of light needed to take photographs. Indeed it is true to say that anything that can be seen by eye can also be photographed. A stationary subject that is dimly lit by a candle or brilliantly lit by flashbulb can be recorded so that the two pictures are virtually indistinguishable – simply by exposing for different times. This is because despite their vast difference in brightness both sources give the same, hard quality lighting. However it is not possible to have hard subject lighting, with its associated hard-edged shadows, and then by some camera or processing technique turn this into a photograph with soft, diffused shadows. So although bright lighting is often a convenience, quality of lighting is of greater fundamental importance. And the two are frequently independent of each other.

Hard (or harsh) light sources

We saw in chapter 1 that light travels in straight lines. This means that if we have a relatively small, compact and undiffused light source (e.g. a flashbulb, a coiled filament clear glass electric lamp, or even just a lighted match) illumination is directly radiated as if from one common point, as shown in Fig. 12.1. When light from such a source reaches a three-dimensional subject it not only illuminates it but creates an abrupt hard-edged shadow. This is of course because parts of the subject nearest the light totally

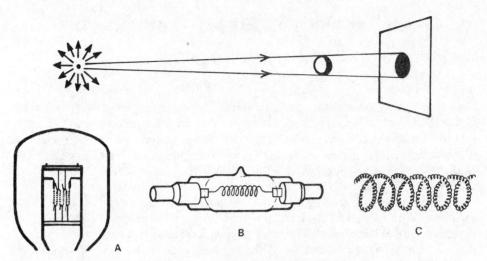

Fig. 12.1. 'Hard' light source. Top: A point source of light gives hardest lighting and sharpest shadows. Bottom: Compact, tungsten filament lamps designed for hard lighting (A) Gas filled spotlight lamp, (B) Tungsten halogen lamp for a spotlight or Halogen lighting unit, (C) Detail of the coiled coil filament commonly used in compact tungsten light sources.

block rays from reaching parts of the background etc. behind it, giving this surface an extreme and sudden transition from full to nil illumination. Strictly speaking we can produce an absolutely sharp shadow only by using a truly point source lamp — anything larger begins to soften the shadow edge. But in practice we are helped by the *distance* of the light source — moving it further away makes the source effectively smaller. Try this in the darkroom by holding a lighted match 30 cm (12 in) or so from an object and observing the shadow it forms on the wall; then move the match to the far side of the room and comparing the new shadow edge. So our light source may be larger than a theoretical 'point', provided it is sufficiently distant. A classic example of this is the sun, which we know to be vast in actual size but, because of its immense distance, it is a relatively small, compact source of light in our sky.

Typical hard light sources include:

Candle or match flame Direct sunlight

Magnesium ribbon Domestic lamp (clear glass)

Flashbulb or compact flashtube

Spotlight

Sealed beam lamp

Hand torch

Electric arc

Direct moonlight

All these provide similar lighting quality, although varying in their intensity and (in the case of flash) in duration.

GENERAL NOTE ON TUNGSTEN LIGHTING. Most photographic studio lamps (not flash) produce their light from a bulb containing a fine filament of tungsten metal. Movement of electrons when electric current is passed through the filament causes it to heat up and radiate light. Hence the general term 'tungsten lighting', still occasionally

referred to as 'half watt' lighting. (This term originated with the earliest electric lamps, claimed to give the equivalent of one candle power for every half watt of electricity consumed.)

The heated filament of a tungsten lamp very slowly evaporates with use and would soon blacken the inside surface of its glass envelope, reducing the illumination. To slow this reaction the envelope may be 'gas filled' with inert nitrogen and argon, or partly evacuated, or may be of tungsten halogen design.

Tungsten halogen lamps use a halogen vapour filling (often iodine) to reduce filament evaporation. To work properly the envelope must become very hot; glass will not meet this requirement and an envelope of tougher material such as quartz is used instead. Hence quartz iodine is one form of tungsten halogen lamp. The main physical difference between tungsten lamps of conventional design and halogen lamps (see Fig. 12.2) is that the latter are much smaller for the same light output, with a thicker envelope that does not appreciably blacken as the lamp grows older. Always avoid fingering the envelope of this type of lamp. Natural grease left on its surface becomes burnt into quartz, creating weaknesses which may crack the envelope. The makers therefore supply each lamp in a small sleeve which is removed once the lamp has been mounted in its lighting unit.

Some tungsten lamps are designed to be 'overrun', i.e. have thin filaments which on normal mains voltage give greatly increased light output, but have a life of only an hour or so. These are discussed more fully on p. 217.

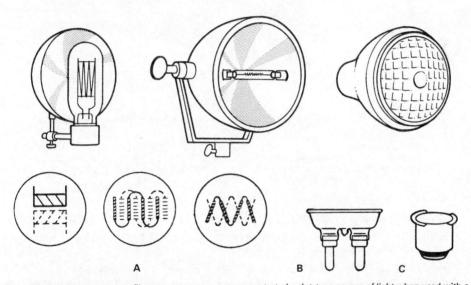

Fig. 12.2. A compact tungsten filament acts as a more concentrated point-type source of light when used with a polished rear reflector. This may be (top row) an attachment to the lampholder; the whole lamphead; or internal silvering of the glass envelope itself. (A) When properly located the reflector forms an inverted image, giving a 'double filament' effect (broken line denotes reflected image in each case). Lamps with separate reflectors may need bi-post (B) or pre-focus (C) caps to ensure filament is correctly aligned at right angles to lens axis.

SPOTLIGHT. A spotlight is a lighting unit designed to give hard illumination over a controlled, limited area (unlike a bare point source which radiates light indiscriminately in all directions). It provides an intense beam that we can vary in width, usually by focusing the lamp behind a simple lens.

The heart of the spotlight is a tungsten lamp with a very compact filament. It is of course physically difficult to pack a wire filament into a small area, particularly as it must also be long enough to give a high level of illumination. To help matters filaments are usually coiled coils, arranged in a tight 'grid'. A concave mirror is positioned behind the filament and this may be part of the spotlight head (see Fig. 12.3) or built into the lamp itself. This mirror reflects forward from the back of the filament light that would otherwise be lost. When properly positioned it forms an image giving a double-filament effect, shown in Fig. 12.2. The lamp has a base cap which ensures that the filament is always aligned properly, with its grid square-on to the front of the spotlight. Lamps for spotlights (generally termed projection lamps) range in wattage from 150 W to 10 kW (10,000 watts). The types most often used for still photography are either 500 W or 1000 W.

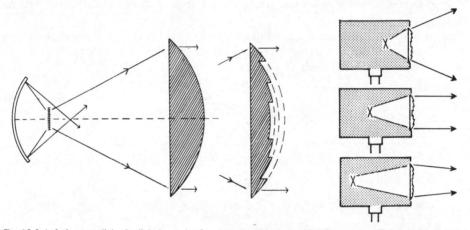

Fig. 12.3. Left: In a spotlight the light beam is often converged by a moulded Fresnel lens. This is less bulky and disperses heat more readily than an equivalent plano convex lens. Right: Focusing movement of a spotlight lamp allows the beam to be varied from broad to narrow. The broad setting (top) most closely simulates light from a point source and therefore gives hardest shadows.

The main body of the spotlight has light-trapped louvres top and bottom to ventilate the lamp, and a large simple condenser lens at the front. If this condenser were plano convex shape it would need to be very thick in order to have the right focal length and diameter to converge a useful quantity of light. This amount of glass would be heavy and liable to crack from the heat of the lamp on its inner face. Most spotlights therefore use instead a fresnel lens – a relatively thin disc of glass carrying concentric stepped rings (see Fig. 12.3). Each step has the surface curvature of a much thicker lens, and their combined effect gives the same overall light convergence. The fresnel lens is

therefore thinner and lighter, and like the cylinder head of an engine, loses heat easily through convection and radiation from its larger external surface area.

Within the spotlight, the lamp and reflector unit can be focused toward and away from the condenser. As Fig. 12.3 shows, when positioned farthest from the condenser the light cone from the lamp is refracted into a narrow beam of light, forming a relatively small intense patch of illumination on the subject. When the lamp is close to the condenser the light cone is refracted into a divergent beam, illuminating a larger subject area less brightly. But as this now approximates a point light source situation sharper shadows are formed. (In fact removing the lens altogether by opening the front of the spotlight gives hardest shadows of all, but light is then spread over a much wider area at still lower intensity.)

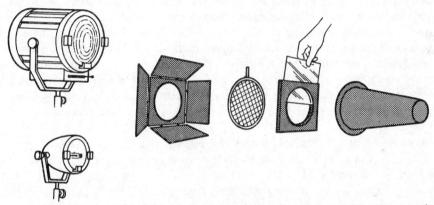

Fig. 12.4. Clip-on accessories for focusing spotlight and Halogen lamp units (Left to right) Barndoors; metal gauze diffuser; acetate filter holder; and 'snoot'.

When handling a spotlight remember that the closely-packed lamp filament is very vulnerable to electric shorting or fracture when knocked or vibrated. Avoid jolting the unit whilst it is switched on. Bear in mind, too, that heat rises, so make any adjustments to angle or focus from beneath the head. Spotlights ventilate efficiently only when in a more or less horizontal position. If they are used pointing vertically up or down for more than short periods, or with something obstructing the vents, overheating and damage are inevitable. As for the lighting effect, remember that the spotlight gives greatest intensity but least hard shadows when focused for narrowest beam; on wide beam light intensity is reduced but its quality is hardened.

There are several very useful accessories designed to attach to the front of the spotlight. These include 'snoots' – cone shaped metal tubes of various lengths giving a more distinct edge to the projected patch of light. 'Barndoors' consist of four overlapping hinged metal flaps (see Fig. 12.4) allowing beam shape to be modified to rectangular or square. Both accessories are useful to prevent unwanted light-spill reaching parts of the subject or the camera – particularly when backlighting. Clip-on diffusion screens made of heat resistant metal gauze soften light quality, and various coloured

acetate filters are available to tint the colour of the light. Another special accessory is an additional lens system that turns the spotlight into a simple effects projector. Shaped metal masks can then be inserted between the two lenses to produce sharply-defined shadow patterns for studio backgrounds etc.

Apart from the optical focusing spotlight discussed above, the advent of the small tungsten halogen lamp bulb has made possible the so-called Q.I. or 'Halogen lamp' (see Fig. 12.2, centre). This uses a compact tungsten halogen lamp mounted within a polished concave reflector in a simple can-shaped head. No condenser is used but the lamp may be focused backwards or forwards within the reflector to regulate the width of beam produced. The resulting hard light source is similar to the optical spotlight although not capable of such fine control. However it is much smaller, lighter and cheaper to buy. Mounted on lightweight telescopic stands, halogen lamps are very popular for location work. A range of clip-on accessories is available.

Another spotlighting variation is the sealed beam lamp – a mushroom shaped bulb having its own integral reflector, mirror coated on the inside of the glass. Similar bulbs are made for car headlamps and for display lights in shops. Because the lamps are entirely self-contained they can be used direct in any ordinary domestic lampholder. However, beam width cannot of course be varied, cost per lamp is relatively high, and they are easily broken in use. Lighting intensity is usually uneven and shadow quality less than sharp.

FLASHBULBS AND TUBES. Contrary to popular belief, flash sources are not necessarily hard in quality. The same principles of source size and distance governing quality apply. Hardest flash sources are those which are physically small, e.g. the miniature tube used in the amateur electronic flash unit, and the midget flashbulb.

Electronic flashes are produced by a high voltage electrical discharge through a gasfilled glass tube. The flash tube can be any convenient shape, being scaled upwards in size according to the light output the complete unit is designed to give. However, even high powered flash can provide quite hard lighting if the tube is shaped into a tight coil (Fig. 12.5) and used direct in a specular reflector. Alternatively it may be a long straight tube designed to give diffused lighting. Electronic flash is sometimes called strobe lighting, particularly in the U.S.A. However, this term becomes confused with the English use of the word which applies more narrowly and means stroboscopic – a special flashing lamp pulsing at a controllable frequency.

A fairly complex power pack is needed for storing electricity from battery or mains and then discharging it briefly through the flash tube when required. This is triggered by a low voltage circuit connected to the 'X' socket on the camera shutter. Powerful electronic flash units are still bulky and expensive but once bought thousands of flashes can be produced for very little cost. These larger units are mains operated and may therefore have a tungsten modelling lamp) appropriately shaped and located very close to the tube) so that lighting quality can be pre-viewed. The short duration of flash is a great aid to spontaneity when working in the advertising and portrait studio; pictures may be taken as fast as film can be wound-on and there is not the heat and glare associated with tungsten studio lighting.

LIGHTING QUALITY

A simple subject like this really only has one predominant plane or surface. Hard, direct sunlight (Plate 49, top) from an oblique angle early in the morning emphasises the texture of the wall and recesses such as windows. However, the shadow shapes form a strong element in the picture and within shadow areas there is little texture or detail.

Plate 49a (bottom) Soft lighting on an overcast day illuminates all parts evenly. The picture contains more detail throughout, but gives less information on subject texture and form.

HARD, DIRECT LIGHTING

The three pictures on this page were each lit by one distant spotlight.

For Plate 49b (bottom left) the spotlight was behind, slightly above and to the right of the camera. Almost everything is illuminated, but this frontal lighting has a flattening effect, suppressing texture and form. (A small direct flash used on the camera gives similar results).

Plate 49c (top left). Spotlight from one side, slightly to the rear, placed about 60 cms above floor. Dramatic effect, giving strong texture emphasis to the plane of floor and central area of string ball. But elsewhere (right and left sides of ball) surfaces are grossly over and under-lit—this may have been acceptable to the eye at the time but is beyond the capabilities of photographic reproduction.

Plate 49d (top right). Top back lighting exaggerates the top texture of the string ball, gives glare to floor, and merges ball shape with the featureless, dominating shadow.

SOFT, DIFFUSED LIGHTING

These three pictures were lit by a large, diffused floodlight placed fairly close to the subject.

Plate 49e (top left). Flood from the same top back direction as the spotlight in 49d. Contrast is generally lowered and shadows no longer hard-edged. However side of ball facing camera appears flattened and largely featureless, and its top surface tends to merge with floor background.

Plate 49f(top right). Flood from the same direction as Plate 49c. Naturalistic lighting which reveals texture of string and floor, and the spherical form of string ball without overdramatisation. Compare with Plate 49i overleaf.

Plate 49g (bottom right). Floodlight directly above and behind the camera. Pattern and detail within the string ball, but minimum texture information and flattened form.

SUPPLEMENTING THE LIGHTING

Plate 49h. The same spotlight arrangement as Plate 49c, but now adding a second spotlight on the left to provide shadow detail. Results in a confusing second set of shadows and over-symmetrical lighting of the ball.

Plate 49i. As Plate 49c but using a large white card curved from the camera to a position well to the left, remaining close to the subject, but just outside the picture area. Card reflects sufficient spotlight illumination to lighten the shadow side of ball without Introducing new shadow lines. Strong separation of string ball from background.

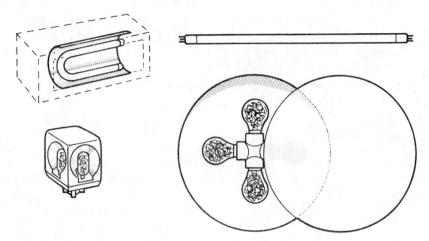

Fig. 12.5. Top: flashtubes. Bottom: flashbulbs. The compact U-tube electronic flash-head and the small flash cube both give hard lighting, whereas the long straight tube and the diffused cluster of large flashbulbs give softer quality.

Flashbulbs produce light in an entirely different way, by the actual burning of combustible wire (usually zirconium or a mixture of magnesium/aluminium). This burn-out occurs in a glass envelope which has an anti-shatter coating usually dyed blue to make the illumination the same colour as daylight and electronic flash. Flash-bulbs are smaller than flashtubes of equivalent light output, but cannot be so varied in shape. Consequently their light is generally harder in quality when used direct.

Equipment to fire flashbulbs is simple, compact and inexpensive. The power source is basically a small battery feeding a circuit completed by connection through the 'M' contacts of the camera shutter. This provides a brief delay period allowing the bulb to burn to full brilliance before the shutter opens fully. As flashbulbs can be used only once, cost per flash is much greater than with an electronic unit. Bulbs also have to be changed for every exposure. However this form of flash is robust, very portable and can give high intensity of illumination. Bulb flash is still used to light large areas, e.g. in industrial and architectural work. For more detailed evaluation of flash sources see *Advanced Photography*, chapters 5 and 6.

DIRECT SUNLIGHT. This is such a familiar form of lighting that we can easily take it for granted and forget to use it intelligently. Direct sunlight in a clear sky provides perfect point source lighting, giving pin sharp shadows. Of course, it also illuminates unlimited areas at high intensity, and is absolutely free! But the sun is by no means a controllable light source. It acts like a spotlight moving on a set path across the studio and subjects have to be placed to suit the sun's position or, in the case of buildings etc., the photographer must choose exactly the right time of day. This is where a compass is useful. Quality of light can also change unpredictably from hard to diffuse illumination owing to the scattering effect of cloud. Height of light is linked to direction – the sun is lowest when in the East or West – and to time of year. Similarly colour changes rapidly

at dawn or dusk when the sun's rays pass obliquely through the earth's atmosphere, which then filters out most blue wavelengths. In winter particularly, daylight is of shorter duration than the photographer's day. Despite these inconveniences, the visual effect of sunlight is universally familiar and therefore contributes to realism. In fact, as we shall see, the principles of using artificial light in the studio are to a large extent founded on natural daylight conditions.

Soft (or diffuse) light sources

If, instead of a point-source light, we use a large source of scattered illumination the shadows formed by objects are soft edged and indistinct. As Fig. 12.6 shows, the size of

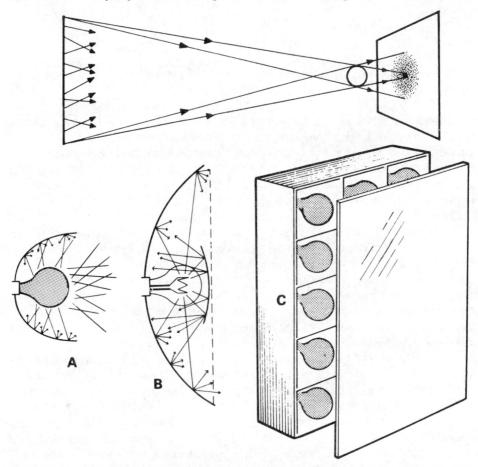

Fig. 12.6. 'Soft,' diffuse light source. Top: The larger (and closer) the source of light the more shadows become diluted and soft edged. Bottom: (A) 'Photographic' lamp in a matt white flood reflector. (B) Large matt white shallow flood – a shield which blocks all direct illumination allows clear or pearl bulbs to be used. (C) 'Egg-box' bank of photographic lamps, further diffused by tracing paper.

the source and the fact that rays are scattered from every part of it in all directions, means that there is hardly any part of the subject or background that does not receive *some* diffused light. In extreme cases (e.g. a subject outdoors under a totally overcast sky) shadows may be practically non-existent.

For the most part soft lighting is created by arranging that light rays from a source are scattered by passing through a diffuser such as cloud, tracing paper, ground glass, etc., or reflected off a diffuse surface such as matt white paper or paint. Notice how the *closer* this diffusing material is to the subject the softer the lighting quality becomes. This is because light then reaches the subject from a wider range of directions, like a larger light source further away.

Diffuse light sources include:

Fluorescent strip tube Floodlight

Overcast daylight or light wholly from a blue sky

Any hard light source placed behind diffusion material or reflected from a diffuse surface

Any continuous light source moved around during a time exposure.

FLOODLIGHT. Most floodlights use a lamp with a tungsten filament in a fairly large etched 'pearl' glass envelope. This is housed in a large matt-white-surfaced reflector to increase its effective size. Because the lamp itself diffuses light in all directions (i.e. is 'non-directional'), the exact position of filament relative to the reflector is not critical and the bulb is usually fitted with a screw-threaded cap. Floodlamps may either be of the 'photoflood' or 'photographic' type. Both these appear physically similar, having etched glass envelopes, but the *photoflood* is designed to be 'over-run'. This means it has the type of filament usually found in a lower voltage lamp which, when used on the normal mains circuit, gives brilliant light for a lifespan of only 2–3 hours. Photofloods are relatively low in cost and popular with amateur photographers who only occasionally use studio lighting. The professional considers their short life impractical, although he may keep a photoflood in the camera bag to illuminate shadows in architectural interiors, etc. Owing to over-running, photofloods produce light that is slightly bluer than spotlight and photographic lamps, and is the standard to which all type A colour films are balanced to give acceptable colour reproduction.

Photographic (also known as 'Photopearl' or 'Series B') lamps are a compromise between the domestic pearl lamp, with its long life but low light output, and the photoflood. Photographic lamps are usually 500–1000 watts, have a life of 100 hours, and although more expensive than photofloods are generally used in professional floodlight units. The colour of light they produce is the standard for correct reproduction when using type B colour films. As can be seen from Fig. 12.7, reflector size and shape can vary from something deep and little larger than the lamp itself, to a large shallow dish. Smaller, deep reflector floods take up less space in the studio but give a narrower distribution of light and cannot provide such diffuse illumination as larger diameter units. The usual reflector finish is matt white to give maximum scatter of light, but an aluminium paint finish gives a slightly harder effect. Both reflectors need respraying every year or so as the paint gradually discolours or grows dirty.

REFLECTED OR DIFFUSED LIGHT SOURCES. Virtually any light source – flash, tungsten or daylight, however harsh – can be made to give soft diffused illumination by making it reach the subject *indirectly*. There are two main ways of doing this: (1) by turning the light away from the subject and reflecting it off a convenient surface such as a matt white wall, or (2) by placing a diffusing screen between lamp and subject to scatter the direction of the illumination. In Fig. 12.7, for example, a spotlight pointed towards a white studio wall may produce a patch of light about one metre wide. This reflected (bounced) light has the same quality as a one metre diameter floodlight.

Bounced lighting is particularly useful when a large studio area has to be evenly and softly lit. A whole wall and ceiling can be illuminated by a mixture of whatever lighting units are to hand – giving an almost shadowless, overcast daylight quality. This is one very valid reason for painting the studio throughout in a matt white washable paint. If the ceiling is very high a white canopy can be suspended over the set; similarly, if the walls are unsuitable, use reflector boards made up from large sheets of polystyrene, painted plywood or just background paper stretched across a frame. Silvered reflectors, made from foil or aluminium-painted material, give more directional reflections.

Most of these methods also work well with bounced flash – pointing the flash head towards the ceiling or a nearby wall softens its quality and spreads its illumination. Another convenient reflector is the white-lined inside surface of a shallow umbrella. This can be folded up out of the way when not needed, and is of course very lightweight and portable for location work.

If, on the other hand, lighting quality is to be softened by means of a diffusion screen between lamp and subject this needs choosing carefully. A large sheet of tracing paper or translucent plastic is perhaps the most practical screen material but must be well spaced away from the lamp to avoid heat damage. Only wire diffuser grids are sufficiently heat-resistant to attach directly onto the front of the lighting unit, but these give limited diffusion. Another approach is to make up a 'window light' (see Fig. 12.6) so-called because it gives results similar in quality to an indoor situation near a window on an overcast day. The unit is full window size, with a translucent plastic front. It could contain several fluorescent strip tubes, or long electronic flash tubes plus fluorescent modelling lights. Alternatively an 'egg-box' arrangement of photographic lamps is possible, provided the diffuser sheet is protected from the heat, perhaps by spacing.

Inevitably when lighting is reflected or diffused to soften its quality there is an accompanying loss in *quantity* of light. As we saw in chapter I no surface will reflect 100% of the illumination reaching it, and in practice the average white ceiling absorbs about half the light.

PAINTING WITH LIGHT. Sometimes with a still life or architectural interior it is possible to 'spread' a hard or insufficiently diffuse tungsten light source to produce more shadowless illumination. An exposure of several seconds at least is needed, so the lens should be well stopped down and/or a neutral density filter fitted. During the exposure the lamphead is kept constantly on the move, blurring the shadows and giving a result similar to a floodlight of a size equal to the total path of movement. The easiest technique is to move the lamp in a series of arcs over the camera, maintaining the same

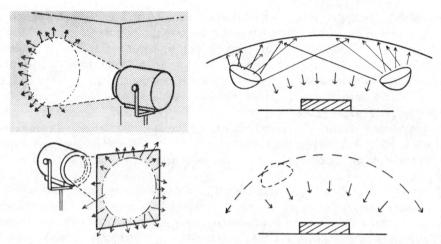

Fig. 12.7. Improvising a soft light source (left) by 'bouncing' hard lighting from a matt white wall or directing it through diffusing material. (Right) by bouncing flood or spotlights from a matt white overhead canopy, or spreading a light source by moving it during a time exposure.

distance from the subject and therefore keeping exposure level constant. Avoid touching camera or tripod with the trailing mains lead.

INDIRECT DAYLIGHT. Most of the diffuse light sources we have discussed within the studio are paralleled by natural conditions outdoors. The sun obscured by a cloud gives lighting quality similar to a spotlight used behind a diffuser. Of course, when the cloud layer totally fills the sky sunlight is more completely scattered, and for an unenclosed subject such as open landscape the effect is almost shadowless.

Somewhat similar conditions occur on a clear day when the subject is photographed completely in shadow, e.g. within the shade cast by a large building. The only light reaching this area is scattered from the blue sky and is therefore highly diffused. In the Northern hemisphere artists use studios with windows facing north so that they receive only scattered light, never direct sunlight. Hence 'Northlight', a term which is sometimes generally applied to large diffused light sources.

Practical Lighting - Basic Principles

First of all try to decide what contribution lighting is to make to the picture. Given that it will provide enough illumination to allow convenient shutter and aperture settings, what else should your lighting do? Perhaps it is to emphasise the form and texture of a new building, or a product photographed in the studio. It might be used to highten the features in a dramatic male character portrait, or be kind to an ageing woman's wrinkles. Lighting may be the means of separating out one element or area from others, or be used to reveal extreme detail throughout. It can 'set the scene' and contribute most of the atmosphere to the picture, or just help simplify a situation which would be difficult for an emulsion to record.

Probably the best way to discover what lighting can do is to photograph a variety of still-life objects in the studio, where everything is under the photographer's control. But even in natural, 'existing light' situations much can be learnt simply through observation. Look up from this book for a moment and observe how your own surroundings are lit. Hard lighting or soft . . . even or uneven? Which areas are picked out by their lighting, and which suppressed? Are any textures emphasised? And how would a black and white photograph record the scene as it appears now? Remember that the photographic process has a tendency to *increase* rather than reduce contrast. Half close your eyes and look through your eyelashes at the scene – shadows now seem darker and lighting contrast appears increased. This is a good guide to how it will look on the final print.

LIGHTING FOR TEXTURE. If we are showing a single textured surface – such as a fabric sample, one face of a building, or a technical specimen like Plate 98 – one hard light source can very effectively emphasise the most minute surface irregularities and undulations. It should illuminate the surface obliquely. If this results in one end receiving much more light than the other, remember the inverse square law and move the light further away – the ratio between nearest and furthest distances from the light will then be reduced.

Try adjusting the lighting unit or the subject through 360° until the most effective direction and height of illumination is seen. For subjects such as wood, which has a linear 'grain', best direction will probably be at about right-angles to the grain and not very high above its surface. The temptation with one hard source is to over-dramatise texture and exaggerate it out of all proportion, so that quite slight undulations look like featureless black holes. Of course, sometimes unlit cavities form interesting graphic patterns, as in Plate 91. But with most three-dimensional subjects we are concerned with lighting not one but several important planes and what is good for one surface may be harsh and unsatisfactory for others. Remember that in black-and-white photography a black, featureless shadow attached to an object can easily dominate the picture and destroy what was intended to be the centre of interest.

One solution then is to introduce a second light source, preferably without introducing a second set of hard shadows. (We are rather conditioned by seeing the world lit by one sun, not two.) So a diffuse light – perhaps illumination bounced off a white reflector – might be used to lighten ('fill-in') and reveal some detail in the first set of shadows. It will have to be positioned quite close to the camera to introduce light into all the shadows seen in the composition (see Plate 49i). Another approach is to change the main, hard light source for something softer (e.g. use a flood instead of a spotlight) with or without a fill-in light. In fact the more objects and separate planes we have to deal with in one picture the simpler and more generalised our lighting should be. The subject in Plates 49b—i for example – consisting of surfaces that are spherical and flat, and having various cavities – can be lit effectively by a single large diffused light source, Plate 49f. This may not emphasise texture on any one plane (such as the wood) quite as much as a hard light source, but then the string would create shadows which would confuse most of its form. Our overall soft lighting is therefore a successful compromise.

The light source should preferably not be too near the camera, Plate 49g, where it would flatten and destroy modelling, but instead could be directed from one side or even from the rear of the subject. If the general effect is good but the immediate foreground rather under-lit, a reflector board positioned vertically somewhere below the lens could redirect part of the main illumination back into this area.

LIGHTING FOR DETAIL. Quite often record photographs of technical subjects need to show the minutest detail without noticeable influence of lighting – rather like a draughtsman's line drawing. A similar need occurs in head shots where perhaps the face is to appear like a mask, devoid of modelling and starkly revealing the lines of the eyes, mouth etc. The basic requirement here is for soft, even frontal lighting. One approach, often used for small still life objects, is to have a large sheet of tracing paper with a central hole through which the camera lens and lens hood protrudes. Two or more light sources are then directed through this diffuser from the camera side. Alternatively it may be possible to use a ring flash – an electronic flash tube, circular in shape, which fits like a collar around the lens and so floods the subject with soft frontal lighting. Another technique, suitable for portraiture, is to use an umbrella and/or a trio of reflector boards large enough to form a cubicle enclosing photographer, camera and sitter. Spotlights or flash placed to reflect off its inner surface give an even soft light, rather like being in a tent.

LIGHTING FOR FORM AND SEPARATION. When lighting a three dimensional object we can communicate its form strongly by arranging that each facet, and the background, show distinct differences in tone. For example, when photographing a box shape showing its top and two sides, carefully adjust lamp height, direction and placement of reflectors so that each of these three surfaces record as different tones of grey. The background can be made yet another tone – particularly if it is well back from the subject and so can be lit quite separately by another lamp to match or contrast with any subject brightness values.

If the subject has graduated tone values you can light the background unevenly so that the darkest parts of the subject appear against the lightest area of background and vice versa — a device called tonal interchange. But remember that strongest lines and shapes occur in a monochrome photograph when the lightest area is placed adjacent to the darkest, e.g. Plate 62, so make sure this emphasis is justified. The edge of an unimportant but deep shadow on a white surface can easily attract more attention than the main subject itself.

AUGMENTING EXISTING ILLUMINATION. Often artificial light is used in a secondary role – to modify an 'existing light' situation. Photographing by natural light indoors, for example, we are frequently faced with excessive contrast between areas near windows and other parts of the room. However, by reflecting a powerful light source off the ceiling or a wall not included in the picture, shadow area illumination can be raised to a level where detail will just record. This will not destroy the natural lighting appearance of the scene, providing it is not overlit or lit in such a way that an alien set of shadows is formed.

A still simpler solution is possible when working outdoors, at least for subjects of

manageable size. Imagine we have a portrait that looks fine side lit by direct sunlight, except for the over-dense shadow one side of the head. Rather than rotate the figure and have to use direct frontal lighting we can position our subject near a light toned wall on its shadow side so that diffused sunlight is reflected back into this area. Even a newspaper will do as a just-out-of-frame reflector for a head shot, and the photographer may find it worthwhile carrying several rolled up materials of various reflective characteristics. Diffused flash can play a similar role filling-in harsh daylight. However, as you cannot then see the lighting balance created, flash distance and shutter speed must be carefully calculated (see Advanced Photography chapter 6).

On other occasions existing light can be augmented in reverse—e.g. a group photographed outdoors on a dull overcast made to appear in 'sunlight'. This calls for a flash, spotlight or other *hard* light source directed from a suitably realistic angle, combined with the existing soft lighting. Remember that an imaginary line joining light source to subject and extended shows the position and length of shadow. If the light is placed too low your picture will appear to have been taken at sunset! Many of the above techniques allow the right degree of lighting balance to be judged visually, or you can measure and compare values with a meter as discussed on pp. 262 and 266.

LIGHTING FOR ATMOSPHERE. As far as possible lighting should contribute as much to the atmosphere of a photograph as carefully chosen props and models. A dramatic subject or situation justifies dramatic use of hard lighting, whereas in a nostalgic or romantic picture softer illumination will probably be more appropriate. If the character of an interior can be communicated by smoky shafts of sunlight and black shadows, supplementary lighting is unnecessary and may even be destructive.

In the studio remember that light or shadow patterns thrown across the subject can suggest an environment just as effectively as showing an elaborate background. A window frame silhouette cut from black paper and placed between a light source and the set forms window-shape patches of 'sunlight' for, say, a cookery still-life. And in miniature this same shape will be shown reflected in the glossy dome of a frying egg, the surface of a glass of milk and even (if it is a close-up) in the eyes of a model.

Well considered lighting requires just as much patience and organisation as the actual camerawork. The difference between adequate and outstanding landscape photography, for example, often hinges on the fact that the photographer has waited for the right weather, the right time of day — even the one right time of year — to achieve a particular visual situation.

Photo-Electrics

One of the easiest ways to sever good client-photographer relations is to set up your lighting on his premises, switch it on – and blow all his main fuses. Apart from inconvenience and delay, overloading can be dangerous if wiring is in any way deficient. Some elementary knowledge of electricity is essential.

The limiting factor to the number of lamps which may be connected to a power circuit is the total current flow, measures in AMPERES. Each circuit in a building is wired to carry safe-

ly a maximum amperage – a simple lighting circuit may be designed for 2 amps, or 5 amps; power points for 5 amps, 13 amps, 15 amps; special power outlets for 30 amps or more. Rather like water-pipes, the wires and insulation must be progressively thicker the higher the current flow they are intended to handle. If more than the designed current is drawn from the circuit, wires begin to warm up (acting virtually as filaments) and there would be obviously be a risk of fire.

To prevent this, a thin piece of wire is located in each circuit which heats up more rapidly than the main wiring, melts and breaks the circuit. This fuse must obviously be appropriate to the circuit — use of too thin a wire may unnecessarily reduce the loading which the circuit will safely stand; use of too thick a wire may lead to dangerous overheating. The maximum safe loading for each circuit in a building is normally written inside the fuse box.

The type and size of power socket will also serve to indicate maximum loading (provided the fuses are correctly wire). The current flow through each of our lighting units depends upon the power consumed by the lamp, measured in watts, and the 'pressure' of the electricity supply in VOLTS.

$$\frac{\text{Wattage of lamp}}{\text{Voltage of supply}} = \text{Amps drawn from the mains}$$

EXAMPLE 1. Using four 500 W spots on a 250-volt supply each lamp draws 2 amps; together the lamps draw 8 amps. This would overload a 5-amp power point and we should have to look for a 13- or 15-amp outlet, or plug some of the lamps into another separately fused 5-amp circuit, perhaps on another floor.

Example 2. You arrive on location with two 1000 W spots, three 500 W spots and two 500 W floods. The laboratory in which the pictures are to be taken has one 15-amp and one

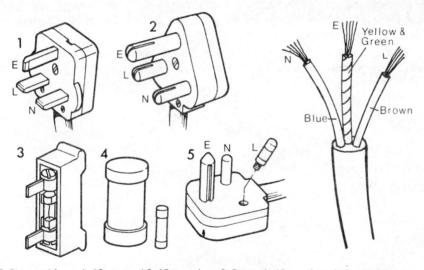

Fig. 12.8. Plugs and fuses. 1: 13 amp and 2: 15 amp plugs. 3: Domestic 15 amp fuse. 4: Cartridge fuses – normally located within plugs or appliances. 5: A 13 amp plug using a cartridge fuse as one of its pins, for easy accessibility. Right: European colour coding for Live, Neutral and Earth wiring, corresponding with plug pins.

5-amp 250 volt power point on separate circuits. How could you safely connect up all the lamps?

Answer. Total amps drawn by two 1000 W lamps =
$$\frac{1000}{250} \times 2 = 8$$
 amps

Total amps drawn by five 500 W lamps = $\frac{500}{250} \times 5 = 10$ amps

Total 18 amps

This could be distributed in several ways, for example, by plugging one 1000 W spotlight into the 5-amp circuit and the remaining lights into the 15-amp socket, through a distributor box.

N.B. A cold filament has much less electrical resistance than a warm one. When switching on a lamp the sudden flow of current through the cold filament momentarily exceeds what the lamp would normally draw. Lamps should therefore be switched on one at a time to avoid a collective surge which may burn out the fuse.

Electricity is paid for in 'Units'. Each unit is the amount of electricity consumed by 1000 watts (1 kilowatt) burning for one hour.

1 UNIT = 1 KILOWATT HOUR

A 500 W spotlight therefore consumes one unit every 2 hours, a 100 W lamp one unit every 10 hours, and a 2 kW spotlight uses a unit every 30 minutes.

In our Example 2 above, where we were using a total of 4500 W of lighting, we were consuming $4\frac{1}{2}$ units of the client's electricity every hour. Price per unit varies in different parts of the country and with different tariffs. Generally speaking we pay on a 'two part' tariff whereby the first 100 or so units are fixed at one price, and thereafter additional units are paid for at a much lower rate.

Two ways in which the life of a tungsten lamp can be extended have already been discussed – by maintaining efficient ventilation and avoiding jolts, particularly when the

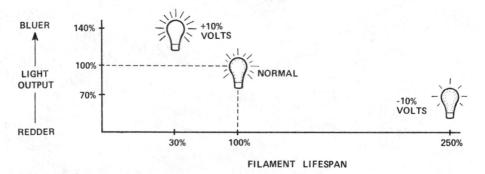

Fig. 12.9. Decreasing the voltage passed through a lamp reduces light output but greatly extends its life.

lamp is hot. Another method of extending life is to 'underrun' the lamp, e.g., use 250-volt lamps on 240-volt mains. However, this slightly lowers the illumination and increases its red content. Lamps must not therefore be underrun if being used for colour photography.

Sudden surges of current through a cold filament also shortens its life (rapidly switching on and off a lamp is likely to break the filament or blow the fuses, or both). On the other hand the life of a lamp can be extended by 'pre-warming' the filament. This can be done by wiring pairs of lamps in series with each other so that each receives only half the normal current. When actually required for photography they are switched back 'in parallel' with each other to receive normal loading.

TABLE 12.1
TUNGSTEN LIGHT SOURCES – SUMMARY

Type	Power	Life	General Characteristics
General service (domestic lamps)	5–150 W	1000 hours	Low cost, low illumination level.
Photographic ('Series B', 'Argaphoto', 'Photopearl', etc.)	500 W or 1000 W	100 hours	Large etched bulb; usefully high illumination level; standard lighting for type 'B' colour materials. Largely used for professional floodlights.
'Photoflood' No. 1 (low voltage filament No. 2	275 W 500 W	3 hours	Etched bulb; lower cost than above; very high level of illumination (and heat); standard for type 'A' colour
overrun)			materials. Popularly used by amateurs.
'Projection lamps'	100–2000 W and up to 10 kW	100 hours	Clear bulb; compact filament; pre-focus or bipost cap; designed for use in an optical system – spotlight, etc.
Tungsten halogen lamps	1000 W up to 5 kW	100 hours	Clear, very compact bulb; designed for spotlight or simple reflector unit.

Chapter Summary - Lighting - Equipment and Handling

- (1) Clearly distinguish lighting quantity from quality whereas *quantity* is mostly an exposure problem, *quality* is an important visual device.
- (2) For hardest illumination choose a point-source type light source (spotlight, compact flash etc.) and use it direct, some distance from the subject. Softest illumination occurs when a large, diffused light source (floodlight, 'bounced' lighting etc.) is used close in to the subject.
- (3) Many point source tungsten lamps today are of tungsten halogen design, offering greater filament efficiency and smaller size. Over-run lamps

- ('photofloods') are intended to give boosted illumination level at the cost of shortened life.
- (4) Electronic flash differs from bulb flash in that its initial cost is greater and running costs less. Time is not wasted changing spent bulbs, but bulky electronic units are still needed to match the light output of large flashbulbs. Both tend to give hard lighting unless reflected or diffused, or (electronic) designed with an elongated or ring shaped flash tube. All bulbs and lower powered electronic flash are normally battery operated, and so independent of mains supply.
- (5) Daylight, ranging from harsh direct sunlight to soft overcast illumination, changes in quality, direction, height, quantity and colour.
- (6) In practice lighting should help to express the important qualities of the subject. Visually preview your result, remembering that it is better to light to a slightly lower contrast than you envisage on the print. This is particularly true of pictures finally intended for the printed page.
- (7) Hard oblique lighting can be excellent for single, textured surfaces, but when there are many planes at various angles and complex collections of shapes the results are often uneven and confusing. Diffuse light is more likely to be successful.
- (8) For maximum information photography aim for soft, even frontal lighting; for separation of planes and emphasis of form, light for tone variations, including graduation and tone interchange. Remember existing light situations can be modified by either shadow-filling or shadow-forming.
- (9) Try to arrange that your lighting is in sympathy (not working against) the atmosphere and mood you want to create, and the eventual function of the picture.
- (10) Don't exceed the amperage maximum of the power point circuit fuse. Total watts + volts = amps drawn. Cost is based on the Unit (= 1 kW hour). For maximum life a tungsten lamp should be properly ventilated and protected from vibration and jolts, particularly when hot.
- (11) For a first purchase consider basic units that are manœuvrable and versatile. Whereas a hard light source is easily diffused, the reverse is not true. Ensure your equipment suits your particular operation compact, mobile kits for location orientated work, flash with modelling lamps for people pictures in the studio, etc. Other types of lighting can then be hired for the occasional special job.

Questions

- (1) You go on location with some 2 kW and some 500 W spotlights. The voltage of the supply is 250 volts. How many amps will each spotlight draw? How many 500 W spotlights may be safely connected to a 13-amp socket? How many 2 kW spotlights may be safely connected to a 13-amp socket?
- (2) List the main features, characteristics of, and differences between the following:

- (a) a photoflood lamp.
- (b) a tungsten halogen lamp.
- (c) a lamp suitable for use in a spotlight.
- (3) Describe two alternative lighting techniques to produce virtually shadowless illumination on a small engine part. Which would you actually use. Explain why.
- (4) Draw a diagram showing the optical layout of a focusing spotlight. Give an example of an occasion when it might be used
 - (a) 'broad beam',
 - (b) 'narrow beam'.
- (5) Give a brief account of the lighting equipment you would choose and the way you would position it for each of the following subjects:
 - (a) Copying a glossy bromide print.
 - (b) A cup and saucer, for a china shop showcard, stressing delicacy of design and high quality finish.
- (6) Draw a diagram to show the connection of a colour coded standard flexible cable to a 13 ampere, 3 pin fused plug.
- (7) Discuss the practical considerations in choosing and using lighting for general location work away from the studio.

XIII. SENSITOMETRY

We are now almost ready to combine optics, camera, sensitive material and subject lighting, and discuss the problems of correct exposure. We noted earlier that exposure produces a few atoms of silver in some of the grains of the emulsion, the number of grains affected being broadly in proportion to the light dosage received. Later, these atoms form centres for developer action, creating silver in visible quantities — again in proportion to the original light received. The emulsion therefore has a conversion action — converting the light dosage of the optical image into 'blackness of silver' on the negative.

Naturally, these are limits to the performance of the emulsion. Too much exposure creates dense 'burnt out' highlights,* too little exposure and shadows are 'degraded' and empty. The degree of development too affects the difference between tones, contributing to

'hard' or 'flat' negatives.

As photographers we could go on using these rather vague colloquial terms to describe the combined effect of subject, emulsion, exposure and development on the final negative. However, if we are really to understand the problems of determining correct exposure it is helpful to have an accurate idea of the limits of tonal performance of an emulsion. 'Flat' and 'burnt out' are not precise enough descriptions. How flat... and could this be compensated in processing? Essentially, we need to be able to forecast what type of negative (in terms of tonal gradation) will emerge from the processing solutions.

The most logical way of gathering this information is to test emulsions by giving them a strictly controlled wide range of light dosages, processing them under different controlled conditions and accurately measuring the tones or blackness that result. This scientific, analytical approach to the performance of photographic emulsions is called 'sensitometry'.

Definition: 'Sensitometry' - the scientific study of light sensitive materials.

Sensitometry will not predict for us whether our pictures are successful, for this depends on much more than just the measurement of tonal values produced. So although our technical understanding may be handicapped later, we can manage in basic practical photography without studying this area. On the other hand, sensitometry is a convenient and universal 'shorthand' used to compare the speed and tonal performance of different emulsions, discover the limits of effective exposure, compare developers and developing conditions, and relate negative qualities to prints.

The Characteristic Curve

The first reliable approach to accurate sensitometry was established by two scientists who were amateur photographers – F. Hurter and V. C. Driffield. Appalled at the general lack of accurate technical information from manufacturers of early gelatin-

^{*} The terms 'highlights' or 'shadows' always refer to the reproduction of these subject areas.

coated plates, in 1876 they commenced logical evaluation of emulsion performance. A treadle sewing machine was converted into equipment for applying a series of known light dosages to the sensitive material (the first 'sensitometer').

Methods of measuring the 'blackness' of the processed results were pioneered, and by plotting original light dosage against these 'blacknesses', Hurter and Driffield produced a 'performance' graph of a photographic emulsion, which they called its 'characteristic curve'. From this they could measure speed, emulsion contrast, and the influences of subject and development.

Performance graphs – plotting one variable against another – are of course common enough for any 'conversion'. For example, the overall performance of a gas fire can be graphically expressed by plotting gas consumed against heat emitted; an engine performance by plotting fuel intake against power, etc. If maximum information is to be presented both input and output scales should span as wide a range of conditions as possible. Let us imagine that we are preparing the performance or characteristic curve of a normal contrast medium speed negative emulsion. The experiment will be described step by step, and finally we shall see what practical information can be read from the graph (see Fig. 13.4).

Stage I - Controlled Light Dosage

When the camera shutter is opened a whole range of light intensities – from the darkest shadows to the brightest highlights – is projected on to the emulsion surface. To give our test film its range of controlled light dosages we could therefore put it in a camera and photograph a scene, having first carefully meter-measured the relative brightness of every object in the picture. The disadvantages of this system are: (a) the physical difficulty of accurately making so many meter readings; (b) a subject is needed containing a complete range of brightnesses between extreme highlights and shadows (preferably equally spaced) if we are to get maximum information from our graph.

Alternatively, the material can be set up in the darkroom and exposed, like a test strip of printing paper, to a wide range of 'doubling' exposures. One way to do this is to use a rotating 'sector wheel' – a rotary shutter between light source and emulsion, with elongated apertures cut so that different parts of the film receive a range of exposure durations. Although this method gives a wide range of 'dosages' it does not match practical conditions, in that the emulsion used in a camera receives a range of brightnesses for a common period of time. The test strip or sector wheel method gives a range of times to a common brightness. It is, therefore, more accurate (and convenient) to give our light dosages by the 'step wedge' method (see Fig. 13.1).

A step wedge is a piece of neutral (sometimes called 'grey') film or glass divided up into parallel strips, each of which transmits a known percentage of light. A step wedge with 15 steps from opaque to almost complete transparency, each one progressively transmitting half the light of its neighbour, will present a range of brightnesses from 1 to 16,384. Step wedges are marketed by photographic manufacturers for testing purposes.

By exposing such a step wedge in contact with our test emulsion (under a convenient

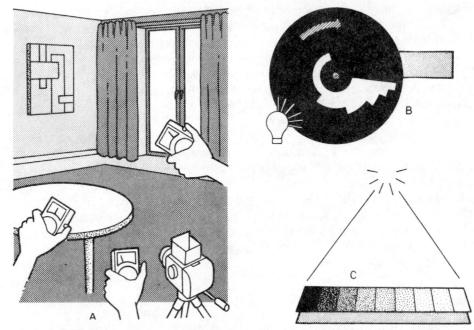

Fig. 13.1. Possible methods of giving 'controlled light dosage' to an emulsion under test. A: Photographing a subject in which every subject brightness is measured. B: A range of exposure times given behind a sector wheel. C: A range of intensities given by one exposure under a 'step wedge' of known transmission values. Method C closely approximates practical photography, without the inconvenience of finding an extreme brightness range subject and multiple meter readings.

light source such as an enlarger) we are thus able to give an enormous range of light dosages with one exposure. Although a real subject is not being exposed on to the emulsion we are producing an effect wider than the widest range of subject brightness ever likely to be met in practice – and under more convenient conditions. (N.B. Strictly the position of the exposing light should be adjusted so that the processed test emulsion shows results after an exposing time approximately equal to likely duration in practical camera use – say 1 sec or less. If a tungsten enlarger is used as the light source, the curve produced is strictly applicable only to tungsten light exposures. Exposure to (bluer) daylight will give slightly different results, particularly if the emulsion is not panchromatic.)

DEVELOPMENT. In order to control results it is essential strictly to control developer dilution, temperature, agitation and timing. These would normally be as close as possible to usual working conditions.

THE HORIZONTAL GRAPH AXIS. We can now start to prepare the graph for our emulsion characteristic curve. Relative light dosage (which we will call 'exposure') applied to the emulsion will be calibrated on the horizontal axis; the resulting blackness on the vertical axis.

It would be useless to mark our horizontal scale on the graph paper as an arithmetic

230

progression 1, 2, 3, 4, 5, 6, etc. The reason is that our original step wedge gave a range of *doubling* relative brightnesses from 1 to 16,384 and on an arithmetic progression the first two steps would be consecutive numbers (1 and 2), the last two would have 8,192 units separating them (8,192 up to 16,384). In addition, the axis would need to be impossibly long. It is, therefore, more sensible to use a multiple progression 1, 2, 4, 8, 16, etc. reaching 16,384 in fifteen calibrations, and giving equal spacing to the first and last step.

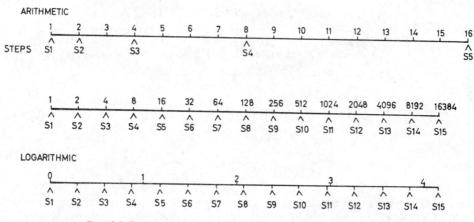

Fig. 13.2. Three ways of scaling the 'light dosage' (Exposure) graph axis.

Still, the higher numbers are uncomfortably large for a graph scale. It is therefore accepted practice to mark out the horizontal axis in a logarithmic progression to the base 10 (see Appendix C, p. 377). With this scaling the numerals 1.2.3.4. represent 10, 1000, 10,000 and 100,000 respectively. Each doubling of exposure given by consecutive steps on the step wedge can now be marked in on the graph scale at 0.3 intervals (0.3) is the log-to-the-base-ten of 2). The horizontal axis of the characteristic curve is therefore known as the log E axis.

Stage II - Resulting Blacknesses

How does one measure the 'blackness' of a tone on a processed negative? Hurter and Driffield established the principle of comparing the quantity of light *incident* on the particular silver deposit being measured with the quantity *transmitted*:

$$\frac{\text{Light incident}}{\text{Light transmitted}} = \text{OPACITY}$$

e.g., if of 100 units of light shining on the tone to be measured only 10 are transmitted, the tone has an 'opacity' of 10. However, since measurement of our processed emulsion will be plotted on a graph which already has one axis calibrated in \log_{10} we shall also

have to convert opacities into logarithms. Instead of calling such a scale 'log 0' the log_{10} of opacity has its own name – 'Density'.

Definition: Photography DENSITY = log₁₀ opacity

In the example above, where 10 units of an incident 100 units of light were transmitted, the density of the tone would be 1. Other examples are as follows:

TABLE 13.1
TRANSMISSION, OPACITY, DENSITY

Incident light on emulsion	Light transmitted by emulsion (% Transmission)	: 'Opacity' and 'Density'	
		20	1.3
100	20	5	0.7
100	50	2	0.3
100	80	1.25	0.09

DENSITOMETERS. Fortunately for the photographic scientist there is no need specially designed to give readings in density figures. This is known as a 'densitometer'. sity, for every tone on the emulsion. Instead, we can use a piece of optical equipment specially designed to give readings in density figures. This is known as a 'densitometer'. A transmission densitometer is used for measuring photographic images on transparent bases and a reflection densitometer for images on opaque bases such as paper prints (see chapter XVIII).

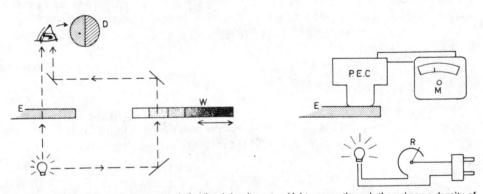

Fig. 13.3. Transmission Densitometers. Left: Visual densitometer. Light passes through the unknown density of the emulsion (E) and a movable step wedge (W). When the two densities seen as (D) in the eyepiece are matched, density is read from a scale on the wedge control. Right: Photo-electric densitometer. The lamp is first adjusted by resistance (R) to a standard brightness. The emulsion is then placed under the photo-electric cell head and light received measured in terms of density on meter (M).

Transmission densitometers are generally of two kinds: (a) a visual comparison system by which light passed through the negative is compared with light from the same source, passed through a grey wedge of known density; (b) a photo-electric cell which measures the light transmitted through the negative from a light source of known intensity, and gives a direct density reading on a galvanometer. The photo-electric densitometer is able to 'read' densities far in excess of the visual type, owing to the former's limitation by eye sensitivity.

Recapping:

- (1) The function of sensitometry is to analyse the performance of an emulsion scientifically and to present its qualities in a universally understandable manner:
- (2) With the aid of a performance graph or 'characteristic curve' of an emulsion we are able quickly to assess its limits of tonal reproduction, tone distortion to be expected, relative speed, maximum density, fog level, etc. Characteristic curves also allow accurate comparison of emulsions and developers.
- (3) Steps in preparing a performance graph: A test emulsion is given a range of light intensities of known increment, and processed under prescribed conditions.
- (4) The resulting processed silver deposits are measured on a densitometer, a separate density reading being made for each original exposure intensity.
- (5) Relative exposure, converted to log_{10} , is plotted on a graph as log E, against *Density*.

The Curve Itself

Let us imagine that the densities we have measured from our processed test emulsion are as follows:

TABLE 13.2

DATA FROM PROCESSED TEST EMULSION

Step on Original Exposing Wedge	Relative Exposure ('Light Dosage')	LogE	Measured Density
1(Opaque)	1	0.0	0.05 (Fog level)
2	2	0.3	0.07
3	4	0.6	0.13
4	8	0.9	0.20
5	16	1.2	0.30
6	32	1.5	0.50
7	64	1.8	0.75
8	128	2.1	1.00
9	256	2.4	1.25
10	512	2.7	1.50
11	1,024	3.0	1.78
12	2,048	3.3	2.05
13	4,096	3.6	2.25
14	8,192	3.9	2.40
15	16,384	4.2	2.45

We therefore mark out our graph paper with $4\frac{1}{2}$ large divisions to span the necessary 4.5 along the horizontal log E axis, and $2\frac{1}{2}$ similar divisions to span 2.5 on the density axis. Each relative light dosage can now be plotted against its resulting density.

The plotted graph has a characteristic 'escalator' appearance instead of the straight line we might have expected. In the centre of the graph is a 'straight line portion' but below and above this lie a 'toe' and 'shoulder' of reduced slope. What does this mean in practical terms?

As previously mentioned, when the emulsion is exposed in a camera it is in fact submitted to a range of light intensities. The 'brightness range' of the subject (i.e., the ratio of illumination reflected from highlight and from shadows) is most unlikely to span the 16,384-to-1 test range given to the film for curve purposes. Even brilliantly sunlit scenes seldom exceed $500:1(2\cdot7\log range)$ and where lighting is controllable, as in the studio, $20:1(1\cdot3)$ is a more common subject brightness range.

This being so, when we increase the general level of exposure, subject brightness can be made to correspond to a group of log E values in various positions along the axis. For example, if by use of aperture and shutter, we give a generous level of exposure, we are, in effect, arranging that the subject brightnesses all correspond to light dosages at the high figure end of the log E axis — they are 'overexposed'. Or by smaller apertures or fast shutter speeds they may be made to equal to low light dosages — 'underexposed'. Or they may be made to fall somewhere in between the two. This is rather like the fingers of a pianist's hand, able to press a group of keys anywhere in a long keyboard, from very high to very low pitch.

Under the processing conditions this film has received and assuming that our $\log 1.3$ range of subject brightnesses are made equivalent to light dosages at about the middle of the $\log E$ axis, we can read off the negative density range expected. If subject shadows have a density of 0.75, subject highlights have a density of 1.85 – giving a density range of 1.1.

Although overall this is less than the subject brightness range, all the subject tone differences are proportionally represented in terms of density differences. All tones have been compressed evenly. However, as soon as we start to overexpose, the curve shows that not only will all the densities become greater, but tones in the subject highlights become less and less separated. The negative could be described as appearing 'dense with poor tonal separation in the subject highlights'.

To forecast the effect of underexposure, move the group of subject brightnesses left along the log E axis until they correspond to *low* levels of light dosage. Reading off the resulting densities shows that the negative will become overall less dense but this time the subject shadows will reproduce with increasing tone compression. The negative is thin, with lost shadow detail (see Plates 51–53).

The fact that the performance graph is a curve and not a straight line warns us that there are limits to the amount by which exposure can be varied, for quite apart from the negative becoming darker or lighter there is risk of especial loss of either highlight or shadow gradation.

Gamma

Let us look again at the type of negative produced in the emulsion when exposure brings

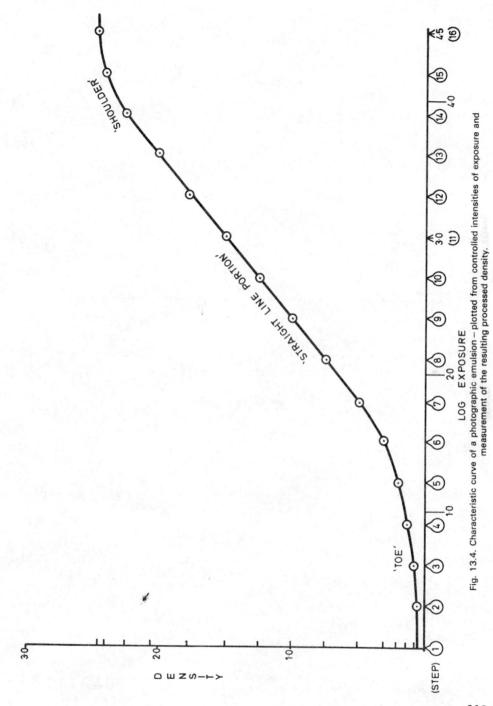

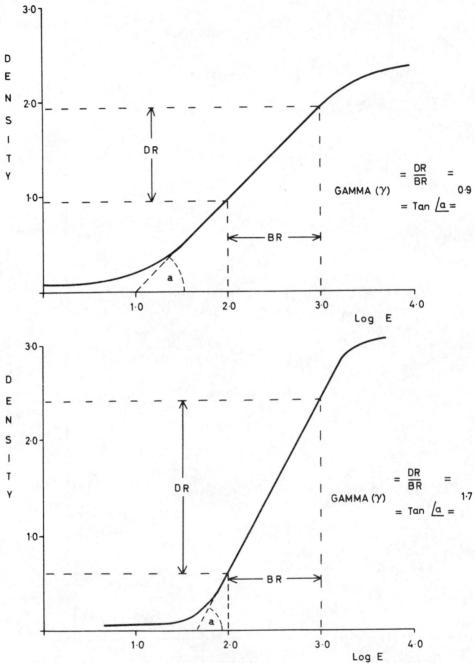

Fig. 13.5. Gamma – a measure of curve slope – indicates the ratio of negative density range (DR) to subject brightness range (BR) we can expect for exposures falling wholly on the straight line portion.

subject brightnesses to fall on the straight line portion of the characteristic curve. The density range of the resulting negative will depend upon the slope of the straight line portion. For the same subject brightnesses, a steep slope indicates that a great density range between highlight and shadows will be formed on the negative. This slope is therefore a useful guide to *emulsion contrast*. A steeply pitched characteristic curve invariably indicates a high contrast emulsion.

Instead of vaguely referring to 'the slope (of the straight line portion of the curve)' we use a recognised term, vis., 'gamma'. The value of gamma (written γ) is:

- (a) The log brightness range of a camera image exposed wholly on the straight line zone, divided into the density range of its resulting negative (e.g., if a subject having a 32:1 (1.5 log) brightness range exposed on the straight line portion yields a negative with a 1.2 density range, gamma = 1.2/1.5 = 0.8).
- (b) The tangent of the acute angle made by extending the straight line portion downwards to meet the log E axis.

If the straight line portion of characteristic curve has a slope of 45° its gamma will be 1 ($\tan 45^\circ = 1$), and, provided that only the straight line portion of the characteristic curve has been used for exposure, the negative density range will exactly equal the log brightness range of the image on the emulsion. In practice most 'normal contrast' emulsions have a gamma with normal development of about 0.8-a value which with 'average' subjects gives a negative density range well matched to printing paper characteristics. Emulsions with gamma much in excess of 1.0 can be considered of moderately high contrast. 'Line' emulsions may have a gamma of 3.0 or more.

The gamma achieved with a given emulsion increases with the degree of development given – reaching a maximum depending on emulsion and developer. Gamma is therefore a measure of the degree of development of a material.

Gamma is often inaccurately stated to indicate final negative contrast. It is only one contributing factor. The contrast or density range of our final negative depends upon

- (a) type of subject and the way it is lit,
- (b) scatter of light within the lens and camera,
- (c) whether the exposure is made wholly on the straight line portion of the curve, or partly on shoulder or toe,
- (d) the type of emulsion and the gamma to which it is developed.

We could in fact have a very contrasty subject exposed on emulsion processed to a low gamma and a low contrast subject processed to high gamma — both yielding approximately the same density range on the negative. This control by development is often useful when we cannot alter subject lighting.

Definition: 'Gamma' – a measure of the slope of the straight line of the characteristic curve. Gamma indicates the combined effect of emulsion type and degree of development. It is a contributing factor to final negative contrast.

Gamma (γ) = tan between straight line portion and log E axis.

GAMMA AND WAVELENGTH. The gamma of an emulsion's performance graph varies with the colour of the existing light. This means that photographs taken through colour filters may process to negatives of greater or lesser density range than expected. Different

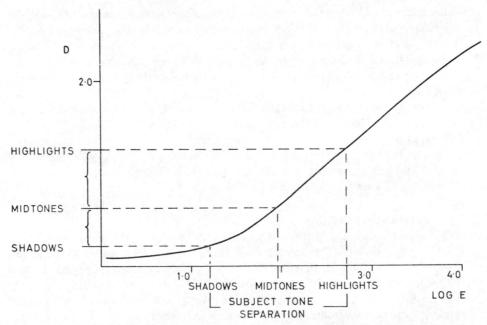

Fig. 13.6. 'Correctly exposed' negatives normally use part of the 'toe' performance region. The slightly compressed separation between midtone and shadow densities thus produced on the negative will be cancelled out by the characteristics of the final printing paper. (See Figure 18.1.)

materials respond in different ways, but, generally speaking, blue wavelengths give lower gamma values, and pictures made through red filters may need less development to give the same negative contrast.

Correct Exposure

By looking at the shape of the characteristic curve it might be thought reasonable to suppose that 'correct exposure' occurs only when all subject brightnesses fall on the straight line portion. However, for most purposes it is best to expose a continuous tone negative so that some of the shadow brightnesses fall on the upper part of the toe. An exposure meter, correctly used, will do just this for the photographer. The advantages of using part toe, part straight line portion are:

- (a) Less exposure need to be given we are making maximum use of emulsion speed.
- (b) There is less risk of irradiation within the emulsion if exposure can be kept to a minimum.

Against this we are producing negatives which have lower tone separation in image shadows than in mid tones and highlights. Fortunately, modern printing papers are so formulated that their characteristic curves (see p. 332) are 'S' shaped. This causes the shadows to print with greater contrast than the more heavily exposed areas of negative — largely cancelling out shadow deficiencies.

AVERAGE GRADIENT. As most continuous tone photography exposures are made to use parts of straight line and toe sections, gamma alone is not a very precise guide to ratio of subject brightness range to density range. However, if a line is drawn joining the two points on the curve corresponding to 'correct' exposure limits of shadows and highlights, ratio and tan values can be quoted for this line in the same way that gamma is used for the straight line section. Such a line is known as the 'Average Gradient' and values quoted as \bar{G} (gee-bar) figures. Obviously \bar{G} values normally tend to be slightly less than gamma values.

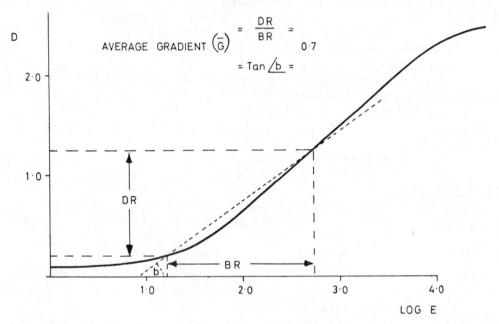

Fig. 13.7. Average gradient – a measure of the ratio of subject brightness range to negative density range when brightnesses do not all fall within the 'straight line' characteristic of the emulsion.

Contrast index. Manufacturers Eastman Kodak Ltd. have adopted for their continuous tone negative materials an average gradient system they call 'contrast index'. The principle is as described above and shown in Fig. 13.7, but with more tightly defined criteria for picking highest and lowest useful densities (detailed in $Advanced\ Photography$ p. 421). And instead of quoting gradient in \bar{G} , Kodak use the term contrast index values. We therefore find C.I. figures instead of gamma figures on characteristic curves published for continuous tone films, developer time/temperature tables, etc. Note however that in the case of emulsions such as line films and some other negative materials used for scientific and industrial photography, exposures are not made on the toe but wholly on the straight line portion of the curve. For these special purpose emulsions Kodak therefore continue to quote gamma values.

Other Information from the Characteristic Curve

FOG LEVEL. Even in the absence of exposure to light a few halides are affected by development to give a background or 'fog level' of density. Generally speaking, fog level is higher the faster the photographic material. Slight fog is unimportant in a negative as it will 'print through' like a neutral density filter when exposed on to paper. On the other hand no fog level at all can be tolerated on printing paper itself.

Speed. The point at which the curve begins to rise above fog level (the 'threshold') is a good indication of comparative overall sensitivity or 'speed'. The nearer the threshold is to the low end of the log E scale the less exposure necessary before tones begin to record — and the faster the emulsion. Modern speed rating systems — ASA, DIN — are based on the amount of exposure needed by an emulsion to yield a density of $0 \cdot 1$ above fog, under strictly controlled exposing and developing conditions.

MAXIMUM DENSITY. The maximum density an emulsion will yield under specific processing conditions is indicated by the top of the shoulder of the characteristic curve. Beyond this point the curve begins to descend (the 'solarisation' region). In fact, if grossly overexposed – e.g., $600 \times$ normal or more – a form of direct positive or solarised image results on the film.

Already, therefore, we are able to 'read' much information from performance graphs published for emulsions. From Fig. 13.8, for example, we can see that emulsion 'A' is faster, has a higher fog level and gives a less dense maximum black than emulsion 'B'. Since the emulsions have different gammas, the same subject appropriately exposed on each emulsion would be recorded with far higher contrast between highlight and shadow densities on B than A. Later in this chapter we should be able to see what further information can be read into characteristic curves.

Recapping

- (1) Having plotted log E against resulting densities the performance graph shows a characteristic curved shape.
- (2) The subject brightness ranges we meet in practice are most unlikely to equal the vast light dosage range given to test emulsion performance. When we vary our camera exposure controls of intensity and time we are, in effect, making the subject tones correspond to a group of light dosages somewhere along the log E axis.
- (3) The curve indicates that subject tones recorded at too high a general level of exposure form negative densities with almost indistinguishable separation of tones in subject highlights. Similarly too low a general exposure level results in poor tone separation in shadows. The curve forecasts results we can expect from over exposure and under exposure.
- (4) Subject tones all exposed between the extremes of under and over exposure i.e., the 'straight-line' portion of the curve produce negative density differences in accurate proportion to the original scene. The ratio of the (log) image brightness range thus exposed on the emulsion, to the negative density range it produces is known as 'Gamma'. Geometrically, gamma is also the tangent of the angle made between the extended straight-line portion and the log E axis.

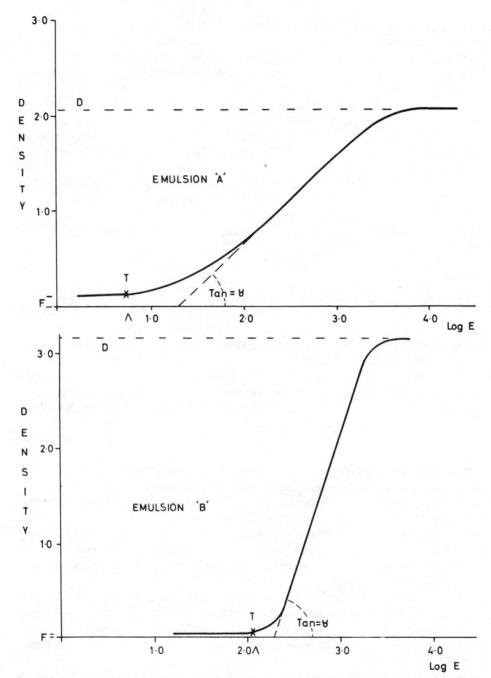

Fig. 13.8. Comparing emulsion differences from their characteristic curves. F, fog level. T, threshold point. D, maximum density.

- (5) Gamma varies with type of emulsion and degree of development. It is a contributory but not sole influence on final negative contrast.
- (6) Most exposure measuring aids aim to make subject shadow tones coincide with the upper part of the curve toe of continuous tone film. The slightly reduced tone separation of subject shadows that this causes on the negative is cancelled out by the characteristics of printing papers. Using this zone of the curve increases effective speed, lowers dangers of irradiation.
- (7) In order to relate more closely to practical usage manufacturers often quote an average gradient between lower and upper useful limits of the curve rather than the slope of the straight line portion alone. The tan of the angle made by a line joining these limits to the horizontal axis is the \bar{G} or contrast index. Gamma is still used for line film etc. where the toe is of little practical importance.
- (8) Comparative speed of emulsions tested under identical conditions can be gauged by the log E position at which the graph begins to rise appreciably after fog.

The Effect of Development

So far, we have been looking at performance curves of emulsions under set conditions of development. Now, by giving identical exposure through a step wedge on to several separate sheets of emulsion the degree of development can be varied for each sheet, and a 'family' of characteristic curves plotted. This gives a good indication of what results to expect when development is extended or curtailed.

Look at the figure accompanying Plates 54–56. Notice how gamma rises: In the presence of soluble bromide (from the developer and/or emulsion) the straight line portions appear to radiate from an imaginary common point below the log E axis. Maximum density rapidly increases with development. Densities at the toe of the curve increase slowly, so that as development proceeds speed (i.e., shadow detail) is slightly improved. Fog level steadily rises.

What does this mean in practice? When a subject with a very wide range of brightnesses has been exposed, the negative resulting from normal processing may have too great a density range (i.e., be too 'hard' or 'contrasty') to give a satisfactory print. If we give rather less than normal development the curves show that our negative densities will be slightly compressed throughout all tones to give a reduced, and in this case more acceptable, density range. Slightly more exposure will be needed (i.e., light dosages made equivalent to values farther to the right along the log E axis) to compensate for otherwise reduced shadow detail due to the lesser development.

The opposite case - a subject which has such a limited brightness range that a negative under normal processing conditions is lacking in adequate density range, or 'flat' - is shown to be improved by increased development. But this time it is advantageous slightly to reduce exposure to compensate for otherwise unnecessary density in shadow detail due to the increased development.

The family of curves also show that when subjects of normal brightness range are known to have been overexposed it is not possible fully to compensate for this by less-than-normal

development. The underdevelopment will certainly prevent the negative becoming too dense overall, but will drastically reduce the density range between highlights and shadows. The negative will look grey and 'flat'.

Conversely, an underexposed extended development negative will show a marked abovenormal density range. Subject highlights in particular will appear dense, and the negative as a whole may be too contrasty to print a satisfactory tone range. Of course, if the original subject had a low brightness range the situation is self-compensating. This explains why the photographer can 'up-rate' (increase) the effective ASA speed of his film by giving extra development more easily when subject lighting conditions are flat than when hard and contrasty. See Time of Development, p. 298.

Characteristic curves therefore allow us broadly to forecast what effect the various permutations of subject brightness range, exposure level and amount of development will give in terms of negative densities.

In order to check whether the photographer can 'read' curves and link them to his practical working, examination questions sometimes ask for the effects of a change in practical procedure to be shown sensitometrically. For example:

'Increase exposure time by 50% and shorten development by one minute.' These instructions are often given when a negative that is too contrasty has to be repeated. Explain with the aid of characteristic curves why these apparent opposites do produce improved negative quality in these circumstances.

Two graphs are really necessary to answer this question.

- (a) Showing the exposure, development and resulting density range on the *original* negative, and
- (b) Showing the modifications and their effects.

In the absence of more detailed information it would be reasonable to assume that the emulsion is of normal contrast and therefore under 'normal' development conditions has a characteristic curve with a gamma of about 0.8 (just under 45° slope). Having drawn curve (a) we can mark in the section of the log E axis occupied by the subject brightness range.

Let us assume that the subject is fairly contrasty – say with highlights $100 \times$ brighter than shadows. The shadow 'light dosage' can therefore be so positioned on the log E axis that it corresponds with the upper half of the curve toe, normal practice for exposure as discussed above. Highlight 'light dosage' will therefore fall 2 units to the right (2 is the \log_{10} for 100).

By tracing lines upwards from these two points until they reach the curve, and then tracing them horizontally to the left we can obtain the densities of shadows and highlights, and therefore the overall density range of the negative. In this hypothetical case the density range is 1.6.

Now to draw the curve (b) showing development and exposure modifications. Remember that development alters the whole curve shape; exposure level alters the location of subject brightness range along the log E axis. We must, therefore, draw the new curve shape first — with lowered gamma, maximum density and fog level and slightly reduced speed (slight overall shift to the right). The amount of this change has to be left to our own discretion as we are unable to tell what the effect of a 1-min development time decrease will be

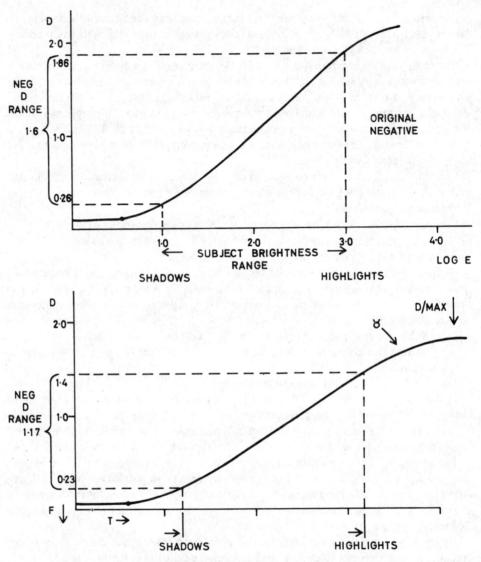

Fig. 13.9. The effect of reducing development (altered gamma, maximum density, fog level and threshold), and increasing exposure (altered location of subject brightness range on Log E axis). Negative density *range* is reduced, with little alteration of shadow detail.

without knowledge of the normal development time or emulsion.

Having drawn the new curve, the new position of subject brightness can be established. As exposure is to be increased by 50% we can move the whole subject brightness range by just under 0.2 units to the right along the log E axis ($\log_{10} 1.5 = 0.18$). Tracing out the resulting densities shows that the new negative will have a similar shadow density (0.23) but

decreased subject highlight density (1.4), giving a density range of 1.17.

In answering the question we would therefore explain that, as illustrated by the curves, shortened development reduces negative contrast; but by increasing exposure 50% no appreciable shadow detail is lost by this shortened development. The collective effect of these apparently opposite controls is therefore to reduce final negative contrast.

Exposure Latitude

(1) We must always bear in mind that the brightness range of most subjects is likely to encompass only a small part of the enormous light dosage range with which the emulsion has been tested. (2) Most emulsions have a 'useful' performance (i.e., shown by upper toe and straight line portion) over much of this range. These two observations (1) and (2) suggest that we can vary the exposure level of our subject either side of 'correct' exposure and still expect a usable negative. Instead of having to be 100% accurate in judging correct exposure we have some 'exposure latitude'.

Definition: Exposure latitude – Variation in exposure level that still gives a processed image without unacceptable loss of shadow or highlight tone gradation.

The amount of latitude available in practice is largely controlled by

- (a) The type of subject and lighting (subject brightness range), and
- (b) The type of emulsion and development (shape of the characteristic curve).
- (a) If we are shooting a scene containing many similarly reflective objects under diffuse illumination such as a distant landscape on an overcast day our ratio of shadow-to-highlight brightness will be inevitably low. Perhaps highlights are only 4 times brighter than shadows (a \log_{10} brightness range of 0.6). But an architectural interior with sunshine pouring through the windows, may have highlights 100 times shadow brightness (brightness range = 2.0).

If both pictures are shot on the same type of emulsion (see Fig. 13.10, top curves) we shall have to be more careful in judging our camera exposure settings for the interior; only slight variation from correct exposure will align either highlights or shadows with the severe tone compressing regions at either end of the characteristic curve. The landscape, however, with its brightness range occupying little more than a quarter of the log E scale spanned by the interior, can suffer much worse inaccuracies in exposure level before tone compression occurs. In fact, its exposure latitude is 25 times that of the interior photograph.

(b) A high contrast emulsion developed to a high gamma records subject tones with dramatic changes of density. Even a low subject brightness range approaches the tone compressing extremes of its performance; contrary subjects may show complete loss of highlight and shadow detail. A lower contrast emulsion processed to a lower gamma (particularly if it is formulated to have a long toe and straight line portion characteristic) offers a wide latitude of exposure. From its curve shape it can be seen that a wide range of light dosages along the log E axis will be more or less proportionally reproduced as densities (see Fig. 13.10, lower right).

We can, therefore, expect maximum exposure latitude when exposing low brightness range subjects, particularly on materials of low emulsion contrast. (Warning: it would be foolish to use flat lighting and low contrast emulsions for all subjects in order to gain latitude. What we gain in exposure freedom would be lost in excessively flat negatives which may be difficult to print successfully.)

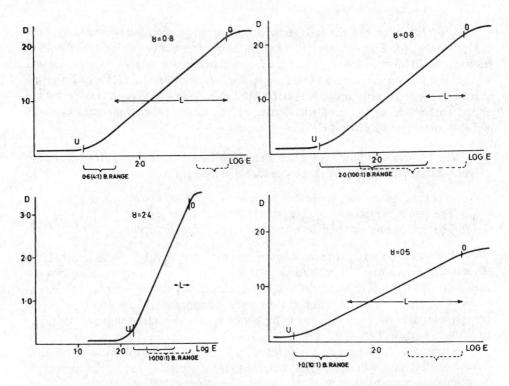

Fig. 13.10. The effect on exposure latitude of (top) subject brightness range, and (bottom) emulsion contrast. U, underexposure limit of useful tone reproduction. O, overexposure limit. L, permissible exposure latitude.

Minimum exposure latitude, demanding particularly careful exposure estimation, occurs with wide brightness range subjects, and/or materials of high emulsion contrast. Line copying in particular offers extremely little room for exposure error.

Exposure latitude, whilst offering us a useful 'safety margin' in exposure calculation, should not be exploited as an excuse for slipshod working. Quality-wise the best use of emulsion speed, and negative characteristics which exactly suit printing paper performance are both results of careful control of exposure. Practical exposure problems are discussed further in chapter XIV.

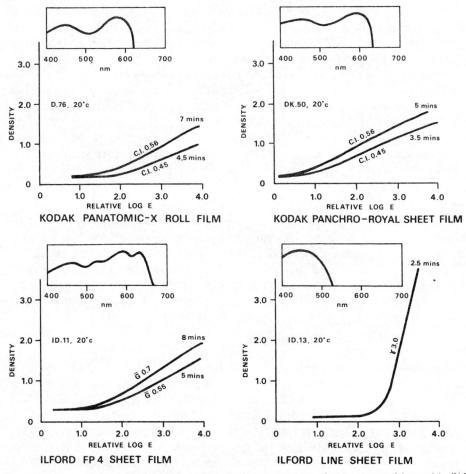

Fig. 13.11. Characteristic curves and tungsten light wedge spectrograms of some commercial materials. (N.B. Relative Log E figures and spectral response should strictly only be compared for emulsions by the same manufacturer.) Courtesy Kodak Ltd., London, and Ilford Ltd.

Information Through Sensitometry

The scientific study of sensitometry and a 'reading knowledge'. of characteristic performance curves enable us to:

- (1) Forecast the tone distortion to be expected from under or over exposure.
- (2) Compare emulsions in terms of gamma, speed, fog level and maximum black.
- (3) Compare the effects of differing development on negative density range.
- (4) Forecast the density range effects of various permutations of exposure and development changes.
- (5) Compare permissible latitude of exposure between differing emulsions and subjects.

Sensitometric curves also allow immediate comparison of the effects of emulsion and surface of printing papers (chapter XVIII). In more advanced photography they offer a simple method of quality control of bulk processing solutions — particularly in colour and motion picture processing. Curves also explain the necessity for certain procedures in duplicating negatives, determining filter factors and carrying out some colour print processes.

Notice how much information is communicated *graphically*, presenting concentrated facts in an internationally understood form and cutting away ambiguities such as 'hard', 'soft', 'thick', 'burnt out'. Data sheets published by photographic material manufacturers covering each of their emulsions carry at least two key graphs – spectral sensitivity and characteristic curve. Between them they offer most of the important information we need to know to compare practical performance.

EXAMPLE 1

In copying a black-and-white wiring diagram we would probably choose an emulsion with a high gamma and short toe. This will yield maximum density difference between subject shadows and highlights (the black circuit lines and white paper). Suitable material (line film, opposite) is seen to be comparatively slow, but this is unimportant in copywork. Exposure level must be accurate to avoid reproducing the whole of our diagram on the toe or distant shoulder of the curve. Finally, an emulsion with blue-only colour sensitivity would aid darkroom handling.

EXAMPLE 2

For general commercial photography a faster emulsion of lower contrast with a long toe and straight line characteristics is more suitable (e.g. Fig. 13.11, bottom left). This will record subjects possessing a wide range of brightness without sudden distortion of tone, and offers wide exposure latitude. At the same time the emulsion can probably be processed to a reasonably wide range of gamma values. This allows us to make compensations when it has to be used on assignments where lighting is found to be more or less contrasty than expected. Panchromatic spectral sensitivity is an obvious choice for such general purpose material. Colour reproduction can then be altered as required, by filtration.

The Limitations of Sensitometric Curves

No performance curves will completely forecast the results of practical photography. They are the results of *laboratory tests* which inevitably differ from the multicoloured subjects imaged with a variety of lenses under all sorts of varying conditions by the practising photographer. (For example, light scatter or 'flare' within the camera lens, particularly when the subject is back-lit, may significantly reduce the brightness range of the image actually projected onto the emulsion.) Curves may indicate tone range but will not say what effect the tone range will have on the viewer. Highlights may be more important with some subjects, shadows with others. It is the photographer who must finally decide whether his picture aesthetically needs predominantly dark or light tones. Curves also offer little information on resolution and graininess, although this is often

implied by speed and contrast of emulsion. Enlarging equipment and even final print viewing conditions also influence the 'best' obtainable negative characteristics.

Chapter Summary - Sensitometry

(More detailed summaries appear on pages 233 and 240)

- (1) Sensitometry, established by Hurter and Driffield, centres on the scientific evaluation of the tonal performance and speed of an emulsion.
- (2) Plotting controlled quantities of light against the silver deposit produced after given processing conditions (log E against D) forms a performance graph with a characteristic curve.
- (3) The curve shape shows that:
 - (a) Tonal reproduction is no longer proportional when subject detail is given too high or too low a level of exposure.
 - (b) By using part of the toe of the curve for exposing the subject, less exposure is needed and risk of irradiation in highlights reduced. Subsequently, printing paper must compensate for the reduced tonal separation of shadow detail.
 - (c) Final negative contrast is largely controlled by subject brightness range and gamma when exposure is all on the straight-line characteristic; by subject brightness and \bar{G} or Contrast Index when part of the toe is used.
 - (d) Fog level rises as emulsion sensitivity and development increases, until in extreme cases deep shadow detail is 'swallowed up'.
 - (e) Comparative sensitivity to light is shown by the position along the log E axis at which density rises appreciably above fog.
 - (f) Maximum density increases with development, reaching a particularly high level in high contrast emulsions.
 - (g) Exposure latitude is greater with low contrast long toe emulsions, and further increased when subject brightness ranges are also low.
- (4) The effect of increased development is to increase gamma and maximum density, slightly increasing shadow detail (therefore speed), and fog level.
- (5) Slightly reduced exposure and increased development have the combined effect of expanding the negative density range, and may often improve the reproduction of a low contrast subject. The reverse technique may bring a subject with a wide brightness range within the emulsion's reproduction capabilities.
- (6) Underexposure cannot be fully compensated by extra development, owing to the proportionally greater effect this has on higher densities. The results are usually dense highlights with little more shadow detail, unless the subject itself had a low contrast range. Conversely reduced development to compensate overexposure yields grey maximum densities and overall low negative contrast.
- (7) Sensitometry cannot provide all the answers as long as these involve aesthetic values and personal preferences. It does form a generally accepted basis on which to compare emulsions, and analytically link subject, exposure level, emulsion type, development and final negative density range.

Questions

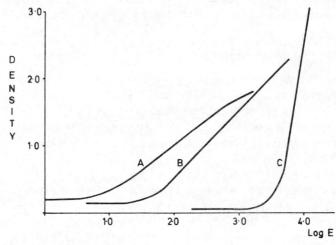

Fig. 13.12.

Questions

(1)

Study the characteristic curves shown above.

- (a) Which is the fastest film?
- (b) Which is the most contrasty?
- (c) Which would be suitable for portraiture?
- (d) Would any film be suitable for copying line originals?
- (e) What is the gamma of Curve B?
- (f) What is the fog level of the three films?
- (2) Define the term 'exposure latitude'. Comment on the statement 'Exposure latitude is equally dependent on the emulsion and the nature of the subject.'
- (3) What is a characteristic curve of a photographic emulsion? Draw on the same diagram typical characteristic curves for:
 - (a) A process film; and
 - (b) a fast film suitable for general photography.

Indicate the principal differences between the two curves.

- (4) Figure 13.13 shows the characteristic curve and wedge spectogram for each of two emulsions.
 - (a) List the practical differences you would expect to find between negatives made under appropriate exposure conditions on emulsion 'A' and emulsion 'B'.
 - (b) Draw the transmission curve of the filter most suitable for use as a safelight when handling emulsion 'B'.
- (5) Two negatives: one underexposed, the other overexposed, are given identical processing. Illustrate on a characteristic curve the differences between the two negatives.

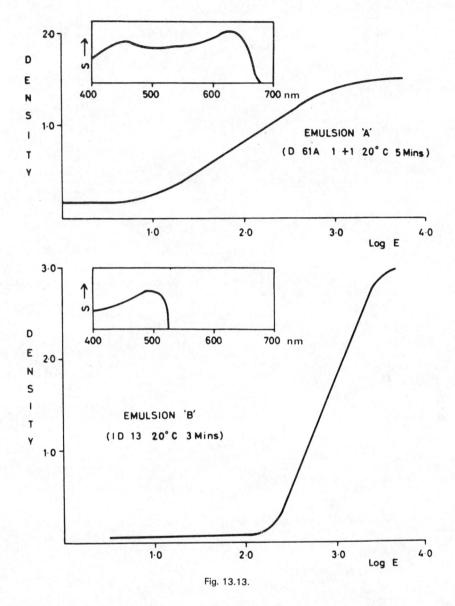

- (6) Illustrate diagrammatically the difference between gamma and C.I. (contrast index). Why are the characteristics of some films described by C.I. values but others by gamma?
- (7) Write a short essay entitled 'Is sensitometry valid in practical photography'. This should discuss the advantages and limitations of sensitometric analysis from the point of view of the commercial photographer.

XIV. EXPOSURE MEASUREMENT

Having examined the colour sensitivity and tonal response of our silver halide emulsion, we can now combine optical image and chemical layer by 'making the exposure'. But making the *correct* camera exposure – i.e., determining the most appropriate combination of image intensity and the time it is allowed to act – means equating numerous variable factors. Several variables can be measured by exposure meters, and we shall have to see how some of these devices work and how to use them. Other factors can be taken into account by calculation, or an intelligent assessment of likely results based on our knowledge of emulsion performance. Our final exposure decision can be considered 'correct' if it yields a negative which subsequently prints easily, reproducing the camera image in the form we originally intended. Control of exposure is an essential part of control of results.

Factors Determining Camera Exposure

At least eight factors have to be taken into account when determining the required level of exposure.

- (1) Incident light. Its source intensity, distance from the subject, direction and colour content relative to emulsion colour response.
- (2) Subject properties. Reflective properties of subject surfaces, their tones and colours.
- (3) Imaging conditions. Scatter of light due to atmospheric conditions haze, smoke, etc.; also light scattered by reflection within the lens and camera. Both lead to lost illumination and lowered image contrast.
- (4) Ratio of reproduction. Increased bellows extension when forming images of close objects reduces the illumination received at the emulsion.
- (5) Emulsion characteristics. Emulsion speed, contrast, performance in under and over exposure (toe and shoulder characteristics), colour sensitivity.
- (6) Intended development. Its effect on emulsion speed and contrast.
- (7) Filters. Light absorption and colour; relative to colour of lighting, subject, emulsion, colour sensitivity and gamma response.
- (8) Subjective aspects. For the purposes of the photograph do we need to record *all* subject tones? If so, is tone compression or expansion desirable on the final print? If not, what tones should be suppressed highlights or shadows?

After considering the above we should have established the *level* of exposure required. This total exposure is now given via what we judge to be the most suitable combination of:

- (9) Lens aperture. Influencing lens coverage, depth of field and focus.
- (10) Shutter speed. Influencing reproduction of subject movement, camera shake effects, and the spontaneity of expression or action.

Factors 1, 2, 5 and 6 can be taken into account by correctly used exposure estimating devices; 4 and 7 by mathematical calculation — leaving 3 and 8 to the photographer's own personal assessment. Since exposure estimating devices offer such an important aid, their mechanical function and method of use deserve study first.

Estimating Devices

THE TEST STRIP. Humble though this device may be, provided time and processing facilities are available, and a large format stand camera is in use, a strip of varying test exposures is the most informative way of checking required exposure. The test strip takes into account all exposure variables, but to make the most of this method three points demand care:

(a) Each section of the film exposed should receive a representative range of image brightnesses. For example, the picture may contain dark foreground, a light middle distance object and dark background. If test exposures are made in horizontal strips, the strip at one end of the film will only carry foreground tone information, and the strip at the other end only background. On the other hand, if the exposure strips are made to run vertically each will carry part foreground, part object, and part background. Where the camera has a revolving back this can be used to make the most informative cross alignment of strips and image for testing purposes.

(b) Some rough idea of what exposure might be desirable (based either on past experience or manufacturers' data). This, coupled with knowledge of the emulsion exposure latitude, helps us determine what range of exposure trials to give. For example, in line copying we might make a guess at 6 sec at f/16, and, bearing in mind the limited latitude of high contrast film, therefore try steps of 2, 4, 6, 8, and 10 sec. In continuous tone copying however, a series of tests 1, 3, 6, 12, and 24 sec would be more informative, owing to the wider exposure latitude of the lower contrast emulsion used.

(c) Having decided the range of exposures to give, make sure each step does in fact receive the exposure intended. It is easy to lose control of the situation. The easiest test

Fig. 14.1. Making a test strip of exposures with the aid of a film holder slide.

strip routine is first to expose the whole sheet for the shortest exposure. Then push in the film holder slide about one fifth of its normal movement. Give a further exposure equal to the difference between first and second intended exposures. The procedure is continued for the remaining strips exposed, until the slide has been pushed fully home.

TABLES. Exposure tables are sometimes published in books or given away by film manufacturers. However, they offer exposure suggestions only for a limited range of 'popular' subject matter, under very general conditions of lighting. Tables that attempt to be more comprehensive often succeed only in becoming incomprehensible — calling for measurement of all lamp distances, geographic latitude, solar time, etc.!

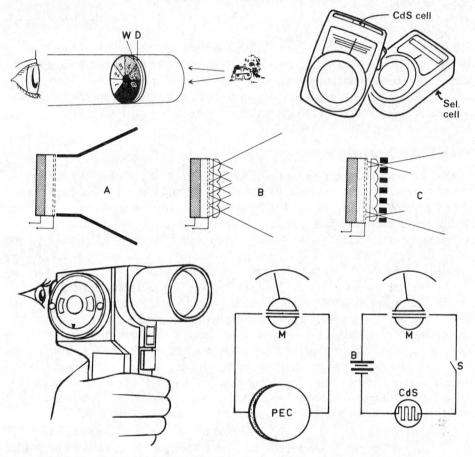

Fig. 14.2. Exposure meters. Top left: Visual extinction meter. Light from subject passes through diffuser (D) and numbered grey wedge (W). Top right: Gossen CdS and Weston selenium cell meters. The selenium cell is much larger, and therefore housed on back to meter. Centre: A selenium cell can be given a 50° acceptance angle by bulky tube (A), or moulded plastic lenslets (B). Perforated baffle (C) for bright light levels usually reduces meter angle. Bottom left: Narrow angle CdS or silicon meter with optical direct vision sight. Bottom right: Circuits of selenium and cadmium sulphide cell meters.

(M) Measuring meter. (B) Battery. (S) Switch.

EXTINCTION METER. Basically, an extinction meter consists of a transparent step wedge in an open-ended tube (see Fig. 14.2, top). Each density 'step' has an overprinted black numeral. When the eye is placed against one end of the tube, and this is pointed at the subject, the number of numerals which can be distinguished will depend upon the level of illumination entering the tube. The numeral which is all but extinguished by the darkness of its 'background' is noted, and used on a calculator outside the tube to give appropriate shutter speed and aperture.

All extinction meters introduce a serious physiological drawback into exposure measurement – the 'adaption' of eye sensitivity. The longer we spend peering into an extinction meter the more the eye adapts itself to the darkened interior, making out more and more detail. Readings are also influenced by the level of illumination the eye has just left.

It is worth noting here that most stand cameras and single lens reflex cameras can be used as extinction meters in their own right. The lens is simply stopped down until hair lines on the ground glass screen can just no longer be distinguished from, say, subject midtones. A simple calculation can then be made to relate this lens aperture position to film speed, and thus actual exposure settings required.

Photo-Electric Exposure Meters

Photo-electric exposure meters register light levels in terms of electricity. To do this, one of two main types of light sensitive 'cell' is commonly used — the 'photo generative' or barrier type selenium cell, and the 'photo resistant' cadmium sulphide or silicon cell. Both types of meter are either built into cameras or made as separate instruments.

SELENIUM CELL METERS. Most separate exposure meters are still of this type and use a flat rectangular or disc-shaped cell which consists of selenium sandwiched between two electrically conductive layers, the top one being transparent. Illumination reaching the cell creates an electrical potential between top and bottom layers in proportion to light received. This weak current is registered on a micro-ammeter and the reading converted into photographic exposure terms via some form of calculator disc. The selenium cell (similar to those used in thousands on the skin of space satellites to recharge batteries) has reduced accuracy under low levels of illumination, owing to the very weak current it produces. A typical meter of this type will give readings down to lighting levels requiring about 1 sec at f/2.8 on 100 ASA film. As sensitivity is directly related to cell surface area better low level illumination performance is possible only if the instrument is much larger, which would make it clumsy to use.

CADMIUM SULPHIDE CELL METERS. Instead of creating current, the cadmium sulphide (CdS) cell varies its electrical *resistance* according to the level of illumination received. It will, therefore, function only with the aid of a battery — the cell being in circuit between battery and measuring meter. Values registered on the meter scale are converted to exposure terms via a calculator in the same manner as the selenium meter.

The CdS meter resulted largely from the development of long-life miniature batteries. Such meters are more expensive than comparable selenium types, but the cell itself is

much smaller and is sensitive enough to read down to moonlight levels. This means that a CdS cell can easily be incorporated behind the lens of a single lens reflex camera to measure from the actual image (see page 258). However CdS meters have a rather uneven response to colours — being somewhat over-sensitive to red. N.B. The mercury battery associated with any metering system should be replaced at least once a year, irrespective of use. It may otherwise suddenly fail when on an assignment.

SILICON CELL METERS. An advanced form of photoconductive cell utilises the semiconductor silicon, which has a more uniform sensitivity range and very much faster reaction time than CdS. Small silicon cells give a very low output current but this is boosted and stabilised by a tiny amplifying circuit. Another advantage of this cell is its lack of 'memory' – recent exposure to intense illumination does not distort its reading response. Silicon cells with their solid-state amplifying electronics are extensively used for through-the-lens exposure meters.

SEPARATE EXPOSURE METERS — DESIGN. General purpose photo-electric exposure meters of both cell types are designed to have an acceptance angle roughly equivalent to the angle of view of 'normal' focal length lenses (about 50°). The aim here is to measure light from the whole subject field when using the meter at the camera position.

One method of restricting the meter to the required acceptance angle would be to place the cell at the bottom of a 'well' or tube of appropriate dimensions. This would make the selenium meter unnecessarily bulky, and a disc of moulded short-focus lenslets is frequently used over this cell instead — giving the desired acceptance angle with minimum cell recess, see Fig. 14.2. Meters using the smaller CdS cell generally have a single lens, or recess the cell behind a window.

When used under bright lighting conditions a perforated baffle plate is fitted over the cell (or a resistance switched into the circuit). A series of scale values appropriate to the upper half of the meter's sensitivity range but stretching along the entire ammeter scale is now in use. For lower lighting levels, when no appreciable needle deflection occurs, baffle or resistance is removed, and lower values read from a second full-length scale. By spacing out the meter sensitivity range over this 'double length' scale, needle deflection between any two consecutive values is increased, greatly improving accuracy. On some models the ammeter scales physically shift position when the cell baffle plate is moved.

High and low level scales generally overlap by one or two values. It is important to note that on baffled meters the action of opening the baffle for low level readings increases the instrument's acceptance angle. If a meter reads, say, '10', on the high scale and after opening the baffle the meter indicates '9', the instrument is not necessarily faulty. Its new acceptance angle probably now includes darker objects around the edges of the previous field of view, causing it to give a lower reading. A meter should generally be moved nearer the subject when the baffle is opened if we intend to measure light from the same area.

Differences in angle of view must also be born in mind when comparing the readings of different meter designs. For occasions where a 'directional' exposure meter is undesirable a diffusion screen of known scatter and absorption can be fitted over the cell

window. This is known as an incident light attachment. Its practical use is discussed later in this chapter.

Through the lens meters — design. There are obvious advantages in having an exposure meter built into the camera — two instruments are combined in one, readings can be made more quickly, and the meter can be directly linked to the camera controls. This last feature has become highly developed in the small format SLR camera. One or more CdS or silicon cells are located appropriately in the light path behind the lens, e.g. within the mirror or in the area of the focusing screen or pentaprism. Meter read-out appears to one side of the focusing screen itself, and takes the form of either a needle (settings correct when in a central position) or two tiny diode lights (correct when both lights are on). The photographer first sets the film speed on an ASA dial, then changes either shutter or lens aperture setting until the meter signals correct exposure. If the camera has an electronic shutter (page 114) this can form part of the meter circuit so that the photographer sets the aperture and the current signal from the photo-resistor controls the delay between opening and closing solenoids of the shutter. (An aperture preferred arrangement).

The advantages offered by a good through-the-lens meter include the time saved transferring readings to settings; freedom from extra exposure calculation when using extension bellows or neutral density filters, and the ability to modify exposure rapidly to meet sudden changes in lighting conditions. It is in fact possible to use fast-reacting silicon cells facing backwards from a position under the lens mount — from here measurement is made of the image actually on the emulsion surface during exposure. The cell determines when the shutter shall reclose.

Photometers

The 'exposure photometer' is an instrument for measuring subject brightness by comparing it with a known light source. A variable resistor is used to dim or brighten an internal torch bulb, bringing its intensity up to a known level, as measured on a microammeter fed from a photo-electric cell close to the bulb.

Having standardised our light source we view the subject through a telescope system at the top of the meter. An optical system allows us to see light from the bulb superimposed as a speck 'floating' in the centre of the subject field. The light source is dimmed and brightened without changing its colour by rotating the outer shell of the meter, which moves grey scales across between bulb and telescope. When the internal lamp matches the subject brightness (i.e., the 'speck' disappears) photographic exposure can be read from the relative position of the outer shell.

Note that as the eye is *comparing* two brightnesses any variation in eye sensitivity affects both brightnesses equally – the limitations of the extinction meter do not apply. Exposure photometers have a wide range of sensitivity, but owing to complexity of design are rather slow to use, expensive, and, like all precision instruments, delicate. This type of meter is now largely replaced by the narrow angle 'spot' meter, see Fig. 14.2 bottom left.

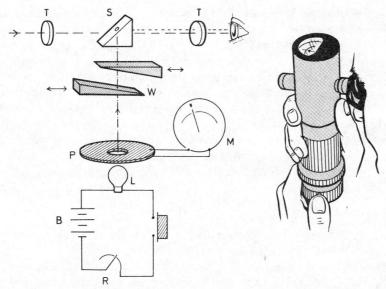

Fig. 14.3. Layout (simplified) of an Exposure Photometer. L, light bulb fed from battery (B) via resistance (R). Annular photo-electric cell fed to standardising meter (M). W, moving grey wedges. S, mirrored spot reflects internal light to the eye, for comparison with light from subject viewed through telescope lenses (T). Right: An exposure photometer in use.

Using a Separate Exposure Meter

THE EXPOSURE PROBLEM. On the face of it, measuring correct exposure might be thought to be simply (a) measuring total light reflected by the subject towards the camera, (b) setting this reading against the manufacturer's film speed on the calculator dial, to find the required shutter setting at each aperture. However, exposure measurement is not only concerned with total light received, but also the relative brightnesses of subject highlights and shadows (subject brightness range).

The eye, with its ability automatically to adjust iris and retina sensitivity when concentrating on different parts of a subject, can 'simultaneously' see detail in both highlights and shadows of over 1000:1 – provided the extremes are not adjacent to each other. The photographic emulsion, however, cannot make these convenient adjustments. As discussed in chapter XIII, its ability to reproduce subject brightness proportionally is limited by 'toe' and 'shoulder' characteristics. Furthermore, if the resulting negative is to yield a print with separate tones for all the separate brightnesses in the subject, our negative density range should not exceed about 30:1. This explains why beginners in the studio, who light a subject to be visually attractive and within the accommodation of the eye, often find that it photographs 'too contrasty', with lost shadow and/or highlight detail.

Apart from those occasions when tonal distortion of highlights and shadows is required for an effect, we can say that: 'Our aim in exposure calculation is to control

final tone reproduction, by making light from subject highlights and shadows affect the emulsion in such a way that all the negative densities formed print as separable tones.'

Every photographer has his own personal methods of using an exposure meter. This is because a meter is not an infallible, magical device, and will give misleading results unless used with intelligence; it is up to the individual to decide which method is best suited to the subject in hand. To begin with, it is a good plan to judge every negative against a carefully kept record of the way the meter was used — so building technique on experience.

There are four popular methods of gauging exposure with a photo-electric exposure meter. (a) To use a 'general' or 'over all' reading, (b) brightness range readings, (c) a 'key tone' reading, (d) a reading through an incident light attachment.

General Readings

Using a separate meter pointed from the camera position, or a TTL meter designed to give an overall reading, we get an 'integrated' measurement of all the brightnesses reflected towards us by the subject. The separate meter should have an acceptance angle matching that of the camera lens. General readings are quick and convenient to make. Set to the appropriate emulsion speed, the meter indicates an exposure which places this 'integrated' brightness reading on the straight line portion of the characteristic curve — the assumption being that shadows and highlights will also fall on the usable part of this curve.

However, this kind of reading can be seriously inaccurate, when the most important parts of the subject are small in area. For example, imagine we are taking a half-length portrait (a) against a black background; and then, without any alteration to the figure lighting (b) with the background changed to white. Because of the large area of background compared with the face a general reading of (a) will indicate that a far longer exposure is needed than case (b), although we know that exposure required for the important area (the face) is the same in both cases.

General readings are, therefore, deceptive unless the subject contains an equal distribution of light and dark areas, as used by the manufacturers in originally calibrating the meter. In practice, general readings are satisfactory for landscapes lit from behind the camera – the meter should be tilted down slightly to reduce the area of sky which is 'read', since the land masses are usually of greater exposure importance. Similarly, studio sets lit by diffuse reflected light, and continuous tone copy original with even distribution of light and dark tones are among other subjects which can be read with sufficient accuracy by this method. (Plates 60 and 91, but not 62).

Brightness Range Readings

This method requires the making of separate local readings of the darkest *important* subject shadow and the brightest *important* highlight. We can then relate this brightness range to the latitude of the film in use. In many cases, the setting of the meter to a point

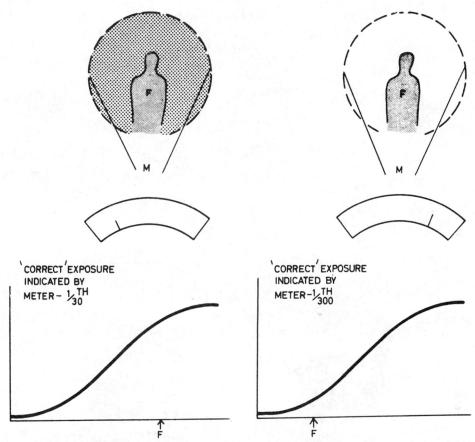

Fig. 14.4. The disadvantage of general meter readings. Figure F is the most important subject, but the meter (M) accepts light from large areas of unimportant background. 'Correct' exposure thus indicated may cause the figure to be over or underexposed.

half way between the two readings will place both extremes on usable portions of the curve.

The Weston meter is particularly useful here, as the under and over exposed average limits of normal contrast material are shown by 'U' and 'O' marks on the calculator dial. (*Note*: The subject brightness range limits shown are 128:1. Light scatter present in all camera lenses reduces *image* brightness range to at least one third the range of the subject. This image brightness range, exposed on to an emulsion processed to a gamma of 0.8, or C.I. of about 0.56, gives a negative density range which is within the 30:1 capabilities of normal printing paper.)

Some through-the-lens meters give a 'spot' reading — measuring only within a small area indicated in the focusing screen. It is therefore possible to fill this area with highlight, then shadow, and choose settings mid-way between the two. If the TTL meter

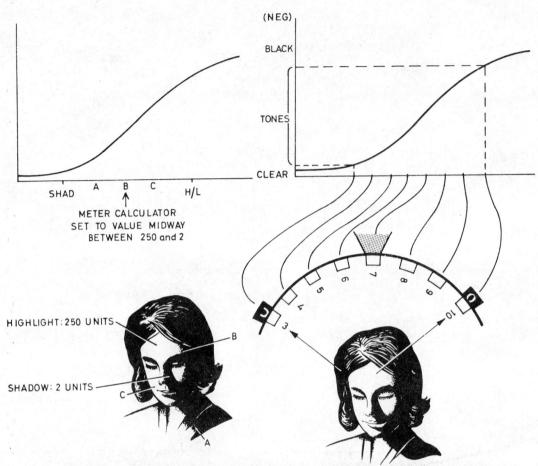

Fig. 14.5. Brightness range readings. Left: Setting the meter calculator dial midway between local highlight and shadow readings gives an exposure level at which most tones are usefully recorded. Right: The 'O' and 'U' calibrations of the Weston meter calculator indicate the approximate performance limits of most general purpose emulsions (normal development) if the negative is to print effectively.

gives overall readings it may be necessary to approach the subject in order to fill the whole focussing screen with first highlight and then shadow areas.

If the subject brightness range as measured is found to be too great we may either (1) reduce our lighting contrast, e.g. by reflecting or otherwise introducing light into the shadows, until meter readings show that a more appropriate range has been achieved, (2) change to an emulsion of lower gamma or (3) give less development. Alternatively (4) fix an exposure level to sacrifice either shadows or highlights, whichever are the least important.

If the meter shows subject brightness range to be excessively low it may be advisable to (1) increase lighting contrast, (2) use a higher gamma emulsion or (3) give more development.

FILTRATION

Plate 50 Fylingdales Moor. On normal panchromatic material the pale blue winter sky would have recorded as a similar tone of grey to the radar domes. Use of a red filter to darken the sky dramatically emphasises the shape of the domes. (G. Turni!!)

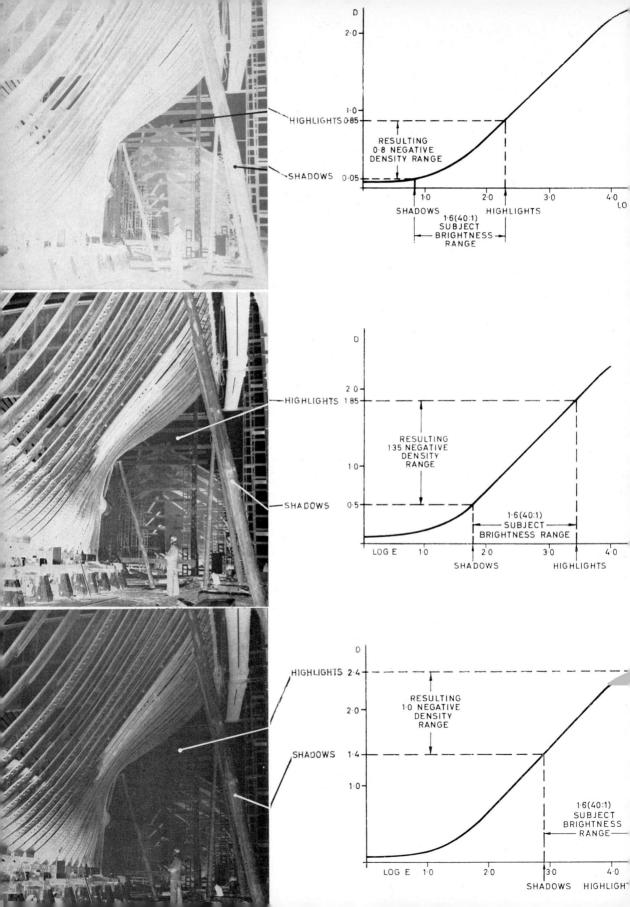

EFFECT OF EXPOSURE

Plates 51-53 (Opposite) The effect of varying the *level of exposure* from under to over-exposure, shown in terms of characteristic curves and actual negatives.

EFFECT OF DEVELOPMENT

Plates 54-56 (and Figure above) Curves plotted for an emulsion showing the effect of 3, 10, and 15 minutes development. Note the influence on gamma, maximum density, threshold, fog level. The effect of development time on negative density range formed (identical subject and exposure level) is shown on the right. Compare with plates opposite.

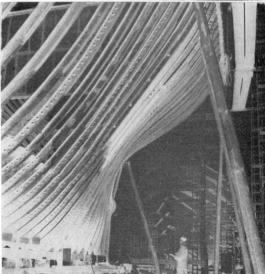

EMULSION COLOUR SENSITIVITY

Plates 57-59 A black hat on a blue background, containing green apples, yellow lemon and grapefruit, and red strawberries. Lettering on the fruit was in purple. The subject was photographed on (Top left) blue sensitive, (Top right) orthochromatic, and (Bottom) panchromatic negative material. Note how the surface texture of some fruit is better recorded in the blue sensitive picture, since the underlying colour has not affected the film.

EXPOSURE MEASUREMENT

Plate 60 A subject such as his—with broadly equal listribution of shadow and nighlight tones—could satisactorily be read with a general meter reading. The acceptance angles of meter and camera should however be similar. (G. Davis)

EXPOSURE MEASUREMENT

Plate 61 (Above) Conditions here call for a highlight or incident light reading, in order to obtain a reading at all under such poor lighting. A meter reading was taken off a white card and the indicated exposure multiplied by eight. (A. Le Garsmeur)

Plate 62 A wide brightness range subject for which a general meter reading could be deceptive. By making local readings of the white curtaining and dark chairs both were just acceptably recorded on the negative. Exposure latitude was almost nil. (John Rose and John Dyble)

Plate 63 (Overleaf) A high key portrait in which good separation of near-highlight tones is all important. A white card reading exposure might be multiplied by four only in order to keep these tones away from the shoulder of the curve. (K. Habibi)

Brightness range readings offer much information but will however take longer to make than general readings. Also, if the subject is small it can be impossible to bring a meter or TTL metering camera sufficiently close to highlights or shadows to make local readings without casting shadows on these areas. In other instances, the subject may be too distant to allow local readings. One way around these problems is not to measure from the true subject, but from a nearby *substitute* with a similar tone and under identical lighting condition. It may also be of more convenient size. For example, in photoreportage work time does not permit readings from the dark and light parts of the subject's face, but you can take readings off shaded and lit parts of your own hand under the same lighting, and expose for the average of these.

A Key Tone Reading

By measuring one 'key' subject tone and appropriately placing this on the characteristic curve, other less important brightnesses can be made to fall within the exposure latitude of the film. We can measure a highlight and multiply the exposure level indicated by an appropriate factor to make it coincide with the top of the characteristic curve. Similarly a mid-grey can be 'pegged' to the middle of the curve, or a shadow to a point on the toe (the latter by *reducing* indicated exposure). This method of using a meter is useful when one particular subject tone value in a scene is of paramount importance — e.g., the human face.

Once again a carefully chosen substitute can be measured instead of the subject. Exposure judged off the palm of the hand will mean that your subject's face will then record on the negative with mid-tone density, even if his black coat is perhaps underexposed and the sky overexposed. Similarly, a key tone reading from grass close to the photographer will serve for equally lit distant downlands in a landscape.

With general subjects it is often convenient to make a key tone reading from a grey card (about 25 cm square) under subject lighting conditions – the card representing a tone about half way between highlights and shadows. A mid-grey matt surfaced material (such as background paper) giving about 18% reflectance is ideal.

A key tone reading is useful, too, when one part of the subject must be recorded at a particular density level. For example, in line copying the aim is to reproduce the white parts of the original as dense black on the negative, black lines as transparent. A piece of white card with similar reflectance to the whites of the original is placed over the copy and a meter reading taken. Line emulsions have little latitude and if about six times the indicated exposure is given (or just below '0' instead of 'arrow' position of the Weston dial) this brightness will be recorded high up on the curve shoulder, giving great negative density. Exposure will not, however, be great enough to cause the subject's black lines to record other than on the bottom of the toe.

White card or 'artificial highlight' readings are useful in colour photography, where it is important not to overexpose highlights. With care the brightest important highlights can be appropriately 'pegged' at the top of the characteristic curve.

When working under low lighting conditions it may be impossible to make a selenium

Fig. 14.6. By using a white plastic incident light attachment to cover the cell the meter can be held facing the camera at the subject position, and measures light reaching the subject over a wide arc.

cell meter register anything but from a white card. If about eight times this indicated exposure is given ('0' on the Weston dial) on normal contrast black and white material, any highlight in the subject should coincide with the top of the straight line portion of the characteristic curve. The other (darker) subject tones, which were too dim to measure, should now record as densities below this highlight. Unless they extend beyond the useful response of the emulsion the negative should contain a full tone range.

The disadvantages of a key tone reading is that it gives us no information about the total subject brightness range present.

Using an Incident Light Attachment

Much unnecessary mystery surrounds the use of the 'incident light attachment'. However, this white plastic diffusion disc or hemisphere placed over the cell of a separate meter is simply a more convenient way of making a 'white card' reading, described above. The meter is placed at the subject and pointed towards the camera, thus receiving the same overall lighting as the subject.

The advantage of such an attachment is that it offers a standard method of making highlight readings, is more compact, and allows normal use of the meter dial. (The plastic absorbs a quantity of light which compensates for the exposure multiplication factor of 8, necessary with the white card.)

From the foregoing descriptions of various meter techniques it can be seen that each offers advantages under particular subject conditions. It is advisable to practice them all when learning to handle a meter — used properly they will all give the same result. You can then decide which reading technique is the most convenient and accurate for the majority of assignments.

Additional Points on Through-the-Lens Meters

If you use a through-the-lens meter be quite sure what area of the picture it reads: over-all, spot, or the compromise 'centre-weighted'. The right parts of the image to be

exposure sampled can then be knowledgeably positioned within the frame. Whereas spot reading meters give the experienced photographer the greatest choice of area to read, used haphazardly by beginners they may measure only odd bits of sky etc., and give grossly inaccurate exposures.

Some TTL meter cameras are influenced by light entering the pentaprism eyepiece. The makers assume that the eye is close to the eyepiece when measuring, blocking out light from this direction. Beware when using this type of camera wearing glasses, particularly if strong top lighting is coming from behind you.

It is obviously helpful to have the shutter speed and f/number selected actually displayed alongside the focusing screen. This gives an immediate indication of the type of depth of field and movement blur effects to expect on the negative.

Modifying readings - special conditions

As we saw at the beginning of this chapter, conventional meter readings may have to be modified under certain conditions. Some of the most common of these are as follows:

SPECIAL DEVELOPMENT. To achieve finest grain from the emulsion it may be desirable to use an extremely fine grain developer which also has the effect of lowering emulsion speed. Conversely we may want to use an active, speed-enhancing developer, or just increase the time in a standard developer to compensate for low contrast subject conditions. In all these cases the most practical way of working is simply to decrease or increase the ASA speed figure set on the meter dial by an appropriate amount.

USING FILTERS. For neutral density (grey) filters and *pale* colour filters it will be sufficiently accurate in black-and-white photography to hold the filter over the cell of the meter (over the lens in the case of TTL meters) when making the reading. However, remembering that most types of meter cell have rather distorted reaction to colour this practice is unwise for deeper, contrast filter colours. The safest procedure is to use the manufacturer's filter factors to modify the camera settings (see page 203).

WORKING VERY CLOSE-UP. If you use a separate meter the exposure as measured must be increased as shown on page 61. A TTL meter measures actual image light and so does *not* require exposure modification.

CHANGING THE DISTANCES OF LAMPS. Having read the correct exposure with lamp(s) one distance from the subject it is possible to calculate from this the new exposure when they are moved nearer or further away. For example, when using flash on the camera, if we halve our distance from the subject the illumination increases fourfold (inverse square law, page 24) so we must stop down the lens by two f/numbers. Strictly this ratio applies only to point light sources, but providing the lamp and reflector are small compared with their distance from the subject the same calculations can be applied.

Example: Two compact lamps are used to illuminate a copy, each $1 \cdot 2$ m (4 ft) from the subject. Exposure is found to be correct at 4 sec at f/16 but the negative shows that lighting is uneven, so we decide to move each lamp back to $1 \cdot 8$ m (6 ft). This means increasing the

exposure time by a factor equal to the square of the new lamp distance divided by the square of the old lamp distance $= 6^2/4^2 = 2\frac{1}{4}$ times. The new exposure required is 9 secs.

Practical Lighting and Exposure Problems

Assignment one. An old black-and-white continuous-tone photograph is to be copied, using a 5×4 in camera. Several patches of yellow stain must not show in the final reproduction.

The copy will need even, shadowless lighting to suppress texture. This is supplied by two floods at 45° to its surface. Lamps are no nearer than about 1 m, as this would give more illumination to the edges than to the centre of the copy, and also make it hot. Evenness is checked with a pencil held to touch the centre of the copy at right angles to its surface; the two shadows it casts must appear equal toned and horizontal. (This system is more critical than meter use.) Finally, after focusing the camera, the photographer removes lens and focusing screen and looks critically through the camera at the copy to check for specular reflections.

If yellow stains are to be indistinguishable from the white paper base a yellow filter is needed on pan emulsion. The meter dial is set for the (tungsten) rating of the normal contrast panchromatic film chosen. As the copy original has a fairly even distribution of light and dark tones a *general* meter reading is taken, indicating 1 sec at f/32 (the aperture chosen for maximum coverage). The manufacturer's quoted factor for the yellow filter in tungsten lighting with this emulsion is $\times 2$ (therefore 2 sec required). Bellows are extended 35.6 cm, and the lens is 203 mm focal length. The final exposure time given is therefore 6 sec.

ASSIGNMENT TWO. A location fashion short of a model wearing casual summer clothes. She is to be shown full-length, leaning against a farm gate in 'idyllic' rural surroundings. The picture is needed for a newspaper feature.

Having selected the right gate and the best time of day, sunlight gives good modelling to the dress, but shadows are too heavy for newspaper reproduction. They need some fill-in reflected back by a 60 in wide roll of white paper held low by an assistant some 6 ft away. Readings are averaged from highlight and shadow areas of the clothes, and the model's face. Exposure on medium speed fine grain pan rollfilm is 1/125 sec at 1/125 sec

ASSIGNMENT THREE. An architectural interior picture is required for a guide-book illustration, showing maximum detail of furnishing and the view seen through a large window. A meter reading of the view (lit by hazy sun) shows it to be 300 times brighter than the darkest part of the interior carpet. One portable tungsten flood just above the camera increases the interior illumination – ratio is now 200:1 (see Fig. 14.7).

A wide-latitude pan emulsion is chosen. As this will be slightly underdeveloped to increase latitude, the film is rated at about half its normal speed. The meter reading is used on the calculator dial so that carpet shadows are located at the lowest useful level of the characteristic curve ('U' position on Weston). View brightnesses are shown to be in

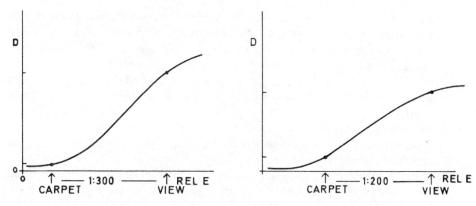

Fig. 14.7. Assignment Two: Left: Natural conditions. Carpet detail is almost transparent, the view dense and irradiated. Right: Improvement by means of auxiliary lighting, increased exposure and reduced development.

the over exposed regions, but these densities will be reduced by the intended underdevelopment.

Minimum aperture will be used to give maximum depth of field and, if possible, allow time for the flood lamp to be moved about during exposure – blurring the additional shadows it creates. Estimated exposure is 3 secs at f/22, but for safety three negatives will be made 'bracketed' around this exposure, i.e. $1\frac{1}{2}$ secs, 3 secs and 6 secs. (N.B. The problem here could be solved in numerous other ways. The windows might be given a short exposure, curtains drawn, and a longer exposure given for the tungsten lit interior. Flash may offer an even better solution (see Advanced Photography, page 129).

Chapter Summary - Exposure Measurement

- Camera exposure largely controls quality of final tone reproduction. 'Correct'
 exposure is firstly intelligent assessment of all factors determining exposure
 level; secondly the best combination of intensity and time to achieve this level.
- (2) Eight main factors determining required exposure level are Incident light; subject properties; imaging conditions; ratio of reproduction; emulsion characteristics; intended development; filters; subjective requirements.
- (3) A test strip exposure check gives maximum sampling information if orientated to receive all image brightnesses, and given an appropriate exposure range under fully controlled conditions. It demands a stand camera, time, and subjects which are essentially still-life.
- (4) Tables and calculators, guides for set conditions and subjects, have limited uses to the professional owing to his range of work. Extinction meters are simple and inexpensive, but readings change as the eye accommodates itself to the dim scale.
- (5) Photo-electric cells of selenium, battery-fed cadmium sulphide or silicon (with

back-up amplifier) all convert light into current flow. In a separate meter current is measured and this reading converted by calculator into exposure terms. Such meters have predetermined acceptance angles, split 'high' and 'low' level scaling, diffusion attachments for incident light reading. Through-the-lens meters built into cameras read out via indicator lights or moving needle near the focusing screen or viewfinder. They may couple direct to the timing of an electronic shutter.

- (6) Photometers compare subject brightness with a 'known' light source. Characteristics include narrow acceptance angle, wide sensitivity range, higher cost and vulnerability to damage.
- (7) Meter exposure readings normally aim to fit brightnesses within the emulsion reproduction range. Meters are used to make integrated; brightness range; keytone; or incident light readings.
- (8) Integrated readings are simple and quick, but inaccurate when important areas
- (9) Brightness range readings reveal whether subject lighting or emulsion latitude require modification, but take longer, and may be impractical with small or distant subjects.
- (10) Key tone readings ensure that an important tone (often the highlight) is reproduced as a density on an intended part of the characteristic curve. The reading may be made from a substitute surface or though an incident light attachment. Readings need interpretation for different subjects, depending on the specific brightness range.
- (11) A good through-the-lens meter is compact, accurate and fast to use, and takes into account bellows extension etc. It is important to know whether the meter gives 'integrated', 'spot' or 'centre weighted' image measurement.
- (12) Having established required exposure, the exposure effect of moving (small source) lamps is in ratio to new and old lamp-subject distances squared.
- (13) Under any practical situation different factors controlling exposure come into varied prominence but the most common is the *purpose of the picture*. Unless this is firmly established first, the priorities of all remaining factors become confused and competitive.

Questions

- (1) List the factors that determine the exposure to be given in order to obtain a correctly exposed negative. If the correct exposure is found to be 1/50 at f/11, what shutter speed would be required at (a) f/5·6 and (b) f/16? For what reasons might it be desirable to work at f/5·6 instead of f/11 under similar lighting conditions?
- (2) Draw and label typical characteristic curves to illustrate the materials you would select for recording:
 - (a) A church interior.
 - (b) A black-and-white line diagram.

- Indicate positions on the curves where exposures for these subjects would be located.
- (3) List five principal factors to be taken into account when deciding the exposure *time* for a film used in the camera.
- (4) An object is photographed at f/16 in the studio using two lamps, one at 2·1 m and one at 1·2 m. The resulting negative shows insufficient depth of field so the aperture is reduced to f/32. To what distances will the lamps have to be moved to maintain the original exposure time for the second negative?
- (5) Explain the principles involved in making (a) A 'general' integrated reading, and (b) an 'incident light' reading, with an exposure meter. Outline one type of assignment for which each of these exposure reading techniques might effectively be used.
- (6) You are photographing a small object close up to give a 1½ times magnified image, A ×4 green filter is needed to change certain tone values. A separate meter pointed at the subject reads ½ sec at f/16. What exposure time would you in fact give, and why is this adjustment necessary?
- (7) Describe how you would use a photo-electric exposure meter to measure the exposure level required for the following subjects.
 - (a) A 10×8 continuous tone copy original.
 - (b) A country cricket match, afternoon sunlight lighting the players from a direction at right angles to the camera viewpoint.
 - (c) An aircraft in flight against a clear blue sky, the picture being taken from the ground with the sun behind the photographer.
 - In each case it can be assumed that medium contrast pan film is being used.
- (8) Exposure meters in current use normally employ selenium or cadmium sulphide. Outline briefly the essential difference in their principles of operation.
- (9) List the advantages, if any, offered by a through-the-lens meter over a separate exposure meter. What is the difference between an aperture preferred and a shutter preferred system of exposure automation?

REVISION QUESTIONS COVERING SECTION II EMULSIONS, FILTERS, LIGHTING, SENSITIVITY, EXPOSURE.

- (1) This figure represents the characteristic curves obtained when a certain film is developed for 6, 10, and 15 minutes respectively in a certain developer.
 - (a) Which developing time applies to each curve A B C?
 - (b) What is the gamma of each curve A B C?
 - (c) What is the fog level of each curve A B C?
 - (d) Using only the straight line portion of the curves, what is the density range corresponding to a log E range of 1.4 in each of the curves A B C?
 - (e) A characteristic curve is often referred to as a H & D curve. Why is this?

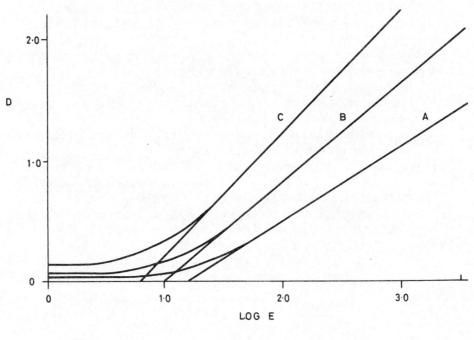

Fig. 14.8.

- (2) Describe your chosen technique for each of the assignments below in terms of
 - (a) emulsion type,
 - (b) lighting,
 - (c) filters (if any),
 - (d) exposure measurement.
 - (1) A diagram printed in red on white paper; the lines to appear dead black on the final copy.

- (2) A hardware catalogue illustration objectively showing six sizes of plastic clothes peg. The pegs range from 5 cm-15 cm high and are of mixed colours red, green and black.
- (3) 'When a surface is illuminated by a point source of light, the intensity of illumination at the surface is inversely proportional to the square of its distance from the light source.' Explain this physical law in your own words. What are its practical effects in photography?
- (4) Explain what is meant by the following photographic terms:
 - (1) Gamma
 - (2) Wedge spectrogram
 - (3) Density
 - (4) Subject brightness range
- (5) (a) Briefly describe how you would set out to plot the performance curve of a film emulsion.
 - (b) What practical information can the photographer obtain by studying the published characteristic curves of a film emulsion.
- (6) Calculate:
 - (a) The number of 1-kW spotlights which may be safely connected to a 250-V 15-amp power point.
 - (b) The exposure required with two point source lamps 10 ft from the subject, if 3 sec at f/16 is correct when the lamps are 4 ft distant.
 - (c) The resulting negative density range if an image brightness range of 40:1 is exposed wholly on the straight line portion of an emulsion developed to a gamma of 0.9.
 - (d) The exposure time necessary on ASA 50/DIN 18 material if film of ASA 400/DIN 27 was correctly exposed at 2 sec.
- (7) Outline the controls the photographer is able to exert over the final visual appearance of his negative,
 - (a) by choice of sensitive material,
 - (b) by choice and control of lighting,
 - (c) by selection of appropriate exposure.
- (8) Describe, with diagrams, the nature of the shadows produced by a diffused floodlamp and an optical spotlight.
- (9) A correct exposure is found to be 1/25 sec at f/4. What is the new exposure time required if the aperture is altered to f/20? Show calculations.
- (10) State the relationship between density and opacity. If a neutral density filter has a transmission of 60% what is the neutral density? Show your working.
- (11) A small but immovable piece of sculpture has to be photographed immediately in existing sunlight, harsh and from one side. You realise that its appearance is too contrasty to record satisfactorily on the general purpose film you carry. Discuss ways of improving results by means of
 - (a) lighting control,
 - (b) exposure/processing control.

Section III

PROCESSING THE RECORD

Secondly, my Hiawatha
Made with cunning hand a mixture
Of the acid pyro-gallic,
And of glacial-acetic,
And of alcohol and water —
This developed all the picture.

Finally, he fixed each picture
With a saturate solution
Which was made of hyposulphite
Which again, was made of soda ...

XV. PROCESSING FACILITIES AND PREPARATIONS

With exposure made and the image in its latent form, the remaining main section of this book looks at negative processing and printing. Both procedures are made easier if an efficient darkroom is available. In this chapter we can discuss what facilities are necessary in a professional darkroom and take a general look at the preparation of photographic solutions.

Darkroom Layout

BASIC REQUIREMENTS. There are four basic requirements for a room to be used for processing:

- (1) It must be light-tight.
- (2) It must have electricity and water supplies, and a waste outlet.
- (3) It must have any necessary heating or cooling of the air, and also adequate ventilation.
- (4) It should allow work to proceed in a logical sequence, including easy access in and out of the room.

(3) and (4) are the most frequently overlooked facilities, and yet if the room is to be used commercially it is vital to be able to work comfortably for long periods. Shutting out light must not also shut out air. Other staff should be able to enter or leave the room without disorganising production.

SIZE. To be adequate, room size naturally depends upon the number of people simultaneously using the darkroom, the maximum time they will be there and the type of work they are doing. For example, a room occasionally used by one individual photographer for processing small quantities of roll or sheet films need be little more than a large cupborad. On the other hand, a printing-room with several enlargers in continuous use needs good ventilation, ample space between dry and wet processing areas and room for printers to move around without getting in each other's way.

As a broad guide, an 'all day' printing-room for one printer should be considered in terms of at least 20 cu m (70 cu ft) e.g. $2 \text{ m} \times 4 \text{ m} \times 2.5 \text{ m}$ high, with an additional 4 sq m of floor space per additional worker.

Walls and ceiling. It is a complete fallacy that darkroom walls and ceiling should be black! Provided there is no white light leak from outside, the lighter and more reflective the walls and ceiling the more even and pleasant safe-light illumination will become. The only desirable local areas of matt black are located (a) on the wall surfaces close to the enlarger, to prevent reflection of stray light from carrier or lens to the paper easel, (b) within 'light-trapped' entrances or ventilation ducts.

Walls and ceiling should have a smooth glossy or eggshell painted finish, or may be tiled; these surfaces are easily cleaned. Poorly maintained ceilings cause trouble through

flaking. Avoid any conditions which will harbour dust — unplastered brickwork, overhead ducts and open shelving all make cleanliness more difficult. Dust and dirt in darkrooms are major causes of pinholes, abrasion marks and dried-in debris on negatives, creating hours of unnecessary retouching.

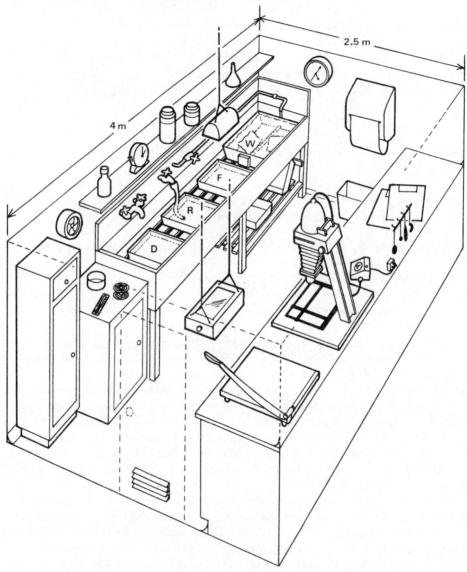

Fig. 15.1. A one-man general darkroom for small format film developing and printing. Note clear separation of 'wet' and 'dry' areas. (Where possible film drying, like print drying, should take place in another room.)

FLOOR. Since water is an integral part of most photographic processes a waterproof floor is an obvious safety precaution. It should also be chemical resistant because, given time, spilt photographic chemical can attack the fabric of the building. There are some good seamless polyester resin bonded flooring materials made for industrial use and a flooring contractor can advise on the latest types. Sealed concrete floors are cheap but become attacked and create dust unless re-sealed regularly; they are also tiring for staff standing all day.

A better scheme is to use chemical resistant plastic or quarry tiles over the whole area and carried up all walls (including a step under any door) to a height of 15 cm—20 cm. The floor could slope slightly to a central drain, and slatted duckboards be provided to raise the standing surface with any step at darkroom entrances. Such a 'sunken' tiled floor will act as an enormous dish in the event of overflow, discharging water down its own drain instead of spreading it to other rooms.

ENTRANCE. If, as in most cases, the darkroom is designed for entry or exit of staff without introducing light, some form of 'light-trap' is essential. The use of two doors, or a curtain and door, allows one to be closed before the other is opened – rather like an air lock. The disadvantages of this system are: (1) two people can open door or curtain simultaneously, so admitting light; (2) the need to handle door or curtains mean that almost inevitably each will in time become contaminated with chemicals, rotting or creating chemical dust. Dishes are also difficult to carry when one hand is monopolised in this way.

It is, therefore, more efficient to use a light-trapped entrance based on a doorless labyrinth system. If carefully designed this need take up no more room than a double door arrangement — and has the added advantage of forming a ventilation air duct. Some photographers use a light-trapped wall hatch (see Fig. 15.2) to pass processed prints from the printing darkroom for washing, without interrupting the flow of work. Better still, construct a water chute with a sheet of rigid black plastic, sloped just below a rubber flap light-trap.

VENTILATION. Whilst windows can be given a light-trapped blackout which still allows passage of air, an extraction fan is highly desirable for any darkroom in regular use. Several types of light-proof fans are designed to extract foul air. They should therefore be mounted in apertures high up on the wall or window blackout.

If double door entrances are used into the darkroom air intake grills will be necessary low down in the doors or suitable walls. Thought, too, should be given to the type of air being drawn into the darkroom. Intake of moist warm air from a glazer, or fumes or dust from industrial work areas should obviously be avoided. Try to arrange that *cool* air enters the room; this can then be raised and held at, say, 20°C by thermostatically controlled radiators.

Interior LAYOUT. Interior working areas should be planned according to workflow needs, being rigorously divided into 'wet' and 'dry' benches. The wet bench, where all processing is to be carried out, is most conveniently a long flat-bottomed sink in which tanks or dishes can stand on duckboards. Conventional glazed earthenware sinks are generally too small or deep, and it will probably be necessary to purchase a custom-built

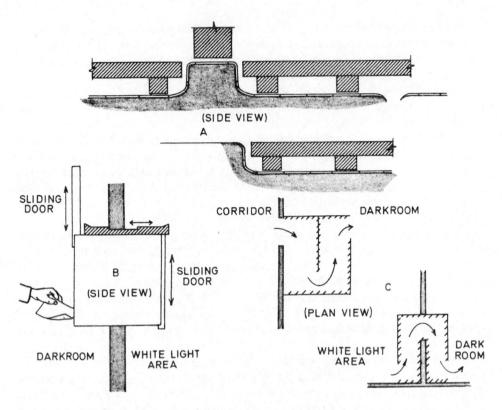

Fig. 15.2. A: Arrangement of floor tiling and duckboards for two adjacent darkrooms with connecting door, and (lower) junction of darkroom and normal workroom. Sunken floors form enormnous 'sinks' in the event of overflow. B: Light-trap hatch for transfer of work from darkroom to white light areas. C: Light-trapped darkroom entries, from (left) corridor or (right) between adjacent rooms.

15 cm-23 cm deep sink long enough to meet our needs.

The sink can be constructed in PVC reinforced with fibre glass, or stainless steel, or built in wood completely covered with one of several forms of sheet plastic, edge seamed by heat. It is advisable to cover the waste outlet in the centre of the sink by a perforated dome. Should a test strip, scrap negative or other debris float over the outlet it is then less likely to create a blockage.

Hot and cold taps usefully feed through a mixer unit for ease of temperature control. All taps should be high enough above the sink to allow standard bottles, buckets, and processing tanks to be filled when necessary. If the sink is fitted against a wall an adequate tiled or plastic splashback is essential. In large printing darkrooms it it is more usual to have the sink centrally placed, releasing a greater wall area for use of enlargers. Space under the sink can be used for vertical dish racks.

It is important that the dry bench or benches be kept dry; it must not therefore be adjacent to the sink. The dry bench will be used for loading and unloading slides, handling dry negatives and printing materials. A smooth hard surface such as laminated

plastic forms a good bench covering. Coving can be fitted at the bench/wall junction to eliminate corners harbouring dust.

Cupboards with doors can usefully be provided under the dry bench for the storage of sensitive materials in immediate use. A few inches toe room under the bench at floor level improves operating conditions. Small-format enlargers can be set up on general purpose dry benches. Bigger enlargers are either free-standing or on their own smaller benches, which may allow projection down on to the floor for increased enlargement.

LIGHTING AND POWER. Two lighting circuits are needed — one for a central white light, the other for safelighting. In addition, three-pin power outlets are needed to supply other equipment. It should be made virtually impossible to handle any light or power switch directly while working with wet hands.

If white light is regularly to be switched on - as in a one-man printing-room - it should be operated by a horizontal 'bus conductor' cord high over the wet bench and attached to a wall pull-switch. Should white light be needed only occasionally its switch can be placed in an out-of-the-way position to discourage accidental fogging.

Safelights (with interchangeable filter colours – see page 195) are generally necessary (a) over the sink (b) near a clock, (c) to give general safe illumination throughout the room. Locally switched safelights may be safely controlled by pull cords hanging from the ceiling. General safe illumination is most conveniently provided by a hanging safelight with filter screens on upper and lower surfaces, the upper screen 'bouncing' illumination off the ceiling. If a large darkroom is used exclusively for printing, a sodium safelight may be an economical general illuminant. It is cheap to run and highly efficient, but, as it takes some minutes to warm up it is best used in darkrooms where it can remain on all day.

Other equipment such as enlargers, contact printers, and immersion heaters must be thoroughly earthed via the third pin of their power points. Particular care must be taken in handling tank immersion heaters; when not in use these should be disconnected and stored away from the sink. In a centrally heated darkroom immersion heaters may be unnecessary for solutions which are left in tanks, and therefore reach the ambient temperature of the room. Dishes of solution are conveniently temperature controlled by an outer, larger dish filled with tap water at the appropriate temperature.

Other facilities. Roller towels should be as fluffless as possible, and positioned near the sink but away from darkroom air intakes. At least two thermometers are desirable — one fitted to the wall indicating air temperature, the other free for dish or tank use. A darkroom clock with sweep second hand, and a ringing minute timer should be provided; both should be luminous. If kept permanently in the darkroom this luminosity will however fade unless rejuvenated every few months by a bright white light. Warning: luminous paint can fog fast emulsions, and luminous clocks should not therefore be left on the dry bench when loading or unloading material.

Shelves should be kept to a minimum for reasons of dust, already discussed. One shelf will probably be necessary for carrying plastic measures and funnel, timer, thermometer and bottles of solution. The darkroom waste bin may be plastic or stainless steel to prevent rust caused by wet test strips. It should be small enough to need emp-

tying every day (accumulated chemicals otherwise crystallise out, forming a source of chemical dust).

Wherever possible the following should be excluded from the darkroom for the reasons stated:

- 1. Mixing of dry chemicals (chemical dust).
- 2. Glazing and heated drying (moisture content and unpleasant temperature).
- 3. Smoking (ash and ventilation problems).
- Chemical processes (e.g. toning) which give off fumes, and can be handled equally well in a ventilated workroom.

Tanks and Dishes

Photographic solutions are most frequently used in either tanks or dishes. Dishes (sometimes known as 'trays') allow maximum visual check of processing and energetic agitation. They also allow processing in a small volume of solution. Dishes are therefore popularly used for prints and for small batches of sheet film negatives which require special processing.

Developer in regular use for negative processing is more economically used in a deep tank holding 13.5 litres or more. This presents a small surface area of solution to the effects of oxygen in the air. Tanks also allow simultaneous processing of many negatives without risk of damage – the exposed material being handled in the tank in hangers (sheet films) or spirals (roll film).

Solutions in tanks are diluted so that their processing times are longer than when in dishes, for tank agitation is less energetic than dish rocking and a fast-acting solution would give uneven results. Most tanks have light-tight lids which allow some or all processing stages to be carried out under white light.

When purchasing processing equipment it is tempting to improvise using containers made for other purposes, and available at low cost. For example, tinned baking dishes would appear satisfactory for photographic dishes, etc. However many such materials either

- (1) react with photographic solutions, destroying their processing properties,
- (2) create severe emulsion fog through chemical action,
- (3) rapidly corrode and disintegrate.

Processing solutions should not be allowed to come into contact with these every day materials:

Copper; Tin (including tin solder); Zinc; Iron (including galvanised iron); Bronze; Aluminium; Chromium or silver plating; Polyurethane.

Tanks, dishes, racks and hangers are therefore specially made for photography from among the following *inert* materials:

Stainless Steel. Strong, light and extremely long lasting, stainless steel of appropriate grade is resistant to all normal black and white processing solutions. Unfortunately, it is also expensive.

Plastics. Several plastics are photographically inert, one of the most useful being hard PVC, particularly for tanks. Apart from tanks, which must be opaque to light, most items are either made in white or transparent plastic. It must be remembered that many are easily softened and distorted by heat.

Fibreglass. In many ways similar to plastic but more robust, fibreglass loses less heat than a plastic of equivalent thickness, but some types are inclined to stain quickly. It is sometimes used in the construction of large sinks or deep tanks to strengthen plastic.

The following materials are now largely superseded by plastics:

Enamelled Steel. A cheap, white material for dishes, but which easily chips. Chipped items must not be used as the unprotected steel quickly rusts.

Hard Rubber. Many large processing tanks have been made of black hard rubber in the past, but it tends to grow brittle with age and becomes difficult to clean.

To Sum Up Darkroom Layout and Facilities

- (1) A darkroom must be planned in relation to the processes to be handled and the maximum number of people intended to be working in it at one time.
- (2) The room must essentially be light-tight without loss of ventilation or easy access, and contain electricity and water supplies.
- (3) Dust control is aided by smooth unobstructed walls and ceiling, suitable industrial flooring, absence of powdered chemical or fluffing curtains and towelling.
- (4) Light toned decorations give more even distribution of safe illumination, both general and local. Enlarger areas, ventilators and light-traps should remain matt black.
- (5) Wet and dry benches must be rigorously separated. Electrical switches over the wet bench should be remotely operated.
- (6) Many common metals react with photographic solutions, creating chemical fog and emulsion stains. Processing equipment is therefore manufactured from inert materials such as stainless steel and suitable plastics.

Chemicals and Solutions

GENERAL PREPARATION OF SOLUTIONS. The chemicals we use for photographic processing may be bought in three main forms — concentrated liquids, which simply need diluting; premixed powders, which require dissolving; or bulk raw chemicals which must be weighed out and dissolved according to a published formula. Of these, concentrated liquids are the most labour-saving and least likely to result in error. However their extra bulk and weight make this the most costly form of purchase, and not all photographic solutions are suited to storage in concentrated liquid form.

Most processing chemicals are therefore still supplied as pre-mixed powders in one or more component packets, ready for dissolving in set volumes of water. This arrangement avoids errors in weighing out. The manufacturer can also make small changes from time-to-time, to improve his product or to keep pace with changes in film

emulsions etc.; his formula does not have to be published. Even with these pre-packed products however, carelessness in dissolving the contents can degrade or destroy the processing chemicals, and this in turn may ruin an unrepeatable assignment. Making up solutions is a responsible job.

Explicit instructions for mixing are always included with prepacked chemicals – particular regard should be paid to the *order* and thoroughness with which packets are to be dissolved, and the *temperature* of the water. Order is important, as some chemicals react with oxygen in the water, rapidly 'oxidising' unless in the presence of certain previously dissolved ingredients (e.g., hydroquinone with sodium sulphite). Temperature must generally be a compromise between a level at which the chemical is sufficiently soluble, and one which will cause it to decompose into some other chemical form. Finally remember that the containers, buckets, mixing paddles etc. used for solution preparation should also be chemically inert, page 280.

MIXING FROM BULK. Despite the almost total use of prepacked and concentrated solution forms, several of the simpler or infrequently used photographic solutions are still economically made up to formula from basic chemicals. These include fixing and stop baths, and some developers, intensifiers and reducers. The next two pages therefore contain general points on mixing chemicals.

Purity of the bought chemicals is important in that residual impurities should be *photographically* inert. It is, therefore, wise to obtain supplies from a 'photographic' chemical manufacturer, whose quality control department is orientated to check for just these substances — resulting in a photographically pure product at a practical price. Very much higher *overall* purity (and consequent expense) would be needed to guarantee the absence of harmful trace elements if the chemicals came from other sources.

Most photographic chemicals are white crystals or powders with little visual identity. In bulk they should be stored in covered bins, tins or bottles in a dry, preferably separate, chemical room. Chemicals left exposed to the air may become oxidised or undergo physical changes. Some dry chemicals such as potassium metabisulphite create sulphurous fumes with strong emulsion fogging and metal corroding properties. Others (e.g., sodium sulphide) are 'deliquescent' – rapidly dissolving in moisture they absorb from the air.

SUBSTITUTION OF CHEMICALS. Most solid chemicals contain a set proportion of water molecules in their crystals, increasing their weight. In some cases it is practical for the manufacturer to reduce this 'water of crystallisation' to a low level, giving a part dried or monohydrate form of the chemical, or by removing the water altogether, to produce an anhydrous (dried or desiccated) form. In these dehydrated conditions a chemical is of course far more concentrated, takes up less storage space and may be more stable. It will, however, absorb moisture more rapidly under damp conditions and can set into a rock-like state.

The actual form in which a chemical is used – crystal, monohydrate or anhydrous – has a very important bearing on weights and measures. Weight for weight, anhydrous powder has a greater chemical content than its crystalline form, the exact ratio depen-

ding on the molecular weights of the particular chemical in its two forms. For example, 64 parts of anhydrous sodium thiosulphate ('hypo') has the same chemical content as 100 parts of the crystal form. Similarly, 37 parts anhydrous of sodium carbonate are equivalent to 100 parts of crystalline sodium carbonate, or 43 parts of the less commonly used monohydrate form.

Because of this major difference between concentrations in which a solid chemical may be used, great care must be taken in reading the weights of components in published formulae. Where a chemical is marketed in several forms, the formula will state whether the weight required refers to crystal, monohydrate or anhydrous. Should you have to substitute another form of the chemical remember that the ratio of quantities varies with each chemical. Here are ratios for photographic chemicals commonly used in several forms.

Substituting sodium carbonate (crystal) for anhydrous multiply quantities by 2.7 Substituting sodium sulphite (crystal) for anhydrous multiply quantities by 2

Substituting sodium thiosulphate (crystal) for anhydrous multiply quantities by 1.6

Substituting sodium thiosulphate (anhydrous) for crystals multiply quantities by 0.63

WEIGHING OUT. Weigh out chemicals in a well ventilated place away from photographic materials, and use a good chemical balance. Pieces of paper of equal weight should be placed in each balance pan, and the chemical weighed on to one of these mats. The smaller the quantity of chemical, the greater weighing accuracy must be. All modern formulae now quote metric weights and measures, although British and American systems are still in use.

TABLE 15.1 WEIGHT

Metric	American
1,000 milligrams (mg) = 1 gram (gm) 1,000 grams (g) = 1 kilogram (kg)	Avoirdupois
	1 dram = 27.4 grains (gr) 16 drams = 1 ounce (oz) 1 ounce = 437.5 grains
$2\mathrm{gm} = 15.43\mathrm{g}$	16 ounces = 1 pound (lb)
Liquid Measure	
1 millilitre (ml) = 1 cubic centimetre (cc)	U.S. liquid units 1 fluid dram = 60 minims 480 minims = 1 fluid ounce (fl oz
1,000 cubic cm = 1 litre (l)	16 fluid ounces = 1 pint 8 pints = 1 gallon (gal)
28.4 cc = 1 fl oz	

Useful capacity conversion figures:

A 5 litre processing tank contains	1.3 U.S. gals
A 13\frac{1}{2} litre processing tank contains	3.6 U.S. gals
A 16 litre processing tank contains	4.0 U.S. gals
A 45 litre processing tank contains	11.0 U.S. gals

Emergency weights: In emergency cases, where proper chemical weights are not available, it is possible to use common British coins as substitutes. Naturally, these must be comparatively unworn.

One half penny $(\frac{1}{2}p)$	1.78 gm
One penny (1p)	3.56 gm
One twopence (2p)	7·13 gm
One fivepence (5p)	5.66 gm
One tenpence (10p)	11.31 gm
One fiftypence (50p)	13.5 gm

MIXING. With all the chemicals in the formula weighed out, each should be completely dissolved in turn, in the order in which they are listed. The solution should be kept moving with a plastic or stainless steel mixing rod, each powder being added slowly. Unless specific instructions are given to use distilled water (as with certain colour chemicals) ordinary sediment-free tap water is perfectly satisfactory for making up photographic solutions. In some localities it may be necessary to have a water filter. Use two thirds of the final intended volume of water for mixing, at a temperature of about 40°C (104°F) for most crystals, or 21°C (70°F) for anhydrous chemicals. After all the ingredients are dissolved make up to the exact final volume with cold water.

Most chemicals either generate or absorb heat from the solution as they are dissolved. Chemicals in anhydrous form raise the solution temperature (an exothermic reaction). Use barely warm water and add the chemicals quite slowly—unless well agitated the powder sets to a rock-like lump which is then difficult to dissolve. On the other hand many crystals, e.g. hypo, have an endothermic effect and considerably lower solution temperature as they dissolve. It is therefore best to start off with much hotter water.

Some chemicals require special care. If you have to use a strong acid this should always be added to water, *never the reverse*, as the first drops of water may be so violently heated by exothermic reaction that acid is thrown in all directions. Sodium hydroxide pellets generate considerable heat as they dissolve and should be mixed at temperatures below 21°C (70°F). See also references to mixing acid fixer chemicals, page 311.

Finally do not spoil all this work by contamination – thoroughly rinse out the dish, tank or storage bottle (including the stopper) before pouring in the newly mixed batch of solution. Mixing procedure for some commonly used developers and fixers appears in Chapter XVI and XVII.

Dilution from Stock

Whether the processing solution has been prepared from bought liquid, prepacked or bulk chemicals, it is usually stored in a fairly concentrated 'stock solution' prior to use. In this form, in a tightly corked container it is compact, less likely to oxidise, and may be quickly diluted as and when required. Photographic solutions are conveniently diluted either 'by part' or 'by percentage'.

DILUTION BY PART. A formula or data sheet may specify that the stock solution be diluted 'One part stock solution to four parts water' (or 1 + 4) for a particular use. These parts mean any unit of volume, as long as the same unit applies to stock solution and water. All the following represent 1 + 4 dilution:

1 litre stock solution plus 4 litres water; total 5 litres working solution 1 fl oz stock solution plus 4 fl oz water; total 5 fl oz working solution

250 cc stock solution plus 1 litre water; total 1½ litres working solution

To calculate the amount of stock solution needed to make up any required final working volume on a parts basis:

Parts stock solution =
$$\frac{\text{Final working volume}}{(\text{Parts water} + 1)}$$

e.g., To fill a $13\frac{1}{2}$ -litre (3-gal) tank with developer diluted 1 + 20 requires 13.5/20 + 1 litres of stock solution, or 13,500/21 cc, i.e., 642.9 cc stock solution.

PERCENTAGE SOLUTIONS. A percentage stock solution is employed when a chemical is to be used in different amounts in various solutions. Provided the chemical keeps well in solution it is easier to use appropriate amounts of say, a 10% solution rather than keep weighing out dry chemical — particularly when quantities are small. Although, in theory, we could keep the ingredients of a developer in individual stock solutions, in practice some would oxidise. It is, therefore, other chemicals such as the ingredients of acid stop baths, toners or reducers which are often handled in this way.

The 'percentage' of a solution refers to the ratio of chemical to the final quantity of its solution in water. e.g., a '5% solution' is five parts of chemical made up to 100 parts with water ('five per cent total'). In photography it is generally accepted that by 'parts' we mean volume per volume in the case of liquid chemicals and weight per volume in the case of solid chemicals. The following are therefore all 5% solutions:

5 cc of concentrated liquid chemical, made up to 100 cc with water; total 100 cc of solution.

Or 5 fl oz of concentrated liquid chemical, made up to 100 fl oz with water; total 100 fl oz of solution.

Or 5 gm of solid chemical,* made up to 100 cc with water; total 100 cc of solution.

Or 5 oz of solid chemical,* made up to 100 fl oz with water; total 100 fl oz of solution.

Example 1. You are asked to make up 100 cc of $12\frac{1}{2}\%$ acetic acid, what is your

^{*} Dry chemical forms - crystal, anhydrous, etc. - are always specified when appropriate (e.g., 'a 5% solution of anhydrous sodium sulphite').

procedure? Answer: 12.5 cc of acid would be needed, with enough water to create 100 cc final volume. Take approximately 75 cc of cold water, and slowly add the 12.5 cc of acid, stirring at the same time, finally adding sufficient water to make up 100 cc.

EXAMPLE 2. How much chemical would you need and how would you proceed to make up 200 cc of 20% potassium ferricyanide (crystal). *Answer*: 20 gm would be needed for a total of 100 cc (i.e., 20%). Therefore 40 gm are required for 200 cc. The crystals would be dissolved in about 100 cc of warm water of at least 52°C (125°F), with constant stirring. Cold water would then be added to give 200 cc overall.

DILUTING PERCENTAGE SOLUTIONS. Starting from a percentage stock solution we may have to prepare a working percentage solution. For example, taking down a bottle of 50% ammonia solution we wish to prepare 100 cc of 2% ammonia. How much stock solution is needed? This is not as difficult to calculate as it sounds, being proportional to the ratio of the percentages of the working and stock solutions.

i.e., We take
$$100 \times \frac{\text{working \%}}{\text{stock \%}}$$
 parts and add water to make up 100 parts.

The answer in the case above will be 4 cc.

EXAMPLE 1. Preparing 100 cc of 10% sulphuric acid from 30% stock, how much stock solution is required?

Answer:
$$100 \times \frac{10}{30}$$
 cc = 33·3 cc stock solution.

EXAMPLE 2. How much 40% stock solution is required to make 2 litres of 15% working solution? Answer: If we were making 100 cc of working solution $100 \times 15/40$ cc of stock solution would be required. However, 2 litres is 20 times 100 cc and therefore $2,000 \times 15/40$ cc stock solution is required, i.e., 750 cc.

Chapter Summary - Processing Facilities and Preparations

- (1) Like all workrooms, a darkroom must be of adequate size, well ventilated and controllable in temperature. It should also be light-tight, reasonably free from dust, allow easy access and offer suitable electricity and water supplies
- (2) Decoration should be light and reflective except in light-traps and adjacent to the enlarger. The chemical resistant floor is designed to cope with floods.
- (3) A duckboarded flat-bottomed sink 'wet bench' with high taps and block-free waste allows dish or tank processing. Power points and switches are potentially dangerous near water. Beware of dust-trap shelves, bench corners, etc.
- (4) Other desirable features include general and local safelighting, clocks, towel, tank immersion heater, thermometers, and dishes and tanks of suitable inert materials.
- (5) Processing solutions are prepared from concentrated liquid, prepacked powder

and bulk chemicals. Bulk chemicals must be of high photographic purity and may be available in crystal, monohydrate or anhydrous forms. Owing to loss of water of crystallisation, dehydrated chemicals are more concentrated. Crystal/anhydrous substitution ratios vary from one chemical to another, being based on molecular weights.

- (6) After careful weighing out of all formulae, ingredients are mixed in listed order. Most chemicals dissolve easily in water at about 20–25°C; crystals create endother-mic temperature drop and may require warmer water. Never add water to acid.
- (7) Most developers and concentrated liquid solutions are diluted for use by 'parts', e.g., 1 + 4 indicates one part stock solution *plus* four of water.
- (8) Other multi-use chemicals are conveniently kept in stock 'percentage' solutions, e.g., parts of chemical per hundred parts of its *final* solution in water. When diluting for use from a stock percentage solution take 100 parts × working %, stock %, adding water to make up to 100 parts working solution.
- (9) Chemical solution preparation is a responsible job take particular care to avoid contamination at every stage.

Questions

- (1) (a) Describe your procedure in preparing a 2½-litre stock solution of 10% sulphuric acid.
 - (b) How would you prepare a 500-cc beaker of 2% sulphuric acid from the above stock solution?
- (2) An industrial photographic unit is being established and you are asked for technical advice in designing a general purpose darkroom for two people. Both film negative processing and enlarging will be undertaken. Write a short report to the Works Engineer pointing out the basic facilities needed, and making out a case for a second room if you feel this is desirable.
- (3) A simple developer formula is:

Metol	3 gm
Sodium sulphite (anhydrous)	50 gm
Hydroquinone	12 gm
Sodium carbonate (anyhydrous)	60 gm
Potassium bromide	4 gm
Water to make	1,000 cc

Working strength: Dilute 1 part with 3 parts of water.

- (a) Rewrite the formula for making 4.5 litres of stock solution.
- (b) Why is the term anhydrous used in connexion with two of the chemicals?
- (4) Complete the following simple calculations:
 - (a) How much potassium bromide is contained in 15 cc of a 10% solution?
 - (b) If the correct exposure time at f/8 is 2 sec, what is at f/14?

- (c) The emulsion used in (b) above had a speed rating of 13 DIN. What would the exposure be at f/8 for an emulsion of 19 DIN? Show your calculations.
- (5) A fixing bath is to be made to the following formula:

sodium thiosulphate (crystals) 25% potassium metabisulphite 5%

If the fixing tank holds 12 litres of solution, give the weight of the chemicals needed. If anhydrous hypo has to be used, what weight would you substitute for the crystalline? (10 parts of crystal are equivalent to 6.25 anhydrous.)

- (6) Describe clearly the correct procedure for making up the following solutions
 - (a) 2 litres of 5% hydrochloric acid
 - (b) 1 litre of 10% potassium bromide
 - (c) 100 cc of 2% acetic acid, from a 10% stock solution.
- (7) Two aspects to bear in mind when preparing photographic solutions from chemicals are
 - (a) the temperature of the water; and (b) contamination.

Dicusss the importance of each and the steps you would take to avoid trouble.

XVI. DEVELOPERS AND DEVELOPMENT

The stage is now set for processing our exposed negative. The image projected on the emulsion within the camera has caused the formation of a few atoms of silver on many silver halide grains — broadly in proportion to light received. At the same time equally small quantities of halogen have been released and absorbed in the gelatin.

The latent image in black and white emulsions is stable enough at normal room temperatures to remain virtually unchanged for several months. Kept at low temperature and humidity levels, such as in a refrigerator, the image can remain developable for several years. However, high humidity or temperature, or subjection to chemical fumes can cause rapid deterioration and complete loss of the latent image within days. It is therefore advisable to process within the shortest convenient time after exposure.

Development, the first stage of processing, is an 'amplification' action. Chemical agents in the developing solution donate electrons to those silver halide grains carrying silver atoms, which thus form 'development centres'. These electrons lead to the formation of even more silver atoms until finally the grain is completely converted to *black metallic silver*. On average, the 'amplification' provided by the development process is of the order of 10 million times.

The reaction creates two by-products -(a) Exhausted or oxidised developing chemicals devoid of their electrons; (b) Bromine, in the form of potassium bromide, which is discharged from the emulsion in proportion to the silver formed. As our developing solution is used it therefore acquires oxidised developing chemicals and potassium bromide - both of which limit its useful life.

Definition: Development – The action of 'amplifying' the latent image into a visible form – by reducing light-affected silver halides into black metallic silver.

In general, the development of an individual grain is an all-or-nothing action; either the grain is completely reduced to silver or it remains substantially unaffected. The range of tones produced in a negative or print results from the fact that the number of grains rendered developable by exposure varies from one point on the material to another.

The developing solution is in reality a 'team' of chemicals, all having a specific part to play. The most important of these are the 'developing agents'.

Developing Agents

There are many hundreds of chemicals which will reduce silver halides to black metallic silver. Unfortunately, most of these 'reducing' agents have an equally rapid effect on both exposed and unexposed silver halides – giving overall density or 'fog'. We are therefore limited to a narrower range of reducing agents which change light-struck

halides to silver more rapidly than unexposed halides. These are known as 'developing agents'.

Even developing agents have some effect on unexposed grains (shown by the 'fog level' on the emulsion performance curves). The essence of development is, therefore, to remove the emulsion from the solution when light-struck halides are substantially reduced, but *before* the remaining halides can be appreciably affected.

Some surprising chemicals will act as developing agents, but to be of pratical application they must be reasonably economic to manufacture, non-toxic and able rapidly to diffuse into the gelatin emulsion. Most, but not all, of the efficient developing agents used in photography are derived from benzene. They include metol, hydroquinone, glycin, amidol, chloroquinol, pyro, paraphenylene diamine. 'Phenidone', a proprietary developing agent, is not derived from benzene. (This has very similar developing properties to metol but is more concentrated and less prone to cause dermatitis.) Metol, hydroquinone and Phenidone are the most universally used developing agents, as we shall discuss shortly.

The Remaining 'Team'

Developing agents in solution are not practical developers. Used alone in this way they take several hours to yield useful density, are quickly oxidised by air in solution, and give unnecessarily high fog level. Other chemical ingredients must be used to counteract these deficiencies.

ALKALI. The presence of a suitable alkali in the developer greatly increases developing agent activity, shrinking development times from hours to minutes. The alkali content of the developer is, therefore, known as an *accelerator*. The increase of activity given depends upon the alkalinity of the chemical chosen as accelerator.

Alkalinity is calibrated by 'pH values' (power of Hydrogen ions); the higher the pH value of a chemical, the higher its alkalinity. The scale is based on the fact that water (neutral) contains 10^{-7} hydrogen ions (acid) and 10^{-7} hydroxyl g ions (alkali) per litre and is therefore given a pH figure of 7. Other solutions, acid or alkali, have different concentrations of the two ions, giving figures above 7 for increasing alkalinity and below 7 for increasing acidity. The two ends of the scale are 0 and 14, representing extreme acidity and extreme alkalinity respectively. pH can be checked by litmus papers or measured by special meter.

Common alkaline chemical used as developer accelerators are listed below, together with the pH values they create:

Borax	pH 9
Sodium carbonate	pH 10
Sodium hydroxide (caustic soda)	pH 11

It can therefore be seen that any developer containing sodium hydroxide is highly accelerated and develops to a higher gamma more rapidly than if carbonate or borax were used.

Unfortunately, there are side effects. The higher the pH the more rapidly alkalinity drops towards neutral with solution use, giving short life developers. High alkalinity also encourages oxidation of the developing agent in solution. For these reasons high contrast (i.e., 'line') developers usually have a very short working life, and are best stored with developing agents and alkaline in separate 'A' and 'B' solutions to be mixed just before use. Borax accelerated developers on the other hand require longer developing times and give lower gammas but offer a far more stable developing solution. Borax is frequently used in long-life tank developers.

PRESERVATIVE. A developing agent dissolved in water – particularly in the presence of an alkali – will quickly turn brown, lose its developing ability and create emulsion stains. This is because the developing agent has been broken down by the action of oxygen in the solution and in the air above the developer surface (aerial oxidation). A chemical must therefore be added which will help preserve developing agents from oxidation. The almost universally used preservative for developer solutions is sodium sulphite, although potassium metabisulphite finds application as a preservative in two-solution formulae.

Most developing agents in the early stages of oxidation form small quantities of quinols — which act as 'catalysts', greatly accelerating further oxidation. The preservative chemical is thought to react with these quinols, inhibiting their catalytic properties and thereby slowing oxidation. At all events a developer containing sulphite has a longer useful working life.

RESTRAINER. Even when using developing agents, some unexposed silver halides tend to be reduced to black metallic silver before development reaches the required gamma. This unwanted fog level can be reduced by including a small quantity of soluble halide, namely potassium bromide, in the developing solution. Potassium bromide slightly 'restrains' developing action overall, but has greater retarding effect on low density areas than highlights.

Ironically, as emulsions are developed soluble bromide is discharged into the developer, increasing the proportion of restrainer and slowing developing action. Restrainer in the original formula is, therefore, most important from the point of view of the first few sheets of film to be processed.

Instead of potassium bromide, some developing solutions contain organic restrainers. These have fog-reducing effects with less loss of light-struck halide density. They are sometimes referred to as developer 'improvers' or 'anti-foggants'.

Developer Types

It can be seen that the tank or bottle of developer which we all take for granted is in fact quite a 'team' of chemicals in solution. Developing agents; alkali; preservative; restrainer – the exact choice of chemicals to serve these functions and their relative proportions is capable of infinite permutations. We therefore have several hundred developing solutions, some published as formulae (*Examples*: Ilford ID-2, ID-11, etc.;

Kodak D.163, D.61a, etc.) and others given proprietary names with unpublished formulae ('Microphen', 'Unitex', 'Microdol X', etc.).

Developers can be broadly classified in the following categories:

- (1) Normal contrast general purpose developers usable for negatives and for printing.
- (2) High contrast, rapid working developers for line work or where maximum and minimum density values are required.

(3) Normal or low contrast fine-grain developers – for negatives from which high magnification enlargements are needed.

Modern fine-grain developers are almost invariably patented formulae, available only in prepacked chemical or concentrated liquid form. In this book we shall look particularly at the preparation and use of normal and high contrast formulae.

The M.Q. or P.Q. General Purpose Developer

Both metol-hydroquinone and Phenidone-hydroquinone formulae are based on the use of a mixture of two developing agents with differing characteristics. Hydroquinone in carbonate accelerated solutions is slow working, meaning that it has a long induction period or time elapsing between commencement of development and the first appearance of the image, but given time yields a useful tone range with strong highlight densities. Metol and Phenidone have shorter induction times, give low contrast detail over the whole negative but produce only low highlight density.

However, hydroquinone used together with metol (or Phenidone) gives results that are even better than the sum of the characteristics of the two agents. This *superadditivity* effect gives us a combination which, given a properly exposed emulsion, collectively produces good shadow and mid-tones detail, and useful density in highlights – all within a practical processing time.

Phenidone is often used as a replacement for metol in M.Q. type developers. As it is more concentrated smaller quantities are needed — a factor which enables P.Q. developers to be marketed in concentrated liquid form without danger of salting out. Characteristic M.Q. and P.Q. developer formulae:

M.Q. FORMULA

(Ansco 61)	Quantities	Function
Metol	1 gm	Development agent
Sodium sulphite (anhydrous)	15 gm	Preservative
Hydroquinone	2 gm	Developing agent
Sodium carbonate	13 gm	Alkali (pH 10)
Potassium bromide	1 gm	Restrainer
Water to	1000 cc	

P.Q. FORMULA

(Ilford ID-67)	Quantities	Function
Sodium sulphite (anhydrous)	75 gm	Preservative
Sodium carbonate	37.5 gm	Alkali (pH 10)
Hydroquinone	8 gm	Developing agent
Phenidone	0.25 gm	Developing agent
Potassium bromide	2 gm	Restrainer
IBT restrainer solution	15 cc	Anti foggant
Water to	1,000 cc	
(Dilute 1 + 5 for tank use.)		

Note the modified order in which components are mixed in the M.Q. formula. This is because metol is difficult to dissolve in a strong sulphite solution. Normally, a small quantity of the weighed-out sulphite is added to the mixing solution before starting to dissolve the metol. This reduces oxidation risk without prejudicing metol solubility. Phenidone is more soluble in the presence of an alkali than in plain water; it can, therefore, be dissolved with the hydroquinone in a P.Q. developer. When mixing from prepacked powder chemicals, the developing agents, plus a small quantity of preservative, are often found supplied in one packet, the remaining ingredients in another.

Once mixed, M.Q. and P.Q. developers will keep for several weeks in filled well-stoppered stock bottles. Stored in a deep tank a 'floating lid' should be left covering the surface of the solution when not in use, preventing air contact and thus reducing developing agent oxidation.

The Caustic-Hydroquinone High Contrast Developer

Provided it is activated by an alkali of high pH, hydroquinone is an obvious choice of developing agent to yield maximum emulsion contrast. Fairly large quantities of

HIGH CONTRAST DEVELOPER

Stock Solution 'A'	(Ilford I	(D-13)	Stock Solution 'B'
Hydroquinone Potassium metabisulphite	25 gm (dev. agent) 25 gm* (preservative)	Potassium hydroxide Water to	50 gm (alkalipH 11) 1,000 cc
Potassium bromide	25 gm (preservative) 25 gm (restrainer)	Water to	1,000 cc
Water to	1,000 cc		

(Equal parts of A and B are mixed just prior to use.)

potassium bromide must be present to inhibit an otherwise high fog level and minimise shadow density. A large quantity of sodium sulphite or the acid preservative potassium metabisulphite will also be needed to keep the hydroquinone operational for as long as possible. Alkali and developing agent must be stored apart.

This developer demands some care in mixing and use. Potassium hydroxide (caustic potash), like sodium hydroxide, generates heat when mixed and should be dissolved in

^{*} Metabisulphite is used in preference to sulphite here because being slightly acid it is a more efficient preservative.

cold water. The chemical should not be touched with the hands. Once A and B are mixed together the developer will remain active for only an hour or so. The developing agent will oxidise, although, because of the presence of the preservative, the solution may initially show no physical change. When developing agent and preservative are oxidised the solution will turn yellow brown. The A and B components should therefore preferably be freshly mixed for each negative or batch of negatives processed. Development is usually carried out in a dish – remember that owing to the high alkalinity of the caustic the negative emulsion will become slippery and rather soft. Use of a stop-bath and acid fixer is advisable if dichroic fog is to be avoided (see chapter XVII).

High contrast developers are intended for high contrast line emulsions, on which they produce very dense maximum blacks and clear whites (see Fig. 13.11, bottom). If used for normal contrast fast films results often show a high fog level.

Recapping Developer Content

- A developer acts as an 'amplifier', reducing light struck silver halides which carry
 a few atoms of silver into grains of black metallic silver. Collectively, these grains
 make up visual densities.
- (2) All developing agents eventually reduce the whole halide population in an emulsion to metallic silver. However, light struck halides are reduced first and development is halted before the 'fog level' becomes excessive. The most generally used developing agents are metol, hydroquinone, Phenidone.
- (3) Developing agents function most efficiently in an alkali solution (pH above 7). The greater the alkalinity the faster the action of the developer but the more rapid the developing agent oxidation. Common alkalis or accelerators borax, sodium carbonate, sodium hydroxide.
- (4) A preservative in a developing solution inhibits breaking down of developing agents by oxygen in solution or the air (aerial oxidation). Sodium sulphite and potassium metabisulphite are common developer preservatives.
- (5) Finally, a restrainer or anti-foggant slows the developer effect on unexposed halides. Potassium bromide is widely used as a restrainer.
- (6) Choice of chemicals and their comparative quantities determines a developer's characteristics broadly, high contrast, general purpose or fine grain.
- (7) General purpose M.Q. or P.Q. developers are superadditive systems, with a performance that cannot be obtained by using these developing agents singly.
- (8) High contrast developers usually employ a contrasty developing agent at high alkalinity plus ample bromide. The working solution has a brief life owing to developing agent oxidation and rapid drop in pH, despite preservative.

DEGREE OF DEVELOPMENT

Assuming that our latent image was 'correctly' exposed, the *amount* of development the emulsion will receive is controlled by:

- (1) The developer constituents and solution condition.
- (2) Developer dilution.
- (3) The solution temperature.
- (4) The time of development.
- (5) The amount of agitation given.
- (6) Emulsion type.

If we are to get predetermined and repeatable results all these factors must be controlled.

Formula and Solution Condition

These two factors have to be considered together because type of developing agents and pH of solution, together with quantity of preservative, all help to determine the energy and useful working life of a developer. The changes which can occur in a developing solution are

- (a) The developing agents oxidise broken down by oxygen in solution or the air, or used up in developing silver.
- (b) Alkalinity changes, pH drops with the amount of emulsion developed.
- (c) Bromide content increases, due to soluble bromide acquired from emulsions.
- (d) Solution level drops, owing to developer absorbed by the dry gelatin and carried on into the next solution.

The most important of these changes, (a), is indicated by the solution growing brown, and in extreme cases staining the emulsion gelatin. Where a powerful alkali is present to accelerate a high contrast developing agent, oxidation rate is greatly increased. Low alkali slow working developers may last a month or more; if large volumes are in use it may be an economical proposition to 'replenish' from time to time, greatly extending this life.

A replenisher solution contains suitable concentrations of developing agent, alkali, preservative, but no bromide. The exact formula is based on the formula of the original developer and its anticipated conditions of use. A suitable quantity of the appropriate replenisher solution is added to the depleted solution (if necessary 'topping up' with fresh developer). Alternatively set quantities of developer are 'bled off' from the tank and replaced with replenisher. Replenishment cannot go on indefinitely (except in special circumstances) as the concentration of bromide usually becomes excessive and the whole solution must be thrown away.

If the same tank of developing solution is used day in, day out, some record should be kept of the area of emulsion it has processed. A series of ticks for every 500 sq cm of film developed can be recorded on a label. This enables us to know when to replenish — or at least gradually to increase development time and so compensate for reduced activity (as recommended by the developer formulators) to the point at which the solution is so close to exhaustion that it must be discarded. This point can only be approximated of course, as it will be influenced by amount of silver reduced on each emulsion.

Another, more critical method of monitoring the solution is to use control strips.

TABLE 16.1 DEVELOPERS—KEEPING PROPERTIES AND PROCESSING CAPACITY

	Working	solution:	Stock so	olution in	Approx. no. of films
Type of	Open	Covered		container:	processed per 2 litres
developer	dish	tank	Full	Half-full	(without replenishment)
MQ/PQ	24 hrs	1 month	6 months	2 months	12, 36 exp. 35 mm films, or equiv.
Caustic- hydroquinone	4 hrs	24 hrs	6 months*	2 months*	$50, 4 \times 5$ in sheet films, or equiv.

^{*} Sep. A & B sols.

These are pieces of film pre-exposed by the manufacturer under a grey scale. After processing the highest and lowest densities are measured and related to strips put through the developer previously.

Developer Dilution

The amount we dilute the developer will affect:

- (a) Development time required. When dish processing it is more convenient to have a short processing time, but in a tank a short development time may give uneven results.
- (b) The maximum gamma achieved. Development rate falls off with dilution. Even given a long development time a diluted solution will never produce the emulsion contrast given by a concentrated developer. This is why contrast developers are also used highly concentrated.
- (c) Working life and keeping properties. In diluted solutions oxygen in the water is able to make greater inroads into the developing agents since the concentration of preservative is diluted. Hence a stock solution has a longer life when stored in as concentrated a form as the solubility of its ingredients allows.

Solution Temperature

(Most temperatures in this book are quoted in both centigrade and Fahrenheit values. To convert from one scale to another add 40, multiply by either 9/5 (°C to °F) or 5/9 (°F to °C), then subtract 40 from the result.) See also page 375.

The temperature of the processing solution affects:

- (a) The activity of individual developing agents. In general, the lower the temperature, the slower a developing agent functions.
- (b) The gelatin of the emulsion. Temperatures above about 24°C (75°F) notably soften gelatin, making the emulsion very susceptible to damage. When processing at this or higher temperatures the emulsion may need its gelatin 'hardened' before processing, e.g., in a 10% formalin (formaldehyde) solution.
- (c) The final emulsion gamma produced.

Within the range 13°C-24°C (55°-75°F) temperature effects can be virtually nullified by alteration of timing. These temperature limits are generally used owing to the inconveniently long development time and adverse effect on certain developing agents created by temperatures below 13°C. Above 24°C timing becomes embarrassingly short, emulsion fog level increases and gelatin becomes dangerously soft.

Most manufacturers publish 'Time/Temperature' graphs indicating the necessary compensation of temperature by time and vice versa needed to give the same gamma. Strictly such a graph applies only to a particular developer formula. Alternatively,

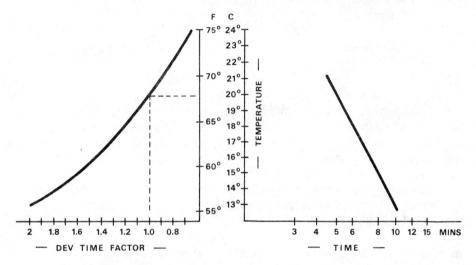

Fig. 16.1. Time and temperature. Left: Development time factor when correct time is known for 20°C. Right: A time/temperature graph. (Both graphs apply to an MQ/PQ developer, dilution and conditions of agitation stated).

alteration of timing can be calculated from the 'temperature coefficient' of the developing agent used. This is the ratio of development times needed to produce the same emulsion contrast at temperatures 10°C apart. Most M.Q. type developers have coefficients of about 3.0, i.e., a drop of 10°C can be compensated for by making development three times as long (see Fig. 16.1, left).

Obviously, any major change in solution temperature *during* development will drastically affect results. For consistency, some form of solution temperature control is desirable. As suggested in chapter XV, this may be achieved by some form of heated water jacket – the tank surrounded by warm water in a sink or a large water filled dish containing the developer dish. Various immersion heaters are also available.

CONCLUSIONS. Where possible developer temperatures should be maintained, unfluctuating, at the recommended solution temperature. Other temperatures between 13°-24°C are practical but require compensation by altered timing ('Time and Temperature' development).

The Time of Development

Altering the time an emulsion remains in the developing solution will affect:

- (a) fog level;
- (b) evenness of development, notably if the timing is reduced to a very brief period;
- (c) the emulsion gamma produced.

'Recommended' development times from manufacturers aim to give a gamma (usually about 0.8) which will convert an 'average' subject brightness range to a density range of about 1.0. In order to show what gammas are produced at other development times 'Gamma/Time Curves' are published for a particular combination of development, emulsion and temperature.

Points to note from curves such as Fig. 16.2 (right) are: (1) The 'gamma infinity' (i.e., maximum possible gamma) the developer will give. Prolonging development beyond this to improve negative contrast is pointless, as it will noticeably develop unexposed halides, increasing fog level. (2) The rapidity with which gamma increases. Suppose, for example, we had exposed a subject with a wide brightness range and therefore wish to develop to a slightly lower gamma than normal (say 0.7). We would choose a developer with a curve which does not rise too steeply at about this gamma — otherwise an error of a few seconds in time may make enormous differences in final negative contrast. Such a powerful solution may also call for a development time which is too short for even development.

Note on 'pushing' development. Sometimes a film is uprated (exposed as if having a higher speed rating) and the resulting underexposure 'compensated' by prolonging development time. As the family of curves for developer A in Fig. 16.2 shows, density at the toe of the curve rises and the whole curve creeps to the left — both effectively increasing emulsion speed. But you can also see that this increase of development time has much greater effect at the top of the curve, building up density and contrast, as well as raising fog overall. It is these factors that limit the amount of compensation you can give. The situation is helped if the subject lighting contrast was low; and some emulsions are designed to respond more favourably to pushed development than the one shown here.

Agitation

Often overlooked or handled on a purely casual basis, agitation of the emulsion during development

- (a) influence the overall rate of development, and
- (b) influences the evenness of developer action.

The gelatin is rather like a sponge, soaking in developing agent from the solution. Unless the emulsion is moved within the solution developing agents within exposed areas quickly become exhausted. Similarly the bromide by-product, discharged from the gelatin as silver is formed, stays within the local area. Subject highlight areas of the negative soon cease to develop except where there is an adjacent shadow (unused developing agents here can diffuse to the highlight giving greater density along the border).

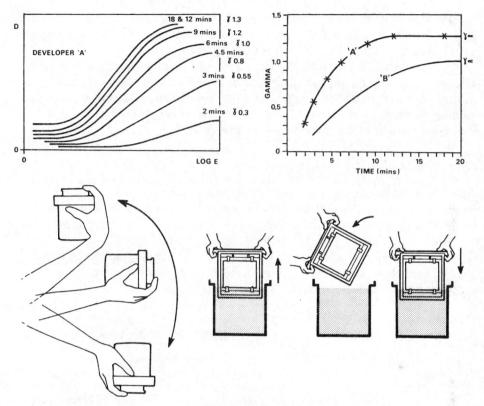

Fig. 16.2. Top left: Characteristic curves for an emulsion processed for a range of development times. (Right) The characteristic curve information plotted as a gamma/time curve; showing also the results of processing the same material in softer working developer 'B'. (Temperature, dilution and agitation conditions as stated.) Similar curves are published for C.I./Time, see Fig. 16.4, top. Bottom left: Routine for agitating a rollfilm tank not fitted with a spiral rotating rod. (Right) Basic agitation routine for a rack of sheet films in a deep tank.

If the film is standing upright in the developer, the discharging bromide, being denser than the developer, gently diffuses down the negative towards the tank bottom. Since bromide is a development restrainer, image areas over which it passes receive less development. The result is light toned 'streamers'. In all, then, lack of agitation gives under-developed, unevenly processed negatives which could be disastrous. Agitation is particularly important when developing very large format film, e.g. 10×8 in.

At the other extreme over-enthusiastic continuous agitation may also lead to uneven action, particularly if the negatives are clipped in hangers. Such a strong solution current is produced across the emulsion surface that the clips act as 'breakwaters' and give rise to 'flowmark' densities at negative corners. We therefore have to steer a middle course — above all remaining *consistent* in the agitation given.

Most recommended development times for specific gammas assume that if processing is carried out in a tank agitation will be 'intermittent'. This generally implies agitation of

the film hanger, plate rack, or roll film spiral for 5 sec about every one and a half minutes. If continuous agitation is given, as in dish development, overall developing time can be reduced by about 20% to give the same gamma.

Some deep tank units use a regular discharge of gas in bursts from the bottom of the developer tank. Nitrogen is generally chosen because it is photographically inert. Movement of bubbles agitates the solution. In automatic processing machines agitation is provided by the rotating action of transport rollers, recirculation pumps, or just the mechanical passage of the film through the developer.

Emulsion Type

For the same developing conditions, and assuming correct exposure, the amount of development received depends upon emulsion type. For instance, most fast emulsions are thickly coated and contain silver halides in a variety of sizes, including comparatively large crystals or grains. It takes time for developing agents to be fully absorbed within a thick emulsion, and longer for large light-struck grains to be fully reduced to silver than small light-struck grains. In general, then, the faster the emulsion the longer development must be to produce a similar gamma.

TABLE 16.2

DEVELOPMENT TIMES GIVING NEGATIVES WITH SIMILAR PRINTING CHARACTERISTICS

35 mm)	Pan X	Plus X	Tri X	Recording Film
D-76 (20°C)	5	$5\frac{1}{2}$	8	
Acuspeed (20°C)	$6\frac{1}{2}$	$7\frac{1}{2}$	9	15 mins

Conclusions on Development Controls

- (1) If we are to maintain any form of film-to-film consistency in development, or have any control over intended modifications, careful monitoring of development conditions, dilution, temperature, time of immersion and agitation is necessary.
- (2) Powerful developers, giving maximum emulsion contrast, are best handled in small, fresh, disposable quantities. Slow, long-life developers should have the total area of emulsion they have processed recorded and times gradually lengthened. Use appropriate replenishers for large tanks, where this is more economic than remixing.
- (3) If M.Q. developers are used in diluted form we must expect lower emulsion contrast and poorer solution-keeping properties.
- (4) Developer temperature has a decisive effect on the time needed to reach a certain gamma. Choice is limited by temperatures at which (a) developing times become inconveniently long, and some or all of the developing agents become practically inert, and (b) gelatin becomes dangerously soft and time is too short for even action. Between about 13°C-24°C temperatures can largely be compensated by

- time using time/temperature graphs or the 'temperature coefficient' of the developing agents.
- (5) Development time is directly related to gamma produced and shown on gamma/time (or contrast index/time) curves for an emulsion in various developers. Fast, thick emulsions need longer development to reach a set gamma.
- (6) Agitation is essential for even development redistributing fresh developer and diffusing away discharging bromide. Agitation technique is a compromise between over and under effects, and should be as rigorously applied as timing and temperature controls.

Development Technique

Note on allergies. Since it is impossible to process without coming into some physical contact with solutions it is fortunate that most photographic chemicals are reasonably harmless. Individual photographers, however, are allergic to metol, which can give rise to skin dermatitis of the hands. Should signs of irritation appear after first using a metol-containing developer, rubber gloves should in future be used for processing. When possible change to less toxic Phenidone (P.Q.) developers.

At all times avoid unnecessary immersion of hands in solutions – and of course make regular hand rinses to avoid chemical contamination of other solutions, slides, enlarger, etc. Use rubber gloves or try to postpone processing when the hands carry cuts or grazes. Acid fixer in particular causes unpleasant stings if allowed to enter such abrasions.

H AND PROCESSING – DISHES. Choice between dish and tank processing depends upon convenience and the type of developer. If flat film is only occasionally developed, or if a short-life developer is needed, dish processing is an obvious choice. A dilution and temperature should be chosen which will yield the required emulsion contrast within a reasonably short time (say 3–5 minutes) since you may be working in the dark for the whole period.

Development times for dish processing generally assume that continuous agitation will be given. Dish rocking should be both from side to side and to and fro without slopping too much solution into the sink. The emulsion is likely to receive more even initial penetration of developer if the solution contains a 'wetting agent'. This is a chemical used in very diluted form which lowers the 'surface tension' of the solution. (Household detergents are based on 'wetting agents'.) The solution will then not only spread more evenly over the emulsion, but there is less risk of air bells forming which create undeveloped spots on the negative. Most concentrated liquid and prepacked developing chemicals already contain wetting agents.

If several sheet films must be processed at one time and the dish holds a generous depth of solution sheets can be added to the developer one at a time on top of each other and gently 'shuffled' during development. However there is far less risk of damage if a tank is used.

HAND PROCESSING - TANKS. The two types of tank we are most likely to use are

the 13.5 litre ($3\frac{1}{2}$ U.S. gallon) deep tank (B in Fig. 16.3) which accepts sheet films in hangers and roll and 35 mm films in spirals, and small tanks, typically 300 cc, for individual films or spirals. Deep tanks are usually made of a suitably opaque PVC material in sets of three – for developer, stop bath and fixer. A floating lid rests on the surface of the developer tank to reduce oxidation; this is removed completely when processing is carried out. The main lid is loose fitting but light-tight so that white lights can be switched on to check time etc. once films are in the solution.

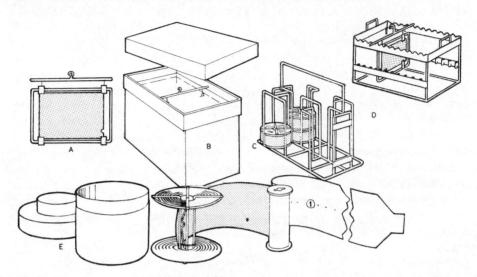

Fig. 16.3. Processing accessories. A: Clip hanger for a sheet film. B: Opaque PVC 13.5 litre processing tank. C: Rack for batch processing of roll and miniature film in spirals. D: Rack for processing several sheet films on hangers. E: Stainless steel rollfilm tank and spiral (note that film backing paper is removed when loading spiral).

In the dark, sheet films in clip hangers are either suspended individually from a ledge near the top of the developer tank, or are pre-loaded into a rack (see Fig. 16.3 D). The rack makes it much easier to agitate a batch of film without hangers falling to the bottom of the tank. Roll and 35 mm films are pre-loaded into plastic or stainless steel spiral grooved reels. These make the awkward long length of film much more compact to handle, yet presents the complete unobstructed emulsion surface to the action of the developer. Care and practice is needed to load spirals quickly in the dark, without kinking the film (which produces black crescent-shaped marks, Plate 69) or leaving one part of the coil in contact with another (gives undeveloped patches). Loaded spirals – both roll and 35 mm size – can be contained during processing in a stainless steel rack.

Most small tanks are designed to contain just one spiral, although multiple versions are made. Only one tank is needed because the tank lid contains a light trap through which the sequence of solutions can be poured in or out. Once the roll or 35 mm film on its spiral has been inserted and the lid closed all further processing can take place in white light.

Quick and even first application of developer is just as important as agitation. The rack of sheet or roll films is lowered smoothly into the deep tank of developer. Tapping the top part of the unit protruding from the solution helps dislodge any air-bells clinging to the emulsion. The whole rack is then lifted out and replaced 2–3 times during its first 15 seconds development. The lid – and lights – may then go on until agitation is next due, about $1-1\frac{1}{2}$ minutes later. In darkness again the rack is raised, tilted and reimmersed twice. This sequence is continued until the development time is complete, whereupon the rack is raised, drained for a few seconds and transferred to the next tank containing the stop bath.

In the case of small tanks some photographers prefer to insert the loaded spiral into the dry tank and then pre-soak the film by pouring in water plus wetting agent. Having agitated the spiral, the solution is left for a minute or so to swell the gelatin evenly, then poured away and replaced by developer. (N.B. Pre-soaking slightly alters rate of development, so minor adjustment to times may be needed.) The more usual routine is to have the tank body filled with developer at the correct temperature – then in darkness load the spiral and lower it into the tank, tapping it firmly on the bottom to dislodge air bells. Then the lid is fitted and all further operations continued in white light. Normally, continuous agitation is needed for the first 15 seconds, then for 5 seconds at about one-minute intervals. Most tank manufacturers recommend agitation by turning the whole tank over and back, taking about 2–3 seconds. Some tanks have a plastic agitator rod protruding through the lid – rotating this rotates the spiral. At the end of development time the developer is poured out and the next solution poured in.

MACHINE PROCESSING. Most black-and-white negative machine processors used in professional (as opposed to photo-finisher) darkrooms are of the roller transport type, e.g. Kodak Versamat. These use solutions at temperatures close to the maximum the emulsion will safely tolerate and produce dry-to-dry results in about three minutes. The machine is mounted in the darkroom wall so that individual sheet, roll and 35 mm films (the latter attached to leaders) are guided through a feed slot in the dark end of the machine and emerge ready for printing in the workroom next door. Development time is varied by increasing or slowing the motor speed. Replenishment of developer and fixer is automatic — triggered by each film — with the solutions feeding from large chemical tanks which need refilling every month or so. Although the capital cost of such machines is high they are extremely labour saving and consistent in quality.

Other machines such as drum discard types (e.g. the Colenta) designed for colour processing, are quite easy to re-programme for black-and-white negatives (see Advanced Photography page 328).

Reading Technical Data - Emulsion and Developer

By reading characteristic, gamma/time, and spectral sensitivity curves we can not only select suitable materials and appropriate development for different types of work, but (within limits) also produce similar results on different materials.

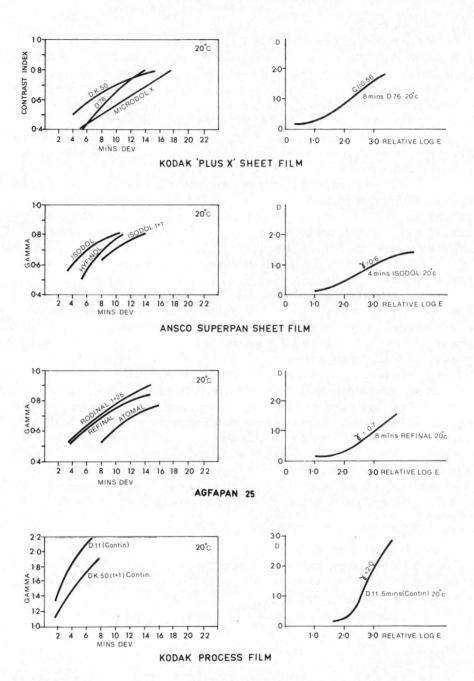

Fig. 16.4. Gamma/time, Contrast Index/time and characteristic curves for various emulsions. All curves assume intermittent agitation unless otherwise stated. (N.B. Characteristic curves should not be compared in terms of emulsion speed, owing to differing test criteria).

EXAMPLE: Referring to the Agfa and Ansco published curves (Fig. 16.4) we are photographing a building with an image brightness range of 50:1 (Log $1\cdot7$) on Agfapan 25. By exposing partly on the toe of the curve and developing to a gamma of $0\cdot7$ we produce a negative density range of $1\cdot1$, which prints successfully with proportional tonal gradation from highlights to shadows.

If the film were to be developed in a tank we might use Rodinal and give 8 minutes at 20° C with intermittent agitation. Alternatively, if the negative must be fine grained for high magnification enlargements, the slower working Atomal fine grain developer could be used for 13 minutes. If the same subject were shot on Ansco Superpan sheet film we could develop to a gamma of 0.7 in 6 minutes using Isodol at 20° C, or in $9\frac{1}{2}$ minutes using the same developer diluted 1 + 1. The latter would be more satisfactory for tank processing as the longer time lessens the risk of uneven development.

Cross-relating film and developers is made more difficult when one manufacturer publishes gamma/time curves, another \bar{G} /time, and yet another C.I./time curves. However, close examination of film characteristic curves in these cases will usually give enough information for working relationships to be established. Most developers by one manufacturer are suitable for another manufacturer's emulsions, with a few specialist exceptions. We should not however expect to find developer performance curves published for many such combinations.

Chapter Summary - Developers and Development

- (1) Development is an amplification of the latent image converting a few silver atoms into visible quantities of black metallic silver. The by-products of development are oxidised developing agents and soluble bromide.
- (2) A developing solution consists of a 'team' of chemicals: developing agents (metol, hydroquinone, Phenidone, etc.); alkali (borax, sodium carbonate, sodium hydroxide, etc.); preservatives (sodium sulphite, potassium metabisulphite) and restrainer (potassium bromide or proprietary 'improvers').
- (3) Increasing solution alkalinity, measured in pH values, increases developer activity but hastens aerial oxidation of developing agents. Preservatives help to inhibit growth of oxidation. Restrainers lower the effects of developing agents on unexposed halides.
- (4) M.Q. or P.Q. developer formulae utilise the superadditivity of pairs of developing agents. High contrast developers use hydroquinone developing agents accelerated by powerful hydroxide alkali.
- (5) The factors controlling the degree of development an emulsion receives are: Developer formula and condition; dilution; temperature; time; agitation; and the type of emulsion processed.
- (6) During use developing agents are oxidised, alkalinity drops, bromide increases and solution may be lost. Large tanks of expensive developer may justify 'replenishment' to keep the solution working at normal activity.

- (7) Increased dilution decreases maximum gamma, grain size and solution life; increases necessary development time.
- (8) Temperature affects the characteristics of developing solutions, emulsion vulnerability and speed of development. Within limits *temperature* can be compensated by *time*.
- (9) Increasing developing time raises emulsion gamma, fog level, and improves evenness of development. Relationship of time to emulsion contrast is shown on a 'gamma/time or contrast index/time curve'.
- (10) Regular, effective agitation is essential for even development action.
- (11) When tank processing adopt a strict routine to prevent airbells, and give consistent agitation. Short-life, high-contrast developer is normally used in dishes. Processing machines, although expensive, give fast through-put, reduce labour costs, and produce very consistent results.
- (12) Most manufacturers publish a range of gamma/time curves for a particular emulsion with different developers. Where several developers will yield the required gamma, choice can be based on grain size and timing convenience.
- (13) Develop to the most suitable gamma for your particular combination of subject, emulsion and required result. Although this must be partly based on experience, ability to draw information from published data curves is a useful guide, particularly when using a film or developer for the first time.

Questions

(1) (a) Rewrite the formulae given below to make 20 litres of each solution, placing the chemicals in the order in which they should be dissolved.

Developer	, , , , , ,	Replenisher	
Potassium bromide	4.0 gm	_	
Sodium carbonate (anhydrous)	48 gm	48 gm	
Sodium sulphite (anhydrous)	72 gm	72 gm	
Metol	2.2 gm	4.0 gm	
Hydroquinone	8.8 gm	16.0 gm	
Water to make	1,000 cc	1,000 cc	

- (b) Name the function in the developers of: Sodium carbonate, sodium sulphite, water.
- (c) What is the purpose of a replenisher and how is it used?
- (2) Sodium carbonate is supplied for photographic purposes in either the ANHYDROUS or the CRYSTALLINE form. What is the difference between these two forms?
 - What part does sodium carbonate play in an M.Q. developer?
- (3) You are required to process a batch of ten roll and 35 mm films in a 13.5 litre tank of P.Q. developer. How would you ensure that:
 - (a) airbells and uneven action was avoided,
 - (b) the temperature remained constant at 20°C?

- (4) Draw ONE of the following curves and give a brief explanation of its usefulness in practical photography:
 - (a) a characteristic curve,
 - (b) a gamma/time curve,
 - (c) a temperature/time curve.
- (5) A well-known developer has the following composition:

Hydroquinone	20 gm
Sodium sulphite (crystals)	20 gm
Caustic potash	20 gm
Potassium bromide	1 gm
Water up to	1,000 cc

Explain briefly the functions of each of the constituents and say whether you would expect the above to be a contrasty, normal or soft working developer. Explain why.

- (6) Explain briefly why an M.Q. developer:
 - (a) must be alkaline,
 - (b) must contain sodium sulphite,
 - (c) takes longer to develop a fast film than a fine-grain one.
- (7) (a) Explain why many M.Q. developers are made up as 'stock solutions'.
 - (b) What are the advantages (if any) of using Contrast Index rather than gamma to express the degree of development received by a negative?

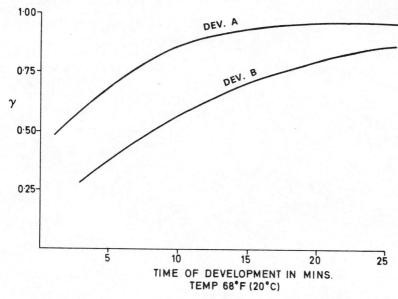

Fig. 16.5.

(8) Briefly explain the following terms applied to photographic processing:

Development Reducing agents and developing agents Superadditivity

Temperature coefficient

- (9) You are about to develop a correctly exposed film in fresh developer. List the main *processing* factors which will affect the contrast of the negative produced, together with a brief explanation of why the contrast should be affected.
- (10) Study Fig. 16.5 (previous page) and then answer these questions:
 - (a) Define gamma and explain the significance of this term.
 - (b) What developing time is required to give a gamma of 0.7 in each developer?
 - (c) If you required a gamma of 0.5 which developer would you use? Give a brief explanation for your answer.

XVII. FIXING, WASHING AND DRYING

Once developed, our negative is still far from being fully processed. As removed from the developing solution the emulsion contains:

- (1) a black metallic silver image;
- (2) silver halide grains which, having received insufficient light in the camera to be appreciably affected by the developer, still remain and give a strong creamy background to the image;
- (3) active developer still absorbed in the gelatin.

We cannot take the negative out into the light, for this would cause remaining grains to become developable, the developer in the emulsion then turning these black. Even with the developer washed from the gelatin the silver halide grains would in time darken into silver of their own accord. Then how can we make the image permanent?

Thinking back to the manufacture of light sensitive materials, we said that silver halide grains are insoluble in water. We cannot therefore remove them from our emulsion merely by washing. A chemical is needed which will 'fix' the negative in a permanent form by converting silver halide into soluble salts, which can then be dissolved away by washing. It must of course do this without appreciably affecting the developed silver image. One chemical is eminently suitable to perform this task — sodium thiosulphate. (In the earlier days of chemistry this was wrongly named 'sodium hyposulphite'. The name has been changed, but the abbreviation 'hypo' is still used.)

Dichroic Fog

A hypo (sodium thiosulphate) solution changes silver halide into a series of colourless, largely soluble salts known by the elaborate name of 'argentothiosulphates'. Imagine our negative in the fixing bath – slowly its creamy appearance changes as first the silver halide remaining in the image mid-tones, then the greater volume in the shadows, is converted to invisible soluble salts. These soluble salts begin to diffuse out of the emulsion. . . . And here we may find ourselves in trouble, for if any active developer is still present – either in the emulsion or contaminating the hypo solution – this may reduce the newly formed soluble salts to metallic silver, almost as though they were exposed silver halide.

Silver inadvertently formed in this way from the diffusing salts forms a uniform deposit over the whole gelatin surface. The 'scum' or 'fog' is of such finely divided metallic silver ('collodial silver') that the size of individual grains is close to the wavelength of visible light. This gives the negative an appearance which is slightly greenish by reflected light and purplish by transmitted light. The effect is therefore known as 'dichroic fog'.

Definition: 'Dichroic fog' - An overall deposit of collodial silver formed over an emul-

sion surface. It is due to the action of developing agents on soluble salts formed by a silver halide solvent such as hypo.

This fog or scum can often be wiped off the emulsion surface whilst still wet (at severe risk of negative damage). If allowed to dry in it becomes far more difficult to remove and prints very noticeably. Prevention is therefore better than cure, and the easiest way of stopping the formation of dichroic fog is to ensure that no active developing agents are present as the emulsion is fixed. With this need in mind we can now discuss stop baths and fixers in detail.

Stop-Baths

As the name implies, a stop-bath is a solution intended to stop development. The stop-bath can be used between developing and fixing, and in immediately halting development it serves four functions:

- (1) it allows exact control over the amount of development the film receives;
- (2) it prevents carry-over of active developing agents by the gelatin into the fixing bath, there risking the creation of dichroic fog.
- (3) in neutralising the carried-over alkaline developer it also preserves the life of the fixing bath (normally acid) and, in the case of hardening fixer, its hardening properties too.
- (4) it cushions the emulsion from too great a change in pH, which in extreme cases gives reticulation (page 315).

The simplest stop-bath of all is just a water rinse lasting 20—30 secs, which washes sufficient developer from the emulsion. Development is slowed rather than halted, but a water rinse is convenient and certainly better than no 'stop' at all. Water rinses are popular when processing printing papers, as the print can, if necessary, be returned from the rinse to the developer (to develop up areas which are too light and which the printer failed to control during exposure).

In negative processing, however, more rapid cessation of development is desirable and an 'acid' stop-bath is often used. You will remember that without 'acceleration' by the alkali, developing agents slow in their developing abilities from minutes to hours. In an acid solution most fail to act completely. Placing the developer-filled emulsion for 10 seconds or so in a suitable acid solution will thus neutralise developing agent activity, halting development and removing the possibility of dichroic fog in the following fixer.

The acid chosen must not, of course, be strong enough to bleach the silver-image, damage the gelatin, or later when carried into the fixing bath decompose the hypo. This rules out most strong mineral acids. Instead a weak (2—5%) solution of either acetic acid, citric acid, or potassium metabisulphite is commonly used. Some proprietary acid stop-baths contain an 'indicator' component which changes the solution colour (usually from yellow to reddish purple) when the stop-bath is becoming exhausted. An acid stop-bath is most valuable when using a rapid high alkalinity developer, as there is then greater risk of fixer-neutralisation, dichroic fog, and rapid staining through aerial oxidation of developing agents in the emulsion.

If films are placed in the stop-bath by mistake for the developer, they may be

b

NEGATIVE FAULTS IN SHOOTING

Plates 64-67

(a) Movement of subject.

(b) Movement of camera.

(c) Light fog (probably within the camera).

(d) Condensation on or within the camera lens.

С

NEGATIVE FAULTS IN PROCESSING

Plates 68-71

- (e) Uneven development of rollfilm. In top right corner emulsion was touching the adjacent turn of film in the processing spiral. (f) Black crescents caused by kinking rollfilm when loading spiral. Circular patches are dryingmarks. (Both shown here magnified \times 4) (g) Contamination of the emulsion—probably with hypo—prior to processing. (h) Melting of the emulsion by washing at a high temperature.

h

PRINTING FAULTS

Plates 72-77
(a) Satisfactory print.
(b) Light passed through unmasked negative rebates reflects as flare from the edges of the print masking easel.

Condensation or grease on the enlarginglens. Uneven illumination of the negative (condenser enlarger). Grit, etc., on the top surface of the enlarger condensers. Negative buckled in the carrier.

(c) (d) (e) (f)

PRINTING FAULTS

Plates 78-83

- (g) Uneven development.(h) Handled with fingers contaminated with fixer.

(i)

Excessive 'printing in'.
Shift of easel or enlarger between basic exposure and printing in (right half).
Abrasion of the emulsion surface. (j)

(k) (l)

Prolonged exposure to a safelight whilst partly covered by other sheets.

k

thoroughly washed (in the dark of course) and then processed normally. Providing the stop-bath was not contaminated with hypo the silver halides should have remained unaffected and freed from acid will develop as intended.

Fixing Baths

Definition: 'Fixation' – The action of changing undeveloped silver halide into soluble salts, later removed from the emulsion by washing. The fixing solution therefore renders the photographic image stable in white light.

To do this we can use thiosulphate in either:

- (1) 'plain' hypo,
- (2) acid fixer,
- (3) acid hardening fixer, or
- (4) rapid fixer forms.
- (1) PLAIN HYPO. A simple solution of between 20% and 40% crystaline sodium thiosulphate will form a 'plain' fixing bath. Solution strengths greater than 40% risk bleaching the silver image if the negative is left fixing for long, and later mean that extra washing is needed to rid the hypo from the emulsion. Strengths below 20% call for inconveniently long fixing times.

Whenever a plain hypo solution is used an acid stop-bath is *essential* – to prevent developer oxidation stains and dichroic fog. Usually it is far more convenient and safe to use a fixing bath which is itself acid.

(2) ACID FIXING SOLUTION. We have to take care in acidifying our fixing solution. The acid content should be sufficient to neutralise developing agents, yet not strong enough to bleach the silver image or decompose the sodium thiosulphate into sulphurous compounds.

Decomposition is less likely to occur if a weak sulphurous acid is present, formed (a) by a weak acid in the presence of sodium sulphite. Alternatively, (b) we can use a bisulphite alone to form weak sulphurous acid in solution. Taking (b) first, perhaps the most widely used acid hypo formula contains:

Sodium thiosulphate (crystals)	300 gm	(i.e., 30%)
Potassium metabisulphite		(,,
(or sodium bisulphite)	25 gm	(i.e., 2.5%)
Water to	1,000 cc	
(In solution the bisulphites form sulphure	ous acid and sodiu	ım sulphite.)

Hypo crystals require hot water for mixing, owing to their temperature-reducing 'water of crystallisation' content. Potassium metabisulphite however should be dissolved in *only warm* water. If mixed into the hot hypo solution there is a strong risk that it will decompose the sodium thiosulphite into strong sulphurous compounds (denoted by the solution turning milky). Normally, then, the hypo is dissolved in about half the final volume of hot water, and allowed to cool. The potassium metabisulphite, dissolved in a small quantity of warm water, is added only when both solutions are cool. Cold water is

then added to top up the mixture to the formulated volume.

Turning to formulae based on (a) above, acetic acid plus sodium sulphite forms a safe and efficient acidifier, viz.:

Sodium thiosulphite (crystals)	300 gm
Sodium sulphite (anhydrous)	10 gm
Acetic acid glacial	15 cc
Water to	1,000 cc

(The action of acetic acid on sodium sulphite is to form weak sulphurous acid.)
The hypo is dissolved in about half the final volume of hot water and allowed to cool.
Sodium sulphite is dissolved in some warm water, allowed to cool, and the acid slowly added whilst stirring. Finally the two parts of the solution are added and made up with cold water to final volume.

(3) ACID HARDENING FIXING SOLUTION. If it is anticipated that general handling conditions and/or wash water or drying temperatures are likely to be high enough to lead to gelatin damage, a gelatin hardener can be included in the fixing bath. Hardening agents – commonly chrome or potassium alum – combine with the gelatin, raising its melting temperature and increasing resistance to abrasion.

Chrome alum (purple crystals forming a blue-green solution) has rather greater hardening power than potassium alum, but loses these properties more rapidly. However, it can very conveniently be added to an existing metabisulphite acid fixing bath at the rate of 12 gm per 1,000 cc of fixer (162 gm for a 3-gal tank). Once added, the hardening properties of the combined solution slowly deteriorate, whether used or not, and become negligible after 2–3 days.

When a hardening acid fix is intended for use over a longer period than a few days, potassium alum (white crystals giving a colourless solution) is a more practical hardening agent. Potassium alum is most efficiently used added to a sodium sulphite/acetic acid fixer.

We now have a fairly complex solution in which the pH value is becoming critical—too much or too little acidity will affect the performance of different chemical components and even decompose the hypo. Since other solutions (stop-bath or developer) are constantly being carried over into the fixer, some form of 'buffer' chemical is necessary to help maintain constant pH over reasonably long periods of use. Hence, acid hardening fixing bath formulae usually have a five-part composition viz.:

Sodium thiosulphate (crystal)	250 gm	(Fixing agent)
Sodium sulphite (anhydrous)	15 gm)	(Sulphurous acid
Acetic acid glacial	17 cc }	forming components)
Boric acid (crystal)	7.5 gm	(pH 'buffer')
Potassium alum (crystal)	15.0 gm	(Hardening agent)
Water to	1,000 cc	

The solution is prepared in a similar manner to acetic acid fixing baths – the boric acid and potassium alum crystals being dissolved in with the non-hypo components.

Many photographers wishing to harden emulsions use proprietary concentrated

solutions of 'liquid hardener' or 'liquid acid hardener' which contain potassium alum. These can be conveniently added to dissolved sodium thiosulphate to form the required hardening acid fixing bath. Remember that the hardening action of this bath depends upon a steady pH — use of an acid stop bath to maintain fixer acidity is therefore advisable and worthwhile.

If it is necessary to harden the gelatin earlier than at the fixing stage a hardening stopbath consisting of chrome alum and sodium bisulphite can be used. Formalin (formaldehyde) is also a gelatin hardener. Since it hardens most efficiently in an alkaline solution it is useful for hardening *before* development when, say, tropical processing.

(4) RAPID FIXERS. Where speed of fixation is more important than cost of chemicals 20% ammonium thiosulphate can be used in place of 30% sodium thiosulphate. (Alternatively, it can be formed by adding ammonium chloride to normal fixers.) Most 'rapid fixers' are marketed as a concentrated liquid, since ammonium thiosulphate in dry chemical form has poor keeping properties. Emulsions should not be left in a rapid fixer longer than is necessary for fixing, otherwise these solutions quickly tend to bleach the silver image.

The keeping properties of the three types of fixer described above when stored unused at normal room temperature is in the order of one week (in dish), one month (in tank), or two months (in a stoppered bottle).

STABILISATION. An alternative to fixation, 'stabilisation' is the conversion of silver halides into colourless, fairly stable compounds which can be left saturating the emulsion. In this way washing is unnecessary. However, the image is not particularly permanent and retains a slight white deposit in the emulsion. Stabilisation processing therefore finds its main application in the production of white based prints, where speed and convenience are of greater importance than maximum permanence — although work can be re-fixed and washed later. A strong (35%) solution of ammonium thiocyanate makes an efficient stabiliser. See also page 346.

Fixing Time

Most negative emulsions are fully fixed in fresh acid hypo solution within about 5-10 minutes. As a guide many photographers leave the film in the solution for at least twice as long as the emulsion takes to lose its creamy appearance.

The factors which in practice affect the rate of fixation are: (a) The type of formula; (b) the exhaustion of the solution; (c) the temperature of the solution; (d) agitation; (e) the emulsion undergoing processing.

THE TYPE OF FORMULA – ammonium or sodium thiosulphate, and the actual hypo concentration – naturally influences fixing speed. The more chemicals in addition to hypo in a bath the longer fixation will take. Thiosulphate concentration can, within limits, be increased to hasten the process, but in solutions above 40% fixing rate shows very little improvement.

EXHAUSTION. Fixing solutions will not oxidise and can be stored, unused for long periods. Like developers, fixers become slower as they are used, but for rather different

chemical reasons. The more emulsion fixed, the greater the accumulation of soluble argentothiosulphates in the solution. In addition, iodide which is less easily broken down into argentothiosulphates than other halides, is accumulated from negative materials. Apart from this accumulation of silver salts the fixing agent itself slowly becomes exhausted. Carry over the solutions such as developer — particularly when no acid stop bath is used — also dilutes and reduces the acidity of the fixer.

The first sign of exhaustion is an appreciable increase in the time taken to clear the emulsion – in fact as a rough guide we should discard a fixer once film clearing time has increased to twice what is was when fresh. If we continue to use an exhausted solution the silver halide may still clear, given time, but the concentrated soluble silver salts will be difficult to wash out of the emulsion, with consequent risk of later staining.

Apart from timing the emulsion clearing period, fixing baths can be monitored by keeping records of the area of emulsion the solution has processed. As a guide, one litre of acid fixer should fix up to 1.25 sq m of negative emulsion; equal to 100 5-in \times 4-in or 30 35 mm or 120 rollfilms. It is also possible to check solution pH with an indicator paper sold for the purpose (most solutions should differ no more than 0.5 from their original pH when fresh).

We can establish whether the silver accumulating in the fixer is excessive by a simple chemical check: 1 cc of a 5% potassium iodide solution is added to 25 cc of the fixer solution. If the mixture turns cloudy, and does not clear with shaking, this will be a sign that sufficient silver exists in the fixer sample to form the insoluble silver halide silver iodide. The fixer can therefore be regarded as exhausted. A fixer should be discarded when its silver content is more than about 2 g per litre (films) or 6 g per litre (paper).

The life of a fixing bath can be prolonged by replenishment, bleeding off a predetermined amount of solution and replacing it with fresh fixer. However, calculation of correct replenishment rate is not easy because exhaustion varies with quantity, type, and even the level of exposure of the emulsion processed. Apart from users of automatic processing machines with film-activated replenishment systems, most photographers just discard the exhausted fixer — or they may decide to 'regenerate' it. This involves physical removal of the accumulated silver salts, and is most conveniently achieved by electrolytic methods. Two electrodes are lowered into the solution and a low current passed between them for a period of some 48 hours. The silver builds up as a grey scaling on the cathode electrode. From this it can be removed and sold for silver refining.

The regenerated fixer now requires the exhausted hypo and hardener content to be replaced, and to be given additional acid to bring the solution back to the required pH (usually about 5.0). The solution can then go back into use, virtually as a fresh fixer. (Silver can alternatively be subtracted from an exhausted fixer and sold for refining by adding chemicals – zinc or sulphide – which precipitate the silver as a thick sludge. This precipitation however, will permanently destroy the fixing properties of the solution.)

Equipment for electrolytic regeneration is relatively expensive, and the process is not economically justified unless large volumes (at least 50 litres) are regularly involved. Generally, then, we use a fixing bath until the time it takes to clear the emulsion

becomes inconveniently long - say twice as long as when new. The solution is then thrown away and more made up fresh.

FIXER TEMPERATURE. Fixation rate increases with increase of temperature, but in practice we are limited by risk of decomposition of the hypo into sulphur compounds by the acid content, and over-softening of emulsion gelatin. Where speed is essential it is more practical to change to a rapid fixing agent such as ammonium thiosulphate or thiocyanate with hardener, working at temperatures up to 50°C (122° F). This will fix in about 30 sec.

At the other end of the temperature scale, fixation with hypo becomes very prolonged as temperatures approach zero. Ammonium thiosulphate is a more practical fixing agent at such temperatures and will still fix within minutes. But wherever we have control over the temperature of our processing solutions, the fixer should be as closely matched to developer and stop bath as possible — preferably within about 3°C (5°F). This reduces expansion and contraction strains on the emulsion which in extreme cases gives a permanent net-like wrinkling of the emulsion surface known as 'reticulation' patterns.

AGITATION. Remembering that fixation relies on the entering of fixing agents into the gelatin and diffusion of soluble complexes away out of the emulsion, agitation materially hastens fixation. N.B. Normal photographic wetting agents are unsuitable for use in fixers.

THE EMULSION CONTENT. Although we vaguely talk of a 'sheet of film', the time an emulsion takes to fix must depend upon the volume of undeveloped silver halides it carries. Heavily exposed negatives such as line copies or subjects shot against light toned backgrounds will require a shorter period of fixing than negatives with little density. Thick fast emulsions contain more halides to fix than thin slow emulsions (including paper).

Fixing Technique

Basically the technique of fixing is no more than an extension of the disciplines of development. Provided the fixer is acid, any remaining traces of developer in the emulsion should be rapidly neutralised and white light can safely be switched on 1–2 minutes after the film enters the bath. Do not overlook the importance of occasional agitation (say every 1–2 minutes).

It is good practice to use *two* flixing solutions where practical; one actually clears the emulsion and a second, fresh fixer, with its lower concentration of silver salts, ensures fixation of any small residue of insoluble halides. The second fixing solution also more readily accepts soluble salts from the emulsion, so that less are left for removal in washing. Use the first bath until testing shows it to be exhausted, then discard it, replace with the second bath, and mix up a new second bath. Having done this for four successive new second baths both fixers are discarded and made up afresh. Two bath fixing is particularly valuable for prints. See pages 345–6.

Summarising the Main Points of Fixation

- (1) Our aim in fixing a negative is to make the image permanent by changing the remaining silver halide into soluble silver salts which can be removed by washing.
- (2) The fixing chemicals must not affect the developed silver image. Nor must active developer be present during fixation, as this may change the soluble silver formed into a scum of collodial silver or 'dichroic fog'.
- (3) The most efficient fixing agent is sodium thiosulphate (hypo). By acidifying the hypo any developer carried over in the emulsion is neutralised but the acid must not be strong enough to decompose the hypo or attack the image. Potassium metabisulphite or acetic acid with sodium sulphite are effective acidifiers.
- (4) If gelatin protection is desirable during later stages, the fixer may contain chrome alum (short life) or potassium alum hardening agents.
- (5) Timing for fixing usually 5–10 minutes will vary with formula, degree of exhaustion, temperature, agitation and the emulsion itself. In general, we should fix for twice the clearing time.

Washing

Our purpose here is to rid the gelatin of soluble silver salts and fixer ... leaving the black metallic silver image virtually alone in the gelatin of the emulsion. Unless this is done properly the following may happen:

- (1) Hypo left in the emulsion may decompose and react with the image, changing it into silver sulphide, and giving the image of a sepia-coloured or bleached appearance.
- (2) The residual soluble silver salts may decompose into silver sulphide, staining the emulsion yellow or brown particularly in highlight areas.

None of these effects are very welcome in a valuable negative (or worse still in the client's print) and it behoves us to find an effective method of emulsion washing. The trouble is that we are washing out *invisible* salts, and must therefore imagine what is going on.

It will assist us in this if we remember that all the unwanted by-products are heavier than water, and diffuse out of the gelatin like pigment from a sponge. Running a tap at full pressure, into an open roll film tank is, therefore, far less effective than leaving the film soaking and changing the water completely every few minutes. The first method may make more noise, but the salts we are trying to remove remain at the bottom of the tank undisturbed, whilst fresh water pours off the top (see Fig. 17.1).

An outlet at the bottom of the tank is needed, or a funnel to direct water down to the bottom and force diffused salts out at the tank top. Twenty minutes wash should then be sufficient. The 'frequent changes' system takes into account the need for gelatin to diffuse away its by-products. If the water is completely changed once every two minutes for, say, six changes, the emulsion will have steadily diluted its unwanted chemical contents to a harmless level. When several films must be washed simultaneously, ensure

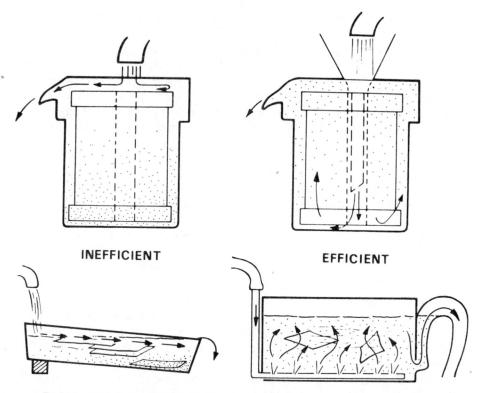

Fig. 17.1. Methods of washing (top) rollfilm, (bottom) prints. Bottom right: Syphon print washer.

that space permits ample diffusion between each film hanger or spiral. Some excellent syphon wash tanks are available which automatically drain and refill every few minutes. Look out for particles of rust, sand, algae etc. in the wash water which may settle on the emulsion, leaving blemishes. A water-filtering cartridge attached between tap and wash tank may be advisable. Note that extra washing time is needed when the water is at low temperature - at 5°C give 20% longer than at 20°C.

If time (and water) must be conserved, and maximum permanence is essential, the use of a clearing agent or hypo eliminator may be justified, see page 346.

Tests for Permanence

Two 'classic' methods of testing processed emulsion for permanence enable us to know (1) whether silver compounds still remain in the clear areas of gelatin, and (2) whether the wash water still carries hypo.

Test 1. A drop of 0.2% sodium sulphide solution is placed on the clear rebate of the dry emulsion. If the gelatin still contains silver, this will react to form yellow or brown silver sulphide. Any visible stain probably denotes that the fixer was becoming

exhausted. Alternatively, the time of fixation or efficiency of the washing system are at fault.

Test 2. A solution is made of 0.1% potassium permanganate and 0.2% sodium hydroxide. This is diluted further until it appears just pink, and is poured into two beakers. Drippings from the negative or print are added to one beaker and similar drippings of tap water into the other (as a 'control'). If colour disperses from the test solution in the first beaker more rapidly than the second this is probably because hypo is still present in emulsion and/or wash water. Washing should therefore be continued further.

Drying

The purpose of final drying is to 'set' the gelatin emulsion evenly, cleanly and within a reasonable period of time. Oddly enough, drying is responsible for more common negative faults among experienced photographers than any other process. This is probably because the photographer tends to relax at this stage of processing, under the false impression that all his worries are over.

WHAT TO AVOID. Common negative defects caused in drying are:

- (1) Dust and fluff settling on the emulsion and drying into the gelatin. This can often be removed by resoaking and sponging over the emulsion surface.
- (2) Water droplets causing patches of uneven density ('drying marks') lighter or darker than the adjacent image. This is due to uneven drying action and thought to result from differences in the packing of image grains at different rates of drying. Where a dry emulsion is splashed with water droplets, or left to dry with droplets on the face of the gelatin, these dry slowly from the edges and cause some silver density to be pulled from the centre towards the edge. This results in a light patch with darker boarders (see Fig. 17.2). Drying marks are most serious as they can very rarely be removed, although one should always try by thoroughly resoaking the negative.
- (3) White powdery deposit on the front or back surface of the material is often caused by lime ('hard water') in the wash. This can usually be removed by gently rubbing with a soft cloth, and prevented by fitting a water filter to the tap.

PRECAUTIONARY MEASURES. Bearing in mind the above hazards, negatives should always be dried in a dust-free atmosphere, preferably in a steady current of low-humidity air. Never hang up films in a living or reception area where carpets exude dust as people pass by. If a drying cabinet with heater and fan is used, its location must be chosen carefully. Most cabinets suck in air at floor level and will act like miniature vacuum cleaners if the floor is dusty.

Films and plates should not be placed in so close together that they dry more quickly at their edges than in central zones. But, if this is seen to be happening do *not* spread them out as the remaining damp areas will speed up their drying rate and leave marks. Note that Estar based film absorbs less water, and so dries faster than acetate film.

Perhaps the most valuable aid to efficient drying (ironically, in view of its name) is a wetting agent. A post-wash rinse in a solution containing wetting agent lowers surface

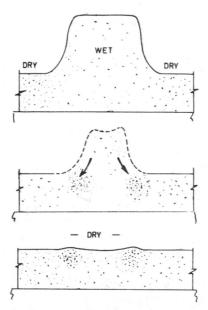

Fig. 17.2. Emulsion cross-section showing the formation of a 'drying mark'. A water droplet causes local swelling of the gelatin. Stresses set up in drying alter the packing of image grains, giving a light patch with dark surround in what was previously even density (see Plate 69).

tension and reduces the risk of water drying in droplets on the film. If a sheet film has been dried in its processing hanger we should be careful in releasing corner slips – these can sometimes harbour droplets of water which may run over the emulsion surface. If a rapid drying is essential for say, press photography, negatives can be soaked in 60% industrial alcohol or methylated spirits. They will then quickly dry in a current of warm air.

Cleaning Up

DISH CLEANING. Dishes, tanks and solution bottles – particularly those used for developers – accumulate brown or black stain. The discoloration is generally caused by oxidised developing agents, silver, and lime deposit from hard water. A very convenient solution for stain removal consists of:

Potassium permanganate (or potassium bichromate)	25	gr
Sulphuric acid (concentrated)	5	cc
Water to	1,000	сс
(N.D. TI :1 . C . 1 . 1		

(N.B. The acid must of course be added to the water.)

The container being cleaned is then rinsed, and flushed with a little fresh acid fixer or 2% potassium metabisulphite solution. Stains on fingers can be removed either with this cleaner or with a little citric acid (lemon juice).

Always take care when disposing of processing chemicals, bleachers, cleaning solutions etc. If flushed down the drain they should be well diluted with water. In the case of highly corrosive or toxic chemicals or the regular disposal of large quantities of any processing solution you may have to obtain the advice of the local authorities before using the public sewer. Most film manufacturers offer an advisory service. Always consider the possibility of regeneration of solution, e.g. silver extraction from used fixer.

Negative Faults

At this stage we can most easily evaluate our processed negative and hold an inquest on its deficiencies (if any). The number of faults – both from operating and processing – that a negative can carry is extremely discouraging. In fact, when we come to list them all and their infinite permutations it seems a miracle that useful negatives are ever produced. Yet the professional must always produce predictable technical results.

Disciplines and controls are not, therefore, just academic rules to be given lip-service, but vital bread-and-butter needs. By all means break technical rules to get effects — but unless you have have the basic discipline needed to consistently carry out straight negative making first, your more original results will never be fully under control.

Some negative faults have already been illustrated when we discussed camera movements (plates 17–31) and sensitometry (plates 51–56). Other common operating and processing faults are shown as plates 64–71, insofar as they can be reproduced on the white paper base of the page instead of on a transparent support. Some *print* faults appear as plates 72–83.

Apart from under or over exposure or development, negatives are most often spoilt

by:

- (1) Unintentional unsharpness.
- (2) Light fog.
- (3) Uneven density caused in processing.

To help localise sources of trouble the most likely causes of these faults are as listed below:

- (1) Unsharpness.
 - (a) Camera shake.
 - (b) Subject movement.
 - (c) Insufficient depth of field.
 - (d) Inaccurate scale focusing.
 - (e) Rangefinder incorrectly coupled, or SLR mirror out of true.
 - (f) Camera back or movements shifted when the film holder was inserted.
 - (g) Grease, condensation or dust on the lens.
 - (h) Film did not exactly register with the plane of the focusing screen.
- (2) LIGHT FOG. (The condition of the normally clear 'rebate' bordering the negative is an important clue in deciding whether fogging occurred in camera, or in darkroom).

- (a) Light-leak into the sheet film holder or camera back.
- (b) Hole in the bellows or lens panel (rebate unaffected).
- (c) Light-leak between the filmholder and back of viewcamera (rebate unaffected).
- (d) Lens flare (rebate unaffected).
- (e) Irradiation (rebate unaffected).
- (f) Unsafe safelight (rebate affected).
 - Wrong colour.
 - Too bright.
 - Too near.
 - Leaking white light.
- (3) Uneven density in processing.
 - (a) Emulsion contaminated with grease, hypo, developer, chemical particles, or water.
 - (b) Contaminated dishes or solutions.
 - (c) Insufficient developing or fixing solution.
 - (d) Insufficient agitation of developer.
 - (e) Exhausted developer or fixer.
 - (f) Development time too short.
 - (g) Emulsions stuck together.
 - (h) Air bells.
 - (i) Undissolved chemical particles in solution.
 - (i) Uneven drying.

Negative Filing

Not only can negatives suffer damage when dry, but in a busy studio numbers quickly grow out of hand. The sooner a negative can be enclosed in a negative bag and allocated a reference number the safer for all concerned.

Studios and departments all have their own filing methods, but most keep sheet films and plates in individual bags, stored upright in some form of filing cabinets. Roll films and 35-mm films may be cut into convenient strips – say 3 and 6 negatives respectively – and kept in folders or albums. Write the reference number in ink on the actual negative rebate as well as on the bag or album leaf. This number then appears automatically on contact prints, and corresponds with an entry in negative register, where work is either listed by date, subject or client. See *Professional Photography*, Chapter VIII.

Where time and type of work justifies, it is very useful to make and file contact prints from all negatives as a matter of routine. Such a file is helpful when searching for past photographs reordered on description alone.

Special Processes

There are many special black and white processes which are well beyond the scope of

this first-year book. Two, however, seem to break the rules of processing so that an outline explanation here would be helpful. One is 'monobath' processing and the other the 'instant picture' (e.g. Polaroid) process.

Monobaths. Single solutions combining the properties of a developer and a fixer. Formulation is critical, and often contains a P.Q. highly alkali developer and sodium thiosulphate. The monobath has to be so adjusted that the developer is powerful enough to predominate, the fixer having a long induction period and taking precedence only when the required gamma has been reached. Monobaths must also be balanced to remain stable in storage and re-use, and must not give rise to dichroic fog. The film is simply placed in the solution and regularly agitated until fully processed about six minutes later.

Apart from simplified processing advantages, it is impossible to overdevelop, and temperature is relatively unimportant (between 18°C (65°F) and 24°C (75°F), increase in developer activity is matched by increase of fixation). The disadvantages: fixed gamma according to the combination of solution and emulsion used; the monobath may not be satisfactory with all emulsions; production of grain which is not particularly fine; and increased cost. Monobaths are used in a few special purpose automatic processing systems, but most commercial photographers prefer the gamma flexibility offered by conventional developers for the variety of subject brightness ranges they can encounter in their work record.

Instant picture process. A 'diffusion transfer' process, which in effect utilises a highly controlled form of dichroic fog to give both a negative and a positive image in one short processing step. In the Polaroid version the emulsion, after being exposed to the camera image, is squeegeed face-to-face with a sheet of gelatin-coated white paper inside the camera or film pack. During this squeegeeing a pod of chemical in viscous (rather like 'Vaseline') form is broken and spread between the two surfaces. The pod contains a highly alkali developer and a fixing agent, which now develop the black silver negative and dissolve unexposed halides respectively.

The soluble silver salts so released diffuse to the blank white paper base, together with developer which changes them to black silver. (The paper contains trace chemicals to encourage anchorage.) After a few seconds print and negative are peeled apart. If the negative is designed to be reclaimable, it may be placed in a weak alkaline solution to remove its anti halation backing and allow viscous chemicals to be sponged from the emulsion.

Uses of instant picture sheet films include exposure checks before photographing on expensive colour materials, or when shooting subjects too small for reliable meter readings. It is also useful whenever the client must have one print urgently, or where the photographer wishes to check his lighting balance. When non-photographic personnel are working on location (i.e. scientists, metallurgists etc.) this process allows the user to check immediately the technical quality of his results, reshooting until satisfied. At present cost per exposure limits the application of the process. Polaroid black-and-white and colour materials are discussed further in *Advanced Photography*, Chapters 9 and 12.

Chapter Summary - Fixing, Washing and Drying

- (1) Following development, the remaining unwanted silver halide must be removed, preferably by converting it to a soluble form, to be dissolved away by washing. Once this is done, the image carrying emulsion will then be 'fixed' permanently.
- (2) The most convenient fixing agent is sodium thiosulphate (hypo) which changes silver halide into soluble argentothiosulphate complexes.
- (3) If active developer is present in an excess of hypo it may reduce these complexes into a collodial silver, settling on the emulsion as 'dichroic fog'.
- (4) An intermediate acid stop-bath serves the twin purpose of accurately halting development and preventing fixer contamination, with its attendant risk of dichroic fog.
- (5) Hypo, most efficient as a fixer at a solution concentration of about 30%, is conveniently used in a weak acid solution to neutralise developer. Weak sulphurous acid is formed by either potassium metabisulphite, or acetic acid plus sodium sulphite. When mixing, hypo should be dissolved separately to other components and the two component solutions combined when cool to form the fixer.
- (6) The addition of a hardening agent (alum) gives some protection to the gelatin from subsequent temperatures or abrasions. Potassium alum offers the best working life, added to a sulphite/acetic acid fixer, plus boric acid pH 'buffer'.
- (7) Stabilisation, the faster alternative to fixing, converts silver halides into compounds which remain in the emulsion. Washing is unnecessary but permanence is reduced.
- (8) Fixing time (normally double the 'clearing time') depends upon formula and state of solution, temperature, agitation and the amount of silver halide in an emulsion to be fixed.
- (9) As the fixer is used it accumulates soluble silver salts, loses fixing agents and acidity. Emulsions fixed in exhausted solution may still contain soluble silver salts. The soluble silver content of a fixer can be checked with iodine; it can be removed by electrolysis.
- (10) Fastest fixing is possible with ammonium thiosulphate at temperatures just below sulphurisation, with vigorous agitation.
- (11) Washing is a diffusion of heaver-than water salts from the gelatin. Regular changes of still water may be more effective than poorly applied deluges. Image permanence can be monitored by checking both the silver content of clear emulsion areas (sulphide test), and residual hypo (permanganate colour change).
- (12) Drying demands particular care to avoid dust, uneven drying marks and scum. Irremovable drying marks are best avoided by use of a wetting agent and maintenance of a *steady rate* of drying.
- (13) Overall processing demands discipline and care if we are to get predictable results and minimum failure through negative faults. Discipline includes finishing the job by container cleaning and negative filing.

Questions

- (1) Describe the process of fixation. Explain why potassium metabisulphite is sometimes added to the fixing bath.
- (2) When using a field camera for outdoor photography, a number of factors other than inaccurate focusing can contribute to unsharpness in a negative. Name four such possible causes.
- (3) What is understood by the following photographic terms:
 - (a) latent image,
 - (b) drying marks,
 - (c) floating lid,
 - (d) stop bath with indicator,
 - (e) reticulation.
- (4) Following the progress of an imaginary sheet of film, outline the changes which will occur in its emulsion at each processing stage between camera exposure and final negative filing.
- (5) Name the chemicals (not the quantities) and method of compounding an acid hardening fixing bath using potassium alum as the hardening agent.
- (6) Explain briefly why:
 - (a) fixing baths should normally be acid,
 - (b) it is advisable to use two fixing baths,
 - (c) a fixing bath acidified with acetic acid must also contain sodium sulphite.
- (7) Describe the appearance of negatives which have been:
 - (a) developed in a tank without proper agitation,
 - (b) fixed in a stale fixing bath,
 - (c) underexposed and overdeveloped,
 - (d) handled before development with fingers contaminated with hypo.
- (8) Why is efficient washing of negative material essential? How would you achieve efficient washing of a dozen 4 × 5 in negatives, and how would you test that the washing had been adequate?
- (9) Negatives are frequently spoiled during the drying process. List the possible faults together with the steps necessary to avoid them.
- (10) Describe ONE photographic use of each of the following chemicals:
 - (a) potassium bromide,
 - (b) silver nitrate,
 - (c) potassium permanganate,
 - (d) potassium alum,
 - (e) sodium thiosulphate.

XVIII. PRINTING AND FINISHING

However successful or otherwise our negative may be, it is the *print* which the client normally receives and upon which he judges results. The printing and finishing stages of the photographic process are therefore as equally important as negative technique. A good print cannot be made from a bad negative, but far too many inferior prints are produced from good negatives — one reason why photographers take good care to employ skilled printers.

Basically the printing process is the creation of a photographic image on an opaque base (generally by contact or enlargement from a negative). We shall also look at the preparation of positive images on transparent bases - i.e., black and white transparencies. As with negative making, we shall use a silver halide emulsion, exposing it to an image (normally the negative), and develop, fix and wash the result. There are, however, slight differences all along the line in the type and practical performance of the emulsions and processing solutions used. We shall also have to look carefully at the way enlarger construction influences results.

Starting with a newly dried negative, then, this chapter takes us through the final stages of basic technique before our photographs burst upon a waiting public.

Factors Controlling Final Print Quality

The six main factors controlling print quality are:

- (1) The quality of the negative condition, tone separation, graininess, size.
- (2) The printing material image colour and contrast, and the base upon which it is coated.
- (3) The optical arrangements for printing.
- (4) The overall and local control of exposure.
- (5) The type and degree of development.
- (6) The ultimate conditions under which prints are presented and viewed.

Preparation of Negatives

An ideal negative should need no preparation at all before printing. The photographer should be able so to visualise and prepare his optical image in the camera that the remaining photographic process is a routine. But this is seldom the case.

For no fault of our own we may be forced to shoot subjects which are not ideally prepared in terms of background, lighting and actual conditions. We may need image modifications such as alterations to proportions and size, change of tone contrast, and darkening or lightening of local areas. These are more easily handled in the printing than camera operating steps of photography.

Work on the actual dry negative is one means of making some of these modifications. Techniques include spotting, blocking out and masking.

CLEANING AND SPOTTING. The humblest form of negative preparation is the removal of any hard water scum marks from the back of the film or plate, by gentle rubbing. This should preferably be done with a cloth soaked in carbon tetrachloride, or an 'anti-static' cloth, which will not create a static charge and thereby attract dust on to the surface.

If necessary clear or opaque specks in the image (probably caused by dust before exposure or during drying respectively) can now be repaired by spotting in with dye or watercolour, or removed with a retouching blade. The advantage of doing this on the negative is that when numerous prints are required it will otherwise be necessary to spend hours retouching each one. On the other hand, faulty retouching (particularly knifing) may do irretrievable damage to the negative and will be impractical if the negative is smaller than about 4×5 in. Most photographers with limited retouching skill prefer to 'spot in' clear specks black, so that they print white and be spotted on the print itself.

Spotting is undertaken with a fine-pointed sable brush using diluted black water colour or water soluble retouching dye. Large dust specks are matched into surrounding density with tiny closely grouped specks of grey pigment or several washes of diluted dye applied to the required emulsion area. If too much dye or pigment is applied all can be washed off again by soaking the negative.

The spotting of high contrast line negatives which contain only black and white tones can be much more crudely handled. Instead of dye, concentrated pigment or liquid opaque (as used for blocking out) is used to 'patch' clear specks.

Undesirable wrinkles in portraits, creases in backgrounds, and surface defects in products, frequently record as light-toned lines on the negative. They may be camouflaged with gentle pencil strokes on the emulsion surface. However, there is a limit beyond which the emulsion will not accept pencil, as the surface grows too shiny. A matt varnish or 'retouching medium' rubbed over the whole negative surface increases the amount of pencilling which can be given. At any time varnish and pencil can be removed with petrol.

Bear in mind that at best retouching is *emergency treatment*. That background stain, that lighting cable left in the picture area, the shadows left by debris in the film holder, could all have been avoided by proper visual consideration of the subject, and efficient working. There is something wrong with the photographer who spends half his time retouching his negatives . . .

BLOCKING OUT AND MASKING. Record pictures of equipment for catalogue illustration or sales representatives' albums may be required to show the item objectively against a plain white shadowless background. Where this cannot be conveniently arranged in the studio it may be photographed in any location, later to have the background erased from the negative.

To do this a dense red pigment blocking out opaque is painted over all background areas of the emulsion. Particular care is taken to accurately follow the edges of the sub-

ject. When printed, the opaque prevents light passing through background areas of the negative and the resulting print shows the subject against pure white paper. The technique is useful whenever strong tonal separation is desirable, when shooting fixed machinery in unattractive surroundings or when subjects must be supported on strings or obvious packing (see Plate 85).

Blocking out demands considerable brush skill, a large format negative and a reasonably simple subject outline. Straight line edges can be blocked out with red transparent tape. Camera viewpoint should be chosen with the needs of blocking out in mind — preferably showing the simplest subject outline. Another way of working is to make a large print and either cut out the subject and mount it against a white background or bleach out background areas; the result is then copied.

When *complete* loss of background is undesirable the negative may be 'selectively masked' to give a 'ghosted' background, by proceeding as follows:

- (a) The actual subject is blocked out on the negative, leaving the background unaffected.
- (b) A weak positive transparency is made by printing on to another sheet of film in contact with the negative. This positive is underexposed and underdeveloped.
- (c) The blocking out is washed off the original negative, and dry negative and positive combined.

Since the positive only carries background detail it now 'masks' the background areas of the negative, making them denser and less contrasty. The combination yields a print in which the subject appears with full density and contrast, against a pale low-contrast background – similar to a background which has been sprayed over with grey water colour (see Plate 86).

Light Sensitive Printing Materials

Since we are printing from black and white negatives there is little reason why our printing emulsion should be other than blue sensitive. On the contrary, non-sensitivity to yellow and red enables us to handle most sensitised paper and print film materials under orange safelights. Other characteristics of printing materials that concern us because they effect final print quality are: (1) Image colour; (2) emulsion contrast; (3) paper surface and base.

Image 'Colour'

Image tone or 'colour' is obviously more important with printing materials than negative emulsions. The reason for the exact tone of black formed is linked with speed. Both depend on grain size.

CONTACT PAPERS. Printing papers coated with extremely fine grained silver chloride are very slow in speed, and would develop to give finely divided metallic silver images of brownish black appearance. However, certain 'bluing agents' are added to give the more acceptable and familiar blue-black image which characterises contact

prints from developing and printing laboratories.

Chloride or Contact Paper is popular in mass printing laboratories and is fully developed in about 45 sec in 20°C (68°F) M.Q. developers. Such paper is printed emulsion-to-emulsion in contact with the negative, the two being sandwiched between a pressure pad and glass panel behind which a white light is located. The extremely low speed of contact paper is no inconvenience, as the printer light is quite bright. Bright yellow safelighting can be used in the darkroom.

Bromide papers. Papers coated with silver bromide halide are some one hundred times faster than contact papers. They are, therefore, more suitable for recording the dimmer image protected by an enlarger, and are the materials most often used for professional photography. Bromide papers develop in about 2 min at 20°C (68°F) in M.Q. or P.Q. developer solutions, giving a neutral black image when fully processed.

N.B. Although the silver halide grains in bromide paper emulsions are larger in size than those in contact paper emulsions, they are still appreciably finer and more thinly coated than the silver halide grains in fast negative emulsions. Any grainy appearance in a print may be *emphasised* by the *contrast* of the printing paper, but is still essentially the grain of the negative.

Chlorobromide papers. Papers containing both silver chloride and silver bromide share characteristics between the two. Exact proportions of the two silver halides vary with proprietary products ('Bromesko', 'Record', 'Kentona', etc.). In general, chlorobromide papers are rather slower than bromide papers and give a warmer, rather browner black, which is much influenced by development. Since the silver chloride content develops more rapidly than silver bromide, development in dilute or highly restrained solutions give warmer image blacks than more active developer. More care is needed to match the colour of prints batch-to-batch, but these 'warm toned' papers are popular amongst a few professionals for commercial photography, and exhibition work.

Despite their slow silver chloride content the presence of silver bromide content demands orange safelighting. Some chlorobromide papers are slightly sensitised to green light to increase their overall speed. It is therefore important that safelights should measure up to the paper manufacturer's recommendation in terms of wattage and distance.

LITH PAPERS. Bromide papers with an extremely high contrast emulsion really intended for photo-lithography but able to give interesting visual results ranging from pale straw yellow, through brown, to intense black depending upon the degree of development given (see page 343). Lith paper, e.g. Kodalith, has orthochromatic sensitivity to improve its speed and so must be handled under *deep red* safelighting. (This of course is also safe for bromide and chlorobromide papers). Special lith developer should be used but all other processing stages are as normal.

Transparency materials. Monochrome transparencies for projection as visual aids etc. are made by contact or reduction printing through the enlarger. The image is printed on to 35 mm film coated with bromide emulsion and handled just like printing paper (e.g. Kodak Fine Grain Positive Film). Similarly, blue sensitive 5×4 in sheet film

such as Kodak Process film can be used and the tiny image later cut from the film. Results are mounted in 5 cm square colour transparency frames. Some firms still market 5 cm square bromide lantern plates for making projection transparencies. Rolls and large sheets of the above films are available for making large display transparencies — either for direct display or use in an overhead projector. (See also note on tone range, page 352).

Emulsion Contrast

Whatever the emulsion used, each paper (except lith) is made in a range of separate emulsion contrasts designated by a 'grade' number and description in terms of 'hard' or 'soft'. Glossy bromide paper, for instance, is available as Grade 1 (soft); Grade 2 (normal); Grade 3 (hard); and Grade 4 (very hard).

The purpose of these grades is to allow us to compensate for high or low density range negatives. Thus a *contrasty* continuous-tone negative might more acceptably represent the original subject when printed on Grade 1 paper. This would give a similar result to a *low* density range negative printed on Grade 3. As an approximate guide, using a diffuser enlarger, a negative with a density range between 10:1 and 30:1 will print satisfactorily on Grade 2 paper. However in practice choice of grade is mostly a subjective decision, and depends on the effect we are seeking and the actual subject itself. Sometimes an image looks much more powerful when contrast is exaggerated on very hard paper.

Some popular papers for enlarging are made in five or six contrast grades. Note that each grade number relates to its own manufacturer's printing products but seldom matches exactly the gradings of other manufacturers. Grade 2 of maker X may in fact be similar in contrast to Grade 3 of maker Z. Lith paper is made in only one grade of contrast.

Characteristic curves for printing papers are prepared and published in a similar form to negative emulsions. A controlled series of light dosages is given through a step wedge, the processed results measured with a reflection densitometer, and density plotted against exposure. Characteristic curves for four grades of the same make of glossy bromide paper (Fig. 18.1) shows that:

- (a) All four grades give virtually the same black and same (fog-free) white.
- (b) As negative density range (which is 'subject brightness range' to the paper) becomes greater, a softer grade of paper is needed to reproduce all the original subject tones as separate print tones between black and white.
- (c) All the curves are more 'S shaped' and have less straight line portion than the characteristic curves of negative materials. Negative densities (representing subject shadows) falling near the top of a paper curve print with greater contrast than other densities. This has the effect of counteracting the slight shadow tone compression caused when we give minimum acceptable exposure in the camera (see page 238).
- (d) A good high contrast negative should print well on any grade. Here we are not in-

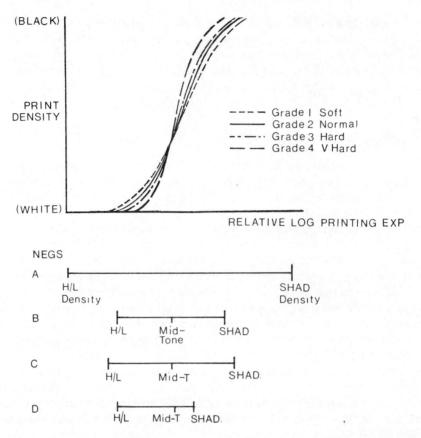

Fig. 18.1. Characteristic curves of four grades of glossy bromide paper. Below: Density ranges of four negatives relative to paper curves. A: A high contrast line negative will print with dense blacks and clear whites on all grades. B: A 'normal' contrast negative, prints with full tone gradation on grade 2 paper. Note that mid-tone to shadows correspond to the steepest part of paper curve. C: A contrasty continuous tone negative requiring grade 1 paper. D: An underexposed negative. Printed on grade 4 as shown, mid-tones to shadows receive maximum contrast increase, but highlights will appear 'burnt out'. This negative will not print with full tone range on any grade. (Curves relate to liftord paper, which has matched speed throughout all grades.)

terested in intermediate tones and only require dense black and pure white; our line negative should have such an extensive density range that subject shadows and highlights will reproduce well over the maximum density and under the minimum density of all paper curves.

(e) Should our negative be extensively underexposed or overexposed we cannot produce a full-tone-range print on any grade. This is because negative densities no longer 'fit' any paper characteristic curve. It will probably be found that one grade is required for say, shadow densities, and another grade for other tones. N.B. Some manufacturer's hardest paper grades are slightly slower than their other grades. Therefore when changing to a paper of highest contrast printing exposure time must be increased.

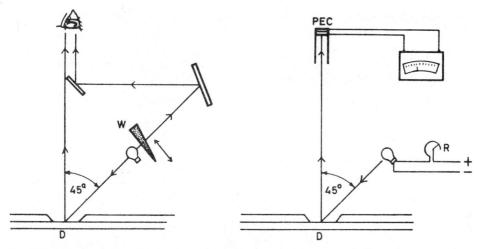

Fig. 18.2. Reflection densitometers. Left: Visual densitometer. Light is reflected at 45° from the print density under measurement (D) and compared with light transmitted through a movable step wedge (W). Right: Photoelectric densitometer. The 45° lamp is first adjusted via rheostat (R) until the meter reads a set 'zero' on the white print base. Measurements of image densities are then made from the meter dial.

VARIABLE CONTRAST PAPER. One ingenious solution to the need to stock various grades of paper is variable contrast bromide paper marketed in some countries. Typically this is coated with a mixture of a low contrast emulsion sensitive to green and a higher contrast emulsion sensitive to blue-violet. By printing through one of a range of pale yellow or violet filters the paper can be made to give the same effect as a range of contrast grades. Moreover we can expose most of the print through one filter and then locally print-in, say, a highlight area through another filter giving harder contrast. In practice many professionals find this filter manipulation time-consuming and prefer to stock graded papers.

Base and Surface Texture.

As outlined on page 170, most of the commonly used printing papers are now manufactured with either paper or plastic-coated paper bases. This difference has a more marked effect upon their processing characteristics than their visual appearance and the following comments therefore apply to both types unless otherwise stated.

Both base colour and surface finish have important limiting effects on the range of tones we can expect to produce on printing papers. The tonal extremes are limited at one end of the scale by density of deepest black and at the other by the whiteness of the paper base. Consider first the brightness of highlights. Several kinds of bromide paper are available with cream or ivory base tints, as well as white. Cream tinted paper cannot reflect as much incident light as ivory, not ivory as much as white. Consequently the brightest highlight reproduction on cream based paper has a density equivalent to a pale grey on white paper. This is even more extreme on those bromide papers (e.g. Kentint,

Autone etc.) manufactured with base tints in bright green, red, silver, and gold, as used occasionally for posters and other display work.

The blackness of the deepest possible image shadow is greatly influenced by the printing paper's surface, being greatest with a glossy surface and least dense with a matt surface. The reason for this is shown in Fig. 18.3. Light is specularly reflected from a

Fig. 18.3. Characteristic curves of grade 2 glossy, semi matt, and matt bromide paper. Below: Specular and diffuse reflection — a limiting influence on maximum black.

smooth glossy surface in one direction, according to the angle of incidence. When looking at the finished print we naturally avoid the one viewing position which gives us a glare spot. Seen from all other angles the black parts of the image reflect very little light to the eye and so appear very dense. Matt surfaced papers however diffusely reflect light in all directions. There are no glare spots, but from every viewing position *some* light is seen diffusely reflected from black areas. Matt paper is therefore unable to form densities beyond a dark grey, whereas glossy paper can create several extra separable tones between this grey and its own maximum black (see curves). Semi-matt surfaces such as 'fine lustre', 'velvet stipple' etc have an intermediate effect.

A combination of white base and glossy surface therefore gives us the highest overall 'tonal staircase' we can expect on a paper print. The actual separation of grey tones (the 'height' of each tonal step) between these maximum and minimum densities is controlled by contrast grade. A great deal of commercial photography is intended for final reproduction in publications, and the extra separable tones in picture shadows and highlights given by white glossy paper helps the blockmaker and printer produce highest quality results. Similarly this is a good choice of paper for objective record photographs, where maximum detail and subtle tone reproduction is important.

Glossy plastic-coated base papers dry naturally with a highly reflective surface finish; paper based glossy papers give a full gloss only if glazed by drying in contact with a polished surface, explained on page 347. Many other paper surfaces and base tints are marketed — most manufacturers have sample book of prints made on each type. Cream or ivory tinted papers may help contribute to a visual impression of warmth or sunniness in certain portraits. The grey blacks of matt paper are helpful in misty, gentle, atmospheric pictures. A textured paper offers some camouflage to coarse image grain on the negative or — more blatantly — might be chosen to make the picture less like a bromide print, more like a painting, or show card . . . or whatever. We should not however use strong, regularly textured paper for prints intended for reproduction. The surface pattern interferes with the process of blockmaking and the work will probably be returned for reprinting on glossy paper.

Used with restraint other permutations of emulsion, surface and tint can usefully reinforce mood, but are all too often used to patch up unimaginative photographs. Some print surfaces, in particular, are so assertive that – like the use of vivid writing ink – results have a 'gimmick' quality which can sour into affection.

Apart from colour, the base *thickness* of non-plastic-coated papers ranges from 'air mail' (a thin paper of light weight) through 'single weight' to 'double weight', which is similar to thin card. Single weight paper is normally used for prints up to about 10 in \times 8 in, or larger if these are to be mounted or dismembered for paste-ups. Most large prints beyond 10 in \times 8 in are more safely printed on double-weight paper, as there is then less risk of creasing in processing and general handling. Some photographers consider that even small prints are worth printing on double-weight papers as the result has the 'feel' of a much higher quality product. This more than compensates for the slight extra cost of the paper. Note that all paper based prints tend to expand or contract slightly during processing, drying etc. When enlarging to precise image sizes use plastic-coated paper which offers greatest dimensional stability.

Other printing materials with much more unusual bases are available in some countries. These include 'photo-linen', a linen laminate which after processing can be draped, or pasted on to walls. Also emulsion coated opal plastic for making large black and white display transparencies.

In choosing our printing material we need to consider the visual effects of image colour, contrast grade, surface and paper base tint. At the same time certain technical associations must be remembered – emulsion speed and its link with image colour; maximum black and white and its limitation by surface and base tint; base thickness

and physical and psychological handling. About 85% of commercial photography is printed on bromide or chlorobromide glossy emulsions on double or single-weight white paper. Most D & P (developing and printing) laboratories contact print on white single-weight glossy chloride paper, and enlarge on single-weight white glossy or semi-matt bromide paper.

When ordering printing materials we have to stipulate: (a) Size, (b) emulsion, (c) surface, (d) grade, (e) thickness, (f) base colour. As with certain negative material most of this information is coded in manfacturers' labelling.

PRINTING EQUIPMENT

The equipment – notably the enlarger – with which we make our prints has a strong influence on results. This may seem rather strange, for the negative is surely evenly illuminated and imaged sharply by all good enlargers. The major difference lies with the manner in which the negative is illuminated, direct lighting producing a more contrasty final print than when diffuse light is used.

Basic Enlarger

The term 'enlarger' although common usage, is deceptive. 'Projection printer' is the more accurate description of an optical device to give prints both larger and *smaller* than the original negative. Basically we require:

- (a) A lamphouse containing reflector and lamp to evenly and effectively rearilluminate the negative. This housing must not, of course, leak light or overheat and buckle the negative.
- (b) A removable negative carrier that holds the negative flat, and parallel with the printing paper. It should preferably do this without the use of sandwiching cover glasses, owing to the four extra surfaces introduced which may collect dust and scratches. Nevertheless, glasses may be essential for thin, large format film, i.e. film pack negatives. Some carrier stages incorporate metal masking plates which slide parallel and close to the negative to mask off most of the negative areas not required on the print. This prevents flare (light scatter), particularly when enlarging a small area of a predominantly transparent negative.
- (c) An enlarging lens at an adjustable distance from the negative, connected to it by bellows and moved by rack and pinion or helical mount focusing. Bellows or tube should be long enough to allow reduction printing where the lens must be closer to the printing material than the negative. The lens is designed in such a way that it remains unaffected by any heat radiations from the enlarger lamp; its aberrations will be corrected for highest resolution with close subject (negative) distances. Optimum focal length varies with negative size and the condenser, if used (see below). Most enlarging lenses have a maximum aperture of about f/4.5 and are fitted with positive 'click' stop settings for easy adjustment in the

Fig. 18.4. Basic condenser enlarger. Arrowed lines denote path of light through condensers, broken lines show light refraction by lens. M1, focusing movement of lens, relative to distance of negative and easel, affects image sharpness. M2, movement of light source relative to lens position, affecting evenness of illumination. M3, movement of whole body, relative to easel, affecting image size. N: Negative carrier. E: Masking easel.

darkroom. On some, f-numbers as such are discarded and a $\times 1$, $\times 2$, $\times 4$ series of exposure ratios substituted.

(d) An easel to hold the printing material flat and in the focal plane of the projected negative image. This will carry adjustable metal masks to cover up some quarter inch around the edges of the printing paper and so yield white borders.

All the foregoing basic enlarger components could be arranged in horizontal or ver-

tical alignment. Horizontal enlargers, once justified when heavily constructed in wood, today take up too much valuable bench space. This construction is now limited to equipment for giant photo-murals, where the necessary 'throw' would otherwise mean an inconvenient height between enlarger and paper.

The modern enlarger is a light alloy vertical structure – the 'head' (lamphouse, carrier and lens) counterweighted, and smoothly raised and lowered on rails. Refinements include pivoting carrier, lens panel and easel – 'enlarger movements' for image shape modifications. The raising or lowering of the head may be linked through a cam to automatically adjust lens focusing. The image on an autofocus enlarger remains sharp and simply increases in size as the head is raised. The enlarger may also allow head pivoting about 90° to project horizontally for photomural work. Most enlargers today are used with a time switch, calibrated in seconds, fitted in the lead to the lamp.

The earliest enlargers used daylight to illuminate the negative. Diffusing panels were fitted in skylights, 45° mirrors protruded through apertures in outside walls. But thanks to unreliable weather and the fortunate arrival of mains electricity, electrical light sources were quickly adopted. Today we use tungsten lamps or blue-rich tubular sources with diffuse or direct (condenser) optical systems.

DIFFUSE ILLUMINATION. We require even, usefully bright rear illumination of the negative. The most obvious illumination system is a tungsten lamp placed between a matt white reflector and a translucent grainless diffuser just above the negative carrier. This will give even, diffuse illumination to the negative, similar to light from a negative viewing box. Unfortunately, if our tungsten lamp is to be powerful enough adequately to illuminate large format negatives it will also grow hot. This means a large lamphouse, and consequently restricted height for the enlarger head relative to the darkroom ceiling (see Fig. 18.6H).

Cold cathode vapour tubes bent in the form of a grid are a more efficient replacement and provide even, heatless light of high blue content. Such a light source may be fitted in a shallow drawer-shaped lamphouse (see Fig. 18.6G), consumes very little current and burns for over 5,000 hours. A transformer is usually needed.

Strictly, a diffuse negative illumination system is inefficient. The light emerging through the negative is scattering in all directions, more into the bellows than towards the lens. More would be made of available light if it could be *directed* through the negative towards the enlarger lens. This demands a type of 'spotlighting' optical system using a compact filament lamp and a *condenser*.

DIRECT (CONDENSER) ILLUMINATION. A true condenser system of negative illumination uses a large converging lens (diameter exceeding negative diagonal) to gather diverging rays from a compact tungsten lamp filament and direct the light through the negative to a point of focus in the enlarging lens. In this way the lens 'sees' the negative as though rear illuminated by a spotlight. The image finally projected on to the easel is not only brighter for the same wattage lamp but also more contrasty.

This effective increase in negative density range (compared with the same negative printed in contact or through a diffuser enlarger) is due to the 'Callier effect'. As Fig. 18.5 shows, the direct light beam is largely unaltered by clear negative areas, but

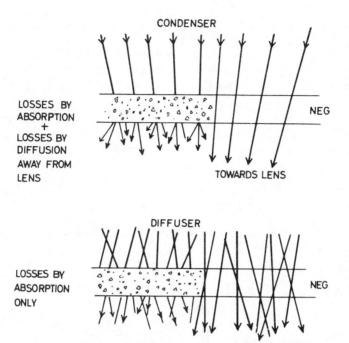

Fig. 18.5. Effects of direct or diffuse enlarger light sources. Top: Righthand clear area of negative passes almost all light directed at the lens. Density areas absorb and scatter light away from the lens. Density range is thus exaggerated. Bottom: Using incident light which is already fully diffused, density differences are determined by absorption only.

becomes scattered and absorbed by the silver grains wherever there is density. Light which is not absorbed emerges from density areas scattered by amounts varying with the density. Much of this light is not now directed at the lens. The greater the density (and therefore scattering) the more the image of that density on the easel appears as dark as if projected by a diffuse enlarger... but clear areas remain 'condenser brilliant'.

This increase in projected brightness range cannot occur in a diffuser enlarger, for all light is already scattered before reaching the negative. Silver densities in such an enlarger can subtract light only by absorption, not by absorption and scatter. You can visually check the Callier effect by comparing the appearance of a negative first in front of a diffuse light box (or overcast sky) and then in front of a spotlight.

Definition: 'Callier effect' – Exaggeration of the differences between silver transmission densities, owing to the combined scatter and absorption of direct illumination within the emulsion. The same silver image, transmitting prescattered diffuse light, has densities dependent upon absorption alone. (The ratio of effective specular to diffuse density values is known as the 'Callier coefficient' or 'Q' factor.)

In practice, the optical arrangements necessary for a *true* point source/condenser illumination system in an enlarger are rather inconvenient. We have to use a compact filament clear projection lamp, and ensure that the condenser optics always imaged its filament on the enlarger lens. At *every* different size enlargement the lamp needs adjust-

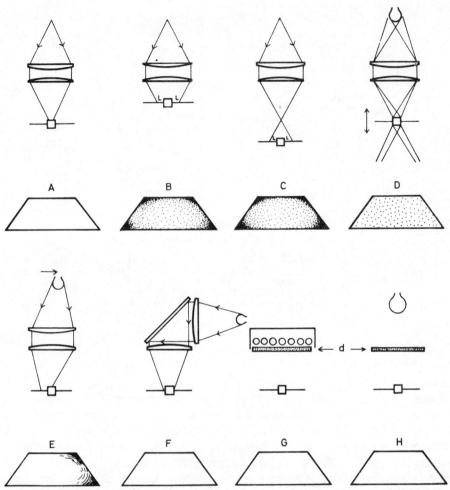

Fig. 18.6. A: A point source light, critically focused, yields brilliant, even illumination. However, (B & C) if the lamp is not refocused for every lens position illumination will be lost at L, giving uneven lighting. D: With a larger lamp broader cones of light are formed — slight change of lens position no longer radically alters illumination. E: A laterally misplaced lamp gives uneven illumination. In B, C & E coloured areas may also appear as most condensers bring different wavelengths to slightly differing points of focus. F: A 45° mirror arrangement to reduce condenser height. G & H: Two forms of diffuse illumination — cold cathode grid and large tungsten bulb.

ment to focus on the new position of the lens. However, point source enlargers are used occasionally for their knife-edge resolution of detail and grain.

The vast majority of condenser enlargers are something of a compromise. They use an opal enlarging bulb which the condenser focuses as a patch of light covering the enlarging lens (see Fig. 18.5 D). In this way we no longer have to keep adjusting the enlarger lamp so that the condenser brings the filament to point focus in the lens — the patch image of the opal lamp will serve for most slight alterations in enlargement size.

However, when making a major change of enlargement (e.g., from 8 in \times 10 in to 40 cm \times 50 cm) lamp refocusing *may still be necessary*. The negative will otherwise be dimly and unevenly illuminated (see 'Setting up' below). Condenser enlargers using opal light sources are sometimes known as 'Condenser-diffuser' or 'Semi-diffuse' enlargers.

FOCAL LENGTH OF CONDENSER AND ENLARGING LENS. The condenser must not only have a diameter sufficient to illuminate the whole negative, but should have a focal length related to the enlarging lens in use. For example, if the enlarging lens has a short focal length it will be positioned fairly close beneath the negative. If the light source is to be brought to focus on the lens, the condenser will either also have to be of short focal length, or the lamphouse tall enough to allow the lamp to be drawn up away from the condenser.

The focal length of an enlarger lens is generally a compromise — it must be long enough to cover the negative (even when closely positioned, for maximum enlargement), yet short enough to give useful enlargement size without needing excessive lens-to-easel 'throw'. It is generally conceded that the lens should have a focal length slightly longer than the diagonal of the negative which it is to enlarge. A convenient condenser then has a focal length some three quarters of the negative diagonal (i.e., about half the enlarging lens focal length).

We must, therefore, carefully bear these points in mind when changing the lens in an enlarger containing a condenser. We cannot, for instance, use a 35 mm negative in a 4-in \times 5-in condenser enlarger, change from the 180 mm to a 65 mm lens . . . and expect to be able to refocus the lamp for even illumination. Under these conditions we must either: (a) Change to shorter focal length condenser (which can be of narrower diameter), or (b) maintain the same 180 mm lens, putting up with the restricted maximum enlargement this offers from the smaller negative.

Physically, a condenser for a small format enlarger may take the form of a simple plano-convex lens. Condensers for large format enlargers usually consist of two such lenses; one lens of the sufficient total thickness and diameter would be more expensive to grind, and may crack from lamp heat owing to the thickness of glass. A fresnel lens is too patterned for use here.

On some enlargers, a 45° mirror placed between the two condenser halves gives a right-angled light path. The lamphouse is thus placed to one side of the optical system. This design is useful when darkroom ceilings are low; it also allows more efficient lamp ventilation (see Fig. 18.6 F).

Many enlarger designs allow complete interchangeability of negative illumination systems – lamphouse and condensers can be removed as one unit and replaced with cold cathode head and diffuser.

Summarising the Practical Effects of Negative Illumination Systems

(1) Completely diffuse light source enlargers yield enlargements with similar density range characteristics to contact prints.

- (2) Exposures tend to be longer than with condenser enlargers of equivalent tungsten wattage, as much of the illumination never reaches the lens. This is partly compensated by using a cold cathode grid, which emits more actinic light for the same electricity consumption.
- (3) True condenser enlargers yield enlargements with increased density range, due to the 'Callier effect' of absorption plus diffusion.
- (4) Condenser systems produce slightly improved visual sharpness by enhanced contrast, but also emphasise grain, emulsion scratches, retouching, etc.
- (5) In a point source condenser enlarger, lamp focusing is necessary for every change of enlargement (i.e. every change of lens position).
- (6) Opal lamp condenser enlargers 'semi-diffuse' retain most contrast yielding features of the true condenser system, but only demand lamp adjustment for major changes in negative enlargement. The bulk of condenser enlargers are of this type.
- (7) All enlargers containing condensers must be used with enlarging lenses of appropriate focal length. Usually the focal length of the enlarging lens slightly exceeds negative diagonal, being about twice the condenser focal length. Condenser diameter must exceed negative diagonal. Unless condenser, negative size and enlarging lens bear a suitable relationship it will be impossible to produce even illumination on the baseboard.
- (8) Diffuser enlargers are more flexible; their even illumination when used with lenses of any focal length (providing they cover the negative) allows a variety of enlargements from a variety of negative sizes.
- (9) Diffuse and opal lamp condenser enlargers both have a place in the commercial photographer's darkroom. In choosing the most appropriate enlarger for a particular negative he must consider its effect on: (a) Suppression of retouching, grain, etc., (b) alteration of printing contrast by about ½-1 paper grades, (c), minimising of exposure times.

Setting Up for Enlarging

Assuming that the enlarger is used with an opal bulb condenser head, we would insert the prepared negative in the carrier, switch on the light source, open the lens aperture, then –

- (a) Move the enlarger head up and down the column, until the image of the illuminated negative is approximately correct size. The lens is then focused until the image appears sharp on the enlarging easel.*
- (b) Remove the negative from the enlarger, and replace the empty carrier. Check the evenness of illumination on the easel. Move the lamp in the lamphouse by means of whatever controls are provided, until the whole area is evenly and brightly lit.
- (c) If required, slightly converging or diverging lines on the negative can be

^{*}In making reduced prints – e.g., projection slides – depth of field exceeds depth of focus. It is easier to move the lens for size approximation, and then critically focus with movement of the whole enlarger head.

'corrected' by propping up the easel non-parallel to the negative (the closer parts of the easel receive a smaller image). On enlargers fitted with tilting negative carriers, correction can be made by combined negative and easel tilt, away from each other. There is then less risk of insufficient depth of focus.

(d) Close the aperture by an amount appropriate to negative density and convenient exposure time. If shading and printing in is anticipated an exposure time of about 10 sec is desirable.

When an enlarger with a diffuser head is used, stage (b) would of course be omitted.

Image Controls During Exposure

During exposure of the print we can modify its final visual appearance by several controls. These include: (1) Darkening or lightening of density overall, (2) increase or decrease of overall contrast, (3) local alterations of density, (4) introduction of blur, soft focus, multiple images, etc.

Correct density and contrast in a print must always be a matter of opinion – both may be considerably distorted yet remain acceptable. In fact, this distortion may usefully contribute to the picture's visual objectives. Meter measurement of required exposure and grade is considered a waste of time by many professional photographers (although always used when colour printing). Photometers and CdS cell meters are sufficiently sensitive to give readings from the projected image, but cannot give as much subjective information as a simple test strip.

As with camera test strips, it is important intelligently to align a paper strip with an area of image carrying a range of tones representative of the negative as a whole. It is pointless to arrange the strip to test only the sky area of an architectural exterior, for example. A range of guessed exposures may be made by progressively covering the strip with a piece of black card. Each exposure zone should again include as wide a range of negative densities as possible.

After processing the test strip the most appropriate exposure is noted. If grey tone gradations are too contrasty a softer grade paper is used for a second test, perhaps reducing exposure if the new grade is known to have greater speed. Similarly, if tone gradation appears too gradual or 'flat', a second test is made on a more contrasty grade of paper. If this is also slower more exposure will be needed. Finally, a complete 'straight' print is made from information accumulated from the tests.

If certain local areas of the print appear too light, a second print is made for the same exposure time. This time by placing the hand or a black card a few inches below the enlarger lens additional exposure can now be given to these lighter areas. Similarly, areas which print too dark may be shaded for an appropriate percentage of the overall exposure.

Shading facilities are rather restricted when using a contact printing box. Sheets of translucent paper positioned on shelves well below the negative allow some modification of local density. Their shadows must be well diffused, for no movement during exposure is likely to be possible. On the other hand such a static shading arrangement gives consistency throughout a batch of prints.

When using your own hand for 'shading' or 'printing in' in enlarging, ensure that the

hand is quite dry, thus avoiding condensation on the lens from rising moisture. Red transparent plastic forms satisfactory shading material and allows the printer to see the parts being shaded. Sometimes the light-obstructing material is best mounted at the end of a wire (a bicycle spoke or unfolded paper clip), this allows 'island' areas to be shaded. Whatever the shading or printing-in material, it should be *kept on the move* throughout exposure in order to blur its outline.

Vignetting effects – darkening or lightening the picture corners – are a simple extension of density modifications. A card with a cut-out aperture is used to *lighten* corners; a shape at the end of a wire for *darkened* vignettes. Image definition can be 'softened' by printing through a stretched silk stocking or grease-covered glass held beneath the lens.

A less transparent material such as a negative bag diffuses the image into a vague area of light. If the printing material is given a short exposure to this 'controlled fogging' after its normal exposure, contrast is reduced by about half a paper grade. This is because the 'fogging' has a greater effect on light tones than shadows, decreasing density range to the point when highlights grey and the print begins to *look* fogged.

Movement of the paper during exposure gives interesting graphic effects. Continuous movement — as with the paper on a rotating turntable — yields tone *streaks*. Intermittent movement gives *multiple images*, densities depending upon the duration of each stationary exposure. Many forms of double printing are also possible, using negatives sandwiched together or separately exposed on the appropriate paper areas.

Print borders are conventionally white — created by the masks holding down the paper edges. When black borders are necessary a piece of opaque card slightly smaller than the image formed is placed in face contact with the paper after the normal image exposure has been given. The negative is then removed and the light from the enlarger allowed to fog the unprotected paper surround. Try giving the same exposure time for fogging as given to the image.

Light fogging techniques can even be used for darkening local parts of the image itself. A small handbag torch pushed into one end of a black paper tube forms a good 'light pencil' which is kept on the move just above the paper in areas where image detail is to be darkened and suppressed. This is a particularly good way to darken areas having mixtures of dark and light tones, which tend still to show detail after minutes of conventional printing-in.

BLACK-AND-WHITE TRANSPARENCIES. Large transparencies for display or small transparencies for projection are made by enlargement or reduction, basically in the same way as prints. Use non-colour sensitive film as suggested on page 328. The following points are worth remembering: (1) Place black paper under the film to prevent halation from the white masking easel. (2) Give very full development (in a dish of print developer) because rich blacks are vital in a transparency. (3) Judge exposure by viewing the test strip against a light box — you cannot assess it properly by reflected light in the darkroom. (4) As soon as practicable clip the film into a hanger and use deep tanks for final fixing and washing. Finally it goes into the drying cabinet like any other hand processed film.

PHOTOGRAMS. Obviously any object placed between the lens and the printing emul-

sion will create shadows, which reproduce white. Objects on glass shelves above the emulsion have 'soft' outlines. Objects removed after part of the exposure reproduce as grey. Semi-transparent objects such as rippled glass, liquids, etc., reproduce their own patterns.

Within this context we can either dispose of the negative altogether or combine negative and shadow casting. Abstract tonal pictures formed in this way have acquired the title 'photograms'. In skilled hands highly attractive graphic effects are possible. Applications range from record covers to fabric printing.

Unfortunately, it is seldom possible to predict results with accuracy, and every photogram is unique in itself. For this latter reason it may be less frustrating to print on to non colour-sensitive film, then use this as a negative.

Print Development

Monochrome bromide paper can be processed either by machine or in a dish. Automatic roller transport machines (e.g. Kodak Veribrom processor) are designed to develop, fix, wash and dry plastic-coated paper at high temperature, and produce a permanent high-quality print in approximately two minutes. These machines are very expensive, but cut production time and allow savings in sinks, dishes, wash units etc. The economic advantages and disadvantages of machine processing are discussed in *Professional Photography*, chapter VI. A cheaper, simplified form of processing machine is made for stabilisation bromide paper and gives a *semipermanent* damp print in about 10 seconds, see page 346.

For the most part, however, we still dish process plastic-coated and non-coated paper, in an M.Q./P.Q. developer used at a greater concentration than for films to give a conveniently short development time. Typically, at 20°C, paper base material needs 2 minutes; plastic-coated paper $1-1\frac{1}{2}$ minutes; and contact paper 50 seconds. Very occasionally developing agents – such as glycin or chlorquinol – may be used in special 'warm-tone' developers, to give strong brown images on chlorobromide papers. All enlarging paper developers contain generous restrainer constituents to reduce the risk of fog, which is much more objectionable on prints than negatives.

A certain amount of latitude in developing is permissible with printing material, and to a very limited degree this can be used to compensate for exposure errors. A slightly overexposed print may be given shortened development time up to the point when:

(a) Development is insufficient to build up full depth of tone – blacks appear greenish grey; (b) development is too short for even action, the print appears blotchy.

Conversely a slightly underexposed print can have its development extended almost up to the point where: (a) Increasing fog level veils highlights, and (b) developer oxidation products stain the gelatin. For optimum print quality and print-to-print consistency, strict time and temperature processing is, however, highly desirable.

Rather greater development latitude is possible with chlorobromide papers, particularly if extra bromide is added to the developer when processing overexposed prints. The result is then a print of warmer tone. Still more spectacular image tone changes oc-

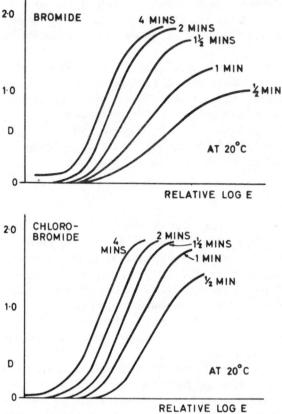

Fig. 18.7. Characteristic curves of two printing papers, given a range of development times. Note the improved latitude of the chlorobromide paper, allowing some compensation of exposure errors. (Bromide developer times relate to paper based material – on a plastic coated base times are proportionally shorter.)

cur when lith paper is grossly overexposed and underdeveloped, or developed in diluted (1:1) or almost exhausted lith developer. Most of the image then appears yellow or orange, with only the darkest shadows having any semblance of black. These eccentricities apart, compensation in processing for errors in printing exposure usually results in a poor quality print. It is more practical to return to the enlarger and make another exposure.

TECHNIQUE. The majority of black-and-white prints are still processed in dishes—taking particular care to immerse the dry print quickly and evenly beneath the solution. This is best handled by using a dish well filled with developer, sliding the print emulsion down into the solution and then turning it face up to expel any air bells clinging to the emulsion. The dish requires gentle agitation throughout development. With care and experience six or more sheets of paper may be processed at one time. Each is fed in at 10-sec intervals and the pack 'shuffled' by regularly raising the bottom print to the top.

From the developer, the print or prints are removed to a 1% acetic acid stopbath or

water rinse, and agitated for 3–5 sec before transfer to the fixing bath. As discussed earlier, the argument for a water rinse is that the print can be examined under a safelight before fixing and any light areas swabbed with developer. This, however, is not to be recommended as a regular practice owing to the risk of developer oxidation stain and uneven development, and the inability to produce even two matching prints by this method.

Fixation and Washing

A hardening fixing bath may help protect non plastic coated papers in hot weather conditions, but normally acid hypo solutions are most commonly used for print fixing. Unlike negative fixers, the sodium thiosulphate (crystal) content should not be more than about 20%. This is adequate for the thin emulsion coated on paper, creates less risk of bleaching the silver image, and except in the case of plastic coated prints, reduces the quantity of chemical which must later be washed from the highly absorbent paper base.

It is unwise to fix prints in a fixer solution which has been used for films and plates. The reasons are:

- (a) The higher concentration of hypo may bleach or alter image colour particularly fine-grain chloride or chlorobromide papers.
- (b) The fixer may contain a high proportion of silver salts, and although able to fix the thin emulsion, the solution deposits great quantities of these salts in the base. Certain argentothiosulphates built up in negative fixers approaching exhaustion are difficult to wash even from gelatin, and may subsequently cause stains.
- (c) The presence of dissolved antihalation dye from negatives may stain the print.

As it is very important to supply prints to the client in as permanent a form as possible, proper fixation and washing deserve care. Two print fixing baths are highly desirable. The first does the bulk of fixing, the second dissolving last traces of emulsion silver salts. Prints need about 5 min in the first fixing bath and up to a further 5 min in the second (fresh) solution. With plastic coated papers these times are reduced to about 1 minute. Processing times are always shorter with these papers because of more rapid absorption of chemical by the emulsion and less carry-over of solution by the plastic base. Again, plastic papers are designed to work well with more concentrated developer and rapid (ammonium thiosulphate) fixer, bringing times down to 1 min and 30 sec respectively. When the first fix approaches exhaustion point it can be drained away, replaced with the second solution – and the second fixer made up afresh.

It is false economy to overwork a fixing solution. Remember that, unlike film, we cannot *see* the creamy halides dissolving from the emulsion because of the white paper base. Discipline is therefore important (test for fixer exhaustion, page 303).

WASHING. Traditionally, most of the time required in print washing is spent removing chemical residues from the fibres of the paper support. Diffusion from the emulsion itself is much more rapid. This is where plastic-coated paper — with its sealed-in base — allows significant time-saving, requiring only 2–3 min wash against 15–20 min

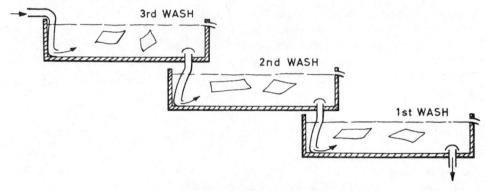

Fig. 18.8. Cascade print washer.

for non-coated base papers. However, in the latter case urgent work can be speeded by using 0.3% hydrogen peroxide as a hypo eliminator, changing the residual hypo into a less harmful chemical. This treatment is followed by a 5 min wash.

The main physical requirement in washing is to provide a flow or regular change of water, and prevent prints floating into unwashed 'clumps'. Rotary and siphon print washers (see Fig. 17.1) are very efficient, but one of the best systems is a 'cascade' of shallow tanks (see Fig. 18.8).

Water sprays into the top tank, spilling over like a waterfall through all the other tanks to final waste. Newly fixed prints are placed in the *lowest* tank. When the next batch is ready for washing the first batch is raised to tank No. 2, and so on. When the prints have reached the top tank and received about 20 min total washing with regular separating (30 min for double-weight) washing can be said to be complete. Tests for washing, see page 317.

STABILISATION PRINT MATERIALS. A number of continuous tone and high contrast printing papers are available with emulsions already containing developing agent (principally hydroquinone) in addition to silver halide. After exposure the developing agents are activated with an applied alkaline solution; the system avoids the usual inertia whilst developer penetrates the gelatin, and development is completed within 2–4 sec. The paper then passes through a stabiliser (see page 313) for 3–5 sec and emerges ready for handling.

Processing is by small bench top machine with motor-driven rollers which rapidly draw the print into a trough of alkali, then transport it through a stabiliser trough. In this way the paper base never really absorbs much solution and the final print emerges damp-dry. Stabilisation prints have a life of only a few months, assuming they are not subjected to strong light, high temperature or humidity. They can however be conventionally fixed and washed at a later date to make them as permanent as normal prints. Stabilisation prints are useful for quick Press purposes but their limp, slightly 'tacky' feel and poorer tonal quality discourages more general use. Many of their time-saving advantages have been superseded by resin-coated bromide papers which offer excellent quality and near-archival permanence.

Plate 84 (Previous page) A print from a wholly hand made negative—red dye poured over acetate film and spread with a roller squeegee. Images produced this way, although difficult to control, have formed thebasis of fabric designs, posters etc. (R. Closa)

IMAGE MODIFICATION AT THE NEGATIVE STAGE

Plate 85 (Left, top) Blocking out the background to a $5'' \times 4''$ negative, on a light box. The red opaque pigment will appear as clean white on print. Note the use of adhesive tape for long straight edges.

Plate 86 (Bottom) The result of selective masking to 'ghost out' background areas. See page 327

Plate 87 (Above) A high contrast negative bound in register with a high contrast positive of slightly lower density gives a print resembling an ink and colour wash drawing.

Plate 88 (Overleaf, top) A 'straight' print from a negative of a wide brightness range subject.

Plate 89 (Overleaf, bottom) From the same negative but shading shadow areas and allowing the windows extra exposure has increased the informational content of the print. Whether one of these prints is 'better' than the other will depend upon the purpose of the photograph.

Final Print Presentation

DRYING. Prints can be dried by various methods, not all of which are suitable for all types of papers. Having first removed surplus water from the face of the print, we can either (1) bring the back of the print into contact with a heated surface such as an electrically warmed drum or hot plate (see Fig. 18.9); or (2) pass the print through a hot air dryer using a conveyor belt system; or (3) leave prints face up on muslin or cheesecloth racks, for drying naturally at room temperature.

Stabilisation prints should not be dried by (1) or (2) unless conventionally fixed and washed first — chemicals remaining in these materials contaminate the equipment and even the effect of heat can stain the print. Plastic-coated paper prints are designed for drying by method (2). Method (3) is also quite practical because this paper dries quickly and without curling; but if we use (1) great care must be taken because the non-porous coating prevents moisture from the emulsion evaporating through the print base. The emulsion must face away from the heated surface, which should never exceed 90°C. Failure to do this will melt the plastic, resulting in blisters or total adhesion of the print to the hot surface. Prints on non-coated paper can be dried by any of the methods above.

Fig. 18.9. Print dryers and glazers. A: Rotary glazer. B: Flat bed glazer. (Both machines can be used for drying by facing prints away from polished surface.) C: Simple muslin racks for drying at ordinary room temperature. D: Heated air dryer for plastic coated paper. Sectional drawing of this dryer shows (F) Fan, (H) Heater supplying hot air to (P) print entering through roller squeegee and transported on open net belts (N).

GLAZING. Whereas glossy plastic-coated paper air-dries to give a highly glazed surface, other glossy paper gives only a semi-gloss result unless 'glazed'. Glazing means bringing the print face into tight contact with a polished surface, and then allowing it to dry so that the soft gelatin top-coating 'sets' with a matching glazed surface. Polished stainless steel, electro (chromium) plated metal, or even glass are all suitable glazing surfaces.

Metal surfaces allow heat glazing, using either a flat bed or rotary machine. To glaze with a flat bed the wet, paper-based glossy prints are first rolled or flat squeegeed face down on a polished glazing sheet, which is then placed on the slightly convex top of the hot plate unit. A tensioned fabric sheet presses down on the back of the print but allows moisture to escape. By rubbing your hand over the top of the fabric it is possible to feel when the prints have dried and are separable from the glazing sheet.

The glazing process is mechanised in the rotary glazer (see Fig. 18.9) which uses a drum with a polished metal shell and internal electric heaters. The wet prints are simply laid emulsion up on a slow-moving cloth conveyor belt which draws them under a spring loaded roller. This squeegees the face of each print to the hot drum. Drum and cloth slowly rotate together, holding the print in tight contact until it emerges dry and glazed near the top of the machine. Glazing this way takes about 5 min.

With both types of glazer it is essential to clean the polished glazing surface thoroughly with a soft cloth before applying the next batch of prints. Grease or gelatin traces cause following prints to adhere to the surface. Bad glazes — due perhaps to uneven drying giving 'oyster shell' marks — are easily removed by just re-soaking the print and either reglazing or allowing it to air-dry as semi-gloss. Do not try glazing paper with surfaces other than glossy, because the result is usually a few ugly patches of glaze. These papers lack the essential extra top coating of gelatin.

Cold glazing to glass is cheap, but slow and difficult. The (plate) glass is treated with a de-greasing fluid, dried and polished. Wet prints are squeegeed into face contact and backed up with felt pads \(\frac{1}{4}\)-in thick. Each pad should contain a desiccating fluid and have been dried in a drying cabinet. Prints dry and can be removed from the glass after about 1–2 hours, whereupon the felts are returned to the drying cabinet to remove the moisture they have absorbed.

Usually finished glazed prints are trimmed to remove any roughness at the edges. Prints can then be sorted, and each negative number pencilled on to the back of its print, unless this has already been done before processing.

Mounting

Dry prints can be mounted on card with convenient adhesive. Some gums, however, contain chemicals which in time will react with the photographic image, bleaching or causing stains. Where a print has a glazed finish we should obviously try to avoid water soluble adhesives. The two most common mounting methods are shellac tissue (dry mounting) and rubber solution.

DRY MOUNTING TECHNIQUE. A sheet of tissue impregnated with shellac is placed

Fig. 18.10. Stages in dry mounting. (1) Tacking tissue to back of print. (2) Tacking print to mount. (3) Covering print prior to placing in thermostatically controlled hot press (4).

over the back of the print and the centre briefly touched with an internally heated 'tacking iron' (similar to a soldering iron). Shellac beneath the iron momentarily melts, and, becoming partly absorbed in the print base, tacks tissue and print together.

The print and its attached tissue is trimmed as desired, and positioned image upwards on the mount. Holding the centre of the print down with one hand, one corner is raised, leaving the tissue in contact with the mount. The tacking iron is pressed down on this exposed tissue to tack it to the mount. Further corners are tacked in the same way.

Cover the print with good quality cartridge paper or (for glossy prints) a polished glazing sheet. Mounting board, print and cover sheet must all be absolutely dry. The whole 'sandwich' is now ready to be placed face up in a top-heated press (65°C–95°C). This exerts even pressure and heat, melting the shellac into print and mount within 5–10 sec. Temperature control is important. Above 99°C plastic coated papers will blister and stabilisation prints may stain.

The advantages of dry mounting are its cleanliness, simplicity, and inert chemical effect (the tissue acts as a seal between mount and print). It gives results which have a particularly flat 'integral' appearance.

Rather than use an expensive press, dry mounting can be carried out with a domestic hand iron. It is, however, difficult to apply even pressure to the whole print when the print area exceeds the size of the iron.

Most dry mounting faults are due to

- (1) Uneven heat or pressure the print has unmounted 'bubbles'.
- (2) Grit between print and press giving pit marks in the print surface.
- (3) Insufficient heat the tissue attaches to print but not the mount.
- (4) Excessive heat the tissue appears attached to the mount but shellac between tissue and print is scorched, detaching the print; plastic coated prints are blistered or face-adhered.
- (5) Dampness in mount or print the print 'sticks' to the press.

Rubber solution. Although less permanent, rubber gum mounting demands virtually no equipment. It is ideal for rapidly mounting photographs with artwork for reproduction, etc. Proprietary rubber gums contain latex dissolved in petroleum mixture. This is spread evenly and thinly over the back of the trimmed print, and over

the whole mount surface. Both surfaces are allowed to dry separately for 10 min, until they are no longer tacky.

One edge of the print is then lowered on to the mount – to which it immediately adheres. (If positioning is critical the mount should be premarked with pencil lines.) The remainder of the print is gently lowered to meet the mount and a cloth rubbed over the picture surface to expel any air bubbles. All surplus gum on mount or print now rubs off easily, forming little balls of rubber.

Care must be taken, however, with some soft card mounts, which may lose their top surface during the rubbing process.

Other mounting methods. Wide double-sided adhesive tape works successfully for prints up to about 16×20 in — try to cover the whole of the back of the print. Aerosol adhesive spray is the best means of mounting one cut-out print upon another, e.g. montages. Large display prints can be mounted on any smooth surface using an impact adhesive. Modern wallpaper pastes are also suitable, but if used on plastic coated papers the receiving surface *must* be porous enough to allow drying.

MOUNTING STYLE. Mounting is either functional or decorative. If functional (i.e., to stiffen up a print) 'flush mounting' imposes least influence on picture content. The most convenient method of doing this is to mount the untrimmed print on a plain mount, and finally cut through both print and mount flush to the edges of the picture.

Flush mounting is general for most commercial subjects, but more emotional subjects, such as weddings, are usually requested mounted with some form of decorative surround. This can range from white or cream slip-in folders, through embossed deckle edged cards, to padded albums with interleaved 'spidersweb' tissue and which play the wedding march on a built-in musical box when opened. The client is always right!

Finishing

Print finishing is most conveniently left until after mounting. The 'spotting' of light coloured defects, as with negatives, is simply carried out with a fine-tipped brush, using dye or water colour pigment. The idea is to 'touch in' tiny specks of tone which then merge with adjacent grain. Care is needed to match image colour with warm-tone papers.

It is almost impossible to spot glazed glossy prints without leaving some evidence of retouching – gum arabic mixed with the water colour will, however, dry with some form of matching glaze. Matt prints, with their receptive surface and grey blacks, can quickly be spotted with pencil alone.

Dark spots can be tackled on the print with white pigment or very careful knifing (not on glossy or any plastic papers). More elaborate retouching in dark or light pigment may require the use of an airbrush. Extensive retouching can be disguised by coating the final print surface with a matt lacquer from an aerosol can. It must be emphasised that print retouching should be unnecessary. The photographer who must spend hours print-finishing is paying the penalty of poor technique — probably at the negative drying stage.

Transparency binding. The positive transparency, or print on film, has so far followed a parallel processing course to paper. After a final rinse in wetting agent and drying in a negative drying cabinet it is ready for finishing and mounting. Unless the situation is desperate, it is generally impractical to spot or knife transparencies for projection, owing to the magnification they will receive.

At this stage, unwanted picture areas are masked off with silver foil over the emulsion, and mounted in a holder as made for colour slides. Finally, the transparency is 'white spotted' for projection. Holding it so that the image is correct left to right but *inverted*, a white spot is attached to the binding in the top right corner facing you. Projectors are loaded with every slide spot at the top right – seen from behind the projector – this gives correct image orientation when screened.

Print Faults

Most print faults stem from the same technical causes as negative faults. For example, white spots from hypo contamination of the dry undeveloped emulsion; uneven density from impractically short development, etc. Assuming an unblemished negative, the most common faults found in finished prints are:

- (1) A greenish black image on bromide prints, due to insufficient development.
- (2) Black lines, often short and in parallel groups; caused by abrasions, probably in fitting the paper under the masking frame.
- (3) White hair marks and specks, due to debris on the negative or cover glasses. If these marks are unsharp, the dirt may be located on a condenser surface.
- (4) Concentric rings rather like map contours. These 'Newton's rings' are created when a negative is out of contact with a cover glass by an amount approaching that of the wavelength of light. Coloured rings are formed by light 'interference'.
- (5) A slight fog-like density increase around the edges of the format close to the white borders. This is due to light spread – either illumination spreading through unmasked rebate areas of the negative, or light reflected from the sides of the masking rails on the paper easel.
- (6) A double image over certain areas of the print only. The enlarger or easel was jogged between the main exposure and the printing-in of these areas.
- (7) Sections of the emulsion are missing. This is caused by gelatin dissolved from the base during overlong washing commonly the result of washing overnight in warm weather.

Some of the above, and other print faults, are illustrated in plates 72–83.

Picture Viewing Conditions

And, now, the final result. All through the process of photography we have been able to exert controls over the final visual result. Now all that remains are the influences of viewing conditions. Viewing distance affects visual perspective (discussed on page 71), illumination influences visual tonal values.

Tonal values. The tonal range possible in a photographic image is limited by the visual extremes of the darkest black and most brilliant white. To obtain widest tone range we must turn to a rear-illuminated transparency viewed in a darkened room. Here there is no blacker reflectance than the most opaque shadow of the image, no brighter area than its highlights. Our tonal range here can be several hundreds to one, compared with about 70:1 maximum for a glossy print. A large black and white transparency (i.e., printed on to a large sheet of film) is a particularly effective way of presenting subjects which were originally backlit and therefore spanned a wide brightness range.

A projected transparency is only tonally limited by the maximum reflectance of highlights offered by the screen, and the dilution of darkest shadows by stray light. Try projecting a lantern slide in a poorly blacked out room; complete the blacking out and notice the improvement in image shadow gradation.

Far behind the tonal range of the transparency comes the glossy, white-based paper print. Particular forms of viewing illumination can visually extend its tone range by increasing maximum black. For example, exhibited glossy prints should be lit from a source high above, so that all specular reflectance is directed down at the floor. The wall behind the viewer should be dark in tone to reduce light reflectance from the print towards him, which would otherwise degrade shadows.

An amazing improvement in print tonal range is seen when a print is illuminated by spotlight in a darkened room. The spotlight should be masked down to cut illumination sharply at the picture edges. The print now appears to have a tonal range almost equal to a projected transparency.

The limited tonal values of matt papers are least affected by viewing illumination. Such prints can therefore be used where viewing conditions are otherwise unfavourable, e.g., large areas of illumination from many directions.

Remembering that our eyes judge 'black' and 'white' against immediate points of reference, the tone of a mount surrounding a print will influence its impact. On a black mount whites appear more brilliant but shadows risk the appearance of a comparative grey. A cream based print on a white mount appears to have strong yellow highlights, and so on.

Looking back through past chapters we can summarise the main factors which control tonal or 'contrast range' of the final viewed result:

- (a) The lighting range on the subject.
- (b) The subject reflectance properties.
- (c) Scatter of light by the lens or camera bellows.
- (d) Negative emulsion: grain size and contrast, coating thickness.
- (e) Level of exposure.
- (f) Gamma of development and characteristics of developing agents.
- (g) Characteristics of printing equipment, size of enlargement.
- (h) Printing emulsion grade, base, surface.
- (i) Level of printing exposure.
- (j) Degree of print development and developing agent characteristics.
- (k) Mount influence and final viewing conditions.

Chapter Summary - Printing and Finishing

- (1) The visual quality of the client's final print is controlled by negative quality, printing materials and equipment, exposure control, development, and final presentation.
- (2) Negative spotting is an emergency not a routine. Blocking out and 'ghost' masking allow background modifications impossible during shooting.
- (3) Chloride (contact printing) emulsions are inherently slow, fast developing and contain agents giving blue blacks. Chlorobromides have faster, warm-tone characteristics controlled by development. Bromide materials give neutral blacks and are fastest of all printing emulsions.
- (4) Emulsion contrast grade is an indication of the tonal *gradient* between black and white. Actual intensity of maximum black is controlled by print surface; white by reflectance of the paper base.
- (5) Paper tonal characteristics largely compensate for tone distortions on a 'correctly exposed' negative. Under or overexposed negatives may not print with acceptable gradation throughout all tones.
- (6) Highly glazed glossy prints offer high-density blacks, as incident light is reflected in one direction. Matt-surfaced paper diffusely reflects light in all directions giving dark grey maximum densities.
- (7) Rear-illuminated transparencies offer maximum tone range; projected transparency range is limited by screen reflectance (highlights), efficiency of black-out (shadow dilution).
- (8) Paper base colour influences visual brilliance of image highlights, base thickness determines physical strength, and 'feel'. Prints on plastic coated bases have greatest dimensional stability, and also process/wash/dry faster than ordinary (absorbent) paper base.
- (9) Type of negative illumination within an enlarger influences negative printing contrast, reproduction of grain, emulsion blemishes, and some visual sharpness. Diffuse light sources produce 'contact' contrast prints, minimising retouching.
- (10) A condenser illumination system gives maximum differential between dense and clear negative areas due to light scatter plus absorption (Callier) effect of the silver image. A true point source condenser system gives maximum Callier-effect, but requires lamp refocusing for every new lens position, hence the wide use of opal lamps to provide some latitude.
- (11) Enlarger condensers must exceed negative diagonal, with focal length related to the enlarger lens.
- (12) Controls during enlarging allow introduction of greater or less local density, overall contrast, blur, 'softer' definition, multiple images. Abstract tonal patterns created by light modulation with actual objects are termed 'photograms'. Black and white transparencies are formed by printing negatives on to film.
- (13) Print developing must be sufficient to form acceptable 'blacks', without creating noticeable fog level or stains.
- (14) Fixer should not be shared with negatives owing to soluble salts absorption into

base and risk of bleaching. Two fixing baths offer greatest fixing efficiency.

- (15) Rapid processing papers contain their own developing agents; development is by alkali application. Owing to stabilisation, image life is reduced.
- (16) Successful glazing of glossy, paper based prints depends upon a properly prepared glazer surface, firm squeegeeing, tension whilst evenly drying.
- (17) Dry (shellac) mounting presents a permanent professional finish, 'seals' prints to mount, but requires temperature controlled equipment. Other methods include rubber gum, double-sided tape, spray adhesive and, for large display prints, impact adhesive or wallpaper paste.

Questions

- (1) Assuming you have a first-class negative to print, what precautions would you take to ensure that an enlargement of good quality is made from it?
- (2) If you were asked to make a hundred prints the same size as the negative, and the negative required some shading, what method of printing and precautions in processing would you adopt to ensure that all the finished prints were identical?
- (3) Draw diagrams of the optical and illumination systems of:
 - (a) a condenser enlarger,
 - (b) a diffuser enlarger.
 - Which would you use to make a print from a heavily retouched negative? Why?
- (4) Under certain conditions the correct exposure is found to be 1/200 sec at f/11; the normal development time for this film is 10 min at 20°C in a certain developer.
 - (a) Negatives A, B, C and D have been exposed and developed as shown in the table below. Describe the appearance of each negative and suggest which grade of printing paper would give the most satisfactory result in each case.
 - (b) What failing would you expect to find in the print made from negative C?

Negative A	Exposure		Development time at 20°C
	1/200	f/11	7 min
В	1/50	f/11	10 min
C	1/200	f/22	10 min
D	1/200	f/22	15 min

- (5) Discuss the modifications to final image appearance which are possible by controls during the actual exposure of an enlargement.
- (6) Draw and label the following:
 - (a) the characteristic curves of soft, normal, and hard grades of glossy bromide paper;
 - (b) the characteristic curves of a normal grade bromide paper having matt, semi-matt, and glossy surfaces.
- (7) Thorough washing and careful drying of negatives and prints are of great im-

- portance. Outline the requirements, emphasising any particular difference in the treatment of negatives and prints. (Tests for adequate fixing and washing are not required.)
- (8) Describe subject matter which might benefit from being printed on each of the following:
 - (a) Matt paper.
 - (b) Cream based paper.
 - (c) A transparent base (for rear-illumination viewing).
- (9) Give one reason for each of the following faults in bromide prints:
 - (a) Blisters.
 - (b) Small white irregular spots with sharp edges.
 - (c) Circular white spots with sharp edges.
 - (d) Large irregular yellow stains.
 - (e) Print too dark.
 - (f) Print too light.
 - (g) General fog all over the print.
 - (h) Print from a sharp negative unsharp overall.
 - (i) Print from a sharp negative unsharp in parts.
- (10) Explain the steps necessary to adjust for optimum efficiency a $5 \text{ in } \times 4 \text{ in condenser}$ enlarger to take 5 cm square negatives. Suggest suitable values for the lenses in each case. List all the differences one might see in prints made from the same negative by
 - (a) a condenser enlarger, and
 - (b) a diffuser enlarger.

REVISION QUESTIONS COVERING SECTION III – PROCESSING THE RECORD

(A simple glossary of chemicals mentioned throughout this book appears on page 383.)

- (1) Describe the layout, facilities and equipment of a printing room intended for producing prints up to 40.6 cm × 50.8 cm from 4 in × 5 in commercial and industrial negatives. Outline the arrangements desirable in an adjacent washing glazing room to handle up to 500 8 in × 10 in prints per day.
- (2) Draw the characteristic curve of a medium speed panchromatic material normally developed in M.Q. developer. Indicate the portions of the curve occupied by normally exposed, under exposed and over exposed negatives. Describe the appearance of prints made from each of these negatives on normal bromide paper.
- (3) Give ONE photographic use for FIVE of the following chemicals:
 - (a) Phenidone,

- (b) sodium sulphite,
- (c) sodium sulphide,
- (d) formalin solution,
- (e) chrome alum,
- (f) potassium dichromate,
- (g) sulphuric acid.
- (4) List the features that you consider essential in an enlarger.
- (5) Describe the likely visual results of each of the following:
 - (a) Processing a negative in hydroquinone caustic instead of P.Q. developer.
 - (b) 'Blocking out' a negative before enlarging.
 - (c) Shifting the paper slightly during enlarging exposure.
 - (d) Placing the negative in the enlarger emulsion upwards.
 - (e) Failing to agitate a sheet film during tank development.
- (6) Research details of two currently available processing machines suitable for the professional studio:
 - (a) to process black-and-white negatives,
 - (b) to process permanent black-and-white prints.
 - Compare their performance against conventional processing in terms of capital costs, running costs, time saved, flexibility, quality and consistency.
- (7) What is the purpose of the fixation process? Describe the advantages gained by the use of an acid fixing bath in comparison with plain fixer.
- (8) Describe the various methods of glazing prints. Give a list of the chief troubles, with their causes, liable to be encountered during glazing operations.
- (9) (a) Convert 86°F into °C.
 - (b) How much potassium metabisulphite is contained in 25 cc of a 2% solution?
 - (c) State the chemical (not quantities) and method of mixing a dish cleaning solution.
 - (d) How would you prepare a 13.5 litre tank of 1% acetic acid from a 2.5 litre bottle of 10% acetic acid stock?
- (10) Given a normally processed continuous tone 6 cm square rollfilm negative describe your technique for producing a finished 8 in × 10 in *negative* paper print.
- (11) Describe the main practical features of the following materials or solutions used in the darkroom:

Stabilisation papers
High contrast developer
Stop bath with indicator
Monobaths.

SECTION IV

SUBJECT AND STATEMENT

First, the Governor, the Father;
He suggested velvet curtains
Looped about a massy pillar;
And the corner of a table
Of a rosewood dining table.
He would hold a scroll of something,
Hold it firmly in his left hand;
He would keep his right hand buried
(Like Napoleon) in his waistcoat;
He would contemplate the distance
With a look of pensive meaning. . . .

... from 'Hiawatha's Photographing' by Lewis Carroll.

XIX. PHOTOGRAPHY IN PRACTICE

In Sections I to III we have looked at some of the principles and procedures of photographic technique. The optics of image forming, the mechanics of the camera, the simple chemistry of processing — is this all that goes to make up photography?

The danger of every textbook – certainly of every theory examination – is that the photographic *process* becomes exaggerated out of all proportion to its true contribution to the final visual result. At its worst this leads us to judge photographs only in terms of their *technical* quality – like the literary critic who seizes on punctuation and ignores the plot.

The photographic process is only one step - a link between what the photographer originally saw and selected, and a permanent, graphic record. Hence, photography in its broad sense is aptly described as 'seeing for keeps'. Until now we have been looking closely at the 'keeps', noting particularly what controls the photo-process offers over final visual results. In this final chapter we can discuss just a few aspects of 'seeing' and perhaps put the photographer's visual ability and technical manipulations into some sort of realistic perspective.

The Purpose of Photographs

Whatever his assignment, the photographer must begin by being sure in his own mind why the picture is being taken. The purpose may be humble — a copy, a simple catalogue illustration. It may be more nebulous — a picture to communicate 'security', 'happiness', 'quality'. No writer would pick up his pen not knowing whether he is commencing a short story or a data sheet. Yet a photographer can easily set up his equipment, carefully consider exposure and check focus, with scarcely a glance at the subject, or thought for the interpretation his picture should make.

Because photography is a means to a visual end the purposes to which it is put vary enormously. If document copying is placed at one end of a 'spectrum' of uses, and decorative non-representational photograms at the other, we see that many applications bear no relation to one another other than some shared use of the photographic process. For convenience we can say that each type of photography requires differing proportions of

- (a) objectivity based on scientific disciplines and technology, and
- (b) subjective interpretation, born through the photographer's personal outlook and knowledge of life, his visual maturity and experience of communicating.

DOCUMENT COPYING or microfilming (photography of documents on to narrow-width film) demands rigorous control of illumination, image resolution, exposure level – aiming for facsimile reproduction. Results are completely standardised; the photographer acts as quality controller and technical adviser. To the scientist,

photography represents a visual notebook. He will use it to record rapid or extremely slow occurrences, to measure light spectra, etc. He requires a high degree of skill to select or improvise appropriate photographic procedures based on firm knowledge of scientific principles.

The photographer handling *report illustrations* aims at factual, maximum information pictures. He may record information revealed through a microscope (photomicrography), or produce magnified images through close-up work with the camera alone (macrophotography). In each case his final photographs are scaled, clean clinical records in keeping with the technical content of a report.

The simple catalogue illustration also has a factual function, plus a degree of sales evaluation. Such photographs will obviously show the product in a favourable light, but must do so in a simple way — the budget is usually slim and final reproduction size small. Passport portraiture involves similar predominance of objectivity.

PRESS PHOTOGRAPHY of the hand-shaking, tape-cutting, speech-making variety is objective in its news content, subjective in the photographer's choice of moment. Architects demand more than good technical building records. The *architectural* photographer must subtly stress important features of design and environment.

PORTRAITURE at its best presents visual evidence of the sitter's character and 'attitudes' as well as his or her physical features. We are now considering those applications where the photographer's own interpretation and influence are increasingly more important than the faithful recording ability of the photographic process, for a photograph can make the sitter look strong or weak, ugly or beautiful, it can satisfy his self-image or the public image he may wish to create.

Photo-Journalism – picture series collectively forming a visual story – not only records events, but comments upon them. The photographer investigates and visually reports to the magazine reader. He must evaluate people, and entire social or political situation . . . he must have 'something to say'.

The 'hard sell' advertising picture presents a product in an attractive and appropriate environment, calculated to make the reader visually associate it with social status, good taste, etc., etc. The product is generally prominent. Soft sell advertising pictures set out to promote the product through an intermediary situation (e.g., a country picnic, to encourage desire to be out and about, and therefore promote petrol sales). Photography may also be used to create a visual impact and draw attention to copywriting. Here, the photographer must work closely with others in a creative advertising team. Top flight advertising photography calls for the highest perceptive levels and sophistication of approach.

Finally we have those forms of photography that are unrestricted by the client's message, or the reportage of facts — in essence photographs that are pictures in their own right. They may range from highly interpretative photographs of actual subjects to light patterns projected direct on to sensitive material. Here the results are essentially original and the photographer's freedom of interpretation is limited only by his own imagination and the characteristics of silver halide. Such pictures may be sold direct

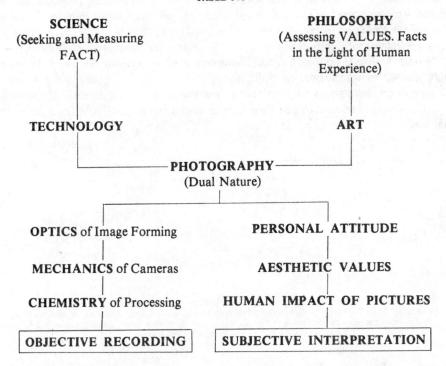

PREDOMINANTLY OBJECTIVE ('Spectrum' of applications) PREDOMINANTLY SUBJECTIVE

Copying		Illustration	al		п (2		Journalism			onistic prints, etc.)
Document	Scientific	Report Illus	Architectur (Record)	Press	Architectual (Building & Environmen	Portraiture	Photo-Jour	Advertising (Hard Sell)	Advertising (Soft Sell)	Expressionistic (Gallery prints,

through galleries, or have applications as book jackets, record covers, posters and fabric designs.

Several broad fields of photography have been omitted from our 'spectrum' as such because they are themselves indefinable. Industrial photography, for example, embraces almost every application discussed, related to the neds of one organisation. Amateur photography ranges from 'Notebook' camera use for recording family events, to many specialised applications where photography is combined with other hobbies.

CONCLUSIONS. There is a vast 'spectrum' of reasons for making photographs. All demand varying proportions of technical expertise and imaginative thinking. Through them the photographer serves society.

No application of photography is 'better' than another; they are merely different. It would be as foolish to approach report illustration in an advertising manner as to handle photo-journalism with formal scientific procedure.

As photographers we owe it to ourselves and the client to first discover the intended application of our work. We can then turn to assessing the subject in the light of this final use.

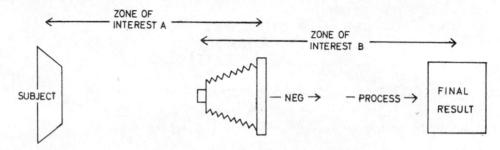

Fig. 19.1. The Wrong Approach is to become preoccupied with one zone of interest to the exclusion of the equally important other zone. Too often a technically adequate photograph is poorly designed, lit and meaningless because the photographer was insensitive to the visual possibilities of his subject. Equally, pictures of immense portent are maimed by lack of technical ability.

Subject Evaluation

In common with the rest of society in complicated modern life, the photographer too often takes objects for granted. There is too little time to spare. Preoccupied with the considerable technicalities of photography — worrying about sharpness, exposure, processing ... Discouraged by the 'recording of reality' action of photography into feeling that we are really only camera minders, unable to do much about the subject anyway ... We can be 'corrupted' into a state where we no longer really look at the things about us.

Have you really examined that table, that nearby ashtray, your own fountain pen? Imagine that you had just arrived from another planet, and having never experienced these objects before set out to evaluate them. Try jotting down a list of the qualities you notice particularly about the table. It has its own particular 'form' (shape, construction, proportions); it has colour and tone values; it has texture and pattern; it has weight and warmth.

Every object has individuality, and every photographer will form his own analysis, giving his own priorities. There are no academic 'rights' and 'wrongs' about this evaluation. It is personal to you — an opportunity to express individual opinion rather than remaining a recording machine-minder.

We are all stimulated when we have a change of environment - a trip abroad, a visit

to an unusual factory. Here we are seeing new things, therefore making new evaluations. After a while the environment becomes commonplace, objects grow too familiary. We lose interest. The young child examines (bites and presses) each new material it meets. Naively it too is making evaluations — hard, soft, warm, sweet. The outstanding photographer always retains the ability to look *freshly* at subjects and situations.

This need for 'visual perception' applies particularly to subjective fields of photography. It also applies to objective applications in that we must intelligently understand the significance of the visual evidence which must be recorded. The objective photographer is therefore aided by a background knowledge of science, engineering or whatever is his field of activity, the subjective photographer by experience of life, human attitudes, and the creative work of others.

But in evaluating subject qualities we must not overlook the *purpose* of making the picture. Is it to promote a product, a mood, a situation? This will influence the priorities given to subject qualities – perhaps suppressing some completely.

EXAMPLE 1. We have to produce a picture advertising an assortment of sweet biscuits. The subjects have prominent *textures*, shapes. They are also sweet, and brittle. The biscuits are to be associated with 'tea-time'.

We would organise a visual situation suggesting tea, emphasising the variety and texture, shape and sweetness of the product, and possibly suppressing brittleness.

EXAMPLE 2. A picture is required of a block of flats. It will form the cover of a brochure for intending flat purchasers. The building is crescent shaped, contains large windows, symmetrical balconies. It is flanked by a factory and a row of shops.

Here we would try to stress the interesting shape and texture of the building; also indicate the presence of convenient shops, but avoid any visual reference to the factory.

This is all really only common sense, but results from thought about the subject long before the camera is even set up. Perceptive evaluation marks effective photography from mere technical competence. No 'rules' of evaluation can of course possibly be applied here, but as a guide we might consider every subject we meet in terms of 'FACT':

F - 'Form' (its shape, size, construction).

A - Attitude (the final purpose of the photograph).

C - Colour and tone qualities.

T - Tactile or touch qualities.

Conclusions. Subject familiarity breeds blindness to its fundamental qualitities. If we can evaluate every subject as if for the first time and equate this to the purpose of the picture we arrive at a 'visual requirement'. Knowing what we want to put over we can now select the appropriate technique to give this interpretation. Here, the writer would turn to words, the artist to paint, the sculptor to clay. We turn to the optics and chemistry of photography.

Interpretation Through Photography

How best can we use the photographic process? First let us recognise its limitations. It can only suggest sound, smell or taste by implication; movement and radiant il-

lumination by symbols (blur and flare respectively); space via perspective, focus and lighting. Monochrome reproduction obviously limits its interpretation of colours.

Photography offers superb accuracy and speed of drawing, and allows wide modifications of tone values. It allows detailed concentration by isolating one object or part of an object. Photography has an air of authenticity, and although we know what manipulations are possible, many observers will trust a photograph where other media would be suspect.

In attempting to convey appropriate subject qualities through photography we use the following main controls: (1) Viewpoint and arrangement within the format; (2) tone values, controlled by lighting, emulsion and processing; (3) sharpness; (4) timing.

VIEWPOINT AND FRAMING. By forming steeply converging or diverging subject lines angularly arranged within the format we can suggest dynamicism. The viewer tends to associate them with his own experiences of instability and movement. Parallel vertical and horizontal lines, with their association with buildings, give a more static, stable impression.

A single subject placed dead centre in the frame may be visually satisfactory if symmetry is an important quality – but generally this arrangement is boring. An interesting psychological point concerns the framing of moving subjects – runners, vehicles, etc. When such such a subject is shown at one side of the frame with an open area in front of it, the viewer assumes motion has just started – there is a long way to go. If the subject is closely facing a format edge with space behind it, an impression of 'leaving' and of frustrated further movement results.

Direction and arrangement of picture component shapes within the format have no fixed rules. Providing the picture purpose is firmly understood the subject should be framed up in a camera viewfinder until it visually appears satisfactory. Before the final printing stage two 'L' shaped cards moved around over a contact print allow us to check the effect of various croppings and format proportions. These are both fine ways of developing your own sense of appropriate framing.

Any so-called 'rules of composition' do not exist in practice, for subjects, picture purposes and photographers themselves create too many variables. Placing subjects and choosing viewpoint is basically a matter of design, common to all visual media. Take pictures, look at pictures (including paintings, television, posters), discuss pictures. Finally – trust your own developing visual judgement.

Tone values. The main contribution of tone value control is in implying mood, allowing subject emphasis. Dramatic visual impression, often sombre, serious, can be achieved by the rim highlights and rich shadows of backlighting. 'Low key' (i.e., predominantly dark toned) pictures are frequently used to dramatise heavy industry. 'High key', predominant use of light tones, is appropriate for simplicity, cleanliness, gaiety. Hence child portraiture is often handled in this key.

It is extraordinary how easily we 'read' information into pictures by implication of lighting. A main light from below the face in portraiture immediately conveys footlights or light from a fireplace — a certain mysticism and dramatism. The same face lit with a main light from above, plus reflector, is immediately associated with 'natural' (i.e., sun

plus sky) lighting. Low direct lighting across a breakfast table contributes to a sunny morning mood and so on.

Subject shape is emphasised by major differences of tone between subject and background. To do this the subject might be suspended on a glass sheet above a separately lit background, or so separated that light subject areas appear against dark background tones to give tonal interchange. Space rendition is emphasised by similar lighting arrangements — combined with other depth symbols such as steep perspective, and differential focus.

Subject texture appearance can be greatly exaggerated or almost erased by harsh side lighting, or flat diffuse illumination from the camera. Where lighting is unalterable we can go part of the way to imply these qualities by choice of negative and paper contrast (this will, however, affect contrast over the whole format and not allow the same local controls).

Don't be deceived by sensitometry into assuming that visual tone effects can all be predetermined by density calculation. Sensitometry is useful for comparing performance, monitoring processing, ensuring facsimile photographic reproduction under laboratory conditions. But when we come to practical photography and actual images our visual 'reading' of final densities is strongly influenced by what we know of the subject. Photograph an ice cream near a window; photograph it again in a dark corner of the room. On one print the ice may be white, in the other grey density – yet we accept both as white because we know ice cream is white.

This subjective aspect must be borne in mind when distorting tonal values of commonplace objects. Make your ice cream a black silhouette if you wish graphically to show its shape – but if only taken to a dark grey it simply looks like a badly printed objective record.

SHARPNESS. Limited depth of field allows us *locally* to concentrate the area of importance, contribute to depth, 'plasticise' forms by out-of-focus rendition. We can create 'gentle', 'soft' moods (particularly appropriate for soaps, etc.) by overall optical diffusion.

TIMING. Our choice of the moment of exposure and its duration enable us to create a whole range of visual impressions of moving subject matter. The same subject photographed simultaneously with six cameras at differing shutter speeds will be reproduced with six entirely different indications of speed. The choice of moment of exposure allows us the enormous advantage over other visual media of retaining the vital part of the action, or the momentary expression. This is a very important means of implying attitudes and situations, through *isolation in time*.

For example, a newspaper may keep a photographic file of a prominent politician – showing him looking happy, glum, preoccupied, even stupid. Many were just momentary expressions during speeches or on some other public occasion. When a political situation arises, appropriate choice of portrait can be made to add strength to the nature of the newspapers' report.

Taking our four main aspects of *subject evaluation*: Form, Attitude, Colour and tone, Tactile qualities, we can apply to each in turn our four main channels of *photographic interpretation*: Viewpoint, Tone values, Sharpness, Timing. Around a structure of this

type we might build our own individual philosophy on visual communication through photography – a major part of photography in practice.

Chapter Summary - Photography in Practice

- (1) Photography 'Seeing for keeps' demands intelligent seeing as well as technique.
- (2) There are no rules, no fixed procedures to 'seeing'. It is largely flavoured by our own attitudes and experience.
- (3) Every subject sets us a visual problem. As a three-stage method of producing an effective final photograph: (a) Establish the purpose of the picture, (b) evaluate subject qualities in the light of this purpose, (c) choose the most effective photographic controls to convey these qualities.
- (4) The time-honoured topic 'Is photography an Art?' misses the whole point of photography. One might equally ask 'Is writing literature?' Photography now has such wide applications that it offers major contributions both to science and art.
- (5) The ultimate test of a photograph might be 'Does it communicate the idea the author intended' no matter whether the picture was created to please himself or to carry information between third parties. As with every other media of communication, if it arouses no emotions or offers no information to the viewer the photograph fails relative to that viewer. This is as near as we can get to defining 'good' and 'bad' in photography.

Practical Projects

- (1) Draw up a sincere list of the qualities you see as important in a fairly abstract material wax, clay, cork, etc. Having expressed these qualities in terms of writing, now make one photograph of the subject for each quality as far as possible suppressing all other qualities. The pictures should therefore form visual substitutes for the words.
- (2) Produce photographs of a sawn block of wood, each of which conveys *one* of the following qualities:
 - (a) textures,
 - (b) shape,
 - (c) weight,
 - (d) colour.
- (3) Photograph a mousetrap twice, each picture meeting one of the following briefings:
 - (a) To provide an objective illustration in a catalogue distributed to ironmongers.
 Horizontal format.
 - (b) To provide a poster advertising the mystery play 'The Mousetrap'. (The picture simply and dramatically to draw attention to the title.) Vertical format. Work on the basis of purpose, qualities, appropriate technique.

VISUAL APPROACH

(Previous pages) Three pictures illustrating some of the visual controls most frequently used by the photographer.

Plate 90 Concrete roofing. A picture which is compositionally satisfying by its sweep-in lines and unsymmetrical figures (viewpoint and arrangement).

Plate 91 Rock texture. Powerful expression of tactile qualities through harsh tone values, controlled by lighting.

Plate 92 Typewriter advertisement. Angular, mathematical arrangements. Diffuse lighting giving shadowless 'clean' tone values... the result is an emphasis on the product's streamlined design points, and a sophistication appropriate to the intended readership.

SUBJECT QUALITY

(These pages) Even the most matter-of-fact object has individuality—a range of fundamental qualities. In this case a common stone has been portrayed in four ways by a photographer in an attempt to express four separate qualities—Plate 93 (top left)—Shape; Plate 94 (bottom left—Texture; Plate (95 top right)—Weight; Plate 96 (bottom right)—Inhumanity or coldness. Awareness of subject qualities is fundamental to photography.

Two pictures which might be considered the subjective and objective 'ex-tremes' of photographic Plate 97 (Left) Photogram, produced on bromide paper with pieces of card under the enlarger. The photograph here is an end Plate 98 (Right) Report illustration (flow lines in a steel casting). The camera used as an objective 'visual notebook'. (R. Plate 99 (Overleaf) Ten pin bowling. Viewpoint and arrangement, simpli-fied tone values, differ-ential sharpness, and isolation in time all contribute to a fine piece of photo-graphic design. (London College of Printing)

SUBJECTIVE—OBJECTIVE

application.

in itself.

Evans)

- (4) Using any subject (or no subject at all) produce pictures representing the following qualities: Rough texture; waterproof; sharp; three-dimensional depth.
- (5) Produce five pictures which portray one of the following concepts:
 - (a) power,
 - (b) space,
 - (c) growth.

en de la graficación de Servicio para de la fila de la compandión de la fila de la fila de la fila de la fila La fila de la graficación de la fila de la f La fila de la fila de

> iderpala Valorites (B) Bossilia

APPENDICES

APPENDIX A

RECOMMENDED READING

The literature of photography can be divided into technical and visual aspects. Technical books are of five main types (1) Practical advice for the beginner or amateur photographer (2) Deeper coverage of a particular aspect for the advanced amateur or professional — exposure, development, enlarging etc. (3) Manuals and textbooks (like this one) covering the underlying principles. (4) Reference books for 'dipping into' for definitions and encyclopedic data. (5) Scholarly works advancing scientific knowledge of one specific aspect. This bibliography suggests titles within the first four categories. These books are being continually updated because equipment and materials of photography are steadily being developed and improved. So try to read the latest editions.

The intense growth of interest in photography by the Arts world has, since the early 1960s, resulted in a flood of books on the visual aspects of the subject. They greatly contribute to visual understanding of the medium. Those in this bibliography represent a wide cross-section of subject approach and style. Many of the photographers are not professionals in the commercial sense, but their pictures influence all serious workers. Some of the work may appear ambiguous and difficult to 'read' at first, but working through these titles via the library or bookshop will help you to develop a broad visual vocabulary, and discover some memorable images. Remember too that outstanding commercial and advertising photography appears more often on posters, in magazines and on record sleeves, than in books. It is a 'throw-away' medium. Consequently try to see a range of current periodicals on a regular basis — some suggested titles are given here.

Photography is a universal medium and most picture books at least are available world-wide, even though they often appear under different publishers in America and in Europe. (In Britain most foreign published photography books are available from the Photographers Gallery Ltd., 8 Great Newport Street, London, W.C.2.) A number of non-profit making organisations such as The George Eastman House, Rochester, NY. and the British Arts Council publish reprints of fully illustrated exhibition catalogues.

If ordinary books don't provide the answer to a technical problem, the enquiry services offered by photographic material manufacturers and professional journals may do so. A growing range of photography is also published in audio-visual rather than book form. For example, there are series of tape-synchronised slide sequences in which well-known photographers show their work and discuss the philosophical background to their pictures.

Clearly any serious student of photography owes it to himself to explore the whole range of photographic information and identify the most helpful sources of reference. Technical and visual stimulus acquired in this way can only enrich the development of individuality.

STARTERS-FOR YOUNG PEOPLE AND BEGINNERS

Craven, G. Object and Image - An Introduction to Photography. Prentice-Hall (New York) 1975.

EMANUEL, W. D. The All-in-One Camera Book*. Focal Press (London) 1976.

GAUNT, L. Commonsense Photography. Focal Press (London) 1975.

LANGFORD, M. J. Starting Photography*. Focal Press (London) 1976.

WRIGHT, C. Pocket Money Photography*. Piccolo (London) 1975.

TECHNICAL ASPECTS

TIME-LIFE, ed. The Camera. Time-Life Books (New York) 1973.

STROEBEL, L. View Camera Technique, Focal Press (London) 1972. Hasting House (New York).

ADAMS, A. Camera and Lens. Morgan & Morgan (New York) 1970. Fountain Press (London).

TIME-LIFE, ed. Light and Film. Time-Life Books (New York) 1973.

ADAMS, A. Natural Light Photography. Morgan & Morgan (New York) 1965. Fountain Press (London).

PETZOLD, P. Light on People in Photography. Focal Press (London) 1971.

TIME-LIFE, ed. The Studio. Time-Life Books (New York) 1974.

BERG, W. F. Exposure. Focal Press (London) 1971.

WHITE, M. The Zone System Manual*. Morgan & Morgan (New York) 1968.

Feininger, A. Darkroom Techniques Vols. I & II*. Prentice-Hall (New York) 1972. Thames & Hudson (London).

JACOBSON, C. I. & R. E. Developing. Focal Press (London) 1976.

TIME-LIFE, ed. The Print. Time-Life Books (New York) 1974.

JACOBSON, C. & MANNHEIM, L. Enlarging. Focal Press (London) 1975.

TIME-LIFE, ed. Colour. Time-Life Books (New York) 1974.

MANUALS AND TEXTBOOKS

FEININGER, A. The Complete Photographer. Prentice-Hall (New York) 1966. Thames & Hudson (London).

JACOBSON, R. ed. The Manual of Photography. Focal Press (London) 1977.

LANGFORD, M. J. Advanced Photography*. Focal Press (London) 1974.

NEBLETTE, C. B. Photography: Its Materials & Processes. Van Nostrand (New York) 1962.

SWEDLUND, C. Photography—A Handbook of History, Materials & Processesú. Holt, Rinehart & Winston (New York) 1974.

REFERENCE WORKS

FOCAL PRESS LTD. The Focal Encyclopedia of Photography desk edition. Focal Press (London) 1969. McGraw-Hill (New York).

PITTARO, E. M. ed. Photo-Lab Index. Morgan & Morgan (New York) 1973.

SPENCER, D. A. The Focal Dictionary of Photographic Technologies. Focal Press (London) 1973.

PROFESSIONAL PRACTICE

HYMERS, R. P. The Professional Photographer in Practice. Fountain Press (London) 1973.

LANGFORD, M. J. Professional Photography. Focal Press (London) 1974.

LINSSEN, E. F. Photography in Industry. Fountain Press (London) 1970.

HISTORY

BEATON, C. The Magic Image. Weidenfeld & Nicolson (London) 1975.

Gernsheim, H. & A. A Concise History of Photography*. Thames & Hudson (London) 1965. McGraw-Hill (New York).

POLLACK, P. The Picture History of Photography. Abrams (New York) 1970.

TAFT, R. Photography & The American Scene*. Dover (New York) 1964.

BOOKS OF PHOTOGRAPHS

ADAMS, A. Yosemite Valley. Ward Ritchie (New York) 1963.

Diana Arbus. Aperture (New York) 1972. Penguin Press (London).

AVEDON, R. Observations. Simon & Schuster (New York) 1959. Weidenfeld & Nicolson (London).

Bill Brandt. Museum of Modern Art (New York) 1969.

Wynn Bullock. Scrimshaw (U.S.A.) 1971.

CARTIER-BRESSON, H. The World of Cartier-Bresson. Viking (New York) 1968. Thames & Hudson (London).

DAVIDSON, B. East 100th Street*. Harvard University Press (U.S.A.) 1970.

DURRELL, L. Intro. Brassai. Museum of Modern Art (New York) 1968.

Robert Doisneau's Paris. Simon & Schuster (New York) 1956.

Frederick Evans*. Aperture (New York) 1972.

FRANK, R. The Americans*. Aperture (New York) 1969.

FRIEDLANDER, L. Self Portrait*. Haywire (New York) 1970.

HAAS, E. The Creation. Viking (U.S.A.) 1971.

HASKINS, S. Cowboy Kate & Other Stories. Bodley Head (London) 1965. Crown (U.S.A.).

HINE, L. Lewis Hine Portfolio. G. Eastman House (U.S.A.) 1970.

KARSH, Y. Karsh Portfolio. Nelson (London) 1967.

André Kertész 1912-72. Grossman (New York) 1966. Thames & Hudson (London).

Dorothea Lange. Museum of Modern Art (New York) 1966.

LARTIGUE, J. H. Diary of a Century. Weidenfeld & Nicolson (London) 1970.

McCullin, D. Is Anyone Taking Any Notice? M.I.T. Press (U.S.A.) 1971.

NEWMAN, A. One Mind's Eye. Godine (U.S.A.) 1974. Secker & Warburg (London).

PENN, I. Moments Preserved. Simon & Schuster (New York) 1960.

RAY-JONES, T. A Day Off. Thames & Hudson (London) 1974.

STEICHEN, E. Family of Man*. Simon & Schuster (New York) 1955.

STERN, B. The Photo Illustration*. Thames & Hudson (London).

TIME-LIFE, ed. The Great Thames. Time-Life Books (New York) 1971.

TIME-LIFE, ed. The Best of Life. Time-Life Books (New York) 1973.

TURNER, P. P. H. Emerson: Photographer of Norfolk*. Gordon Fraser (London) 1974.

Jerry N. Uelsmann*. Aperture (New York) 1970.

Edward Weston: Photographer. Aperture (New York) 1965.

WHITE, M. Mirrors, Messages, Manifestations. Aperture (New York) 1969.

PHOTOGRAPHS AND COMMENT IN AUDIO-VISUAL FORM

Henri Cartier-Bresson; W. Eugene Smith; Bruce Davidson; Cornell Capa; Don McCullin etc. (Slide sets with photographers own recorded commentary). Produced by Scholastic Magazines (New York 1975 for the International Fund for Concerned Photography.

PHOTOGRAPHIC PERIODICALS

Aperture. Quarterly. Aperture Inc. New York.

Amateur Photographer. Weekly. Iliffe, London.

British Journal of Photography. Weekly. H. Greenwood & Co. Ltd. London.

Camera. Monthly. C. J. Bucher Ltd. Lucerne.

Creative Camera. Monthly. Coo Press Ltd. London.

Industrial & Commercial Photographer. Monthly. Distinctive Pubs. London.

Industrial Photography. Monthly. U.B.P. New York.

Ovo Magazine. Bi-monthly. Arts Council of Canada, Quebec.

Popular Photography. Monthly. Ziff-Davis. New York.

ANNUALS

British Journal of Photography Annual. London.

Creative Camera International Yearbook. London.

Photographis. Zurich.

PERIODICALS MAKING EXTENSIVE USE OF PHOTOGRAPHY

Architectural Review. Monthly. London.

Graphis. Quarterly. Zurich.

Harper's Bazaar. Monthly. New York.

Paris Match. Fortnightly. Paris.

Vogue Magazine. Monthly. London & New York Editions.

^{*} Available in paperback.

APPENDIX B

QUICK CONVERSIONS

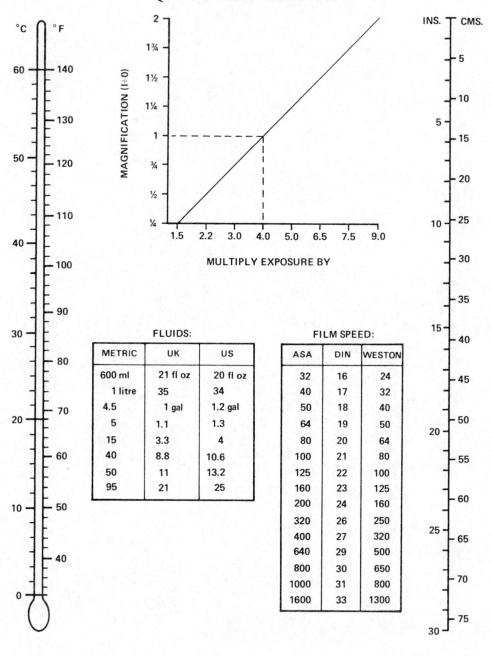

APPENDIX C

RECAPPING LOGARITHMS

When multiplying a number by itself, such as ten multiplied by ten, this can be written 10×10 , or 10^2 : 2 is then said to be the power or 'logarithm' to the base 10 of the number 100. Similarly 3.0 is the log to the base 10 (\log_{10}) of 1,000, 4.0 the \log_{10} of 10,000 and so on.

Logs to the base 10 are known as 'common logarithms'. Logs to other bases may be used, e.g., \log_2 of 16 = 4.0 ($16 = 2 \times 2 \times 2 \times 2$ or 2^4). We can say then that the log of a figure is the number of 'bases' (commonly the base 10) which multiplied together equals the figure.

Simple Use in Mathematics

Instead of multiplying two numbers we can find their logarithms, then simply add these to find the log of their product.

e.g., Multiply 8.493 by 3.746. Log tables tell us that

the \log_{10} of 8.493 is 0.9291

and log₁₀ of 3.746 is 0.5736

their sum is

1.5027

and tables show this to be the log₁₀ of 31.82 Answer.

NUMBERS:

C.1. Logarithmic progressions covering an identical range of numbers.

Use in Photography

- (a) To reduce 'doubling' series of numbers to manageable form. In plotting the performance or 'characteristic curve' of an emulsion it is necessary to scale the exposure axis in doubling multiples, equally spaced. This is conveniently achieved without running into high numbers, by using, \log_{10} of the figure involved. Since \log_{10} of 2 is 0.3 a series of doubling real numbers are spaced out 0.3 apart on the log scale.
- (b) Log scales are also used in certain speed systems to avoid otherwise very high figures when quoting for a wide range of sensitivities. DIN, BS and Scheiner use a $\log_{10} \times 10$ progression in which a doubling of sensitivity is indicated by an increase of 3, tenfold speed increase by an increase of 10, etc.

For convenience in plotting characteristic curves two figure \log_{10} tables are published below:

Numbe	r Log ₁₀	Numbe	$r Log_{10}$	Numbe	$r Log_{10}$	Number	Log10
1.00	0.00	1.82	0.26	3.31	0.52	6.03	0.78
1.02	0.01	1.86	0.27	3.39	0.53	6.17	0.79
1.05	0.02	1.90	0.28	3.47	0.54	6.31	0.80
1.07	0.03	1.95	0.29	3.55	0.55	6.46	0.81
1.10	0.04	2.00	0.30	3.63	0.56	6.61	0.82
1.12	0.05	2.04	0.31	3.72	0.57	6.76	0.83
1.15	0.06	2.09	0.32	3.80	0.58	6.92	0.84
1.18	0.07	2.14	0.33	3.89	0.59	7.08	0.85
1.20	0.08	2.19	0.34	3.98	0.60	7.24	0.86
1.23	0.09	2.24	0.35	4.07	0.61	7.41	0.87
1.26	0.10	2.30	0.36	4.17	0.62	7.57	0.88
1.29	0.11	2.34	0.37	4.27	0.63	7.76	0.89
1.31	0.12	2.40	0.38	4.37	0.64	7.94	0.90
1.35	0.13	2.46	0.39	4.47	0.65	8.13	0.91
1.38	0.14	2.51	0.40	4.57	0.66	8.32	0.92
1.41	0.15	2.57	0.41	4.68	0.67	8.51	0.93
1.45	0.16	2.63	0.42	4.79	0.68	8.71	0.94
1.48	0.17	2.70	0.43	4.90	0.69	8.91	0.95
1.51	0.18	2.75	0.44	5.01	0.70	9.12	0.96
1.55	0.19	2.82	0.45	5.13	0.71	9.33	0.97
1.59	0.20	2.88	0.46	5.25	0.72	9.55	0.98
1.62	0.21	2.95	0.47	5.37	0.73	9.77	0.99
1.66	0.22	3.02	0.48	5.50	0.74	10.0	1.0
1.70	0.23	3.09	0.49	5.62	0.75	100	2.0
1.74	0.24	3.16	0.50	5.75	0.76	1.000	3.0
1.78	0.25	3.23	0.51	5.89	0.77		

APPENDIX D

ANSWERS TO CALCULATION QUESTIONS CONTAINED IN THE TEXT OF THIS BOOK

Page 50 (Chapter II)

- Q. 3. Magnification = times 2.
- Q. 5.

Focal Length	Lens to Subject Distance	Lens to Image Distance	Linear Magnification
20-3 cm	40.6 cm	40-6 cm	1
25 cm	75 cm	37.5 cm	1/2
20 cm	20 cm	Infinity	
10 cm	15 cm	30 cm	2
25 cm	50 cm	50 cm	1

- Q. 6. Distance = $5 \cdot 1$ m
- Q. 7. (a) 50 mm tube
 - (b) 25 mm tube
 - (c) 75 mm plus 25 mm tubes.
- Q. 8. Distance = 122.5 cm

Page 64 (Chapter III)

- Q. 2. (a) Using $(M + 1)^2$ Exposure = 4 sec (b) 23 sec
- Q. 5. $12\frac{1}{2}$ sec

Page 92 (Chapter V)

- Q. 4. (d) (1) 20 mm (2) 34 mm
- Q. 6. (b) 1.25 m

Page 157 (Revision Questions Section I)

- Q. 8. 36 sec
- Q. 9. Focal length = 76 mm

Page 192 (Chapter X)

-	7	7	
1	J.	4	

Film Speed	Light Value	Stop (f/no.)	Shutter Speed
400 ASA	400	f/22	1/250
	200	f/16	1/250
	100	f/11	1/250
	50	f/8	1/250
	400	f/16	1/500
	200	f/16	1/250
	100	f/16	1/125
	50	f/16	1/60
200 ASA	400	f/16	1/250
100 ASA	400	f/22	1/60
25 ASA	400	f/11	1/60
5 ASA	13	f/22	10 sec

Page 226 (Chapter XII)

Q. 1. 3 kW draws 12 amps 500 W draws 2 amps Six 500-W spotlights One 2-kW spotlight

Page 250 (Chapter XIII)

- Q. 1. (a) Film A
 - (b) Film C
 - (c) Films A or B
 - (d) Film C only
 - (e) Gamma = 1.0
 - (f) A = 0.2
 - B = 0.13
 - C = 0.05

Page 268 (Chapter XIV)

- Q. 1. (a) 1/200 sec
 - (b) 1/25 sec
- Q. 4. 105 cm and 60 cm.
- Q. 6. 5 sec

Page 270 (Revision Questions Section II)

Q. 1.

В	C	
10 min	15 min	
0.8	1.0	
0.07	0.14	
1.12	1.4	
	10 min 0·8 0·07	10 min 15 min 0.8 1.0 0.07 0.14

Q. 6.

- (a) Three 1-kW spotlights
- (b) $18\frac{3}{4}$ sec
- (c) 1.44
- (d) 16 sec
- Q. 9. 4 sec.

Page 287 (Chapter XV)

- Q. 1. (a) 225 cc of acid required.
 - (b) 100 cc of 10% stock required.
- Q. 3. 13.5 gm; 225 gm; 54 gm; 310 gm; 18 gm.
- Q. 4. (a) 1.5 gm
 - (b) $6\frac{1}{8} \sec$
 - (c) $\frac{1}{2}$ sec
- Q. 5. 3 kg sodium thiosulphate, 600 gm potassium metabisulphite, 1875 gm anhydrous hypo.

Page 356 (Revision Questions Section III)

- Q. 9. (a) 30°C
 - (b) 0.5 gm
 - (d) 200 cc of stock required.

APPENDIX E

SIMPLE SUMMARY OF PHOTOGRAPHIC CHEMICALS APPEARING IN THE TEXT

Developing agent—poor keeping properties. Amidol

Acid stop-bath. Used to acidify fixing bath - usually Acetic Acid (Glacial)

> with sodium sulphite. Rapid fixing agent.

Ammonium Thiosulphate

Preservative in acid fixers. 'Buffer' for weak acid Boric Acid

solutions, e.g., Acid Fix.

Weak alkali - fine-grain developers. 'Buffer' for weak **Borax**

alkaline solutions.

Developing agent, warm-tone print developers. Chloroquinol

Green coloured hardening agent – short working life. Chrome Alum Formalin (formaldehyde)

Hardening agent generally used prior to develop-

ment.

Development agent - contrast, density building. Hydroquinone

Alkali - similar to borax. 'Kodalk'

Developing agent - soft working. Metol Nitric Acid Solvent of silver to form Silver Nitrate.

Developing agent, non toxic, concentrated, similar 'Phenidone'

action to Metol.

Potassium Alum Hardening agent.

Emulsion ingredient (soluble halide), restrainer, by-Potassium Bromide

product of development.

Dish cleaner with sulphuric acid.

Potassium Bichromate

(potassium dichromate)

Acidifier of fixing baths, preservative, stop-bath, Potassium Metabisulphite

stain clearer.

Potassium Iodide

Test for fixing bath exhaustion, soluble halide.

Dish cleaner with sulphuric acid, test for image Potassium Permanganate

permanence.

Sodium Carbonate Alkali in developing solutions.

Alkali - rapid working developers. Sodium Hydroxide Preservative.

Sodium Sulphite Additive to spent fixing baths to reclaim silver, test Sodium Sulphide

for image permanence.

Fixing agent (Hypo). Sodium Thiosulphate Soluble silver emulsion ingredient. Silver Nitrate

Silver halide. Silver Iodide Silver halide. Silver Chloride Silver halide. Silver Bromide

Sulphuric Acid

Dish cleaner with potassium permanganate.

(N.B. Some of these chemicals have further photographic applications which are beyond the terms of reference of the present book.)

APPENDIX F

BRITISH CENTRES FOR PHOTOGRAPHIC EDUCATION

(based on a survey by the Society for Photographic Education).

Full-time Degree Courses in Photography

MA (RCA) Royal College of Art, Kensington Gore, London, S.W.7.

B.Sc. Photo-Science, Polytechnic of Central London, Riding House Street, London, W.1.

B.A. Photographic Arts, Polytechnic of Central London, Riding House Street, London, W.1.

B.A.(Hons.) Photographic Arts, London College of Printing, Elephant and Castle, London, S.E.1.

Full-time Three-year College Diploma and Vocational Courses

Birmingham Polytechnic School of Photography, Dorrington Road, Birmingham B42 1OR

Blackpool Technical College, Photographic Department, Park Road Annexe, Blackpool.

Bournemouth & Poole College of Art & Design, Lansdowne, Bournemouth, Dorset.

Derby College of Art & Design, School of Photography, Kedleston Road, Derby.

Ealing Technical College, St. Mary's Road, Ealing, London, W.5.

Glasgow College of Printing, North Frederick Street, Glasgow C1, Scotland.

Harrow College of Technology & Art, School of Photography, Watford Road, Northwick Park, Harrow, Middlesex.

North East London Polytechnic, Longbridge Road, Dagenham, Essex.

Salisbury College of Art & Design, School of Photography, New Street, Salisbury, Wiltshire.

Swansea College of Art, Alexandra Road, Swansea, Glamorgan.

Trent Polytechnic, Waverly Street, Nottingham.

West Bromwich College of Commerce & Technology, Department of Photography, Wednesbury, Staffordshire.

West Surrey College of Art & Design, Department of Photography, Farnham, Surrey.

Full-time B.A. Graphic Design or Fine Art Courses with Extensive Photographic Facilities.

Cardiff College of Art

Leeds Polytechnic

London College of Printing

Sheffield Polytechnic

Coventry College of Art

Central School of Art, London

Medway College of Art, Rochester

Manchester Polytechnic Wolverhampton Polytechnic (Intending students should check current course programmes.)

Part-time (Evening or Day Release) Vocational Photographic Courses.
Blackpool College of Art
Berkshire College of Art, Reading
Glasgow College of Printing
Gloucester College of Art & Design
Plymouth College of Art
Paddington Technical College, London, W.2.
Twickenham College of Technology, Twickenham, Middx.
West Bromwich College of Art, Wednesbury, Staffs.

UNITED STATES CENTRES GRANTING DEGREES WITH MAJOR EMPHASIS IN PHOTOGRAPHY

(The type of degree in photography offered is shown in brackets)

Alabama—Spring Hill College, Mobile. (A.A.)

University of Alabama. (B.A., B.S., B.F.A., M.F.A., M.A.)

Arizona—Phoenix College. (A.A.)

Arizona State University. (B.A., B.S., M.F.A., B.F.A.)

California—Art Center College of Design, Los Angles. (B.F.A., M.F.A.)

Bakersfield College (A.A.)

Brooks Institute, Santa Barbara. (B.F.A.)

California State College, Fullerton. (B.A., B.S., M.A., M.S.)

California College of Arts & Crafts, Oakland. (B.F.A., M.F.A.)

Chico State College. (B.A., B.S.)

Citrus Community College, Azusa. (A.A.)

City College of San Francisco. (A.A.)

College of Marin, Kentfield. (A.A.)

Cypress College. (A.A.)

De Anza Junior College, Cupertino. (A.A.)

East Los Angeles College. (A.A.)

El Camino College. (A.A.)

Fresno State College. (B.A., B.S., M.A., M.S.)

Laney College, Oakland. (A.A.)

Los Angeles City College. (A.A.)

Los Angeles Trade-Technical College. (A.A.)

Los Angeles Valley College. (A.A.)

Merritt College, Oakland. (A.A.)

Orange Coast College, Costa Mesa. (A.A.)

Pasadena City College. (A.A.)

San Francisco State College. (B.A., B.S., M.A., M.S.)

San Fernando Valley College, Northridge. (B.A., B.S.)

San Jose State College. (B.A., B.S., M.A., M.S.)

Santa Monica College. (A.A.)

San Joaquin Delta College, Stockton. (A.A.)

University of California at Davis. (B.F.A., M.F.A.)

Colorado — Colorado Mountain College. (A.A., A.S.)

Florida—Florida Technological University, Orlando. (B.A., B.S.)

Palm Beach Junior College, Lake Worth. (A.A., A.S.) University of Florida, Gainesville. (B.F.A., M.F.A.)

Georgia—Georgia State University, Atlanta. (M.F.A., B.F.A.)

University of Georgia, Athens. (M.F.A., Ph.D., D.Ed., B.F.A.)

Illinois—College of Du Page, Glen Ellyn. (A.A.)

Columbia College, Chicago. (B.A., B.S., M.A., M.S.)

Bradley University, Peoria. (B.F.A.)

Illinois Institute of Techology, Chicago. (B.F.A., M.F.A., B.A., B.S.)

Triton College, River Grove. (A.A., A.S.)

Mundelein College, Chicago. (B.A., B.S.)

Southern Illinois University, Carbondale. (B.A., B.S.)

University of Illinois, Chicago. (B.A., B.S.)

Iowa—Hawkeye Institute of Technology, Waterloo. (A.A.)

Kansas-University of Kansas, Lawrence. B.A., B.S., M.A., M.S.)

Kentucky—University of Louisville. (B.A., B.S.)

Louisiana — Louisiana Technical University, Rustion. (B.F.A.)

Northeast Louisiana University, Monroe. (B.A., B.S., M.A., M.S.)

Massachusetts—Endicott Junior College, Boston. (A.A.)

Hampshire College, Amherst. (B.A., B.S.)

Maryland—Maryland Institute College of Art, Baltimore. (B.F.A., M.F.A.)

Michigan—University of Michigan, Ann Arbor. (B.F.A., M.A., M.S., M.F.A.)

Wayne State University, Detroit. (B.A., B.S., B.F.A.)

Minnesota—St. Cloud State College (A.A., B.A., B.S.)

University of Minnesota, Minneapolis. (B.A., B.S., B.F.A., M.A., M.S., M.F.A.)

Missouri-Kansas City of Art Institute. (B.F.A.)

Northwest Missouri State College, Maryville. (B.F.A.)

Southwest Missouri State College, Springfield. (B.F.A.)

Montana-Montana State University, Bozeman. (B.A., B.S.)

New Mexico—University of New Mexico, Albuquerque. (B.A., B.F.A., M.A., M.F.A.)

New York—City University of New York, York College, Flushing. (B.A., B.S.)

Cooper Union Art School. (B.F.A., M.F.A.)

Fashion Institute of Technology. (A.S.)

Pratt Institute, School of Art & Design. (B.F.A., M.F.A.)

Rochester Institute of Technology. (A.S., B.A., B.S., M.S., B.F.A., M.F.A.,

Ph.D., D.Ed.)

State University of New York, College of Plattsburgh. (B.A., B.S.)

State University of New York, College at Buffalo. (B.F.A., M.F.A.)

State University of New York, College at New Paltz. (B.F.A., M.F.A.)

Syracuse University. (B.A., B.S., M.S.)

Nebraska—University of Nebraska, Lincoln. (B.F.A., M.F.A.)

North Carolina—Randolph Technical Institute, Asheboro. (A.S.)

Ohio-Antioch College, Yellow Springs. (B.A., B.S.)

Art Academy of Cincinnati. (B.A., B.S.)

Ohio State University, Columbus. (M.A., M.S., M.F.A., Ph.D., D.Ed.)

Ohio University, Athens. (B.F.A., M.A., M.S., M.F.A.)

Oregon—Linfield College, McMinnville. (B.A., B.S.)

Oregon State University, Corvallis. (B.A., B.S.)

Pennsylvania—Community College of Philadelphia. (A.A.)

Philadelphia College of Art. (B.F.A.)

South Carolina—Clemson University. (M.F.A.

Tennessee—East Tennessee State University, Johnson City. (M.F.A., B.F.A.)

Memphis Academy of Arts, Memphis. (A.A., B.F.A.)

Texas—Cisco Junior College. (A.A.)

Texas Woman's University, Denton. (M.A., B.A., B.S.)

Sam Houston State University, Huntsville. (B.A., B.S.)

Utah—Utah State University, Logan. (B.A., B.F.A.)
Washington State—Everett Community College. (A.A.)
Spokane Falls Community College, Spokane. (A.A.)
Wisconsin—Milwaukee Technical College. (A.A., A.S.)

Up to date information on these and a much larger number of non-degree courses appear in A Survey of Motion Picture, Still Photography, and Graphic Arts Instruction by Dr. C. William Horrell. (Eastman Kodak publication T-17.)

INDEX

A4 size, 172	Brightness range of subject, 229
ASA, 182, 375	'Brightness range' meter readings, 259
Abberrations, 51	British schools of photography, 385
Abrasion Marks, 169	Bromide printing papers, 328
Absorption curves (filters), 194	Bromide – soluble, 289
Absorption of light, 25	'Buffer', 312
Accelerator – developer, 290	Bullet , 312
Acetic acid, 310	00 - 05 204 255
Acid fixer, 311	°C to °F, 296, 375
Acid hardener fixer, 312	Cadmium sulphide (CdS) cell meters, 255
Acid stop bath, 310	Calculators
Aerial image, 36	depth of field, 89
Aerial oxidation, 291	exposure, 254
After-ripening, 166	'Callier Coefficient', 337
Agitation of developer, 299	'Callier Effect', 337
Air bells, 303	Camera filters, 179
Albada viewfinder, 126	Camera movements, 95, 96
Albumen, 163	combined use of, 106
Alkali – developer component, 290	summary, 108
American schools of photography, 386	Camera shake, 120
Amidol, 290	Camera shutters, 111
Ammonium thiocyanate, 313	speeds, 118
thiosulphate, 313	Camera systems, 152
Amperes, 223	Camera types – general, 124
Angle of view, 65, 67, 69	Cameras, 123
and perspective, 69	aerial, 151
	direct vision, 125, 126
Angstrom units, 21	choice of, 153, 155
Anhydrous chemicals, 282 Answers to questions, 379	field, 149
	macro, 151
Anti curl layer, 169 Anti halation dye, 169	micro, 151
Aperture, 55	monorail, 146
effective, 55	panoramic, 151
relative, 57, 58	process, 151
	selection for job, 153
Argentothiosulphates, 309 Autofocus enlargers, 335	single lens reflex, 136, 137, 141, 150
	special types, 150
Automated diaphragms, 60	stand, 146
Average Gradient (G), 239 Axis of lens, 41	studio, 149
Axis of letis, 41	summary, 153, 155
	technical baseboard, 141
B.S., 182	technical monorail, 146
'B' shutter setting, 118	twin lens reflex, 131, 150
Bag bellows, 147	view, 149 (see also technical)
'Barndoors', 213	underwater, 152
'Baryta' coating, 171	Capacity conversions, 283, 375
Bellows extension (see close-up)	Care of lenses, 74
Bending of light (see refraction)	Cartridge (film), 175
Black borders – printing, 342	Cascade print washer, 346
Bladed or diaphragm shutter, 113, 114	Caustic Hydroquinone developer, 293
Blocking out, 326	Caustic Potash (see Potassium Hydroxide)
Blue sensitive emulsion, 185	Characteristic curves, 228, 235, 240, 247
Blur, 120	printing papers, 329, 330, 344
Books on photography, 371	Chemical substitution, 282
Borax, 290	Chemical mixing, 284, 286
Boric acid, 383	Chemicals and solution preparation, 281
'Bounce' lighting, 218	Chemicals, weighing out, 283

Chemicals – summary, 383	Depth of field, 83, 84, 87
Chloride printing papers, 328	calculating, 91
Chlorobromide printing papers, 328	calculators, 89
Chloroquinol, 290	comparison with depth of focus, 88, 91
Chrome alum, 312	practical significance, 85
Circles of confusion, 79, 80	and swing back, 104
Citric acid, 310, 319	and swing front, 101
	Depth of focus, 80, 81, 82
Cleaning of lenses (see care of lenses)	
Cleaning of dishes, 319	comparison with depth of field, 88, 91
'Click' stops, 334	practical significance, 82
Clocks – darkroom, 279	Desiccated chemicals, 282
Close up and exposure, 61	Developer
and focusing, 43	agitation, 298, 299
Coating of emulsions, 167	caustic-hydroquinone, 293
Cold cathode light source, 335	changes with use, 295
Cold glazing, 348	condition, 295
Collodion, 164	content, 294
Colour filters, 193 (see also filters)	dilution, 296
Colour – light, 22	emulsion capacity, 295
Colour sensitivity of emulsions, 185	high contrast, 293
of eye, 184	keeping properties, 296
Colour separation filters, 202	M.Q., 292
Complementary colours, 200	P.Q., 293
Compound lenses, 51	replenisher, 295
focal length, 52	temperature, 296
summary, 63	time, 298
Condensation	types, 291
on lenses, 75	Developing agents, 298
on materials, 176	Developing tanks, 302
Condenser enlarger, 335	Development, 289
layout, 338	centres, 289
Condenser, relationship to enlarger lens, 339	controls – summary, 300
Conjugate distances, 44	degree of, 294
Contact papers, 328	effect on Characteristic Curve, 242
Contrast of emulsions, 179	and emulsion type, 300
Contrast filters, 199	evenness, 298
practical application, 201	latitude, 343
Contrast Index, 239	'pushing', 298
Contrast Index, 259 Contrast Index/Time curves, 304	of printing materials, 343
Contrast – negative, 237	practical technique, 301
Contrast of printing papers, 329	summary, 305
Converging lens (see simple positive lens)	technique – printing, 344
Converging meniscus – shape, 47	time of, 298
Converging verticals, 97	Diaphragm or bladed shutter, 113
Conversion °C to °F, 375	Dichroic fog, 309
'Correct' exposure, 238, 258	Differential focus, 85
Correction filters, 197	Diffraction, 34
Courses in professional photography, 385	Diffuse density, 337
Covering power of lens, 65, 66, 67	Diffuse lighting, 216
and swing front, 101	Diffuse reflection, 25
test for, 66	Diffuser enlargers, 335
Cross front, 98	Diluting percentage solutions, 285
Crystaline chemicals, 282	Dilution by part, 284
'Cut off' – front movements, 101	Dilution from stock, 285
Cut on - front movements, 101	
DIN 192	Direct transmission, 26
DIN, 182	Direct vision cameras, 125, 130
D log E curve (see characteristic curves)	Direct vision viewfinder, 49, 126
Darkroom layout, 275	Dish cleaning, 319
summary, 281	Dish development, 301
Delayed action shutter, 115	Dishes and tanks, 302
Densitometer – transmission, 232	Dispersion of light, 29, 30
reflection, 331	Distortion of perspective (see perspective)
Density, 232	Distortion – wide angle, 72
maximum, 240	Diverging lenses, 47

Diverging meniscus – snape, 47	tact strip 252
Double extension, 43	test strip, 253
Double weight paper, 333	Exposure meters, 254, 255
Drop baseboard, 142	extinction type, 254, 255
Drop front, 98	incident light attachment, 263
Dry mounting, 348	photometer, 257, 258
'Dry' and 'Wet' benches, 277	separate, 256
Dryers for prints, 347	through-the-lens, 257, 263
Drying, 318	Exposure values, 119
Drying marks, 318, 319	Extinction meters, 254, 255
Drying plastic coated papers, 347	Eye, colour sensitivity, 184
Dye sensitising, 167	optics, 123
F	05 +- 05 206 275
Effective aperture, 55, 56	°F to °C, 296, 375
Effective F number, 62	F numbers, 58
Electrical loading, 223	effective, 62
Electro magnetic energy, 19	and exposure, 60
Electro magnetic spectrum, 21, 23	scales, 58
Electronic shutter, 114	'Fall off' – covering power, 67
Emulsion	Falling front (see drop front)
coating, 167	Faults in negatives, 320
colour sensitivity, 185	in prints, 351
contrast, 179	Field cameras, 146 (see also technical cameras)
formula, 165	Field, depth of (see depth of field)
grain-size, 166	Field of lens (see covering power)
ripening, 166	Filing of negatives, 321
silver halide, 165	Film base, 168
speed, 182, 184	Film coating, 168
Emulsions	Film speed conversions, 375
choice of, 179, 189, 191	Films,
home made, 165	roll, 174, 302
high contrast, 180	sheet, 173
manufacture of, 165, 177	Film packs, 174
for printing, 327	holders, 144
resolving power, 180	speeds, 184
Endothermic temperature reaction, 284	choice of, 184
Energy, radiant, 19	Filters, 27, 193
Enlarger, 334	care, 203
autofocus, 335	camera, 179
basic optics, 334	colour, 193
condenser systems, 338	colour separation, 202
negative illumination, 335	contrast, 199
negative illumination summary, 339	correction, 197
setting up, 340	factors, 203
Enlarging, 340,	graduated sky, 202
image control, 341	haze, 202
Equipment for printing, 334	neutral density, 202
Equivalent focal length, 52	polarising, 203
Examination questions (see 'Questions')	qualities, 203
Exothermic temperature reaction, 284	safelight, 194
Exposure	special purpose, 202
close up, 61, 375	summary, 197, 205
'correct', 238, 258	transmission, 193
and F numbers, 60	U-V absorbing, 202
and lamp distance, 264	viewing, 202
latitude, 245, 246	Finishing of prints, 350
practical problems, 265	First ripening, 166
Exposure measurement, 252, 258	Fixation, 311
brightness range readings, 259, 261	Fixation of printing materials, 345
factors determining level, 252	Fixer
factors modifying readings, 264, 375	acid, 311
general readings, 259	acid hardener, 312
key tone reading, 262	exhaustion test, 314
summary, 266	mixing, 311

plain, 311	time curves, 299, 304
prints, 345	'Gee bar' (G), 239
rapid, 313	Gelatin, 163
regeneration, 314	hardening of, 312
Fixing, 309	softening of, 297
technique, 315, 345	General meter readings, 259
temperature, 315	Grades of paper, 329
test of, 317	Graduated filters, 202
time-factors, 313	Graduated sky filters, 202
two bath, 315	Glazing – cold, 348
summary, 316, 323	Glazing – hot, 347
Flash	Glossy paper, 332
tubes (electronic), 214	GOST, 182
bulbs, 214	Grades – paper, 329
cubes, 215	Grains – and irradiation, 181
Flash synchronisation and shutters, 115, 214	Grain size – ripening, 166
Flat bed glazers, 347	Ground glass screen (see focusing screen)
'Flattened' perspective, 70	grand grand (over to busing serven)
Floodlamps, 217	H and D curves (see characteristic curves)
Floating lid, 293	Halation, 181
'Flowmarks', 299	'Half watt' filters, 199
'Flush' mounting, 250	'Half watt' lighting, 211
Focal length, 38, 39	Halides, 165, 167
calculation (see conjugate distances)	Halogens, 165
compound lens, 52, 53, 54	Hardening, 312
compound - summary, 55	Hasselblad camera system, 152
of condenser, 339	Haze filters, 202
diverging lens, 48	Helical screw focusing, 127
long focus lens, 74	High contrast developer, 293
and perspective, 70	High contrast materials, 180
and image size, 39, 40	'High key', 366
of simple lens, 38	Human eye, 123
wide angle lens, 72	Hydroquinone, 290, 292, 293
Focal plane, 36	Hyperfocal distance, 90
Focal plane shutter, 115, 116	Hyperfocal point, 90
distortion, 117	'Hypo' (see sodium thiosulphate)
Focus (see point of focus)	Hypo elimination, 346
Focus, depth of (see depth of focus)	
Focusing screen, 36, 37	Illumination 'fall off', 24
close-up work, 43	Image brightness, 55
direct vision camera, 126	Image conjugate, 42
rangefinder, 139	Image formation
single lens reflex, 138	calculation (see conjugate distances)
technical baseboard camera, 142	negative lenses, 48
thick glass filters, 204	pinhole camera, 33
twin lens reflex, 132	positive lenses, 35
'Fog', chemical, 290	Image principal plane, 52
dichroic, 309	Image-size, 39, 40
light, 320	calculation (see conjugate distances)
Fog level, 240	construction, 41
Formalin (formaldehyde), 383	magnification, 42
Format sizes, 173	virtual, 43
Frame finder – twin lens reflex, 131	Incident light meter attachments, 263
'Fresnel' lens, 212	Inert materials – processing, 280
Fresnel screen, 133, 134	Infinity, 39
Front movements (see Rising front, etc.)	Infra red, 21
Front swings, 100, 101	Integral reflector lamps, 211
Fuses, 223	Interpretation through photography, 363
	Instant picture processes, 322 (see also Polaroid)
Gamma (y), 234, 236, 237	Inverse square law, 24, 264
and development, 298, 299	and close-up exposure, 61
and wavelength, 237	Iodine, 161
infinity, 298	Iodine Quartz (see Tungsten Halogen lamps)
rays, 20	Iris diaphragm, 60

Irradiation, 181	deployment of, 219
그 이렇게 잃었다면 그 그 그 모든 그리고 없다.	electrics, 222
Journals, photographic, 373	for copying, 265
	for detail, 221
'Kettle' - emulsion, 165	'hard' sources, 209
'Key' (see 'high key' or 'low key')	for texture, 220
'Key tone' meter readings, 262	indirect, 219
이번 경기 가게 가장하게 얼굴하다 나 모든 그는 모든	principles, 219
Lamp distance and exposure, 264	quality, 209
Lamp life, extension of, 224	'soft' sources, 216
Lamps	sunlight, 215
caps, 211	tungsten, 210, 225
cold cathode, 335	summary, 225
'half-watt', 211	'Line' developers, 293
handling care, 213	emulsions, 180
integral reflector, 211	Liquid hardener, 313
'over-run', 211, 217	Lith paper, 328
photopearl, 217	Log exposure (see characteristic curves)
prefocus, 211	Log E axis, 230, 234
projection, 225	Logarithms, 377
tungsten halogen, 210	Long focus lenses, 73
Large format camera, 141, 146	'Low key', 364
Latent image, deterioration, 289	
Latitude – development, 298	MQ formulae, 292
exposure, 245	Machine processing
printing paper development, 343	negatives, 303
Lens	prints, 346
angle of view, 65, 67	Magnification
axis, 36	and exposure, 62, 375
calculations, 41, 44	linear, 42
cap, 112	Magnifying glass, 43
care, 74	Manufacture of emulsions, 165, 177
cleaning (see care of lenses)	Masked negative carriers, 334
covering power, 65, 67	Masking – negatives, 326
focal length, 38, 39	Materials inert to processing solution, 280
of human eye, 123	Maximum black of printing paper, 332
sets, 71	Maximum density, 240
shapes, 47	Maximum permissible circle of confusion (see circles of
simple (summary), 40	confusion)
Lenses	Maximum white of printing paper, 332
compound, 51	Meters (see Exposure Meters)
enlarging, 334	Metol, 290, 292
enlarging, relation to condenser, 339	Metol poisoning, 301
long focus, 73	Mirrors, photography of, 99
negative, 47	Mixing chemicals, 281
normal angle, 73	Monobaths, 322
positive, 47	Monohydrate chemicals, 282
simple, 34, 35	Monorail cameras, 146
compound (summary), 63	unusual designs, 150
summary, 49	Mounting
wide angle, 71	dry, 348
Libraries, 371	prints, 348
Light, principles of, 19	rubber, 349
absorption, 25	transparencies, 351
dispersion, 29	Movements, camera, 95
inverse sq. law, 24	Moving light, 218
reflection, 25	
refraction, 27	Nanometer (nm), 21
summary, 30	'Narrow cut filter', 199
transmission, 26, 193	Negative lens – shapes, 47
Light traps, darkroom, 278	Negative preparation for printing, 325
Light values (see exposure values)	Negative spotting, 326
Lighting, 209	Negatives
accessories, 213	density range, 330

faults, 320 hydroxide, 293 filing, 321 iodide, 165 Neutral density filters, 202 metabisulphite, 291, 310 'Newton's Rings', 351 permanganate, 319 Nitric Acid, 165 'Pre-focus' lamps, 211 Nitrogen burst agitation, 300 Practical experiments, 365 Nodal points of lens, 52, 53 'Pre-view' button, 138 'Non colour sensitive' emulsions, 185 Prepacked chemicals, 282 'Normal' angle lenses, 73 Preparation of solutions, 281 Notch coding (films), 169 Preservative - developer, 291 Presoaking, 303 Object conjugate, 44 Principal focal point, 41 Object principal plane, 52 Principal planes, 52 Opacity, 231 Principal points, 52 Optic nerve, 123 Printing quality - factors affecting, 325 Optical centre, 36 Printing, 327 Optical flats, 203 Printing equipment, 334 'Ordinary' emulsions, 185 Printing and finishing, 325 Orthochromatic emulsions, 185 Printing and finishing summary, 353 Ostwald ripening, 166 Printing materials 'Overrun' lamps, 224 base and surface, 331, 332 Oxidation - of developer, 289, 291, 295 characteristics, 327 'Oyster' marks, 336 contrast, 329 image colour, 327 stabilisation, 346, 347 PEC Meter design, 246 pH values, 290, 312 transparencies, 328, 342 Printing papers P.Q. Formulae, 293 Packaging of materials, 173 bromide, 328 'Painting' with light, 218 chloride, 327 chlorobromide, 328 Panchromatic emulsions, 186 'Panning' moving subjects, 121 contact, 327 Paper coating, 170 lith, 328 Papers (see printing papers) thickness, 333 Parallax plastic coated, 171 compensation, 132 Printing - processing, 343 'correction' (twin lens reflex), 133 Print washing, 346 separation, 125 drying, 347 Paraphenylene diamine, 290 finishing, 350 PE paper (see plastic coated paper) Prints, faults, 351 Pentaprism, 138, 139 Prints, viewing conditions, 351 Percentage solutions, 285 Prisms, 35 Percentage transmission, 193 Projection lamps, 211 Perspective, 69, 70 Projection printer (see Enlarger) correct reproduction of, 71 Processing, 275 'Phenidone', 290, 293 rack, 302 Photo-electric cell, 255 tank, 299, 302 'Photoflood' lamps, 217, 225 by machine, 303, 346 Photograms, 342 'Purkinie shift', 185 'Photographic' lamps, 217, 225 Purpose of photographs, 361 Photographic schools, 385 Pyro, 290 Photometer, 257, 258 'Pushing' development, 298 Photons, 19 Pinhole images, 33 'Q factor', 337 Plain fixer, 311 Quartz iodine lamps (see tungsten halogen lamps) Plastic coated paper, 171, 347 Question answers, 379 Plates, 170, 175 Questions, 31, 49, 64, 76, 92, 108, 122, 154, 177, 191, Point source enlarger, 338 205, 226, 250, 267, 268, 287, 306, 324, 354, 355, Polarising filters, 203 Polaroid process, 322 Radiant energy, 19 'Portrait' cameras, 149, 150 Positive lens (see simple positive lens) Radar, 21, 23 Rainbow, 29 Positive lens shapes, 47 Potassium alum, 312 Rangefinder, 128 bromide, 165 coupled, 129, 142

storage, 175 focusing screen, 138 summary, 177, 191 moving wedge, 129 Sensitometry, 228 'split image', 139 information through, 247 Rapid fixers, 313 Ratio of reproduction - and exposure, 61, 375 summary, 249 'Series B' lamps, 225 Rays, 19 Series/parallel wiring, 225 RC paper (see plastic coated paper) Shading Rear nodal point, 52 contact printing, 341 and image shift, 103 enlarging, 341 Rebate, 320 Reciprocity law failure, 183 Shapes of lenses, 47 Sharpness, standards of, 79 Reducing agent, 279 Shellac mounting, 348, 349 Reflection densitometer, 331 Shutter speed selection, 118, 119 Reflection of light, 25 Shutters Reflectors, 211, 216 Reflex (single lens), 136, 137, 141 early, 111 electronic, 114 Reflex (twin lens), 131, 135 Refraction, of light, 27, 28 delayed action, 115 focal plane, 115 Refractive index, 29 general construction, 111 Regeneration of fixers, 314 Relative aperture, 57 summary, 121 within or near lens, 113 Replenisher, 295 Resolving power - emulsion, 180 Silicon cell exposure meters, 256 Silicone fluid - glazing, 348 Restainer - developer, 291 Reticulation, 315 Silver bromide, formation, 165 Silver halides, 161, 162 Retina, 123 Retouching medium, 326 Silver nitrate, 165 Silver sulphide, 316 Retouching - prints, 350 Silver reclaiming from fixers, 314 negatives, 326 Silver, use in photography, 165 Revolving back, 144 Ripening of emulsion, 166 Simple positive lens, 34 evolution of, 35 Rising front, 97 focal length of, 38 Roller blind shutter, 111, 112 summaries, 40 Roller processing - printing materials, 346 Rollfilm, 174, 302 Single lens reflex, 136, 141 Rollfilm back, 144 Sinks - darkroom, 277 Sizes of film, paper, 172 Rotary glazers, 347 Snoots, 213 Rotating stops, 59 Sodium carbonate, 290 'Rotation' of stock, 176 anhydrous/crystal substitution, 283 Royal Photographic Society, 371 Sodium hydroxide, 290, 293 Rubber mounting, 349 Sodium safelights, 196 Sodium sulphide, 317, 383 SLR (see single lens reflex) Sodium sulphite, 291 Safelight filters, 194 anhydrous/crystals substitution, 283 Safelights, 279 Sodium thiosulphate, 309, 311 positioning, 196 anhydrous/crystal substitution, 283 testing, 196 Soft focus - enlarging, 342 Safety film, 168 Same-size photography, 43 Solution preparation, 281 summary, 286 Scale focusing, 127 Scheimpflug principle, 106, 107 Special purpose filters, 202 Spectral sensitivity of eye, 185 Schools of Photography, 385 Schulze, Johann, 161 Spectrograph, 186 Spectrum - visible, 21, 23 Scum on negatives, 318 Sealed beam lamps, 214 Specular density, 337 Specular reflection, 332 Second ripening, 166 Sector shutter, 111, 112 Speed - of emulsions, 182 Sector wheel, 230 Speed rating systems, 182 arithmetic, 182 Selective masking, 326 comparisons of, 182, 375 Selective reflection, 25 and exposure, 183 Selective transmission, 26 logarithmic, 182 Selenium cell meters, 255 Special camera design, 150 Sensitive materials Spotlight optics, 212 preparation, 165

'Spotting' transparencies, 351 Transparencies Spotting of negatives, 326 finishing, 351 of prints, 350 printing, 342 Stabilisation, 313, 346, 347 Transparency tonal range, 352 Stabiliser, 303, 346 Trays (see dishes) Stand cameras, 146 Tungsten filament lamps, 210 Steepened perspective, 71 Tungsten halogen lamps, 210, 211 Step wedge, 230 Twin lens reflex, 131, 135 Stock solutions, 285 Two bath fixing, 315 Stop bath, 310 'Stopping down', 58 Ultra violet, 21 'Stops' (see also Waterhouse and Rotating), 59 U-V absorbing filters, 202 Storage of materials, 175 Underrun lamps, 225 'Streamers', 299 Uneven density - negatives, 321 'Strobes' (see flash, electronic) Uneven development, 298 Studio cameras, 149 'Unit' of electricity, 224 Style of mounting, 350 Unsharpness - negatives, 321 Subject qualities, 362 Use of exposure meter, 256 Substitution of chemicals, 282 Sulphide - silver reclaiming, 314 Variable contrast papers, 331 Sulphuric acid, 319 Ventilation of darkroom, 277 Sulphurous acid, 311 Versamat processor, 303 Superadditivity, 292 View cameras, 148 (see also technical cameras) Supercoat, 168 Viewfinders Surface of printing papers, 331 direct vision camera, 125 'Surface tension', 319 single lens reflex, 137 'Suspended frame' viewfinder, 126 twin lens reflex, 132 Swing back, 103, 104 technical baseboard camera, 141 summary, 105 Viewing filters, 202 Swing front, 100, 101 prints, transparencies, 351 studio camera, 149 Viewpoint and framing, 364 summary, 102 Vignetting, 342 and covering power, 67 and front movements, 98 'T' shutter setting, 118 TLR (see Twin lens reflex) Virtual image, 43 Tables - exposure, 254 Visible light, 21 Tacking iron, 349 Visible spectrum, 21 Tanks and dishes, 280, 302 Visual 'adaptation' of eye, 184 Technical (baseboard) cameras, 141, 145 Visual extinction meter, 254 Technical (monorail) cameras, 146, 150 Visual luminosity curve, 185 Telephoto (see long focus lens) Visual perception, 365 Temperature coefficient', 297 Visual perspective (see perspective) Temperature Visual response to colour, 185 conversion, 296, 375 Visual spectrum, 21, 23 of developers, 296 Volts, 223 of fixers, 315 Test Warm tone for effective fixation, 317 developers, 343 for effective washing, 318 printing paper, 328 for fixer exhaustion, 314 Washing film, 316 Test strip, sheet film, 253 Washing of printing materials, 346 Test strips, enlarging, 341 Washing, test for efficient, 318 Testing of safelights, 196 Water of crystallisation, 282 Texture, lighting of, 220 Waterhouse stops, 59 Threshold, 240 Waterproof paper (see plastic coated) Tilting back (see swing back) Watts, 223 Tilting front (see swing front) Wavelength, 20 Time of development, 298 and Gamma, 237 Time and temperature development, 297 Wedge spectrogram, 186, 188 Wedge spectrograph, 187 Time/temperature graphs, 297 Tonal range - transparency v print, 352 Wedges, 230, 254 Translucent, 26 Weighing out chemicals, 283

Weights - emergency, 284

Weights and measures, 283, 375

Transmission of light, 26

Transmission densitometer, 232

WESTON speeds, 375 'Wet' and 'Dry' benches, 277 'Wetting agent', 318 Wide angle distortion, 72 Wide angle lens, 71 Wire frame finder, 143 Wiring of plugs, 223 'XM' Shutters, 115 X units, 21 Xrays, 21, 176 X synchronisation, 214

Zinc – silver reclaiming, 314 Zone focusing, 89